The Passive-AGGRESSIVE Coloring Book

LARK
New York

An Imprint of Sterling Publishing
1166 Avenue of the Americas
New York, NY 10036

TEXT © 2016 OCTOPUS PUBLISHING GROUP
ILLUSTRATIONS © 2016 BY CHARLOTTE FARMER

THIS EDITION PUBLISHED IN 2016 BY
STERLING PUBLISHING CO., INC.

ISBN 978-1-4547-0988-6

DISTRIBUTED IN CANADA BY STERLING PUBLISHING
C/O CANADIAN MANDA GROUP, 664 ANNETTE STREET
TORONTO, ONTARIO, CANADA M6S 2C8

FOR INFORMATION ABOUT CUSTOM EDITIONS, SPECIAL SALES,
AND PREMIUM AND CORPORATE PURCHASES,
PLEASE CONTACT STERLING SPECIAL SALES AT 800-805-5489
OR SPECIALSALES@STERLINGPUBLISHING.COM.

MANUFACTURED IN CHINA

2 4 6 8 10 9 7 5 3 1

WWW.LARKCRAFTS.COM

The Passive-AGGRESSIVE Coloring Book

(FOR PEOPLE WHO JUST DON'T GET THE WHOLE CALM THING)

CHARLOTTE FARMER

LARK
New York

1. DAWN CHORUS 2. Bathroom Blues

3. Kale Fail 4. Love Your Job

5. GOOD NEIGHBORS

6. How Does your Garden Grow

7. MINDLESSNESS Snacks 8. Rubbish Yoga

9. FLOORDROBE 10. B**E OFF!

11. P**sed off Pets 12. Dating Profiles

13. What have you left on?

14. COMMUTER 15. A REAL Bikini Body
CRUSH 16. Washing up

17. Makeup bag Breakdown 18. Meditation

19. Moths vs Cardigans

20. ?#@$*% Weather 21. MAN FLU

22. It's the LITTLE things 23. Pin Bored

24. PASSIVE-AGGRESSIVE SLEEPING PATTERNS

25. ROAD RAGE 26. footwear FAIL

27. POOL POWER

28. What's REALLY in the Bag?

29. You're DUMPED 30. RED SOCK

31. Cinema Paradiso

32. FLATPACK FURNITURE FAIL

33. PERFECT MAN 34. Fashion Faux Pas

35. Hell is Other People 36. SNACK ATTACK

37. ARE YOU PASSIVE AGGRESSIVE?

We're the **DAWN CHORUS** ...time to wake up

Bandage (used) found in bath

BB Cream - doesn't work

FACE PERFECTING MAKE UP
BB SPF 15 LIGHT

conditioner - almost finished (by someone else)

AVOCADO Hair Conditioner

bits of beard all over the sink

toothbrush - out of battery forgot to charge it

Nail Varnish

Wet towel on the floor

random coin

SUPER LASH

*

*

Dating

Profiles

When did you take that?

...and did you even lock the door?

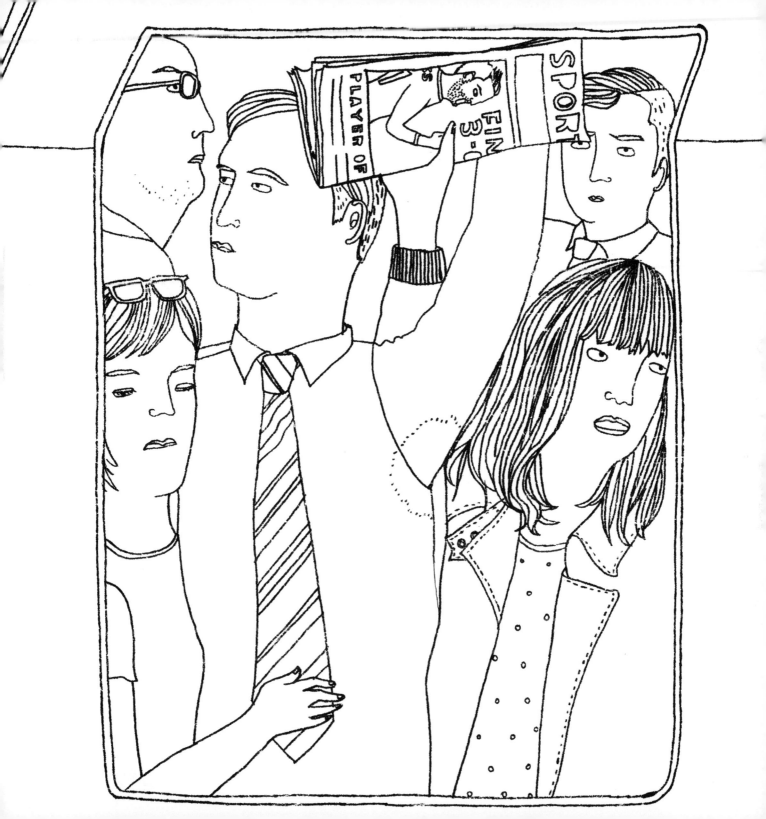

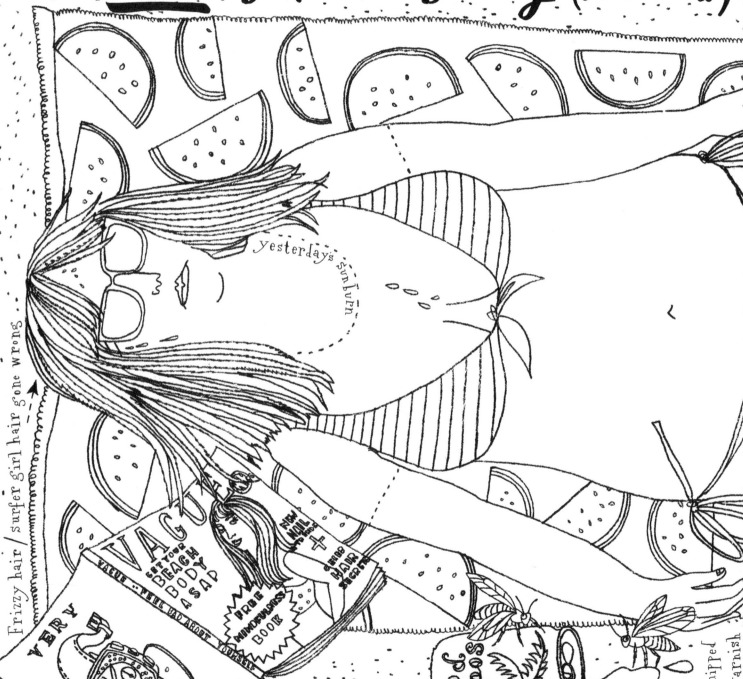

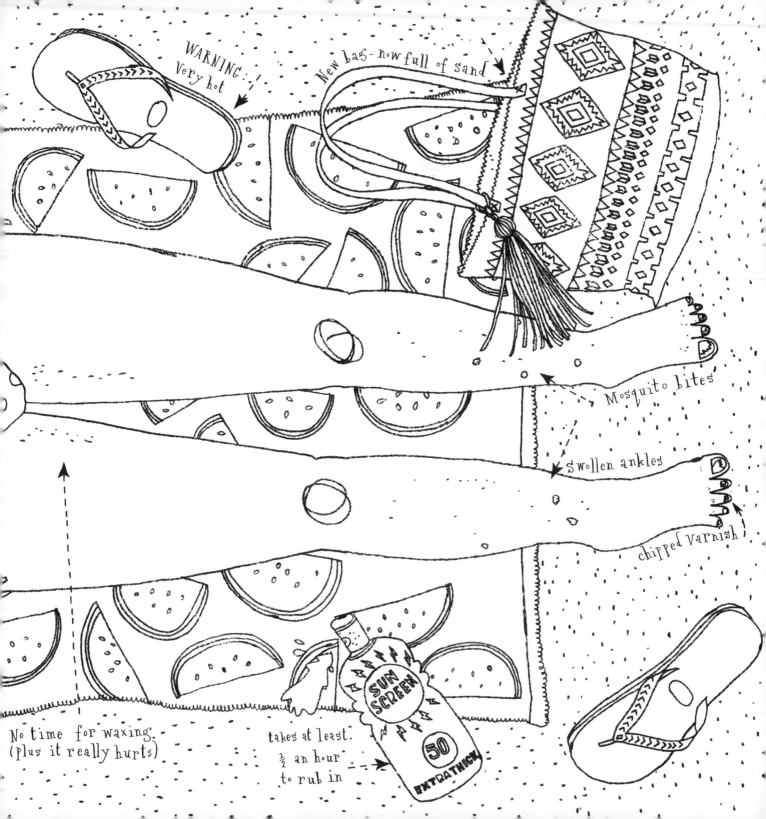

Moths
Vs
Cardigans

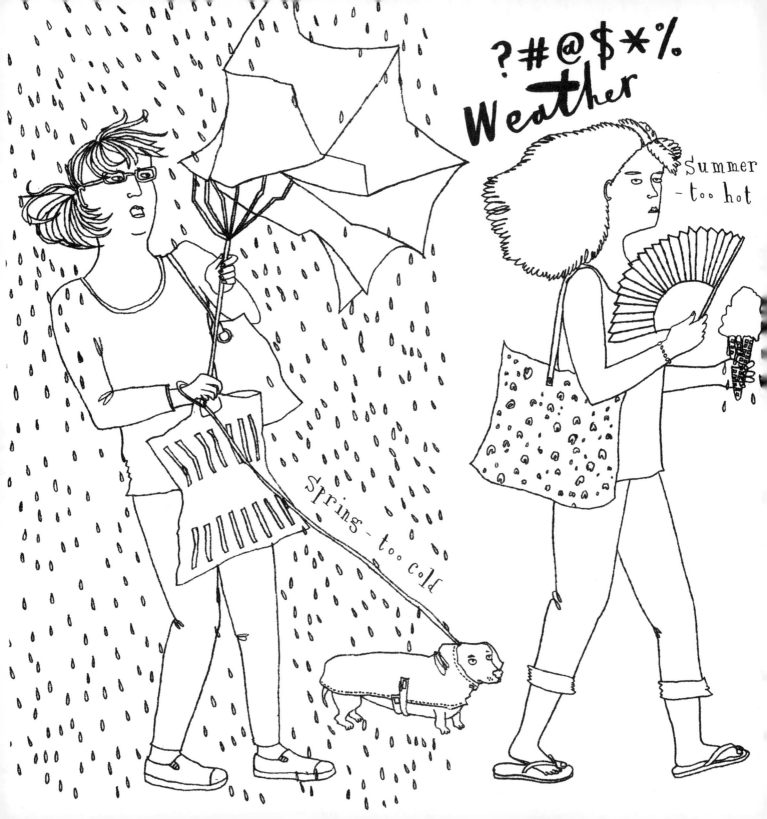

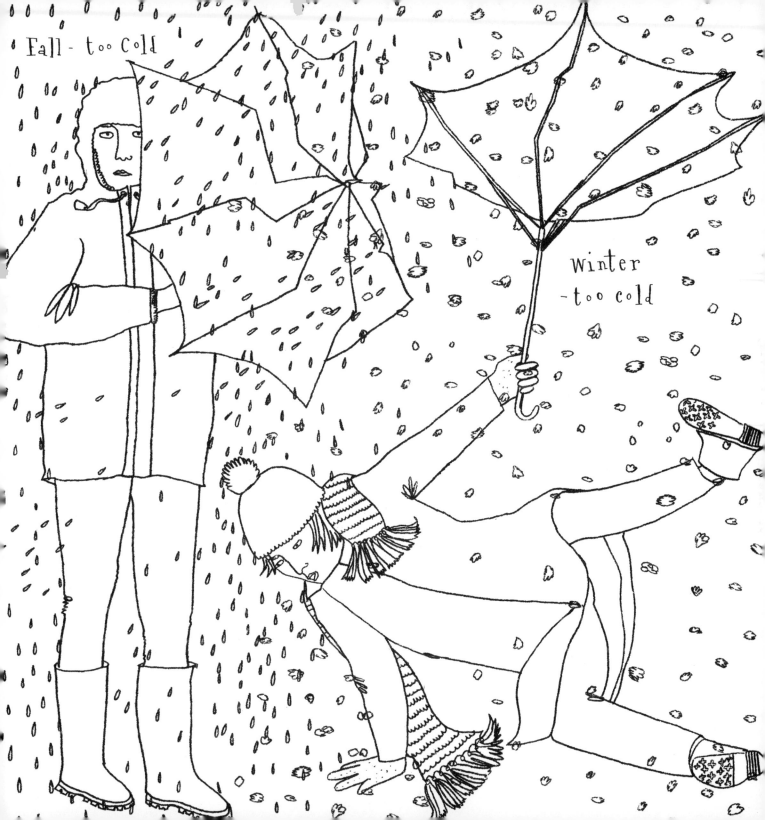

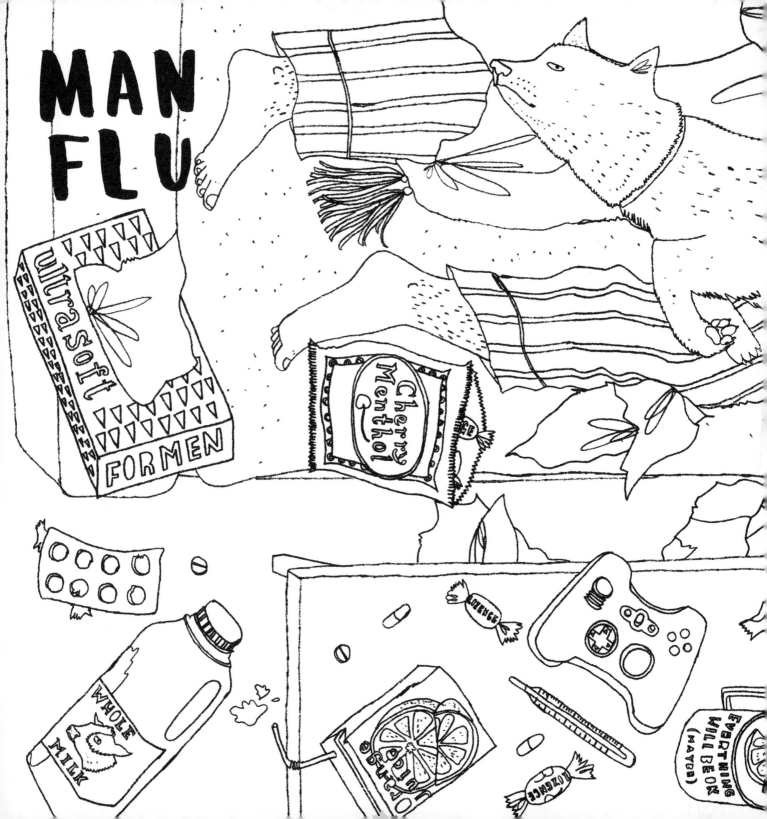

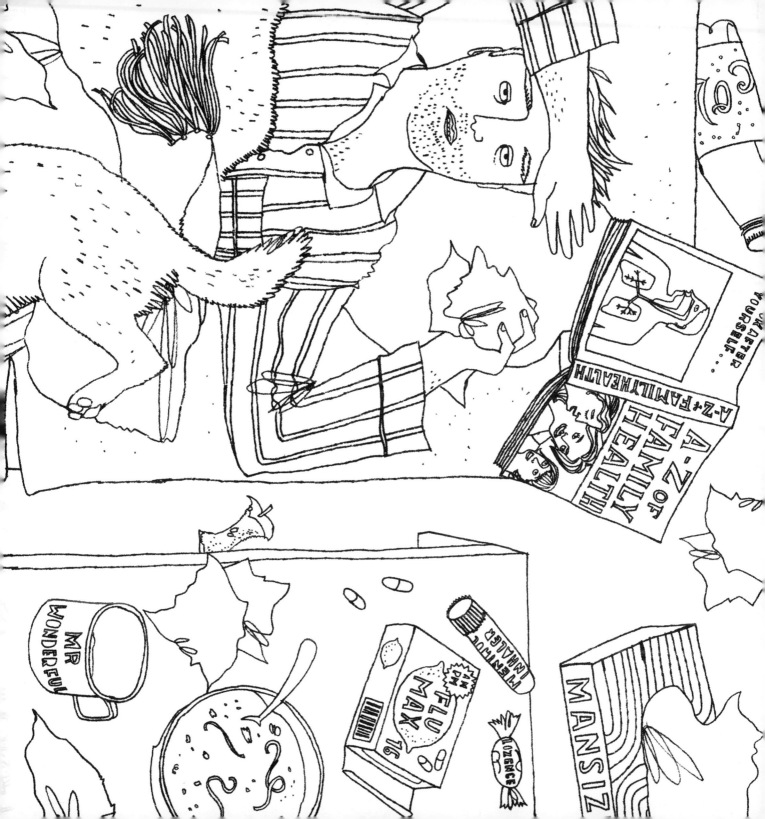

Overly happy people

out of milk, not your turn to buy it

milk
FULL CREAM
100% PURE

tea bag left on the counter

Dream Catcher

No-show sock falling off a minute after you've lft the house

S walking in the rain

Cat ignoring scratching Post

 # Pin Bored

Stretch Run
○ Exercise

Joy

Quiet home

My style

too much cute
○ animaux

Princess
○ Hair

25 mindful LEMON DETOX RECIPES

Healthy mind & Body

Reality

PASSIVE-AGGRESSIVE SLEEPING PATTERNS

FAIL

Dried-out wet wipes

Lemon Wet Wipes

3 PLY TISSUES

lip balm covered in fluff

escaped tampon

(not used but out of wrapper)

book ruined by water

THE Milk THIEF

MARK MUZAK

DAIRY MILK

used tissue

Receipt x20ish
507160

fluff-covered mint

CHOCOLATE

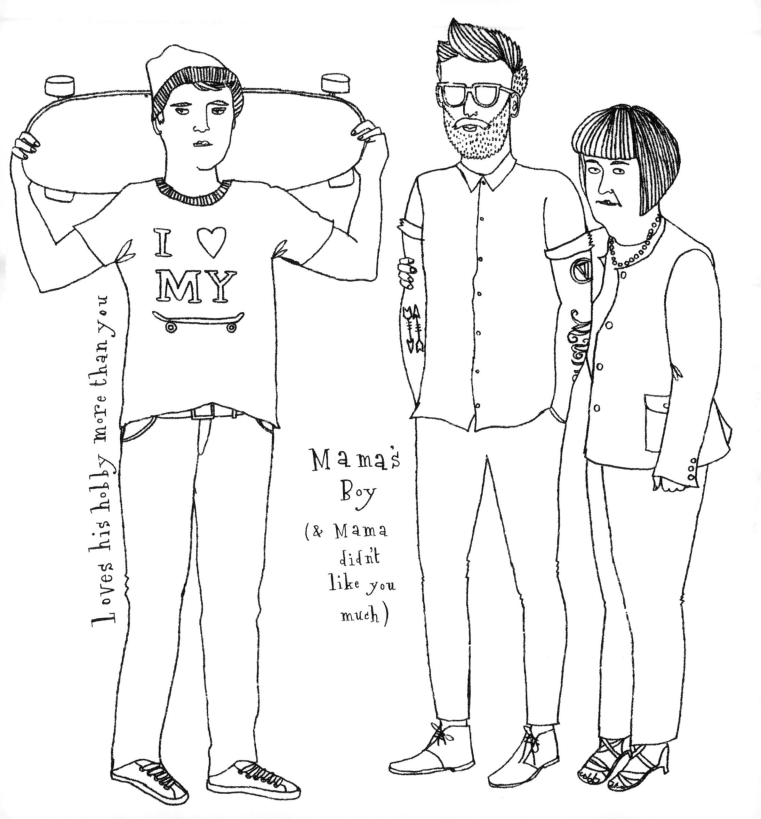

Loves his hobby more than you

I ♥ MY 🛹

Mama's
Boy

(& Mama
didn't
like you
much)

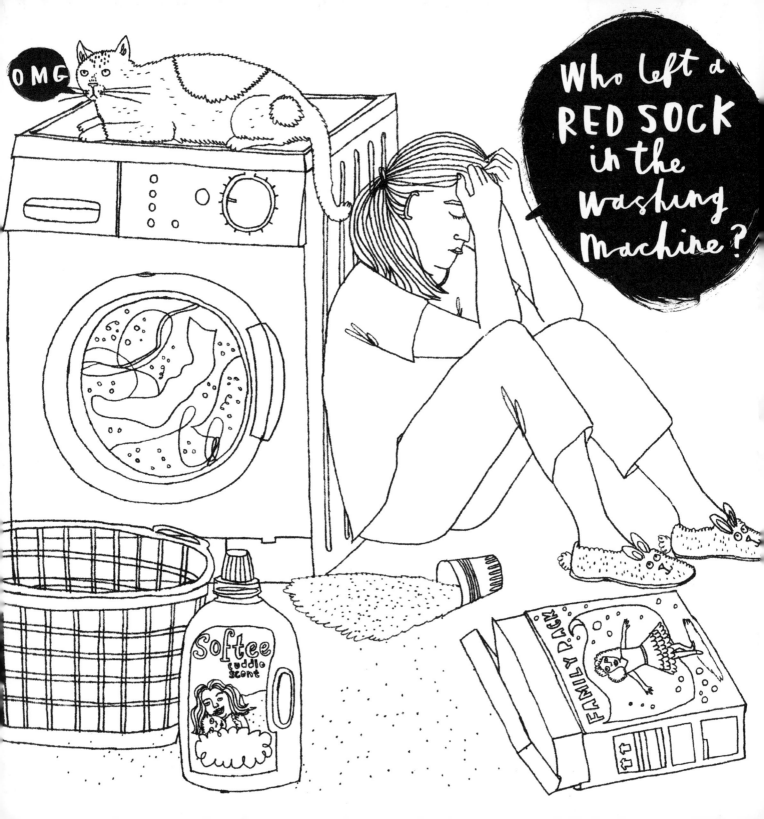

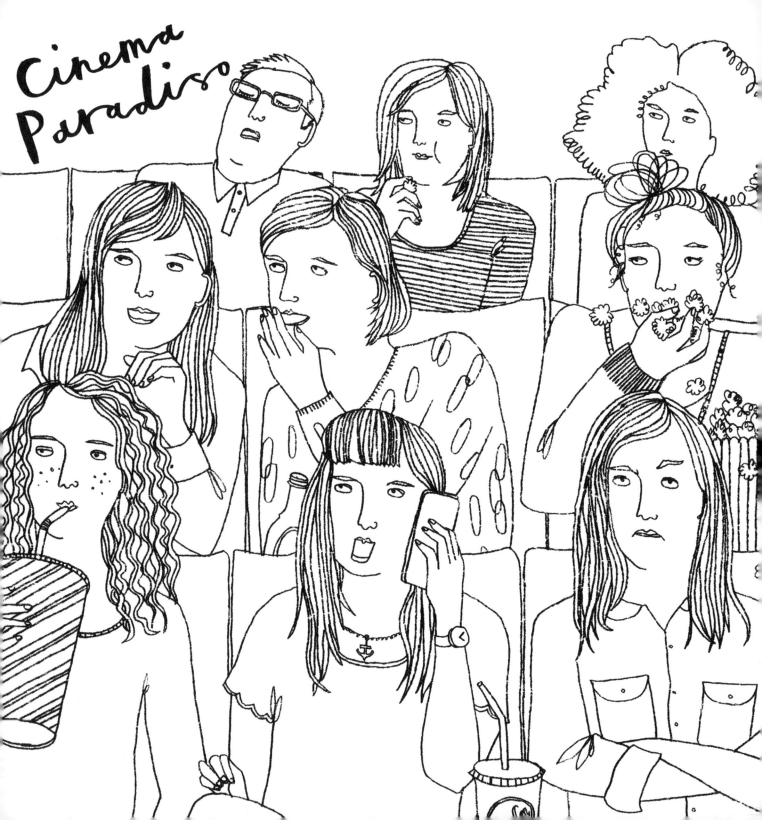

CREATE YOUR **PERFECT MAN** (Because he's probably not out there)

Choose his hair: Stubble? Beard?

A tattoo or two?

What does he wear?

Glasses?

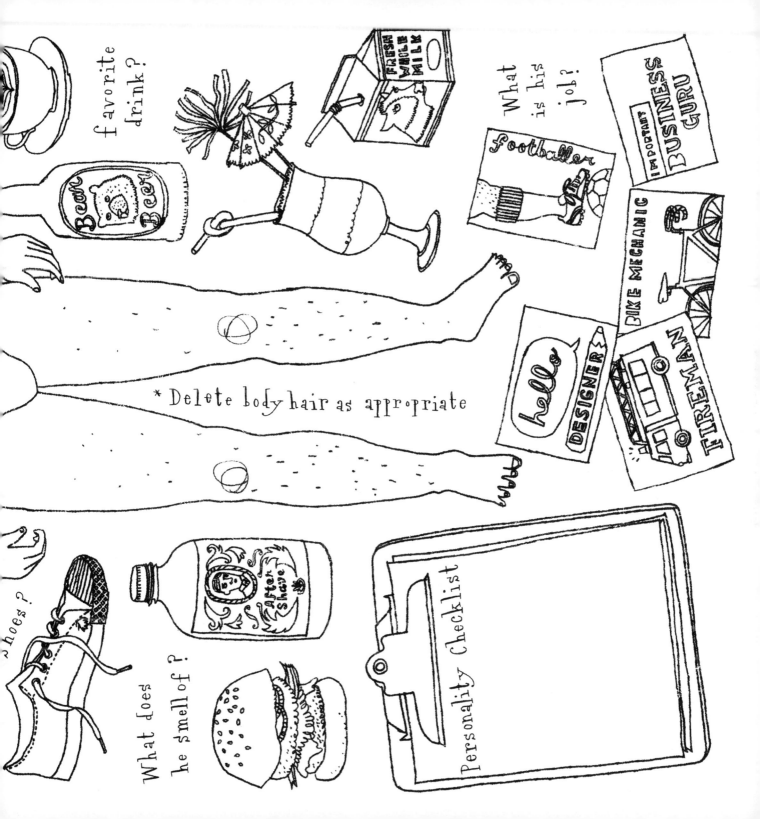

favorite drink?

FRESH WHOLE MILK

What is his job?

footballer

IMPORTANT BUSINESS GURU

BIKE MECHANIC

Beer Beer

hello DESIGNER

FIREMAN

* Delete body hair as appropriate

Shoes?

After Shave

What does he smell of?

Personality Checklist

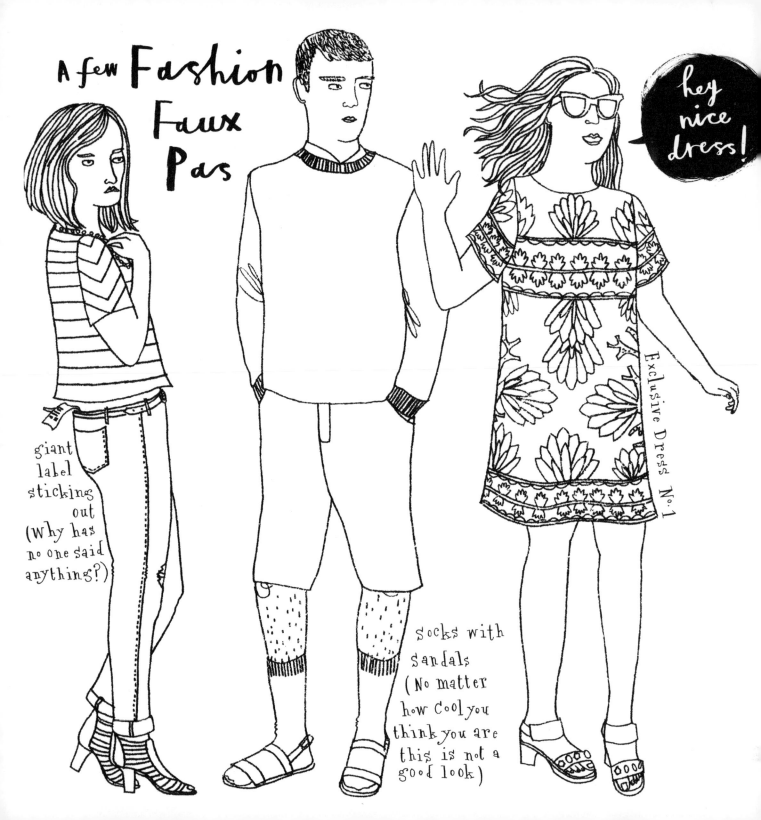

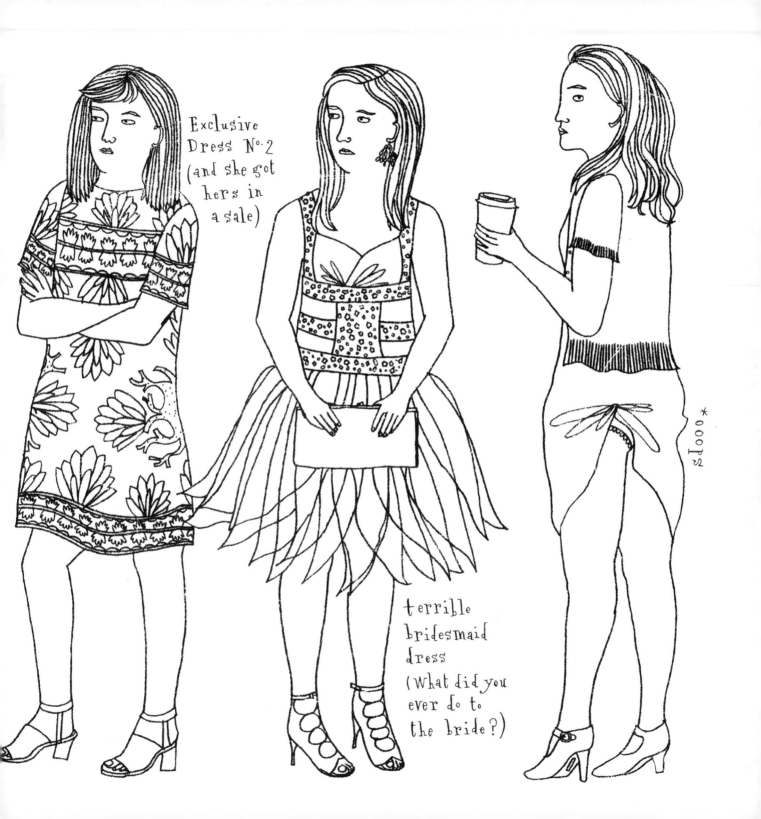

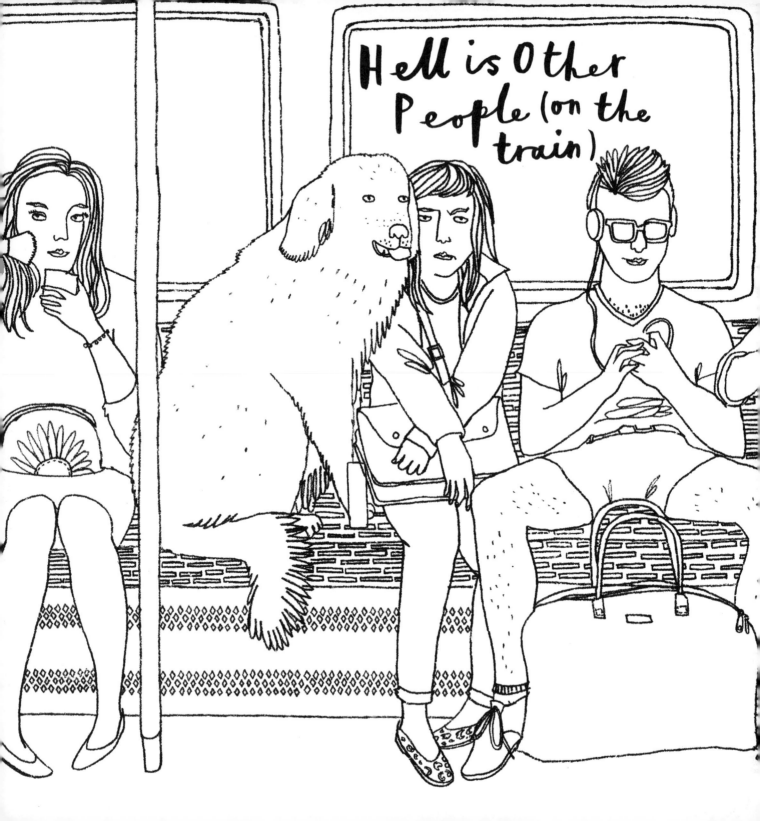

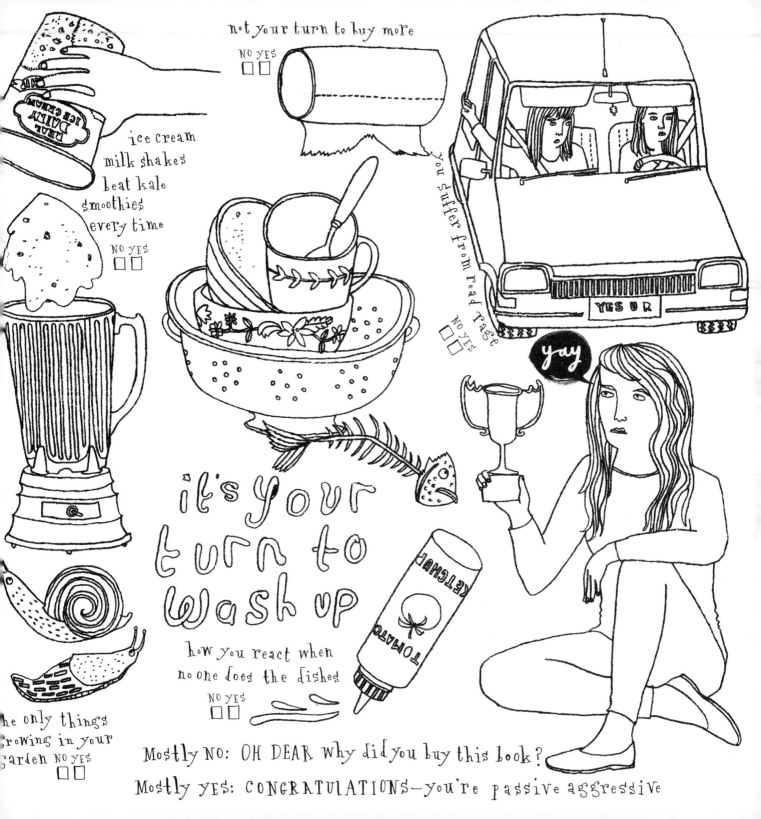

Acknowledgments

MEEOW

thanks

Pat - for putting up with any passive aggressive-ness from me during the making of this book and Margo - who is either aggressive or asleep!

Also thanks to the Ilex team: Rachel (hope you find a ripe 'ripe & ready' avocado one day), Zara, Frank, Roly & Julie

SAN FRANCISCO
49ERS

The Complete Illustrated History

BY MATT MAIOCCO
FOREWORD BY DWIGHT CLARK

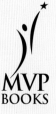

MVP
BOOKS

First published in 2013 by MVP Books, an imprint of MBI Publishing Company, 400 First Avenue North, Suite 400, Minneapolis, MN 55401 USA

MVP Books titles are also available at discounts in bulk quantity for industrial or sales-promotional use. For details write to Special Sales Manager at Quayside Publishing Group, 400 First Avenue North, Suite 400, Minneapolis, MN 55401 USA.

To find out more about our books, visit us online at www.mvpbooks.com.

Library of Congress Cataloging-in-Publication Data

Maiocco, Matt.
 San Francisco 49ers : the complete illustrated history / Matt Maiocco ; foreword by Dwight Clark.
 pages cm
 Includes index.
 ISBN 978-0-7603-4473-6 (hc)
 1. San Francisco 49ers (Football team)--History. 2. San Francisco 49ers (Football team)--History--Pictorial works. I. Title.
 GV956.S3M37 2013
 796.332'640979461--dc23
 2013013938

Edited by Josh Leventhal
Design Manager: James Kegley
Designed by Sandra Salamony
Layout by Kim Winscher

Printed in China

On the front cover: (center) Joe Montana, *photo by Ron Vesely/ Getty Images;* (top left) Colin Kaepernick, 2012, *photo by Thearon W. Henderson/Getty Images; (top right)* Dwight Clark, 1982, *photo by B Bennett/Getty Images; (bottom right)* Frank Gore, 2012, *photo by Leon Halip/Getty Images; (bottom left)* Hugh McElhenny, 1959, *photo by Robert Riger/Getty Images.*

On the frontispiece: Vintage 49ers logo illustration, *from the MVP Books Collection.*

On the title page: Candlestick Park, 2010, *photo by Eric Broder Van Dyke/Shutterstock.com.*

Contents

Foreword

By Dwight Clark

When I first came to the San Francisco 49ers in 1979, I knew very little about the history of the organization. In fact, I was familiar with only one player from the 49ers' past: John Brodie.

Sam Wyche, an offensive assistant under Bill Walsh, called to let me know the 49ers had selected me in the 10th round of the NFL draft. At that point, I didn't know a lot about San Francisco, either. I had rarely left North or South Carolina.

Honestly, I thought I might not be with the 49ers for very long, that I would probably get cut. O. J. Simpson was on the team that year, and in my mind, I knew I could at least tell my kids, "I was drafted by the 49ers; I was on the team for a few weeks; and I got to meet O. J. Simpson." That was going to be enough for me.

But I made the team and ended up with the organization for two decades. During that time, I learned a lot about the 49ers' tradition that included "The Million Dollar Backfield," Jimmy Johnson and Bob St. Clair, and so many other Hall of Famers. I got to know a lot of the great players of the past. Billy Wilson was a scout and a part-time coach. R. C. "Alley Oop" Owens worked inside the building for many years. Gordy Soltau, Len Rohde, and John Brodie were around. It was cool that John became a friend of mine and remains one to this day.

You started hearing a lot more about the history of the 49ers once we got into playoff competition. You heard a lot about the postseason struggles against the Dallas Cowboys. You could tell it meant so much to all the former players to finally get over that hump and beat the Cowboys in the 1981 NFC Championship Game.

Rarely a day goes by that somebody does not ask me about "The Catch." Does it ever get old talking about it? Why would it? I am extremely grateful to be associated with a play that is remembered so fondly by so many 49ers fans.

The coolest thing about "The Catch" is it connects me to 49ers fans forever. Thanks to technology, dads can say to their 10-year-old kids, "This was a great play in 49ers history. Go to YouTube and watch it." Kids come up to me to get that picture signed all the time. You can tell it's a moment from 49ers history that has been passed down for a couple of generations. And it seems to be the kind of play that will continue to be seen and talked about even after I'm long gone. It is recognized as the play that started the dynasty of the 49ers. In reality, the entire season was building up to that championship.

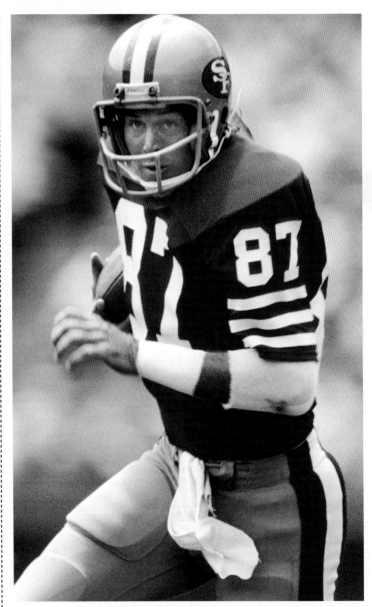

Dwight Clark in action at Candlestick Park, September 1982. RONALD C. MODRA/GETTY IMAGES

Of course, it wasn't just me. I was the exclamation point on that play. There was a sentence, a paragraph, and a book all before that one play that got us to that point.

I played six more years with the 49ers and remained with the organization in a number of different roles until 1998. At first, I was a "go-fer" for Norb Hecker, who was in charge of training camp. Because I was a former player and familiar with the staff, people inside the organization would sometimes come to me if there were any problems. Even the maintenance guys came to me and said, "Jon Gruden is sleeping on the sofa in the president's office. What do we do?" And I'd say, "He probably shouldn't do that. Let's find him another place to sleep." Gruden was an entry-level coach at the time, and he slept every night at the facility. He was a workaholic. I'm not sure he even had an apartment at that point.

One time I picked up a 49ers media guide and read about how Eddie DeBartolo's dad had him work in every area of the DeBartolo Corporation so that when it came time for him to be in charge, he would know a little bit about every department. I thought that was a brilliant idea, so I asked Eddie if I could do that with the 49ers. Eddie was so generous to us players even after we stopped playing, and he said, "Of course." That's when I started moving through the different areas of the organization. I worked in marketing, public relations, and the business office. I even coached during training camp, with my ultimate goal of getting into the personnel department.

General manager John McVay and director of college scouting Tony Razzano took me under their wings. When Carmen Policy moved out to the Bay Area full time, I worked closely with him on the complexities of managing the salary cap. Eventually, I became vice president/director of football operations.

Another opportunity took me to the Cleveland Browns. Then, I returned to my hometown of Charlotte, North Carolina, to work in the construction business. Even during that time, I followed the 49ers closely. When I came back to the Bay Area, I started going to 49ers games with my future wife, Kelly. Her grandfather had season tickets for 30 years.

I sat in the stands wearing a hat and glasses in the end zone 20 rows away from where I made "The Catch." Kelly introduced me to tailgating, which was awesome. We parked out in the masses and paid for parking like everybody else and went in and watched the games.

Even though the 49ers were struggling to win games, my experience of being a fan was spectacular. I told Kelly, "I bet in the '80s when we were winning, this was unbelievable." It had to be a great experience to go to our games knowing you had some of the greatest players of all time, like Joe Montana, Jerry Rice, and Ronnie Lott. You were going inside Candlestick Park to watch true football legends. And you knew the 49ers were going to win nine out of ten times.

Watching the games as a fan was great because I love the 49ers and I love the game of football. But we were not very good, so it tugged at all of us. We were accustomed to a higher class of football.

And, now, we are back. The 49ers are relevant again. General manager Trent Baalke is awesome. He is great at picking players. This team is loaded with talent. The coaching staff, led by Jim Harbaugh, is excellent, too. An innovative and exciting offense, coupled with a bone-crushing defense, has the team back among the best in the NFL. It's great to see the rich tradition of 49ers football continue for another generation to enjoy.

Clark in 2012, posing with the issue of *Sports Illustrated* that celebrated "The Catch." MATT MAIOCCO

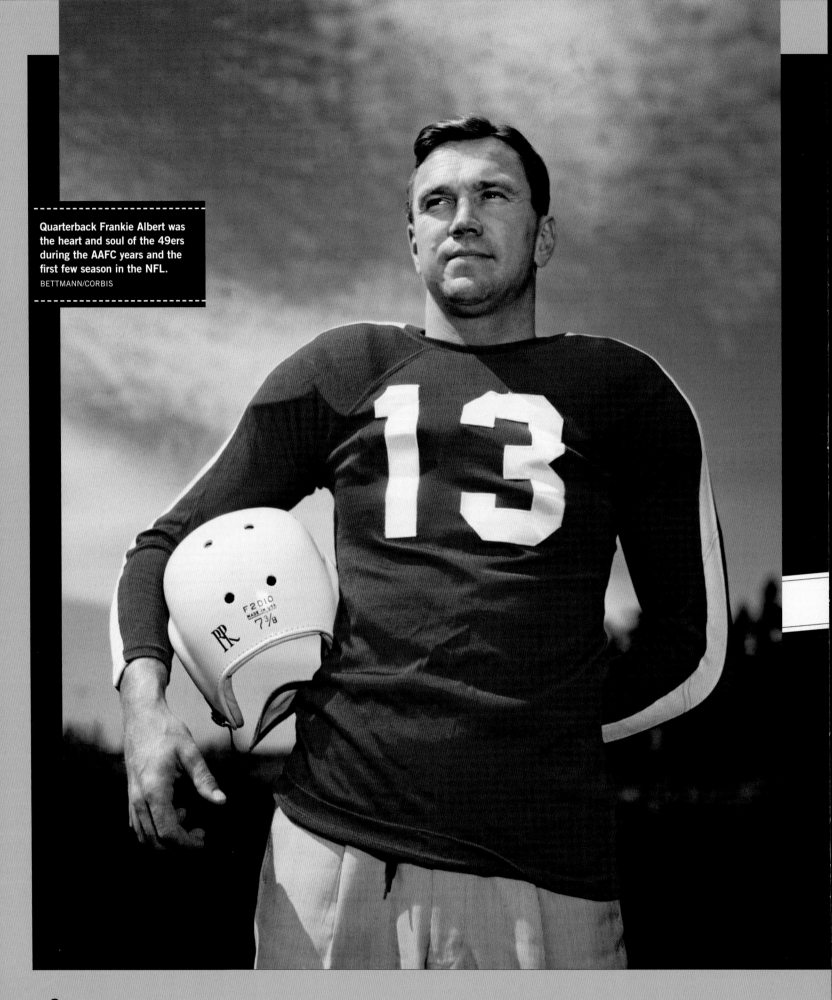

Quarterback Frankie Albert was the heart and soul of the 49ers during the AAFC years and the first few season in the NFL.

FRANKIE ALBERT AND THE BEGINNING OF THE FRANCHISE

1946–1952

The city of San Francisco was on the map for a century before a young lumberman from the Bay Area traveled east to meet with the commissioner of the National Football League to discuss forming an expansion franchise on the West Coast. It would prove to be no easy task.

Program covers from the first three seasons of San Francisco 49ers football

SEEKING A TEAM

A San Francisco native, Tony Morabito had long witnessed the popularity of the Bay Area's college football scene. Each weekend, throngs of fans filled venues, including Kezar Stadium, to cheer on the region's five major college football programs: Cal, Stanford, the University of San Francisco, Santa Clara, and Saint Mary's.

When he took his idea outside the Bay Area, however, Morabito was met with firm opposition. During one early inquiry to league officials, Morabito was advised, "Wait until after the war." He faced plenty of cynicism, skepticism, and outright mockery during a 1944 meeting with NFL officials in Chicago.

The NFL had no teams west of Chicago, and travel costs were regularly cited as the reason the NFL and other pro leagues could not open up the West Coast to franchises. The costs involved in transporting a football team and its staff across the country would be exorbitant, the skeptics said. Indeed, in the mid-1940s, no professional sports organizations were located west of St. Louis.

Commissioner Elmer Layden, who first made a name for himself as one of Notre Dame's Four Horsemen in the 1920s, made it clear that he had no intention of opening up his league to the West.

"He talked as if California was some kind of foreign country," recalled Al Ruffo, who served as Morabito's legal counsel and was present at those initial meetings. Ruffo would also later buy minority interest in the 49ers and become a member of the team's inaugural three-man coaching staff.

But just as it was clear that the NFL would not expand to the West Coast as long as Layden was in charge, it was also clear that Morabito was determined to realize his dream of bringing professional football to San Francisco.

Morabito had a passion for football that began when he was a halfback at San Francisco's St. Ignatius High School. He attended Santa Clara University, but he sustained a shoulder injury during his freshman year and never played football again.

Ruffo, Morabito's teammate at Santa Clara and also head of the San Jose City Council, helped him sketch the blueprint to bring professional football to Northern California. Despite the league's outspoken opposition to the idea, Morabito went ahead and filed an application to form a team. It went nowhere with the NFL.

Ruffo recalled that Layden left Morabito with a final piece of advice: "Well, sonny," Layden told him, "you better go out and get a football first and then come back."

Morabito did not stop with the purchase of a football. He formed an entire football team.

After his unsuccessful meeting with the NFL, Morabito walked across the street from the NFL owners meeting and went to talk with Arch Ward, sports editor of the *Chicago Tribune*. Ward had a plan to form a professional football league to rival the NFL. When Morabito heard of Ward's idea, it piqued his interest.

Stanford and California have been meeting in the annual "Big Game" since 1892. At the 1930 contest, shown here, a full crowd was on hand to see Stanford crush Cal, 41–0, at California Memorial Stadium in Berkeley. LIBRARY OF CONGRESS, PRINTS AND PHOTOGRAPHS DIVISION

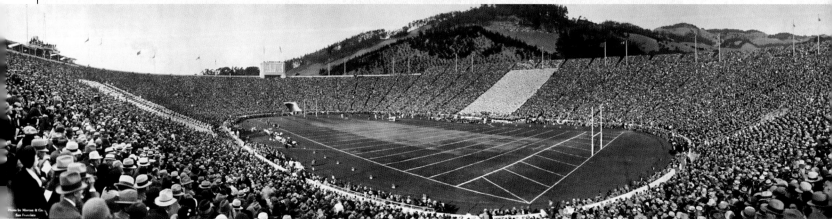

BEFORE THE 49ERS

Long before the San Francisco 49ers arrived on the scene, the Bay Area was known for outstanding and entertaining football.

The University of California–Berkeley, Stanford University, Santa Clara University, Saint Mary's College, and the University of San Francisco competed among the major college ranks and drew huge crowds for decades before Tony Morabito brought professional football to the region.

Cal, which began playing football in 1886, fielded a dominant program in the 1920s. From 1920 to 1925, the Golden Bears went 50 consecutive games without a loss and were known as "The Wonder Teams." Cal went to the Rose Bowl three times during the decade.

After World War II, Cal had a resurgence under the direction of Lynn "Pappy" Waldorf. Known as "Pappy's Boys," those Cal teams won 33 consecutive regular-season games from 1947 to 1950. But the Bears fell to defeat in each of their three trips to the Rose Bowl.

Stanford, which began football in 1892, won a national championship in 1926 with legendary coach Glenn "Pop" Warner at the helm. Clark Shaughnessy coached the "Wow Boys" to a 10–0 record in 1940, including a 21–13 victory over Nebraska in the Rose Bowl. Quarterback Frankie Albert was a consensus All-American and finished fourth in the Heisman Trophy balloting.

Santa Clara first played football in 1896. The university fielded a major college program from 1937 to 1952. Under coach Lawrence "Buck" Shaw, the Broncos won the Sugar Bowl in back-to-back seasons in 1937 and '38 over LSU. In 1950, the Broncos returned to the national scene with a 21–13 victory over Kentucky in the Orange Bowl.

Saint Mary's became a nationally known football entity under the legendary showman Edward "Slip" Madigan, a product of Knute Rockne's staff at Notre Dame. Madigan choreographed well-publicized trips to the East Coast and had a following that included Babe Ruth. The Gaels took down a powerful Fordham team in 1930 that featured the first version of the offensive line known as the "Seven Blocks of Granite." The Gaels defeated Texas Tech, 21–13, in the 1939 Cotton Bowl.

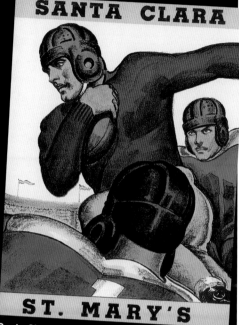

Santa Clara and St. Mary's were collegiate powerhouses in the years before pro football came to the Bay Area.

Historically, the University of San Francisco did not have the kind of success of the other Bay Area schools before the 49ers' arrival. But in 1951, USF might have fielded the best team in the history of college football.

Eight players from Joe Kuharich's 1951 Dons stepped directly into the NFL. Three players—Bob St. Clair, Ollie Matson, and Gino Marchetti—were eventually inducted into the Pro Football Hall of Fame. But USF was left uninvited to the Gator, Sugar, and Orange Bowls because those committees decided to avoid teams with African-American players. The Dons decided to stick together as a team rather than play a bowl game without two of their key players. Despite a 9–0 record, USF final ranking in the Associated Press poll was No. 14.

In 1926, Red Grange's Chicago Bears of the NFL came to Kezar Stadium to take on the short-lived club team, the San Francisco Tigers, led by Buck Bailey.
AP PHOTO/NFL PHOTOS

THE ALL-AMERICA
FOOTBALL CONFERENCE

Ward's new league—the All-America Football Conference—held its first meeting on D-Day, June 6, 1944, in St. Louis, Missouri. Morabito agreed to establish a San Francisco franchise in a league that would not begin play until the fall of 1946.

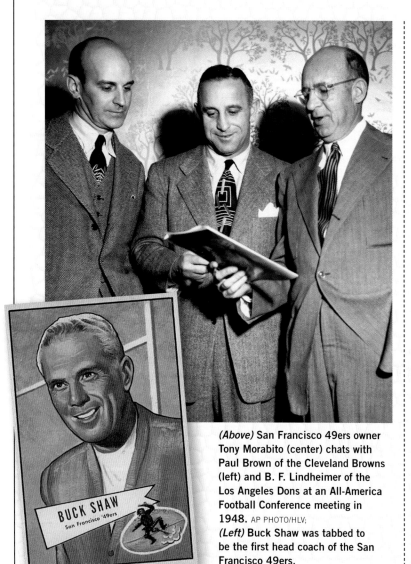

(Above) San Francisco 49ers owner Tony Morabito (center) chats with Paul Brown of the Cleveland Browns (left) and B. F. Lindheimer of the Los Angeles Dons at an All-America Football Conference meeting in 1948. AP PHOTO/HLV;
(Left) Buck Shaw was tabbed to be the first head coach of the San Francisco 49ers.

BUCK SHAW
San Francisco '49ers

The league was formed with eight franchises, including two in California (San Francisco 49ers and Los Angeles Dons), two in cities that already had NFL clubs (New York Yankees and Chicago Rockets), and four in cities that lacked pro football in 1946 (Brooklyn Dodgers, Buffalo Bisons, Miami Seahawks, and Cleveland Browns).

Morabito, who had made his fortune from a lumber and lumber-carrier business, made a huge investment to ensure the success of his 49ers. He and his partners, Allen E. Sorrell and Ernest Turre, invested $250,000 to get the franchise structured before the first kickoff. While some observers believed that Morabito and his group were taking on a huge financial risk, others saw the heavy investment as an indication of a first-class operation.

Morabito quickly lured Lawrence "Buck" Shaw, formerly of Santa Clara University, to become the team's first head coach. The first player signed was former Stanford quarterback Frankie Albert, further establishing the local ties for the new franchise.

According to Lou Spadia, who served the 49ers in a variety of capacities for more than 30 years, the highest player salary was $10,000. "That was for Frankie Albert," Spadia told the *San Francisco Chronicle* in 2003. "The lowest salary was $2,000. The total budget in 1946 was only $250,000, and ten percent of that was for Buck Shaw's salary. I'll tell you, in 1946, $25,000 was utterly fantastic."

Morabito set the direction for the 49ers' organization with the first signing, as there was no doubt that Albert would become the centerpiece. The 49ers would always be known for their innovation around the quarterback position. Albert was the first of many quarterbacks through the years who would form the identity of the franchise.

"Frankie Albert, who really should be a Hall of Fame quarterback, ran the team," end Gordy Soltau said. "Physically and mentally, he ran the team. He called all the plays. He was a great leader. He was one of the best."

THE SILVER FOX

When Tony Morabito began telling others of his desire to start a professional football team, he was not shy about expressing his desire to hire Lawrence "Buck" Shaw as his coach.

Morabito delivered on his promises. He got his football team. And he got his head coach.

After an outstanding career as a tackle and placekicker at Notre Dame under Knute Rockne, Shaw gained fame in the Bay Area with his work at Santa Clara University, where he molded a group of underdogs into back-to-back Sugar Bowl champions. Led by senior All-American quarterback Nello "Flash" Falaschi, the Broncos scored an improbable 21–14 victory over the LSU Tigers on New Year's Day in 1937.

The following season, without Falaschi, Shaw's Santa Clara team was even better. The Broncos turned into a defensive power, rolling to a 9–0 record topped off by a 6–0 victory over LSU in the Sugar Bowl.

Santa Clara dropped football in 1942 due to World War II, leaving Shaw with a record of 47–10–2. He remained at Santa Clara for two years to assist the Army's physical education program.

"The Silver Fox" was on board to be the 49ers' first coach but had to wait until 1946, when the organization joined the All-America Football Conference.

Shaw coached one season at California, where his team defeated a Saint Mary's Pre-Flight team that was led by former Stanford star Frankie Albert. The next season, Albert was Shaw's quarterback in the 49ers' inaugural season.

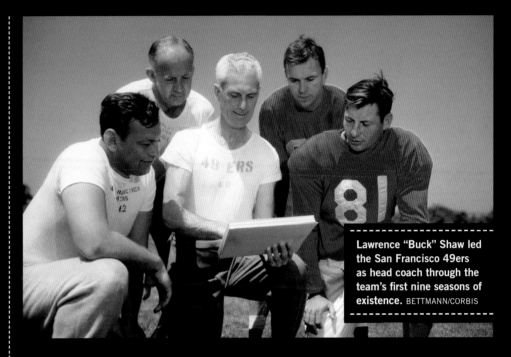

Lawrence "Buck" Shaw led the San Francisco 49ers as head coach through the team's first nine seasons of existence. BETTMANN/CORBIS

In nine seasons with San Francisco, Shaw compiled a 71–39–4 record. His only losing season as head coach came in 1950, the season the 49ers made the jump from the AAFC to the National Football League. The offensive-minded Shaw was not a tough taskmaster, but his team was an offensive powerhouse and a title contender throughout most of his tenure.

"Buck Shaw ran an offense a lot like Bill Walsh's," former 49ers executive Lou Spadia said in Glenn Dickey's 1995 book, *San Francisco 49ers: The First Fifty Years.* "He'd send Norm Standlee out in the flat and throw the ball to him, and Standlee was like a runaway freight train. Unfortunately, Buck never cared anything about defense, and he never looked for players who could play good defense."

Quarterback Y. A. Tittle added, "Buck was a perfect quarterback coach. He would work hard with you during the week and make sure you were prepared. And then in the game, he'd leave you alone. If you threw an interception or called a dumb play, he never second-guessed you."

In a controversial move, Morabito fired the immensely popular Shaw after the 1954 season, during which the 49ers went 7–4–1 despite injuries to several key players, including halfback Hugh McElhenny.

Shaw later got his own NFL championship while coaching the Philadelphia Eagles from 1958 to 1960. After the Eagles defeated Vince Lombardi's Green Bay Packers 17–13 to win the 1960 league title, Shaw retired as coach at the age of 61.

FILLING OUT THE ROSTER

Even the greatest quarterbacks can't flourish on their own, and Morabito surrounded Albert with an impressive supporting cast. The owner hand-picked the inaugural roster of 32 players, and he leaned heavily on the area colleges to fill the locker room.

Fullback Norm Standlee and offensive guard Bruno Banducci, like Albert, were from Stanford. Shaw also helped recruit some of his former Santa Clara players, including end Alyn Beals and linemen Visco Grgich, Dick Bassi, and Eddie Forrest.

At Stanford, Albert had gained fame for his mastery in running Clark Shaughnessy's T-formation during the Cardinals' unbeaten season of 1940 and their run to the Rose Bowl. Specializing in sleight of hand with a variety of bootlegs and play-fakes, the diminutive left-hander would take the snap from center and wheel around with his back to the line of scrimmage. He might fake multiple handoffs to the backs lined up behind him. Then, he would either hand it off or keep the ball himself. That season, Stanford defeated the University of San Francisco 27–0, and two people watching

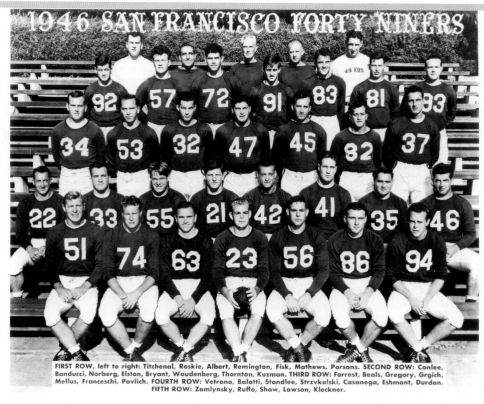

FIRST ROW, left to right: Titchenal, Roskie, Albert, Remington, Fisk, Mathews, Parsons. SECOND ROW: Conlee, Banducci, Norberg, Elston, Bryant, Woudenberg, Thornton, Kuzman. THIRD ROW: Forrest, Beals, Gregory, Grgich, Mellus, Franceschi, Pavlich. FOURTH ROW: Vetrano, Balatti, Standlee, Strzvkalski, Casanega, Eshmont, Durdan. FIFTH ROW: Zamlynsky, Ruffo, Shaw, Lawson, Kleckner.

Team photo of the inaugural San Francisco 49ers roster

the game that day were Spadia and Shaw, the future 49ers' coach.

"I couldn't tell where the ball was," Spadia recalled to *Sports Illustrated*. "No one around me could."

Standlee starred in the Stanford backfield with Albert and had been drafted by the Chicago Bears in 1941, with whom

he won an NFL championship as a rookie. Like Albert, Standlee then served in the armed forces during World War II before returning home to California to sign with the 49ers.

After his Stanford career, Albert played football as an ensign at Saint Mary's Pre-Flight School during the war, along with Grgich, Len Eshmont, and John Woudenberg. The Air Devils played local college teams and served as a minor league, of sorts, for the first 49ers team.

Saint Mary's Pre-Flight School was a haven for some great athletes of that era. Basketball legend Hank Luisetti and baseball's Charlie Gehringer, both Hall of

> **"I played offense, defense, and special teams. I was probably the only Forty-Niner to play sixty minutes, gun to gun."**
> **—John Woudenberg, 49ers tackle, 1946–1949**

GOLD RUSH INSPIRES NAME

San Francisco was a settlement of about 1,000 residents in 1848. Then, James Marshall discovered gold about 150 miles to the east, and San Francisco was never the same.

In 1849, the gold rush was on. San Francisco's population exploded to an estimated 100,000 by the end of the year.

Those who traveled to Northern California to seek their quick fortune in gold were called "Forty Niners." Nearly a century later, when Tony Morabito had an idea to mine a professional football team, part-owner Allan Sorrell suggested a team name that would stick.

The first team logo was inspired by the lawlessness that was rampant in San Francisco as a boomtown. It featured a squinting gold miner with wild shocks of hair and a bushy moustache. He wore a red shirt and checkered pants. With six-shooters in each hand, the Wild West character is leaping in the air. With his hat flying off, the ruffian is firing a shot between his legs while he waves the other pistol above his head.

The 49ers originally incorporated silver into their uniforms because Lawrence "Buck" Shaw's wife convinced Morabito that the color best-suited her husband's nickname, "The Silver Fox."

Ultimately, the 49ers settled on red and gold. The red was said to be inspired by Santa Clara University, Morabito's alma mater. The gold, of course, pays homage to the mineral responsible for San Francisco becoming a major city in the first place.

Famers in their respective sports, were athletic officers at Saint Mary's.

When the war ended, pre-flight assistant coach Jim Lawson found employment as an assistant coach with the 49ers. He encouraged Morabito to sign some of the team's players.

Woudenberg was already experienced in professional football when he joined the inaugural 49ers squad. He played three seasons with the NFL's Pittsburgh Steelers (1940–1942) before spending three years at Saint Mary's.

Woudenberg was named first team All-AAFC in 1947 and 1948 as a lineman, but perhaps his greatest contribution to the franchise came when he told Morabito about Joe Perry, a fullback he saw while assisting the Alameda Naval Air Station team.

"Just give him the ball and point him in the right direction," Woudenberg told Morabito.

Said Bill "Tiger" Johnson, "I was younger than a lot of those guys. I caught the tail end of the war. Those guys had been in the service for four years. John was one of the elder statesmen."

A FOOTBALL TOWN

There were early indications that professional football was going to find a permanent home in San Francisco. Although only 1,100 season tickets were sold for the inaugural season, some 34,000 fans showed up for the first home exhibition game on September 1, 1946, against the Chicago Rockets.

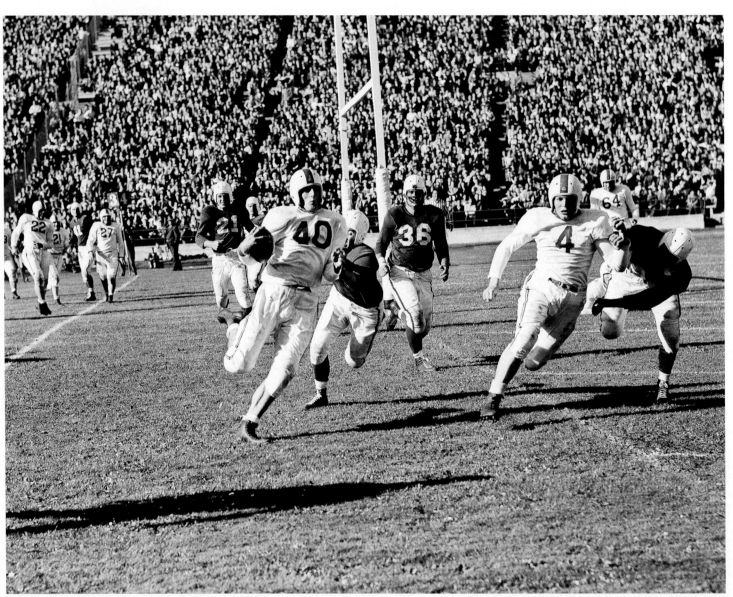

Chicago's Elroy "Crazy Legs" Hirsch eludes the San Francisco defense on this run to the end zone, but Hirsch's Rockets club couldn't stop the 49ers in the opening exhibition game at Kezar Stadium on September 1, 1946. AP PHOTO/CLARENCE HAMM

The Rockets featured future Hall of Fame halfback Elroy "Crazy Legs" Hirsch. But Albert and Beals were the show-stoppers as they combined for two touchdown passes in a 34–14 victory.

The dynamic Albert was the unquestioned leader and drawing card of the first 49ers teams, and he quickly established himself as a star in the AAFC. He ran the ball with aplomb and was even more dangerous as a passer.

Beals was Albert's favorite target. He caught 177 passes and scored 46 touchdowns in those four AAFC seasons (1946–1949)— leading the league in receiving touchdown all four years.

"Beals was my main receiver," Albert recalled. "Boy, did he have some great moves. He was a good faker. I can remember several times setting up to pass and watching the defensive back fall down after Alyn put a fake on him. The back would trip over his own feet. I'd look at the defensive man lying on his butt while Alyn was wide open."

Halfbacks Len Eshmont, John "Johnny Strike" Strzykalski, and Joe "The Toe" Vetrano were standouts as well. Eshmont, a former New York Giant, was one of several players with NFL experience that the 49ers signed. In addition to Woudenberg, Standlee, and Eshmont, the inaugural San Francisco roster included end Bob Titchenal (Washington, 1940–1942) and halfback Parker Hall (Cleveland Rams, 1939–1942).

"Their team, we think, is as good as any professional team we ever saw, including the best of the Chicago Bears teams," *San Francisco Chronicle* columnist Bill Leiser wrote early in the 1946 season. "It is much better than the present National League champion Los Angeles Rams team."

After the NFL initially denied the Rams permission to move from Cleveland to Los Angeles, a settlement was reached and the Rams began play at the Los Angeles Memorial Coliseum in 1946.

Up the coast, San Francisco was gaining pride in its team. The first touchdown in club history came on a 66-yard pass play that involved three players. Eshmont became

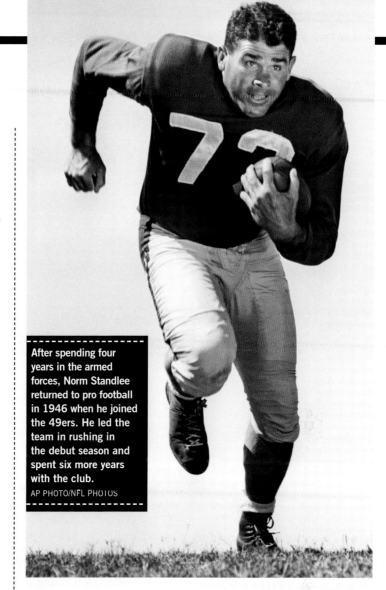

After spending four years in the armed forces, Norm Standlee returned to pro football in 1946 when he joined the 49ers. He led the team in rushing in the debut season and spent six more years with the club.
AP PHOTO/NFL PHOTOS

the first 49ers player to get into the end zone, scoring on a 60-yard run after receiving a lateral from Strzykalski, who initially caught a 6-yard pass from Albert. It was the 49ers' only touchdown in their franchise-opening 21–7 loss to the New York Yanks on September 8, 1946, at Kezar Stadium.

Afterward, Albert said, "One down, that's all."

The 49ers rebounded the following week with a 21–14 victory over the Miami Seahawks. Fullback Dick Renfro, playing his only season of professional football, scored all three of San Francisco's touchdowns in the game.

The 49ers finished the inaugural season with a 9–5 record, placing second in the Western Division behind the Cleveland Browns. That would become a trend for San Francisco during the four seasons in the AAFC.

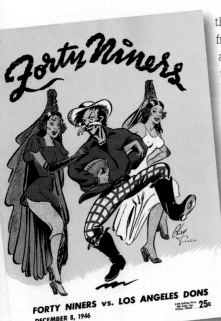

FORTY NINERS vs. LOS ANGELES DONS
DECEMBER 8, 1946

In the 1946 season finale, the 49ers stomped on their intrastate rivals, the Los Angeles Dons, 48–7 at Kezar Stadium.

A HOME WITH CHARACTER

The 49ers' first home was tucked inside a San Francisco neighborhood at the edge of Golden Gate Park. Several bars were just a screen pass away from the gates of Kezar Stadium, ensuring that many of the hearty fans attending 49ers games in those early years demonstrated plenty of team spirit—with assistance from plenty of available spirits.

In addition to its rowdy fans, Kezar was also known for its cool temperatures, fog, and swarms of seagulls.

"We had great fan support," recalled Gordy Soltau, a career 49er. "Kezar Stadium was maybe not the most comfortable stadium from a spectator point of view, but it was a good place to play. The playing field was a wreck by the time we played on it because all the high schools played on it and it was all torn up."

Hall of Fame fullback Joe Perry had a decidedly different point of view.

"It was the worst in the league," Perry said. "The locker rooms were built for high school teams. It was horrendous, really. We just became accustomed to it."

Nobody was more accustomed to it than Hall of Fame lineman Bob St. Clair. Kezar was his home field in high school, college, and the pros. He attended Polytechnic High, across the street from Kezar, before attending the University of San Francisco. St. Clair played 12 seasons with the 49ers. In all, St. Clair logged 189 games at Kezar. In 2001, the City of San Francisco and the Recreation and Parks Department named the playing surface "Bob St. Clair Field."

Aerial view of Kezar Stadium, circa 1952. AP PHOTO/NFL PHOTOS

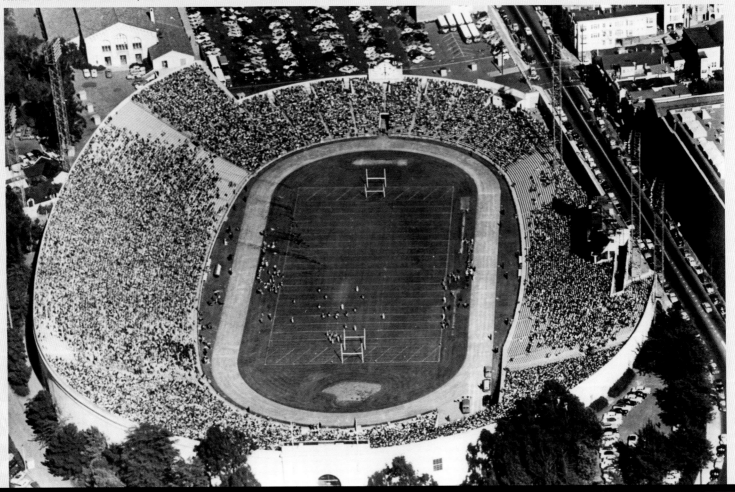

Kezar Stadium was already more than 20 years old when the 49ers played their first game there in 1946. The estate of Mary A. Kezar contributed $100,000 in 1922 to erect a memorial to her mother and relatives. The San Francisco Park Commission approved an additional $200,000 to build the stadium.

The first event held at Kezar was a two-mile race that featured Finland's Paavo Nurmi, a nine-time Olympic gold medalist in the middle and long distances. Nurmi took part in a widely publicized tour of 55 races in the United States over a five-month period early in 1925.

During its long history, Kezar also hosted two world championship boxing matches, as well as rugby, soccer, lacrosse, and auto races.

But the stadium was best known for football. In addition to high school games, Kezar hosted the University of San Francisco, Santa Clara University, and Saint Mary's College football teams. Later, the Oakland Raiders even played their inaugural 1960 season there, sharing the stadium with the 49ers.

The 49ers moved into the quirky 59,942-seat venue for their debut season in 1946. The players had it easier than the fans. Fewer than 20,000 of the stadium's seats were located between the goal lines. All the seats were benches. Team executive Lou Spadia commissioned a study on the feasibility of installing chair seats but found that it would lower the stadium's capacity to 37,000.

It took no time before the 49ers got a taste of what to expect at Kezar Stadium. The 49ers lost their first home game to kick off the All-America Football Conference. The 49ers were 21–7 losers to the New York Yanks in front of 35,698 fans. And the weather was as much of the story as the game.

"Exactly how the weather went, so did the Forty-Niners' plays," wrote Bruce Lee of the *San Francisco Chronicle*. "The second quarter was still warm enough, but the first wispy trailers of fog began sneaking into the stadium. . . . By the time the third quarter started, the fog was whirling across the gridiron."

The 49ers' final home game as members of the AAFC came on December 4, 1949, when Verl Lillywhite led a rushing attack that chewed up 164 yards in a 17–7 playoff victory over New

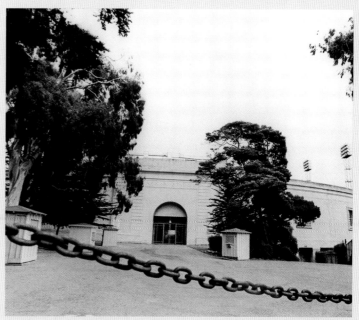

Exterior of Kezar Stadium, in 1971, after the 49ers left for Candlestick Park. AP PHOTO/NFL PHOTOS

York. The next season, when the 49ers moved to the National Football League, Kezar remained their home.

Over the years, Kezar Stadium saw the 49ers introduce the shotgun formation and the alley-oop pass. It was also a place where some iconic events occurred involving the 49ers' opposition.

Minnesota Vikings defensive lineman Jim Marshall in 1964 ran the wrong way after scooping up a Billy Kilmer fumble. San Francisco offensive lineman Bruce Bosley thanked Marshall at the goal line for providing the 49ers with two points for a safety.

Kezar continued as the 49ers' home through the 1970 season when the club moved to Candlestick Park. In 1989, the original Kezar Stadium was badly damaged in the Loma Prieta earthquake. It was demolished and rebuilt as a 10,000-seat stadium.

"It was the worst in the league. The locker rooms were built for high school teams. It was horrendous, really. We just became accustomed to it."
—Joe Perry, on Kezar Stadium

49ERS PROMOTE DIVERSITY

Although the 49ers failed to advance to the playoffs during those first few AAFC seasons, the team grabbed headlines with the 1947 signing of halfback Wally Yonamine, a multisport star from Honolulu who became the first player of Asian descent to play professional American football. He played only one season, but he remains a significant figure in franchise history.

The 49ers honor a nonprofit agency, a youth football coach, and a current 49ers player who have demonstrated a commitment to promoting unity and giving back to the local community annually with Perry/Yonamine Unity Awards. The award is named after Joe Perry and Wally Yonamine, each of whom demonstrated the power of unity to make a difference on the field and in the community.

Joe Perry came to the 49ers in 1948 as part of a rookie class that made up 17 of the 33 players on the squad. Perry had the additional burden of being subject to cruelty because of the color of his skin.

"I was one of the few black players in the league," Perry said, "so I'd get the hell kicked out of me. Wherever you went, it was the same thing. It didn't matter whether it was Los Angeles, San Francisco, or wherever. You got the N-word and all of that stuff. I'd just say, 'Bring it on.'"

In his book, *The Million Dollar Backfield*, author Dave Newhouse writes of a confrontation Morabito had with Buffalo Bills owner Jim Breuil prior to the 1948 season opener at Kezar Stadium.

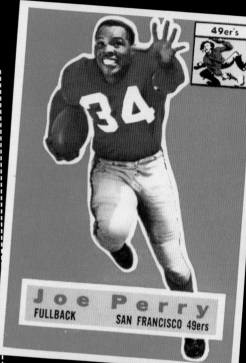

Joe Perry 1956 Topps card

"It makes it tough on all of us who don't sign a Negro," Breuil told Morabito. "Besides, they're troublemakers. Why did you do it, Tony?"

On Perry's first carry with the 49ers, he shot around the right corner en route to a 58-yard touchdown run. Morabito turned to Breuil and said, "That's why, Jim."

TOKYO

Wally Yonamine
OUTFIELDER

Wally Yonamine became a star in the Japanese baseball league after his one season with the 49ers.

SECOND-BEST TO BROWNS, AGAIN

Before the 1947 season, Morabito attempted to sign Heisman Trophy winner Glenn Davis and Doc Blanchard, who formed Army's famed "Touchdown Twins." The two stars were entitled to 90-day furloughs, and Morabito made a strong effort to get the college stars to play for the 49ers with reported contract offers of $35,000 apiece.

The 49ers selected Davis in the AAFC draft and arranged a trade with Brooklyn for the draft rights to Blanchard. However, the Army blocked both men from playing professional football because cadets were not allowed to participate in activities for personal profit during their furloughs.

Although they failed to nab those coveted rookies, the 49ers went 8–4–2 in 1947 for another second place finish in the West, again trailing the eventual league-champion Browns.

A year later, with a roster featuring 17 rookies, the 49ers opened the 1948 season with 10 consecutive victories, powered by an explosive offensive attack that averaged 35.9 points per game during the streak. End Nick Susoeff joined Beals as a primary option in the passing game.

The win streak came to an end on November 14 against the Browns, 14–7, in Cleveland. Two weeks later, the clubs met again at Kezar. The 49ers needed a victory to match Cleveland with a 12–1 record and set up a potential playoff game to determine the Western Division champion.

Beals caught two passing touchdowns and Perry ran in for another to give the 49ers a 21–10 lead early in the third quarter. But the Browns came roaring back with three third-quarter touchdowns, and Cleveland held on for a 31–28 victory. Perry provided the only points in the fourth quarter with his second touchdown of the game.

The Browns were the 49ers' nemesis in the AAFC days. In the league's first three seasons, the 49ers finished behind Cleveland in the Western Division each year. With only seven teams remaining for the final season of the AAFC (the Brooklyn Dodgers folded after posting a combined three-year record of 8–32–2), a playoff system was introduced to determine the 1949 champion.

The San Francisco 49ers and its fan base had proven itself over a four-year period in the AAFC. On December 9, 1949, NFL

West Point's "Touchdown Twins," Glenn Davis and Doc Blanchard, were a top cover story in 1946 and the 49ers' top targets in the 1947 draft, but the Army prohibited them from playing pro ball.

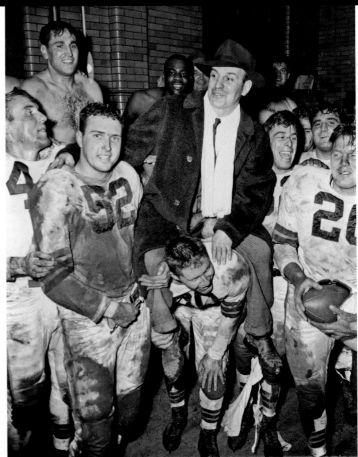

Commissioner Bert Bell—who took over for Layden when his contract was not renewed in 1946—announced that the 49ers, Cleveland Browns, and Baltimore Colts would join the NFL in 1950.

Two days after the announcement that the 49ers and Browns would join the NFL, those two teams met in the final AAFC game.

The second-place 49ers, who finished the regular season with a 9–3 mark, had defeated the third-place Yanks in the first round of the playoffs to set up the ninth meeting in four seasons against Cleveland. Earlier in 1949, the 49ers defeated the Browns 56–28 at Kezar to bring an end to a Cleveland unbeaten streak that spanned nearly two full years. Three weeks later, the Browns got a measure of revenge with a 30–28 win in Cleveland.

Despite the small crowd to watch the final game of the lame-duck league and a muddy playing surface, the game was extremely clean. There were no turnovers, and only one penalty was called.

The Browns took a 14–0 lead on touchdowns from Edgar "Special Delivery" Jones and Marion Motley, who rumbled 63 yards for his touchdown.

The 49ers cut the lead in half on Albert's 23-yard touchdown pass to Paul Salata. Kicker Joe Vetrano kicked his 107th consecutive extra point, giving him at least one point in every game the 49ers played in the AAFC. But the 49ers would get no closer to the Browns.

Cleveland won its fourth consecutive championship with a 21–7 victory in front of a crowd of just 22,550 at Cleveland's Municipal Stadium. The 49ers would finish with a 2–7 record in head-to-head matchups against the NFL-bound Browns.

"If it weren't for the Cleveland Browns, we would've been the best thing since sliced bread," Woudenberg said. "[Cleveland coach] Paul Brown had a scout on us every game. They had [Dante] Lavelli and [Mac] Speedie, two six-foot-five ends. And we'd have Strzykalski, a five-foot-ten back, and so they'd just have Otto Graham thread the needle. We'd have to send our linebackers out to cover those ends, and then they'd run big Mario Motley up the middle."

The next season, 1950, Morabito's team finally began play in the NFL after proving itself as the second-best AAFC team, behind the Browns, over a four-year stretch. Cleveland advanced to the championship game in its first six seasons in the NFL, winning the title three times.

Program from the 49ers-Browns game on October 9, 1949. This game saw one of San Francisco's few victories over the Browns (56–28) during the AAFC years.

ESHMONT CREATES LEGACY

Len Eshmont played just four seasons for the 49ers while the club was a member of the short-lived All-America Football Conference. But Eshmont's legacy with the organization lives on.

Following Eshmont's death in 1957 from infectious hepatitis, the 49ers established the most prestigious team award in his name. The Len Eshmont Award is given each year to the 49ers player who best exemplifies the "inspirational and courageous play" that Eshmont represented.

After an outstanding collegiate career at football powerhouse Fordham, Eshmont was the 36th overall pick by the New York Giants in the 1941 draft. He played just one season before he was commissioned in the U.S. Navy.

One of his stops was at Saint Mary's in Moraga, where he served as a physical education instructor at the pre-flight school. He played on a team there with quarterback Frankie Albert.

Eshmont was named to the All-Service football teams from 1942 to 1944, the only person to be named to the all-star team three consecutive seasons. In 1946, Eshmont and Albert both signed contracts to play in the 49ers' inaugural season.

In fact, Eshmont holds the distinction of scoring the 49ers' first touchdown. He raced 60 yards on a lateral from Johnny Strzykalski against the New York Yanks on September 8, 1946, at Kezar Stadium.

Eshmont played all four seasons in which the 49ers were members of the AAFC before retiring after the 1949 campaign. He scored six of his seven career touchdowns in the first season.

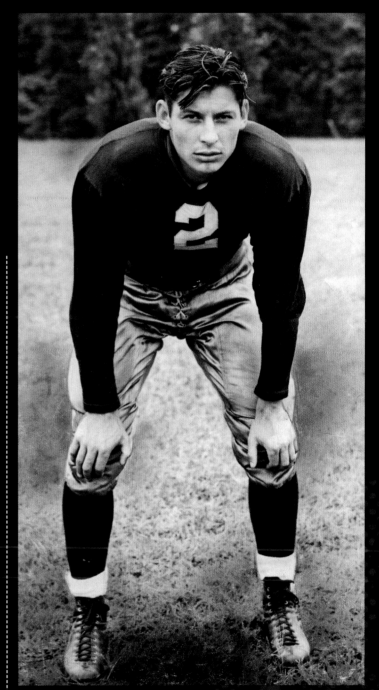

Len Eshmont, from Fordham University

"THE JET" TAKES OFF

Joe Perry lined up behind quarterback Frankie Albert during practice early in his 49ers career. Albert took the snap from center and by the time he turned, the speedy fullback was already past him.

"We were running our 30 and 31 F Trap, which is the fullback up the middle," Perry said. "Frankie was under center, and he would turn to hand me the ball, and I'd be past him. He'd say, 'Damn, you're cheating.' And I told him, 'No, I'm not.'

"I told him, 'Frankie, you got to get me the ball quicker.' And he said, 'Perry is like a jet.'"

And he was known as Joe "The Jet" Perry from then on.

Perry, who scored 22 touchdowns in one season at Compton Junior College, was called into military service. He played football for the Alameda Naval Training Station team, where former 49ers player John Woudenberg saw him and reported back to team owner Tony Morabito.

Upon his discharge from the military in 1948, Perry accepted Morabito's offer to begin playing football professionally.

Perry gained 1,345 rushing yards in his two seasons with the 49ers while playing in the All-America Football Conference. However, those yards did not transfer over as part of his 49ers rushing statistics.

Perry's record of 7,344 recognized rushing yards with the 49ers in NFL games stood as the franchise record for 48 years before Frank Gore eclipsed the mark in 2011. Coincidentally, the 49ers wore "34" decals on their helmets in 2011 in memory of Perry, who died April 25, 2011.

Along with quarterback Y. A. Tittle and fellow backs Hugh McElhenny and John Henry Johnson, Perry helped form the famed "Million Dollar Backfield" of the mid-1950s.

"The Jet" was the first player in NFL history to rush for 1,000 yards in back-to-back seasons, which he accomplished in 1953 and 1954. As a token of appreciation after his 1953 season, Morabito awarded Perry with a $5 bonus for every yard he gained.

"We had an alliance like father and son," Perry said of Morabito. "We had a trust in each other. I never knew how much money I was going to make. I trusted Tony. We only had to shake hands, and we never argued about anything."

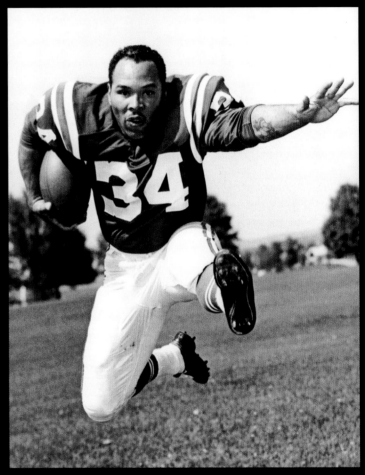

Joe "The Jet" Perry goes airborne in this training camp photo.
AP PHOTO/NFL PHOTOS

When Perry entered the Pro Football Hall of Fame in 1969, his presenter was Josephine Morabito, Tony's widow. "My only regret is that two people, my mother and Tony Morabito, are not here to accept this for me today," Perry said.

In her introduction of Perry that day in Canton, Ohio, Mrs. Morabito said: "He deserves the very best, for he never gave anything less than all of himself."

ON TO THE NFL

The 49ers' transition to the NFL was not nearly as smooth as Cleveland's. On the Friday before San Francisco's debut NFL game, Morabito rewarded Shaw with a five-year contract. But the team struggled in its first NFL season, winning just three games. One rival coach described the 49ers as "not big enough or tough enough." The 49ers featured several standout players and a strong nucleus for future seasons with Albert, who made the Pro Bowl in his first NFL season.

The team's first NFL touchdown came in the 1950 season-opener on September 17 against the New York Yanks (not affiliated with the old AAFC Yanks). Albert tossed a 2-yard scoring pass to Salata in the second quarter. Soltau kicked the extra point and then added a field goal later in the quarter to cut the Yanks' lead to 14–10, but the 49ers went on to lose the opener 21–17. Perry ran in a fourth-quarter touchdown for the final points.

The 49ers went on to lose their first five NFL games before breaking through with a 28–27 victory over the Detroit Lions on October 22 at Kezar Stadium, followed by a 17–14 home win over Baltimore a week later. The 49ers finished their first NFL season with a 3–9 record, as a new era began. Beals was no longer the favored receiver. Alex Loyd, in his only season with the 49ers, and Jim Cason became Albert's preferred targets.

Albert threw 14 touchdown passes in the year and was also the team's third-leading rusher behind Perry and Strzykalski. The 49ers also had standout seasons from guard Grgich and tackle Leo Nomellini, the team's first NFL draft pick.

Grgich was an emotional leader who would light a fire under his teammates with a locker-room ritual in which he would knock a wooden door off its hinges with a forearm shiver. The team would then charge through the opening and onto the field. Grgich also had a way of getting an emotional reaction from the opposition.

One newspaper account reported that an opposing coach offered $100 to any players who knocked Grgich out of a game. "Shucks, let 'em try," Grgich responded. "The harder they try, the more tense they become, the more mistakes they make, and the more chance our line has to capitalize on those mistakes."

In 1951, the 49ers added a healthy dose of toughness to complement Grgich with the selection of linebacker Hardy Brown of Tulsa in the 21st round of the draft. Brown was known for his bone-rattling shoulder tackle. With a vastly improved defense, the 49ers were able to hold the opposition to 95 fewer points over the 12-game season.

Soltau emerged as an outstanding receiving threat in 1951, catching 59 passes for 826 yards and seven touchdowns. Perry and Verl Lillywhite, San Francisco's top two ball carriers, combined for 1,074 to lead the ground game. The 49ers finished with a 7–4–1 record and were in contention for the National Division title until the final Sunday of the season. They closed the year just behind the 8–4 Rams.

In 1951 and '52, the 49ers started to integrate a new young quarterback into the mix. In the 1951 draft, San Francisco selected former LSU quarterback Y. A. Tittle in the first round. Albert was still the quarterback most of the time in that first season, but the youngster began to establish himself.

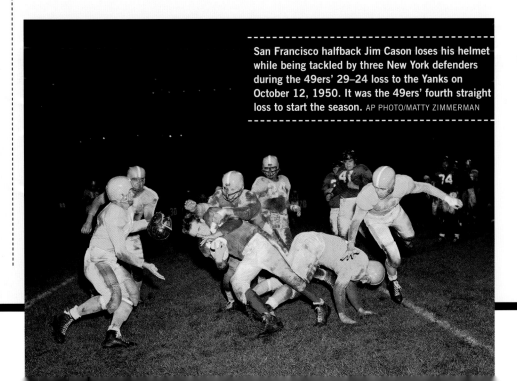

San Francisco halfback Jim Cason loses his helmet while being tackled by three New York defenders during the 49ers' 29–24 loss to the Yanks on October 12, 1950. It was the 49ers' fourth straight loss to start the season. AP PHOTO/MATTY ZIMMERMAN

SCORING MACHINE

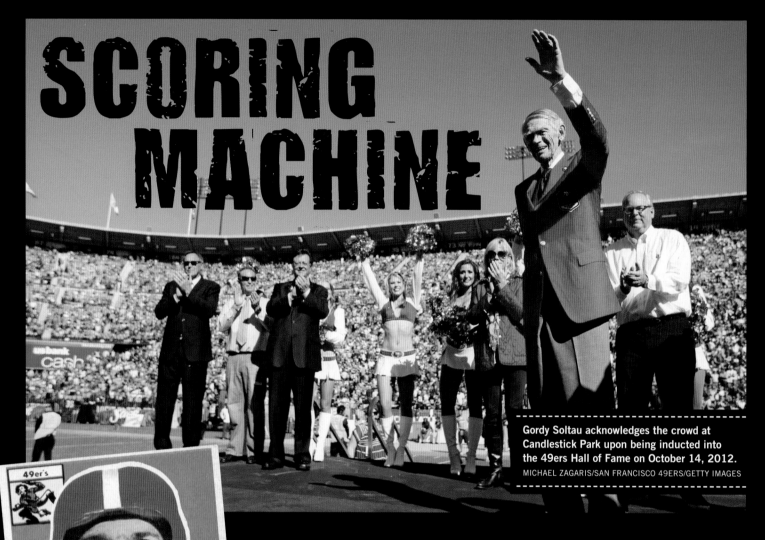

Gordy Soltau acknowledges the crowd at Candlestick Park upon being inducted into the 49ers Hall of Fame on October 14, 2012.
MICHAEL ZAGARIS/SAN FRANCISCO 49ERS/GETTY IMAGES

Gordy Soltau 1956 Topps card

Gordy Soltau played sandlot football as a youngster, during which time his future as a professional football player was being formed.

"Sometimes we had a ball, sometimes we didn't," he said. "But you'd pick teams and play. Somebody had to kick, and I did it. And I kept doing it."

Soltau, who was inducted into the Edward J. DeBartolo Sr. 49ers Hall of Fame in 2012, played for the 49ers from 1950 to 1958. A three-time selection into the Pro Bowl, Soltau caught 249 passes for 3,487 yards and 25 touchdowns in his career. He served double duty as a kicker.

On one remarkable day, October 28, 1951, Soltau established a franchise record when he scored 26 points in a 44–17 victory over the Los Angeles Rams. Soltau's record would stand until 1990, when Jerry Rice caught five touchdown passes in a game for 30 points.

In that memorable game from 1951, Soltau caught three touchdown passes from Y. A. Tittle, added one field goal, and kicked five extra points. What made it even more special was that it came against San Francisco's archrivals.

"When we played the Rams, it was always a good rivalry," Soltau said. "I got pretty lucky against the Rams. I beat them several times with a couple of kicks and a couple of touchdown passes. One game in Kezar, I scored 26 points against them. They never forgave me for that."

EARNING NFL RESPECT

In 1952, the quarterback transition kicked into high gear with Tittle seeing most of the playing time ahead of Albert. But the player who captured most of the attention in 1952 was a rookie running back from the University of Washington. Hugh "The King" McElhenny arrived on the scene as the No. 9 overall draft pick.

During a 1952 National Football League organizational meeting, Tony Morabito had a contentious exchange with George Preston Marshall, owner and president of Washington's football club. Morabito commented that he never thought he'd see the day that San Francisco had a team in the NFL. Marshall shot back, "You still haven't seen the day. . . . You're not a member of the National Football League until you beat the [Chicago] Bears."

Entering the 49ers' third NFL season, the club was 0–4 against the Bears. But that all changed on October 19, 1952. Perry scored on three touchdown runs, and Stanford product Bob White added another. McElhenny had a 94-yard punt return for a touchdown. And Soltau, who gathered in more than 100 yards receiving in the game, added a field goal in the 49ers' 40–16 impressive road victory.

The 49ers stumbled to a 7–5 record after opening the season with five consecutive victories in which they outscored the opposition by an average score of 34–11. During that streak, McElhenny torched the Dallas Texans with touchdown runs of 89 and 82 yards in games three weeks apart.

McElhenny and Perry were both named to the Pro Bowl team. Perry led the 49ers' rushing attack with 725 yards and eight touchdowns, but McElhenny provided the big plays with 684 yards and six touchdowns on just 98 carries (7.0-yard average). He added 367 yards receiving and three touchdowns.

Sport magazine recognized McElhenny as the NFL Player of the Year. Soltau was the NFL's top scorer with 94 points, achieved with seven touchdowns, six field goals, and 34 extra points.

After incredible contributions for the fledgling 49ers organization, Frankie Albert,

Norm Standlee, and Johnny Strzykalski saw their careers come to an end. Strzykalski had a rough time in the final game of the season. He broke his nose for the eighth time in his career. Albert's exit was a lot less painful. He completed 16 of 26 passes for 213 yards in a 24–14 victory over the Green Bay Packers.

Off the field, the 49ers became a profitable franchise. In congressional testimony by 49ers management in 1952, it was revealed that the club had turned a profit of $195,000. Once seen as nothing more than a money pit, Morabito's vision of professional football in San Francisco had turned into a grand success.

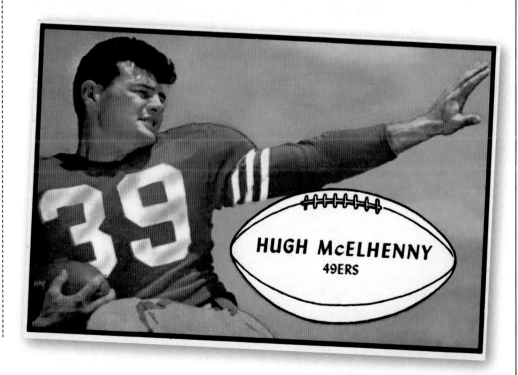

Hugh McElhenny was named First-Team All-Pro in his first two seasons in the NFL.

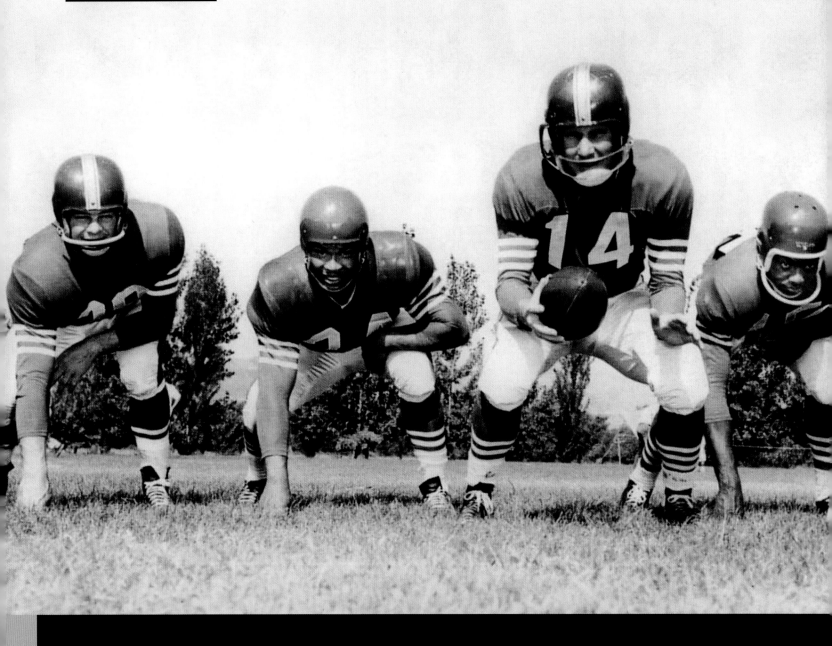

San Francisco's Million Dollar Backfield: Hugh McElhenny, Joe Perry, Y. A. Tittle, and John Henry Johnson

Y. A. TITTLE AND THE MILLION DOLLAR BACKFIELD

1953–1960

The San Francisco 49ers have seen their share of quarterback controversies through the decades. The first of its kind began to develop after the 49ers acquired Yelberton Abraham Tittle Jr. in 1951.

Program covers from
1950s-era 49ers football

QUARTERBACK
CONTROVERSY

Y. A. Tittle was the only player in professional football history drafted in the first round on three separate occasions. He was a top draft pick of the Cleveland Browns of the All-America Football Conference in 1948. The same year, the Detroit Lions of the National Football League chose him with the sixth overall pick.

Tittle signed with the Browns but never played for Cleveland, an organization that already had future Hall of Famer Otto Graham at quarterback. AAFC Commissioner Jonas Ingram sent Tittle to the Baltimore Colts in hopes of improving the league's competitive balance.

Tittle spent three seasons with the Colts, including 1950, when the club moved to the National Football League. After the Colts folded (the current Colts franchise was formed in 1953), Tittle was again eligible for the NFL draft in January 1951.

The 49ers never lost to Tittle's teams in five games against the Colts during that period. Yet, the 49ers were sufficiently impressed by what they saw from the former Louisiana State star that they selected him with the No. 3 overall pick at a time when quarterback Frankie Albert was coming off a Pro Bowl year in the 49ers' first NFL season.

In his first year with San Francisco, Tittle barely knew the offense. In Week 7, he was forced into action when Albert suffered an injury. Tittle threw a fourth-quarter scoring pass to Billy Wilson to pull out a 19–14 victory over the New York Yanks.

A debate raged for most of the next two seasons over whether coach Lawrence "Buck" Shaw should go with Albert or Tittle at the game's glamour position.

"I knew that inevitably we were going to get into this squeeze," Shaw told the *San Francisco Chronicle*. "It's the same thing in Los Angeles where they have [Bob] Waterfield and [Norm] Van Brocklin."

Later in Tittle's first season, Shaw sent the rookie quarterback into a game in which the 49ers held a 20–10 lead over the Detroit Lions. Shaw's order to Tittle was to keep the ball on the field and protect the lead. But Tittle's first call was a long, incomplete pass. When Tittle did it again on second down, Shaw called Albert to get back in the game. Tittle ran to Shaw on the sideline.

"I'm sorry, coach," Tittle told the coach, according to Dan McGuire's 1960 book *San Francisco 49ers*. "I just want some more touchdowns. Those guys almost killed me when I was with Baltimore."

Albert retired following the 1952 season, so there was no controversy for the '53 campaign. But throughout Tittle's 10 seasons with the 49ers, he faced the same challenges that Albert experienced. The 49ers routinely grabbed quarterbacks high in the draft, despite Tittle's lofty status on the team.

In 1956, the 49ers chose Michigan State quarterback Earl Morrall with the No. 1 pick after Pittsburgh selected Gary Glick with the bonus pick. A year later, the club drafted Stanford's John Brodie with the second pick in the 1957 draft.

> **"Y. A. is the greatest competitor you ever saw.** He just likes to win in everything he plays, even cribbage. You've got to watch him when he's pegging up his points."** —Hugh McElhenny, 49ers halfback, on quarterback Y. A. Tittle

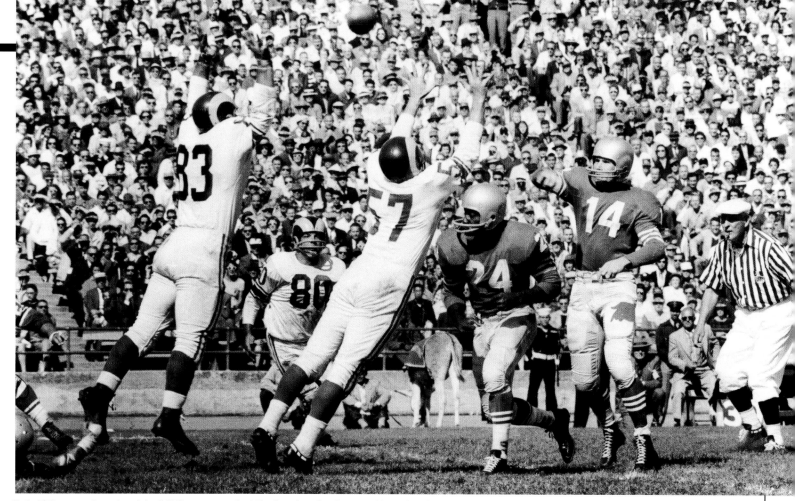

Y. A. Tittle, seen here in a late-1950s game against the Los Angeles Rams at Kezar Stadium, led the 49ers as quarterback throughout most of the decade, during which time he made four Pro Bowl appearances and was a one-time First-Team All-Pro. ROBERT RIGER/GETTY IMAGES

Morrall spent one season as Tittle's backup in San Francisco, throwing six interceptions and one touchdown in four starts. After the Los Angeles Rams pounded the 49ers 58–27 in an exhibition game prior to the 1957 season, Morrall was shipped to Pittsburgh for linebacker Marv Matuszak in hopes of solidifying the team's defense.

Brodie and Tittle were teammates for four seasons before Brodie became a fixture with the 49ers, taking over as full-time starter in 1961.

Another first-round quarterback pick by the 49ers during the Tittle era was Bernie Faloney, a No. 10 overall pick out of Maryland in 1954. Although he played quarterback in college, Faloney was projected as a defensive back by the 49ers. Faloney never played for San Francisco, who offered him a $9,000 salary. Instead, he signed with Edmonton of the Canadian Football League for $12,000, and he went on to enjoy a Hall of Fame career as a quarterback in the CFL.

During his decade in San Francisco, Tittle saw the club undergo many changes, including four different coaches. He was a member of the "Million Dollar Backfield" and famously tossed "alley-oop" passes to teammate R. C. Owens.

"Y. A. is the greatest competitor you ever saw," halfback Hugh McElhenny said. "He just likes to win in everything he

plays, even cribbage. You've got to watch him when he's pegging up his points."

Said Tittle, "I hate to lose."

And in the first season with Tittle in full charge of the 49ers' offense, the team rarely did lose.

San Francisco finished in second place in 1953 with a 9–3 record in the newly renamed Western Conference. (Previously, after joining the NFL in 1950, the 49ers had been aligned as part of the National Conference.)

A 9–3 record would have been good enough in the previous three seasons to earn at least a share of the conference title and force a playoff. But that season, the 49ers twice lost to Detroit, by scores of 24–21 and 14–10, and the 10–2 Lions went on to win the 1953 NFL championship. San Francisco's other loss came at the hands of its old All-America Football Conference nemesis, the Cleveland Browns, 23–21.

Two of the 49ers' defeats came while quarterback Jim Powers filled in for Tittle, who was out of action after fracturing a cheekbone while scoring a touchdown against the Lions. Despite the break being dangerously close to eye nerves, Tittle was back in uniform two weeks later to face the Lions again. He entered the game for several plays in a failed attempt at rallying the 49ers to victory.

LEO THE LION ROARS

The 49ers made the most of their first draft pick after entering the National Football League in 1950.

San Francisco selected lineman Leo Nomellini with the No. 11 overall selection. Nomellini was a two-way player for part of his professional career and was named All-NFL six times—four times on defense and twice on offense. He was selected to the Pro Bowl 10 times in his career, including his first four seasons in the league.

In 1969, Nomellini and fullback Joe Perry became the first 49ers players inducted into the Pro Football Hall of Fame in Canton, Ohio.

On offense, Nomellini saw time at right tackle and left guard early in his career before settling in at left tackle. He helped open holes for Perry. He was a large man for his era, at 6-foot-3, 265 pounds, and he had a unique blend of quickness and brute strength.

"He was as strong as three bulls," Perry said. "He'd slap you on the back and knock you twenty feet."

Nomellini was born in Lucca, Italy, and raised in Chicago. He did not play high school athletics, as he worked in a foundry to help support his family. He played in his first football game while stationed at a Marine base in North Carolina during World War II. After serving in the Pacific, Nomellini attended the University of Minnesota, where he became a two-time all-American and was later inducted into the College Football Hall of Fame.

Nomellini's nickname "Lion" was forged at Minnesota. Bud Grant, his college teammate and later the coach of the Minnesota Vikings, would tell how Nomellini got his nickname.

"We would pull him, we were running the single-wing then, and when

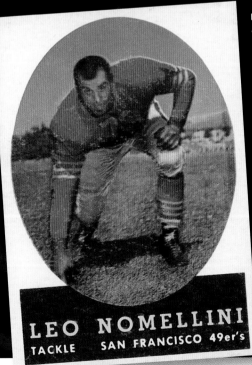

Leo Nomellini
1958 Topps card

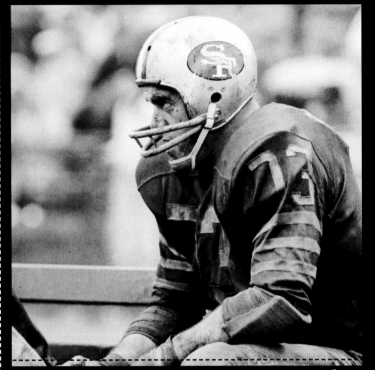

"He was as **strong as three bulls. He'd slap you on the back and knock you twenty feet.**"
—Joe Perry, on Leo Nomellini

Leo Nomellini on the bench during a game against the Cleveland Browns on December 15, 1962, at Kezar Stadium. DIAMOND IMAGES/GETTY IMAGES

he'd come around the corner, he would just roar," Grant recalled. "His blocking technique wasn't so great, but he'd just run you over like a truck."

Nomellini was one of the most durable players in franchise history. He never missed a game while playing for San Francisco from 1950 to 1963. During offseasons, he was a popular professional wrestler, too, as he entered the ring to thunderous cheers as Leo "The Lion" Nomellini.

THE MILLION DOLLAR BACKFIELD

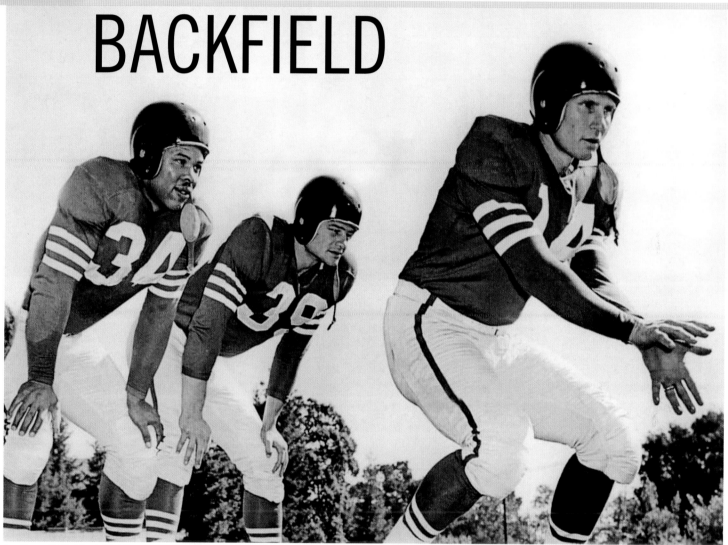

Joe Perry (34), Hugh McElhenny (39), and Y. A. Tittle formed the foundation of the Million Dollar Backfield beginning in 1952, when halfback McElhenny was a rookie and Tittle began taking more snaps at quarterback.

With expectations high for the 1954 season, there was pressure on coach Buck Shaw to deliver. Owner Tony Morabito would not accept anything short of the championship that had eluded him.

In August 1953, after the College All-Star game, the 49ers executed a trade with the Pittsburgh Steelers to acquire the rights to halfback John Henry Johnson in exchange for halfback Ed Fullerton. Johnson, the 18th overall draft pick by the Steelers, spent his first professional season in the Canadian Football League, where he was the league's MVP in 1953.

The 49ers already had a loaded backfield with Joe "The Jet" Perry and Hugh "The King" McElhenny. The addition of Johnson

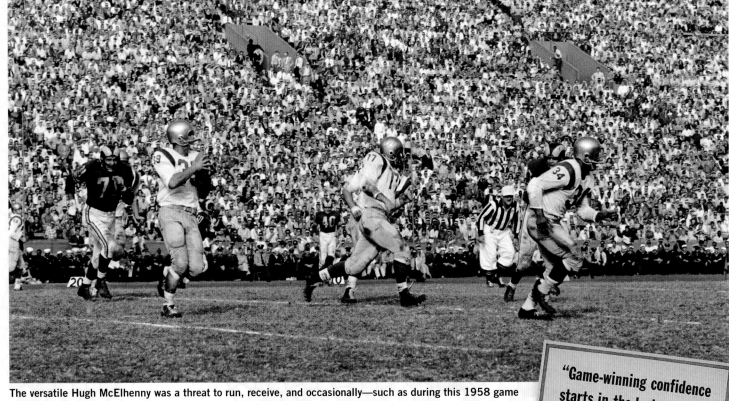

The versatile Hugh McElhenny was a threat to run, receive, and occasionally—such as during this 1958 game against the Rams—even pass the ball on offense. A six-time Pro Bowler and two-time First-Team All-Pro, "The King" was inducted into the Pro Football Hall of Fame in 1970. AL PALOCZY/SOURCE INTERLINK MEDIA/GETTY IMAGES (*Right*) McElhenny in a Wilson Sporting Goods ad, circa 1958

in 1954 made the San Francisco backfield even more formidable.

The 49ers got out to a 4–0–1 record, including a victory over the defending NFL champion Lions in front of 58,891 fans at Kezar Stadium. It was the largest home crowd up to that point in franchise history.

But the 49ers then went into a tailspin, with four losses in their next five games, as three-quarters of the "Million Dollar Backfield"—Tittle, McElhenny, and Perry— missed action with injuries. McElhenny, who separated his shoulder in the sixth game, had 64 rushing attempts the entire season. Another costly injury that impacted the passing game came when end Gordy Soltau missed extensive time due to a shoulder separation of his own.

Still, big things were expected from the Million Dollar Backfield, and that group of players mostly delivered on the promise.

In their first year together, Perry rushed for 1,049 yards and eight touchdowns,

Johnson added 681 yards and nine touchdowns, and McElhenny averaged 8.1 yards a carry and provided six scoring runs in an abbreviated season.

"Joe Perry was an unbelievably great football player," Soltau said. "He had the knowledge, the skills, a great body, and he was fast. Nothing replaces speed. And Hugh McElhenny was one of the best running backs who's ever played. He was just a great player."

McElhenny was one of the great big-play runners of all time. He earned the nickname "The King" when Albert entered the locker room after a 1952 game in which McElhenny had a 94-yard punt return and declared him "king of the halfbacks."

Although Tittle, Perry, McElhenny, and Johnson are all in the Pro Football Hall of Fame, the 1954 season was the only time more than two of those players were named to the Pro Bowl team as members

of the 49ers. Tittle, Perry, and Johnson were selected. McElhenny made the Pro Bowl five times in a seven-year stretch, but his injury prevented him from making it that season.

The 49ers lost four of five games in October and November. After they concluded the season with victories over Green Bay and Baltimore to salvage a 7–4–1 record, there was some thought that Shaw would be back the next year. But owner Tony Morabito made the decision to dismiss the only head coach the 49ers had ever known.

Ultimately, Shaw was fired for not producing a championship in his nine years at the helm. Morabito blamed the failure to meet expectations more on Shaw's "country club" handling of the team rather than the injuries to key players.

"Shaw had one-hundred-percent authority in the drafting of players, selection of assistants, trading, and coaching," Morabito said upon announcing his controversial decision. "So I expect him to accept one-hundred-percent responsibility. Therefore, the failure to win a title must be blamed on Shaw."

Ten days later, former Saint Mary's coach Norman "Red" Strader, known as a strict disciplinarian, was hired to replace Shaw. Morabito made it known that he was determined to bring an NFL championship to San Francisco.

"Strader is the man to give us the inspirational leadership we need with this club," Morabito said. "I can't say how long the contract is for. But you can say that regardless of whether Strader wins a title in 1955, he'll be our coach the following year."

Strader did not take the 49ers to the next level. Things got off to a bad start in training camp. Pro Bowl guard Bruno Banducci, a member of the inaugural 1946 team, held out for a salary raise. Instead of increasing his pay, the 49ers cut him from the payroll altogether. He was released, ending his 11-year pro career.

After only a week of training camp at Saint Mary's College, there was a lot of discontent with the way Strader handled the team. "We're being led around by the hand like a bunch of children," one veteran player was quoted as saying in McGuire's *San Francisco 49ers*.

In one forgettable game in November 1955, the 49ers had three touchdowns called back by penalties in a 7–0 shutout loss to Washington.

McElhenny was hobbled with a foot injury, and he managed only 327 yards rushing on 90 carries for the entire season. Perry,

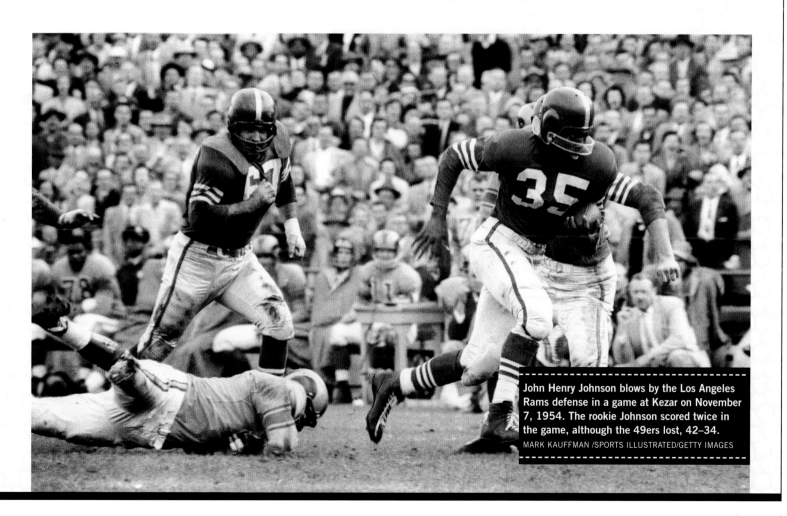

John Henry Johnson blows by the Los Angeles Rams defense in a game at Kezar on November 7, 1954. The rookie Johnson scored twice in the game, although the 49ers lost, 42–34.
MARK KAUFFMAN /SPORTS ILLUSTRATED/GETTY IMAGES

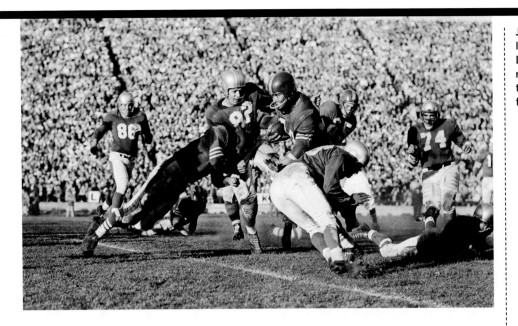

Joe Perry (with ball) breaks through the Detroit line during the 49ers' 38–21 victory over the Lions in October 1955. Perry's 149 yards rushing in the game helped bring San Francisco to a 3–3 record, but the team went on to lose five of the next six games. AP PHOTO/RAY HOWARD

who in 1953 and '54 became the first player in NFL history to rush for 1,000 yards in back-to-back seasons, gained just 701 yards while averaging only 13 carries per game. Johnson played in just seven games and averaged a mere 3.6 yards an attempt.

Johnson probably wasn't the best fit for the 49ers. After all, with Perry and McElhenny already on the team, the 49ers were never able to take full advantage of Johnson's prowess as a runner. In 1955, Johnson also saw action on defense. On May 14, 1957, Johnson was traded to the Detroit Lions for defensive back Bill Stits and fullback Bill Bowman. Stits recorded five interceptions in his two seasons with the 49ers.

Player dissension set in under Strader. Team captain Clay Matthews had the unenviable task of representing his disgruntled teammates in conversations with Morabito.

"We had all kinds of team problems," Matthews recalled. "Red Strader was the coach, and I was the captain of the team, through no choice of my own. All the gripes and things that happened, I had to present to management. All of a sudden at the end of the year, we had a losing season. Red Strader was gone, and Clay Matthews, the troublemaker, was still captain of the team."

Matthews was traded to the Philadelphia Eagles, but he refused to join his new team. He decided to put his college degree from Georgia Tech to work as an industrial engineer. Matthews went on to become a successful businessman and the patriarch of a football family with sons Clay Jr. and Bruce, as well as grandsons Clay Matthews III and Casey, each enjoying long and successful NFL careers.

Under Strader, the 49ers went 4–8 in 1955. When Strader met with ownership after the season, he was asked if the team's final record was indicative of the 49ers' level of talent.

"Absolutely," Strader answered. "In fact, I'd say we were lucky to win four games."

Despite Morabito's promise of patience on the day he hired his second head coach, Strader was fired after one dreadful season. Morabito cited "incompatibility between the head coach and the players."

Veteran leaders like Leo Nomellini (left) and Clay Matthews (right) bristled under the leadership of Red Strader during his short tenure as head coach of the 49ers. MARK KAUFFMAN/SPORTS ILLUSTRATED/GETTY IMAGES

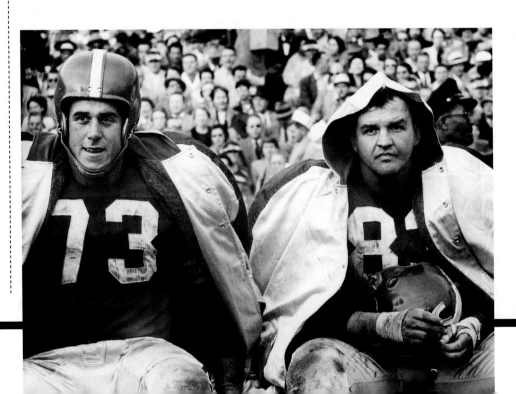

STAR AMONG STARS

Six of the 49ers' marquee players from the 1950s were eventually elected into the Pro Football Hall of Fame. However, that list does not include the only player during that era to earn six consecutive trips to the Pro Bowl.

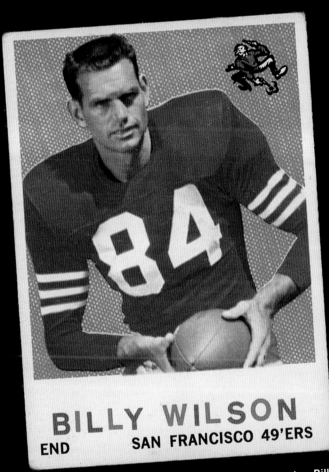

BILLY WILSON

END SAN FRANCISCO 49'ERS

Often overlooked compared to his Hall of Fame teammates, Billy Wilson was a Pro Bowl selection every year from 1954 to 1959.

While the "Million Dollar Backfield" had a flashy name, receiver Billy Wilson's outstanding and consistent play was mostly overlooked, despite leading the NFL in receptions in 1954, '56, and '57.

When Wilson retired following the 1960 season, only Green Bay's Don Hutson had more catches up to that point in NFL history. Bill Walsh campaigned for Wilson to be inducted into the Hall of Fame.

"He was the best receiver in the league and led the league in receiving," Walsh said. "He was MVP of the Pro Bowl [1955] when that game meant something. He was one of the most admired players and respected players in football."

What the skinny 6-foot-3 receiver was able to accomplish was even more impressive because of the talent the 49ers had in the run game. The team featured future Hall of Famers Joe "The Jet" Perry, Hugh McElhenny, and John Henry Johnson in the backfield. With only one ball, it was difficult to keep all the runners happy, let alone the receivers.

Wilson overcame long odds to establish himself as one of the top receivers in the game. The 49ers used a redshirt pick on Wilson in the 22nd round in the 1950 draft. He was the seventh receiver the 49ers selected in their inaugural NFL draft. He did not report to training camp until 1951 after completing his college eligibility at San Jose State.

Wilson was a member of the 49ers organization for more than 40 years. After his playing career, he took positions with the club in coaching, scouting, and public relations.

"When you look at what Billy accomplished in his ten years as a 49ers player, it's quite remarkable," 49ers owners John and Denise York said upon Wilson's death on January 27, 2009. "Considered as one of the greatest wide receivers to ever play the game, Billy's impact on the 49ers organization is far-reaching, not only as player, but also as a coach and administrator. We are grateful for all of Billy's contributions and he will be missed."

THE ALLEY-OOP

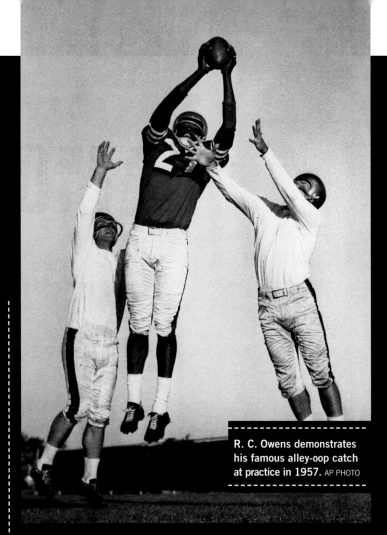

R. C. Owens demonstrates his famous alley-oop catch at practice in 1957. AP PHOTO

The 1957 season opened with the 49ers determined to take advantage of one of their most promising weapons.

R. C. Owens, an outstanding basketball player at College of Idaho, had the kind of leaping ability that had rarely been seen on the football field. And quarterback Y. A. Tittle found a way to take advantage of this unique weapon.

"Alley-Oop is the way we call a pass to R. C. Owens," 49ers assistant coach Mark Duncan said after the grand unveiling of the iconic play on October 6, 1957. "He goes up in the air like a tight-coiled spring. And he holds onto the ball."

On that day at Kezar Stadium against the Los Angeles Rams, Owens leaped in the air to take a sure interception away from defensive back Don Burroughs. Instead, Owens turned it into a 46-yard touchdown.

Then, Owens made another jumping 11-yard touchdown catch before Rams defender Jesse Castete could bat the ball away. Those touchdowns provided the 49ers with a memorable 23–20 victory.

"It's true that the R. C. Owens catches were of the type a man hopes to make once in a million years," wrote *San Francisco Chronicle* columnist Bill Leiser. "And he made two of 'em in the same game."

The following week, Owens again made an acrobatic touchdown grab to defeat the Chicago Bears, 21–17, with 27 seconds remaining in a game at Wrigley Field.

The most dramatic alley-oop took place on November 3 against the Detroit Lions. This time, everybody knew what was coming and the Lions still could not defend it.

Trailing by three points, San Francisco moved the ball to the Detroit 42-yard line with 11 seconds remaining. Owens was surrounded as he ran down the field, and Tittle uncorked a pass that sailed about 50 yards in the air. Despite having All-Pro defensive back Jack Christiansen and Jim David draped all over him, Owens timed his jump perfectly and came down with the winning touchdown.

The alley-oop went away for a while, but it resurfaced in the Western Conference playoff, where Owens and Tittle teamed up for the first touchdown of a return game against the Lions.

"And those alley-oop things from Tittle to Owens are darn-near illegal," Detroit coach George Wilson said. "Or as far as an opposing coach is concerned, they should be."

Owens played five seasons with the 49ers. He went on to the Baltimore Colts, where his athleticism forced the NFL to change its rules. In a game against Washington, Owens lined up under the goal post and swatted away a field-goal attempt. At that time the goal posts were situated at the goal line. Two years later, the NFL made it illegal to block a field goal from anywhere but the line of scrimmage.

Owens had another lasting impact as a member of the 49ers. Bill Walsh hired him in 1979 as alumni coordinator to help former players reconnect with the organization. He spent 24 years in that role. Owens was inducted into the 49ers Hall of Fame in the fall of 2011. He died June 17, 2012.

The alley-oop is still an oft-used term in sports, most commonly in basketball to describe a play in which a player leaps to catch a pass and dunks it in one motion. Nowadays in football, a leaping catch in desperation time has another name.

"I guess you could say the alley-oop was the same as a Hail Mary pass," Owens said in *Forty Niners: Looking Back*, "except we didn't pray."

HIGH OF HIGHS, LOW OF LOWS

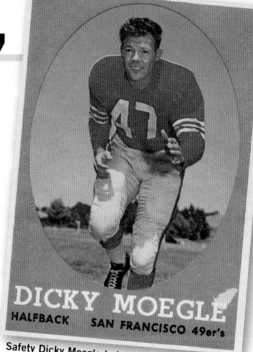

DICKY MOEGLE
HALFBACK SAN FRANCISCO 49er's

Safety Dicky Moegle led the 49ers defense with eight interceptions in 1957. His six picks in 1955 and 1956 were tops on the team in each of those seasons as well.

Morabito decided to return the 49ers to their roots in 1956. Frankie Albert—the first quarterback in franchise history—was named the 49ers' third head coach.

Still feeling the effects of the season with Strader as coach, the 49ers got off to a disastrous start under Albert. The team was in last place in the Western Division with a 1–6 record before ending with a 4–0–1 record in the final five games. The 49ers rode that hot streak into 1957.

The 1957 season was the most emotional in franchise history. The highs were high. And the lows were the worst the organization could ever face.

The alley-oop became nationally known, thanks to Tittle's high-arching passes and youngster R. C. Owens' crowd-captivating ability to rise above helpless defensive backs and pull down touchdown passes.

Owens, a former basketball star at College of Idaho, jumped high in the air to catch two touchdown passes, including one in the final seconds, in the 49ers' 23–20 victory over the Los Angeles Rams on October 6. The next week, Tittle and Owens teamed up again for late-game heroics against the Chicago Bears at Wrigley Field.

The excitement around the 49ers was never greater. Morabito was never more optimistic that his organization was on the brink of a championship.

Then, tragedy struck.

Morabito, the man responsible for bringing professional football to San Francisco, suffered a heart attack while watching his 49ers from his favorite press-box seat on October 27 as the 49ers played the Bears at Kezar Stadium.

The 49ers players learned during the game that Morabito had died. A determined team emerged from a tear-filled locker room at halftime to rally from a 17–7 deficit to win, 21–17, with the clincher coming on Tittle's fourth-quarter touchdown pass to Billy Wilson.

Still riding the emotional surge, the 49ers defeated the Detroit Lions, 35–31, on another one of Owens' patented last-minute alley-oop touchdown catches just a week after Morabito's death.

But then, the heartbroken 49ers proceeded to go on a three-game losing streak. They lost to the Rams, 37–24, in front of an NFL-record crowd of 102,368 at the Los Angeles Memorial Coliseum on November 10. The next week, the Lions soundly beat the 49ers 31–10 in Detroit.

With three consecutive victories to finish the regular season, the 49ers were tied with the Lions with 8–4 records. A playoff game was held to determine which team would face the Eastern Conference–winning Browns.

In the divisional playoff, the 49ers held a 27–7 lead in the fourth quarter, but the Lions came back to shock the 49ers with a 31–27 victory. Tittle threw for 248 yards and three touchdowns, but he also tossed three interceptions, including one on his final attempt of the game. He was hoping to get closer in the game's final minute to set up a potential alley-oop to Owens.

Afterward in a somber locker room, Tittle told McElhenny, "Sorry to let you guys down, Mac."

McElhenny responded to Tittle, who was named the league's MVP by United Press International in 1957, "You've never let us down in your life."

Detroit went on to destroy the Browns, 59–14, to win its third NFL championship in six years. And the 49ers' chance to honor the memory of their immensely popular owner had slipped away.

TONY MORABITO LEAVES LEGACY

Team founder Tony Morabito suffered a heart attack in 1952, prompting his physician, Dr. William O'Grady, to advise him to sell the 49ers and avoid the stress that came with ownership of an NFL team.

"I'll take my chances," Morabito told his doctor.

Morabito did sell some interest in the organization through the years, but he was still the majority owner with 40 percent five years later.

On October 27, 1957, while doing something he loved more than anything—watching a 49ers game—Morabito suffered a fatal heart attack. He died at the age of 47.

"If he had a choice of when he would go," O'Grady was quoted in the *San Francisco Chronicle*, "Mr. Morabito undoubtedly would have chosen exactly as it happened—while watching the 49ers."

Morabito collapsed in his favorite corner chair in the lower press box of Kezar Stadium during second-quarter action with his 49ers playing the Chicago Bears. He was taken by ambulance to a local hospital, where he was pronounced dead.

Although reports and memories of the day vary from source to source, it is known that the 49ers knew at halftime Morabito had suffered a heart attack and probably would not survive. Coach Frankie Albert learned in the third quarter that Morabito had passed away.

"Everybody was saying, 'Let's pull together and win it for Tony.' That's what he would have wanted," said R. C. Owens. "He would have wanted us to give it our best."

The 49ers trailed 17–7 at halftime, but came out in the third quarter with a singular focus to win the game in memory of their beloved owner. Perhaps no player on the 49ers was as close to Morabito as future Hall of Fame fullback Joe Perry. He sat out the first half of the game with a knee injury but insisted on playing in the second half.

"Everyone was downtrodden," Perry recalled. "You can understand that. I don't think there was an individual on the team that did not care deeply for Tony Morabito."

The 49ers defense played its most inspired half of the season, scoring on Bill Herchman's interception return. Later, 49ers safety Dick Moegle returned an interception 40 yards to the Bears' 20 in the fourth quarter with the team down by three points.

"Men played themselves into exhaustion but waived substitutes back to the bench," wrote Ray Haywood of the *Oakland Tribune*. "Others refused first aid for batterings which normally would have brought the doctor onto the field. All performed small miracles on offense and defense."

Four plays after Moegle's interception, 49ers quarterback Y. A. Tittle tossed an 11-yard touchdown pass to Billy Wilson for a 21–17 lead. The defense shut out Chicago in the second half to preserve the win.

"Everybody got pumped up to win that game for Tony," Wilson said in 2005. "I think it brought the team closer together. I hate to say something like that helped our football team, but maybe it did. It's been so long ago, but you still feel it when you think about it."

Afterward, Albert said he found little satisfaction in the victory.

"I'd rather lose them all by 100 points than lose what we did," Albert said.

Chronicle columnist Art Rosenbaum approached Morabito several years before his death to inquire about writing his life story in a two- or three-part series. Morabito politely declined the request.

"The 49ers will go on forever," Morabito told Rosenbaum. "I am here for just a short while. I don't seek publicity. Write a series about one of the players."

Morabito was a controversial figure with a "low boiling point," he admitted. He once referred to NFL Commissioner Bert Bell as "incompetent" and "the quintessence of nothing." He tried to punch Rams part-owner Fred Levy Jr. and refused to speak to Washington owner George Preston Marshall for years. Morabito had a stormy relationship with the local press.

But his players loved Morabito. Long before the NFL gave him permission to compensate players for their work during preseason games, Morabito would slip players a $100 under the table to show his appreciation.

"Nobody got paid for exhibition games in those days," Gordy Soltau said. "That was one of the things we tried to negotiate with the owners and the commissioner."

Morabito made San Francisco a "major league city," wrote the *Chronicle*'s Bill Leiser.

Leiser concluded, "It is fitting that he died on the 50-yard line, himself a member of the capacity crowd, which henceforth will constitute the monument by which he will most be remembered."

49ERS BLOW THEIR BIG CHANCE

Despite a sell-out crowd of more than 60,000 fans at Kezar Stadium, fewer people in San Francisco saw the 49ers' 1957 Western Conference playoff game against the Detroit Lions than in any other major city across the country.

Although the game was televised nationally, NFL Commissioner Bert Bell kept the league's blackout rules in effect, saying it was unfair to those who bought end-zone seats to have the game available on television.

Many locals who could not secure tickets to the game were forced to travel to places where the game was not blacked out. The nearest available broadcasts originated from Chico, Reno, Fresno, Eureka, and San Luis Obispo.

Whether seen from the bench seats at Kezar or on a television set from outside the Bay Area, the 49ers' collapse after building a 27–7 lead early in the third quarter was painful all the same.

The kickoff was moved up 30 minutes from its usual start time of 1:30 pm to allow for the possibility of a sudden-death playoff. And, certainly, there appeared to be little chance of a deadlocked game when the 49ers took a commanding 24–7 lead into halftime.

Quarterback Y. A. Tittle was hot in the first half with three touchdown passes. He hit R. C. Owens for a 34-yard score on an alley-oop pass over unsuspecting Detroit defensive back Jim David. Hugh McElhenny caught a 47-yard pass from Tittle for another touchdown, and Billy Wilson and Tittle combined for a 12-yard score.

San Francisco picked up where it left off in the third quarter. McElhenny darted and dashed 71 yards to get the 49ers on the doorstep of the end zone once again.

However, the 49ers were stopped at the Detroit 3-yard line. Coach Frankie Albert sent in Gordy Soltau for his second field goal of the game. A touchdown would have given the 49ers a four-score lead.

Detroit fullback Tom Tracy, who hadn't carried the ball in the previous four games, led the Lions comeback with two third-quarter touchdowns, including a 58-yarder. The Lions took a 28–27 lead early in the fourth quarter.

Later, many Detroit players would say that they were motivated at halftime because they heard the 49ers celebrating their anticipated victory in their nearby locker room.

"That's a lot of hooey that the Lions made up," Gordy Soltau said. "What they heard right before we went back on the field after halftime, [Albert] got us all together and we did a big cheer. It had nothing to do with the Lions. They thought we were making fun of them. They were a good team. Our defense kind of let us down and Tittle had a bad second half. He threw three interceptions. That's a lot of interceptions to overcome."

The 49ers also lost two fumbles. Even Joe "The Jet" Perry had a costly turnover when his own churning knee knocked the ball from his grasp as the 49ers were driving near midfield in the fourth quarter.

Tackle Bob St. Clair had another theory why the Lions were able to overcome the 49ers.

"All our defensive backs got hurt," St. Clair said. "We had to put offensive backs in there against the Lions. We were ahead by 20 points in the second half, but all our backs went down."

Perhaps nobody summed up the 49ers' failure as well as Dick Moegle, who led the 49ers with eight interceptions that season.

"Ahead 27–7 and blow it," Moegle said in a 49ers locker room that was far more silent than it was at halftime. "How can it be? All we had to do was hold that ball. Instead it was pass, pass, interception."

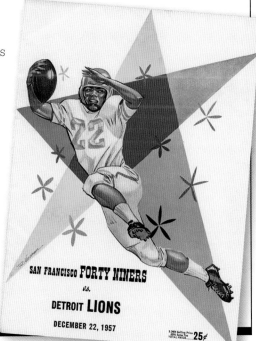

SAN FRANCISCO **FORTY NINERS**
vs.
DETROIT LIONS
DECEMBER 22, 1957
25¢

FRANKIE ALBERT, COACH

When Frankie Albert was the quarterback through the 49ers' fledgling years in the All-America Football Conference and National Football League, he was known as a freewheeler and a risk-taker.

After seven seasons with the 49ers, during which time he kept fans excited with his unique ball-handling prowess from the T-formation and naked bootlegs, he decided it was time to end his playing career.

"I couldn't find anything else I liked," Albert said in a 1957 interview with *Sports Illustrated*. "So I came back and begged Tony Morabito for a job with the 49ers."

In 1954, Morabito put Albert in charge of promotions. The next year, he was an assistant to head coach Norman "Red" Strader. And after Strader's disastrous 4–8 season in his only year in charge, Morabito promoted Albert to head coach.

His approach to football changed dramatically with his job change from being the field general at quarterback to being responsible for the entire team from the sideline.

"You get real conservative when you start coaching," Albert said. "When I was playing, I never thought about a play failing."

Albert spent three seasons as the 49ers' coach. In 1957, the 49ers blew a 20-point lead in the third quarter of their Western Division playoff game for the right to face the Cleveland Browns in the NFL championship. Early in the third quarter, up 24–7, the 49ers passed up an opportunity to go for it on fourth down at the Lions' 3-yard line. They kicked the field goal, which kept it a three-score difference. The 49ers fell apart after that, and the Lions came roaring back for the victory.

The next season, the 49ers fell back to a 6–6 record. In three seasons, Albert's teams compiled a 19–17–1 mark.

"Coaching is a terrible job when you're losing," Albert said. "You worry. I used to worry up until two o'clock of game day when I was a player, but after the kickoff, it was fun. It was hard fun, but it was fun."

As a coach, Albert said he worried all the way through a game—and beyond.

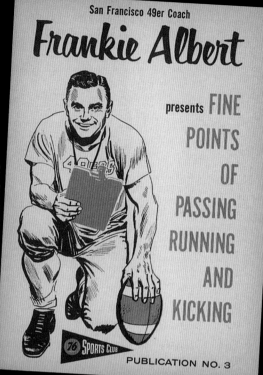

Frankie Albert coaching instructional pamphlet, 1957

"When the game is over, I don't want to talk about it to anyone, win or lose," Albert said. "You get so tired of it. You play it over and over in your mind until you get sick of it."

What made it even more difficult was the abuse that Albert's wife, Martha, received from 49ers fans when the team was struggling.

"There are no more stores where my wife can go without being abused," Albert said in Glenn Dickey's *San Francisco 49ers: The First Fifty Years*. "You can only change markets and butcher shops so often."

> "Coaching is a **terrible** job when you're **losing**."
> —Frankie Albert, 49ers head coach, 1956–1958

Frankie Albert on the sideline during the 49ers' comeback win over the Green Bay Packers at Kezar Stadium, December 16, 1957. AP PHOTO

LARGER THAN LIFE

More than a quarter-century after his football career came to an end, Bob St. Clair was inducted into the Pro Football Hall of Fame. For the first time in his life, it seemed, St. Clair was nearly overlooked.

St. Clair, who played right tackle for the 49ers from 1953 to 1963, was difficult to miss when he was on the field. At 6-foot-9, 265 pounds, St. Clair cut an enormous figure in the 1950s. He was named to the NFL's All-Decade team, and he was voted to the Pro Bowl five times in his career.

Four of his offensive teammates were inducted into the Hall of Fame well ahead of him: quarterback Y. A. Tittle and backs Joe Perry, Hugh McElhenny, and John Henry Johnson.

"The thing to realize is that the 49ers have three running backs and a quarterback from those teams already in [the Hall of Fame]," end Billy Wilson said in 1990, the year St. Clair was finally enshrined. "Someone had to be doing the blocking."

St. Clair was not the only offensive lineman on those teams, but he was certainly the best. And, without question, he was the most unique.

Upon coming to the 49ers as a third-round draft pick (No. 27 overall), the San Francisco native was nicknamed "Geek." In the days of the carnival sideshow, a person who bit the head off live chickens was called a geek. St. Clair ate meat only if it was raw.

Anything was better than what he tasted in 1956 as he used his length to block 10 field-goal and extra-point attempts. That season, St. Clair broke through the Los Angeles' Rams protection unit clear and got his hands on the ball just as Rams punter Norm Van Brocklin released it.

"There wasn't a ball for him to kick, so he kicked my face instead," said St. Clair, who lost five teeth on the play. "They put cotton in my mouth, and I played the rest of the game."

The next season, St. Clair sustained a shoulder injury that was expected to keep him out for the remainder of the season. St. Clair missed seven games and made the trip to New York on the eve of a game against the heavily favored Giants.

While the team was gathered for dinner, St. Clair charged into the room and said, "Moses has returned! I've been gone 40 days and 40 nights, and I'm here to take you to the Promised Land!"

The 49ers upset the Giants, 27–17, and St. Clair was awarded the game ball in the locker room celebration. The 49ers won their final three games to force a playoff with the Detroit Lions.

St. Clair's career came to an end prior to the 1964 season after he sustained his second Achilles tear in three seasons. It ended a remarkable run in which St. Clair played 189 games at Kezar Stadium. He starred on that field for Polytechnic High School, the University of San Francisco, and the 49ers over 19 seasons.

In 2001, the 49ers retired his No. 79, and the City of San Francisco Recreation and Parks Department appropriately named the Kezar playing surface "Bob St. Clair Field."

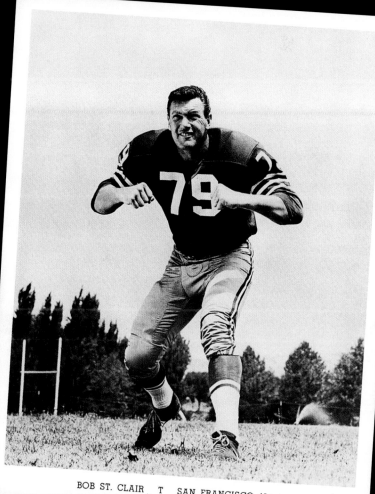

BOB ST. CLAIR T SAN FRANCISCO 49ers

Bob St. Clair team-issued photo

THE WINDOW CLOSES

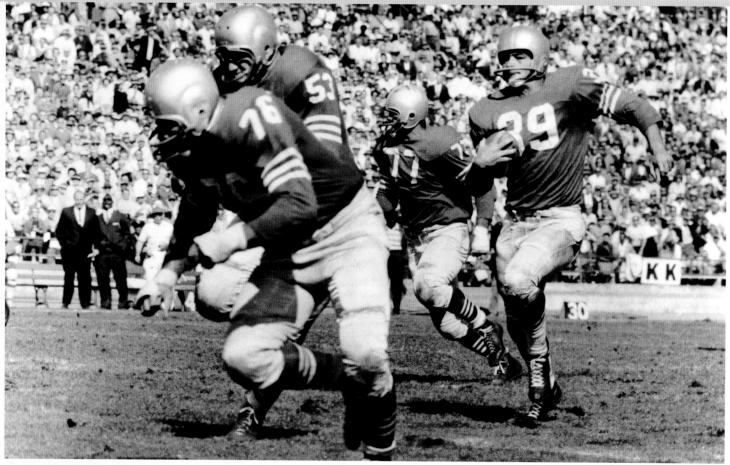

Hugh McElhenny (39) follows the blocking of linemen John Gonzaga (76) and Frank Morze (53) for extra yards against the Los Angeles Rams on October 4, 1959. The 49ers' 34–0 victory put them at 2–0 en route to a 6–1 start, but a poor second half left San Francisco out of postseason contention.

After coming so close to bringing home a championship, the 49ers fell back to the middle of the pack in 1958, at 6–6. What made it even worse was that their West Coast rivals, the Los Angeles Rams, beat them by scores of 33–3 and 56–7.

Albert, who admitted that the demands and worries of coaching was not something he ever enjoyed, resigned as head coach after the season.

Albert's replacement, Howard "Red" Hickey, had the 49ers in strong contention for a Western Conference crown after jumping out to a 6–1 record in 1959. But San Francisco faded with two decisive losses to the Baltimore Colts in the span of three weeks. The 49ers finished in third place with a 7–5 record.

The 1960 season was no different, as the team finished with another 7–5 record. One of the highlights came late in the season when defensive back Dave Baker tied an NFL record with four interceptions in a 23–7 victory over the Rams.

San Francisco still had a lot of talent, most of which was acquired through the draft. Hall of Famer Bob St. Clair, a third-round selection in 1953, was a mainstay throughout Tittle's era at quarterback and into the mid-1960s.

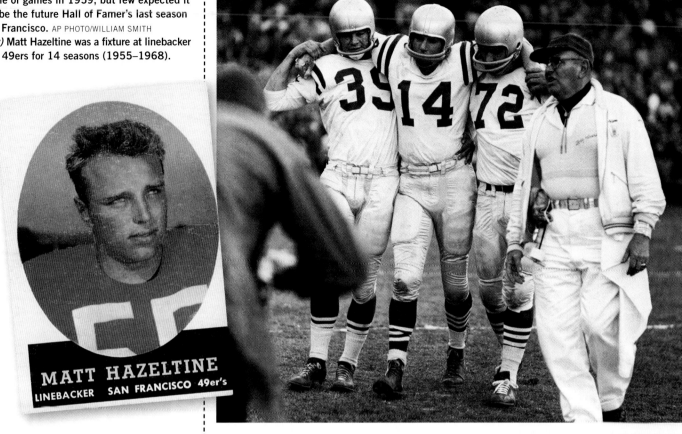

(Right) Injuries caused Y. A. Tittle (14) to miss a couple of games in 1959, but few expected it would be the future Hall of Famer's last season in San Francisco. AP PHOTO/WILLIAM SMITH

(Below) Matt Hazeltine was a fixture at linebacker for the 49ers for 14 seasons (1955–1968).

MATT HAZELTINE
LINEBACKER SAN FRANCISCO 49er's

Guard Bruce Bosley was a second-round draft pick in 1956. He would flourish as a starter over the next decade. Defensive back Abe Woodson, a second-round pick in 1957, was also a dangerous return man. He was selected to the Pro Bowl team in five consecutive seasons, beginning in 1959.

Linebacker Matt Hazeltine, a fifth-round pick in 1955, was named to the Pro Bowl twice in his 14-year career. After he passed away in 1987 from ALS, the 49ers established the Matt Hazeltine Award to honor the club's most courageous and inspirational defensive player.

The 49ers got defensive help in the 1958 draft with the additions of lineman Charlie Krueger and wide receiver/defensive back Jerry Mertens. Drafted as an end, Mertens had little chance to make a contribution with the likes of Billy Wilson, Owens, and Clyde Conner already

on the team. Connor was the leading receiver in 1958 with 49 catches for 512 yards and five touchdowns.

So Mertens switched to defense. He played well against the Baltimore Colts in both games as a rookie when matched against Hall of Famer Lenny Moore. Colts coach Weeb Ewbank, assigned to coach the Pro Bowl, called on Mertens when he needed a cornerback to fill out the roster.

Tommy Davis took over for Soltau as the team's kicker and punter in 1959, and he set records in those roles with the 49ers through the 1960s.

In the meantime, the 49ers were ready to make the transition to a new quarterback. Following the 1960 season, Tittle was practically given away. San Francisco traded Tittle to the New York Giants for rookie lineman Lou Cordileone, who remarked upon receiving the news, "What? Me, even up for Y. A. Tittle? You're kidding."

Cordileone played just one season with the 49ers before he was shipped to Los Angeles for defensive back Elbert Kimbrough.

"That was one of the most infamous trades of all time," said end Monty Stickles, who the 49ers chose with their first-round draft pick in 1960. "Red Hickey traded Y. A. Tittle to the Giants straight up for Lou Cordileone. He went on to obscurity, and Tittle took the Giants to championship games."

Tittle never won an NFL championship, but he was named the NFL Most Valuable Player for the Giants in 1961 and '63. In 1962, he threw 33 touchdown passes and a career-high 3,224 yards.

Tittle was a drop-back passer who at nearly 35 years old was not considered a good match for Hickey's new shotgun offense. The switch was made to John Brodie, and a new era of 49ers football was dawning.

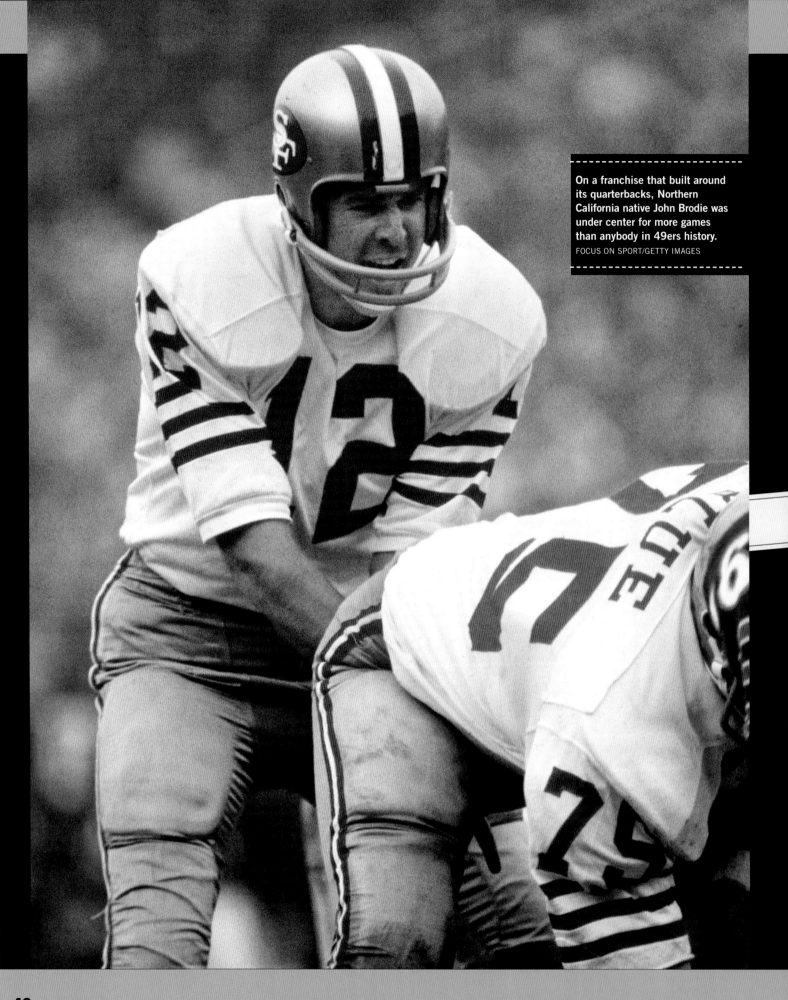

On a franchise that built around its quarterbacks, Northern California native John Brodie was under center for more games than anybody in 49ers history.
FOCUS ON SPORT/GETTY IMAGES

JOHN BRODIE KEEPS BATTLING

1961–1969

With Y. A. Tittle shipped off to the New York Giants in August 1961, John Brodie became the new San Francisco 49ers quarterback. And he had to endure everything that came along with the honor.

Program covers from 1960s-era
49ers football

ROTATING QUARTERBACKS

The 26-year-old Brodie won the starting job to open the 1961 season. He got off to a hot start as head coach Howard "Red" Hickey continued to feature the shotgun formation that the 49ers had debuted with smashing results in the final four games of 1960. Brodie threw four touchdown passes in a convincing 35–3 season-opening win over Washington.

But that performance was quickly forgotten when the 49ers were soundly beaten, 30–10, the following week at Green Bay. Hickey blamed himself, not the offense for the problems. "Ah, what the Packers did to us wasn't the shotgun's fault. It was my fault," Hickey said. "I played it too conservatively."

With the Detroit Lions next on the schedule, Hickey devised a game plan that continued to employ a healthy dose of the shotgun formation, but with a new wrinkle. Hickey decided to call all the plays and shuttle quarterbacks Brodie, rookie Billy Kilmer, and Bobby Waters onto the field on a rotating basis.

The 49ers were impressive in a 49–0 road victory. Kilmer rushed for 103 yards and two touchdowns, Brodie threw for 108 yards, and Waters added another 38 yards on the ground. In the process, Detroit was shut out for the first time in 115 games. It was the worst beating in Lions history.

The following week, the 49ers rolled up 521 yards of offense in a 34–0 victory over the Los Angeles Rams at Kezar Stadium. The rotating quarterback trio—Brodie, Kilmer, and Waters—combined for 201 yards rushing and 261 yards passing.

San Francisco extended its win streak to three games with a 38–24 road victory over the Minnesota Vikings. The shotgun formation and the 49ers' offense appeared unstoppable.

But, then, the person who had once helped develop many of the team's early star players as a college coach had a hand in bringing down the 49ers' unique attack.

Clark Shaughnessy, the former Stanford coach, scouted the 49ers for the Chicago Bears. He watched game film of 49ers center Frank Morze and devised a strategy to counteract the shotgun. Morze had to look between his legs before snapping the ball to the quarterback. Shaughnessy figured it would be nearly impossible for the slow-footed center to get his head up in time to pick up blitzing linebackers.

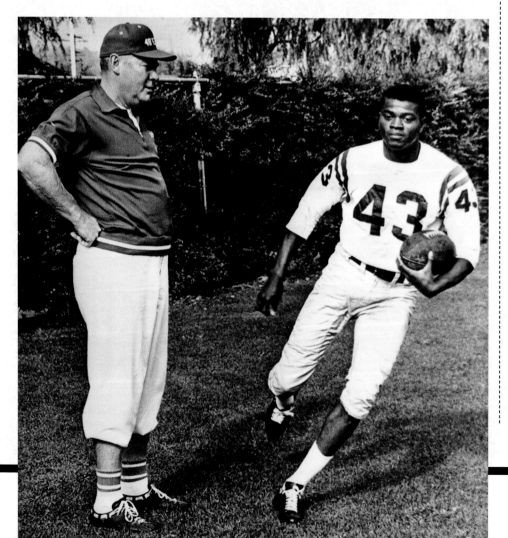

New coach Red Hickey checks out the 49ers fourth-round pick in 1960, halfback Ray Norton from San Jose State. Norton appeared in only nine games in his brief NFL career (1960–1961). Coach Hickey lasted a little longer (55 games), compiling a 27–27–1 record.

SAN FRANCISCO 49'ERS

1960 San Francisco 49ers team

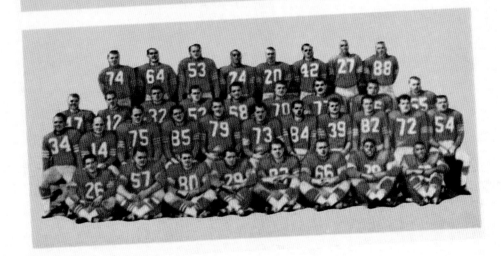

Bears linebacker Bill George exploited the weakness in a 31–0 win by Chicago. Shaughnessy and George started a trend that saw the 49ers score just 37 points in four games, including the shutout loss to Chicago.

Hickey went back to a conventional offense, but the 49ers' struggles continued. After such a promising start, San Francisco won just three of its final nine games to complete the season with a deflating 7–6–1 record and a fifth-place finish in the seven-team Western Conference.

Kilmer was the team's second-leading rusher that season behind J. D. Smith. Kilmer, whom the 49ers drafted because they felt he would be a good fit for their shotgun offense, rushed for 509 yards and 10 touchdowns. Brodie threw for 2,588 yards—the most yards in a single season in franchise history up to that point. He threw 14 touchdowns and 12 interceptions.

The hard-bitten fans of Kezar had a love-hate relationship with Brodie through the years. He heard a chorus of boos during the first half of a game that season against

the Lions that ended in a tie. Afterward, Brodie tried to put himself in the shoes of the paying customers.

"All week long they catch hell from their bosses and maybe sometimes their wives," Brodie told the *San Francisco Chronicle*. "One day a week they get out to a ballgame. All of a sudden, they're the bosses—my bosses. They can shout whatever they want. They can give back what they've been getting all week."

Perhaps Brodie tolerated the fans' fickle nature because he could relate. He wanted to win games far worse than any of the paying customers. Even Brodie's wife, Sue, and the rest of the family were not immune to the catcalls. And she was not about to accept the rude behavior from the patrons at the games.

"It used to bother the kids," Sue Brodie said. "One time I hit somebody over the head with an umbrella."

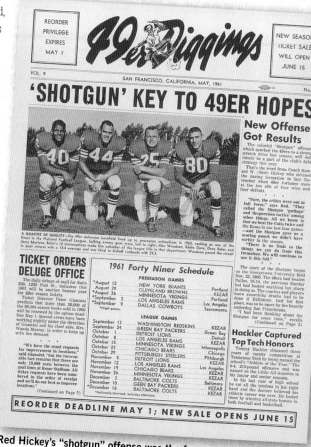

Red Hickey's "shotgun" offense was the focus of the 49ers' offense in 1961.

RED HICKEY'S SHOTGUN

Howard "Red" Hickey had to come up with something in the 1960 season to offset the Baltimore Colts' intimidating defensive line of Art Donovan, Gino Marchetti, and Gene "Big Daddy" Lipscomb.

"I asked my players if any of them thought we could beat Baltimore with our regular offense, and not one hand went up," Hickey said.

So while the team prepared at Georgetown University in Washington, Hickey introduced what would later be known as the "shotgun" formation.

Hickey devised an offensive alignment in which the quarterback lined up 7 yards behind center. Hickey believed the formation would allow the quarterback more time to spot open receivers and also force the Colts to make defensive adjustments they had not practiced. The 49ers ingenuity resulted in a stunning 30–22 upset over the Colts.

Third-string quarterback Bob Waters worked the offense effectively after starter John Brodie was knocked out of the game on a big hit from Lipscomb.

R. C. Owens caught touchdown passes from Brodie and Waters, and Tommy Davis kicked two fourth-quarter field goals in the victory. The Colts had a difficult time handling the 49ers' run game, too, as J. D. Smith gained 85 yards and a touchdown on 13 carries.

And how did the shotgun get its name?

"Well, I'm an old country boy," said Hickey, an Arkansas native. "And I used to go hunting with a shotgun. How 'bout we call it the shotgun?"

The 49ers won three of their final four games in 1960 and then opened the 1961 season with a 4–1 record before the Chicago Bears found an answer for the shotgun. Linebacker Bill George lined up directly over center, and provided the template for every team that would face the 49ers' shotgun.

"In the shotgun, we split our offensive linemen wider than normal," tackle Bob St. Clair said in *San Francisco 49ers: The First Fifty Years*. "That required everybody to move quickly to fill the gap if a defensive lineman came through. Our center, Frank Morze, wasn't very quick. George just went around him on one side or the other. He was in the backfield before the quarterback could even make a handoff. They just killed us."

Brodie was a classic drop-back quarterback who, legendary *Los Angeles Times* columnist Jim Murray once wrote, "runs like fourth-class mail." Hickey liked a mobile quarterback to run the shotgun, which was why he rotated Brodie, Bill Kilmer, and Waters on alternate plays in the 1961 season. Brodie did not seem disappointed at all when the shotgun, as

an every-down offense in the early 1960s, became obsolete.

"The teams that use a lot of tricks are admitting their weaknesses," Brodie told *Sports Illustrated*. "I say you're better off relying on ability rather than tricks."

But Hickey's shotgun formation was in the game to stay. Throughout the next few decades, every team incorporated some form of the shotgun formation into its offensive system. It was the forerunner to the "spread" offense that took over college football in the in the 2000s and began to see more integration into the NFL.

Ironically, the 49ers during their dynasty years in the 1980s and 90s did not use the shotgun formation. But it came back to the organization in the early 2000s under coach Steve Mariucci. One day in 2001, Hickey visited the 49ers to watch a practice.

"What a pleasure it is watching games and hearing the announcers say, 'The Red Hickey shotgun formation,'" said Hickey, who died March 30, 2006. "I invented something people are still using. That makes me happy as the devil. I guess I came up with something good."

"Well, I'm an old country boy, and I used to go hunting with a shotgun. How 'bout we call it the shotgun?"
—Coach Red Hickey, on the naming of the "shotgun" formation

HICKEY'S STAR FADES

When the 49ers closed out the 1960 season with the excitement generated by their innovative shotgun formation, Coach Hickey was signed to a three-year contract extension. He was never popular among the players, however, and the decision to lock him up to a long-term deal was not well received inside the locker room.

A month after Hickey signed his deal, three key players requested trades: guard Bruce Bosley, linebacker Ed Henke, and end Clyde Conner. Bosley and Conner continued to play for the 49ers, while Henke left before the start of the 1961 season and finished his career with the St. Louis Cardinals.

The 49ers had plenty of other questions on their roster, beginning with trying to find a replacement for dynamic pass-catcher R. C. Owens.

In 1961, Owens became the first 1,000-yard receiver in 49ers history when he caught 55 passes for 1,032 yards and five touchdowns. But his days in San Francisco were numbered. Owens had a contract that paid him $10,500 for the 1960 season. Unhappy with his below-market-value deal, Owens played out his option in 1961 instead of signing a contract extension with the 49ers.

In a move that was unprecedented at the time, Owens became a free agent and signed with the Baltimore Colts, a Western Conference rival of the 49ers. Team owner Victor Morabito never again spoke to Colts owner Carroll Rosenbloom for what was widely considered a break in protocol. A year later, NFL Commissioner Pete Rozelle instituted the "Rozelle Rule," which required teams that signed free agents to compensate the player's former team with money or draft picks.

At the close of the 1961 season, the 49ers' receivers were Conner, Monty Stickles, and rookies Bernie Casey and Aaron Thomas.

Based on their need at the receiver position, the 49ers on December 4, 1961, used their first-round selection (No. 8 overall) to draft Lance Alworth, an exciting runner and receiver from Arkansas. Surely, Alworth would provide another offensive threat for the offensive-minded Hickey.

However, Alworth's negotiations with the 49ers did not go well. The San Diego Chargers of the American Football League sent their

In *The Quarterback* section of the October 4, 1961, issue of *The Sporting News*, San Francisco's John Brodie (lower left) was listed as one of the "bellringers" among young NFL quarterbacks, along with Washington's Norm Snead, Philadelphia's Sonny Jurgenson, Dallas' Don Meredith, and Minnesota's Fran Tarkenton. SPORTING NEWS ARCHIVE/SPORTING NEWS VIA GETTY IMAGES

assistant coach for receivers, Al Davis, to negotiate with Alworth. The Chargers offered him a no-cut contract.

"Davis had me sold on San Diego," Alworth recalled to *Sports Illustrated*. "And when I met Red Hickey, I asked for a no-cut contract. He spent ten minutes telling me why I couldn't have a no-cut contract. I told him I had a no-cut offer from the other league, and he said, 'OK.' He guessed I could have one from San Francisco. I didn't much like that attitude. I didn't care which league I went to, except Davis had promised I could play sooner at San Diego, and that was what I wanted."

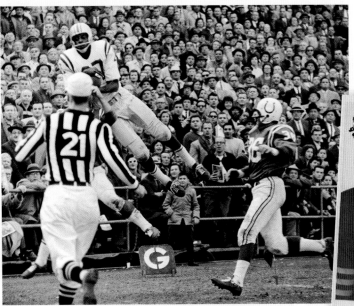

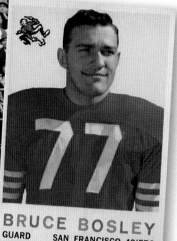

(Left) Seen here in November 1960 making one of his patented leaping catches, receiver R. C. Owens went elsewhere after the 1961 season in search of a bigger payday. In 1961, he became San Francisco's first 1,000-yard receiver. AP PHOTO/WILLIAM SMITH;

(Below) Bruce Bosley spent 13 seasons with the 49ers (1956–1968), although he tried to get away rather than play for coach Red Hickey in 1961.

BRUCE BOSLEY
GUARD SAN FRANCISCO 49'ERS

Alworth would never play for the 49ers. He signed with San Diego and went on to play 11 professional seasons and be inducted into the Pro Football Hall of Fame.

With virtually no help from its draft class, San Francisco finished with a losing record for the first time since 1956. The club began and ended the 1962 season with two-game losing streaks. Sandwiched between two three-game win streaks, the 49ers lost four consecutive games to finish with a 6–8 record.

The 49ers won only one of their seven games at Kezar Stadium, where the fans were growing increasingly restless.

There was plenty of frustration within the ranks, too. Players had grown tired of Hickey's militaristic approach. And Hickey was losing patience, too. After the club lost three games to open the 1963 season, the head coach turned in his resignation, and Jack Christiansen took over. Christiansen fared no better than Hickey.

Two separate car accidents kept the team's top two quarterbacks out of action and doomed the 1963 season from the beginning

Brodie sustained a broken throwing arm and severe facial cuts in May 1963 when he crashed his 1961 Cadillac into a tree in Menlo Park, California. He returned to action before he was fully healed and broke his arm again. He was able to play in only three games that season.

Kilmer sustained a compound fracture of his right leg in December 1962 when he crashed his 1957 Chevrolet on the Bayshore Freeway. After undergoing a four-hour surgery the next day, he developed an infection in the leg and his healing was delayed. Kilmer sat out the entire 1963 season and was never again the same kind of running threat he had been when he entered the league.

About the only thing that went right for San Francisco in 1963 was on special teams. The 49ers gave up 391 points that

Jack Christiansen was hired to replace Red Hickey as head coach early in the 1963 season, but the former All-Pro defensive back didn't fare much better than his predecessor, winning only 40 percent of his games in nearly five full seasons at the helm. AP PHOTO

season, so they had ample opportunities to return kickoffs.

Abe Woodson, one of the outstanding return men in NFL history, returned three kickoffs for touchdowns while leading the league for a record third time. However, because Woodson was just about the 49ers' only scoring threat, teams began kicking away from him. He was traded to St. Louis a year later for halfback John David Crow.

As coach, Christiansen, the former Hall of Fame defensive back for the Detroit Lions, could not prevent the season from turning into a complete disaster. The 49ers finished in last place with an NFL-worst record of 2–12. Inexplicably, one of their victories came against the Chicago Bears, the eventual NFL champions.

The 49ers owned the No. 1 overall pick in the 1963 draft, and the club selected Dave Parks of Texas Tech. It was a move necessitated with Owens leaving as a free agent and the team's inability to convince Alworth to sign a contract.

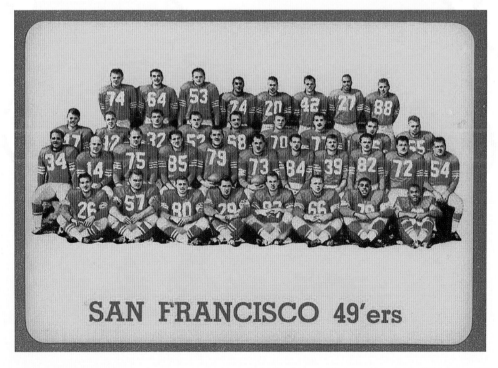

SAN FRANCISCO 49'ers

(Above) John Brodie missed most of the 1963 season due to injury. When he was healthy, he spent most of his time running away from opposing defenses. ROBERT RIGER/GETTY IMAGES
(Left) The 1963 San Francisco 49ers produced the worst record (2–12) in franchise history during the era of the 14-game season.

NO FREE LUNCH WITH VIC

Tony Morabito, the founder of the franchise, owned 75 percent of the organization in 1949. His half-brother Vic Morabito was a 25-percent owner. While Tony was universally liked and admired by the 49ers players, Vic had a different reputation.

Halfback Hugh McElhenny was the 49ers' first-round draft pick in 1952. Quarterback Frankie Albert was a mentor to McElhenny, and he advised the rookie to ask the team for nothing less than $30,000 on his rookie contract. A meeting was set up for Vic Morabito to meet with McElhenny for lunch at the Sheraton on Wilshire Boulevard in Los Angeles.

"I didn't know Vic," McElhenny recalled, "but he seemed to be the guy responsible for signing me. I wish it would've been Tony because he was the real neat owner of that group."

After some social pleasantries, the two men got down to business. Morabito asked McElhenny how much it would take to sign him to a contract. When McElhenny said $30,000, Morabito balked. He told McElhenny that he could not pay that kind of money.

"He excused himself to go to the john," McElhenny said. "And he never came back. I got stuck for the lunch tab, and I ended up signing for $7,000."

Like Tony, Vic played football for St. Ignatius High School in San Francisco. After a year at the Santa Clara University, Vic transferred to Cal, where he was a halfback on the reserve team called the "Rambler" squad. He graduated from Cal in 1941 and joined his father's ships outfitting service in San Francisco. He sold that business in the early 1950s to devote all of his time to the 49ers.

When Tony Morabito passed away in 1957, there was rampant speculation that Vic would not hold onto the team. But two weeks later, Vic put an end to rumors when he issued a statement: "The San Francisco 49ers are not for sale. They never will be."

But, privately, Vic told his wife, Jane, and Tony's widow, Josephine, something different: "If anything happens to me, you'll sell out, if you have any sense."

Vic Morabito died on May 10, 1964. Both he and his half-brother succumbed to heart attacks, and both men died at St. Mary's Hospital, a half-mile from Kezar Stadium.

However, the Morabito widows did not sell the franchise. They remained as owners of the 49ers but handed day-to-day control of the organization to team president Lou Spadia.

San Francisco 49ers owner Vic Morabito (right) with newly hired head coach Jack Christiansen in 1963

TRAGEDY STRIKES AGAIN

The 1964 season was catastrophic for the 49ers before it even began. Team owner Vic Morabito suffered a fatal heart attack in May. He died at the age of 45.

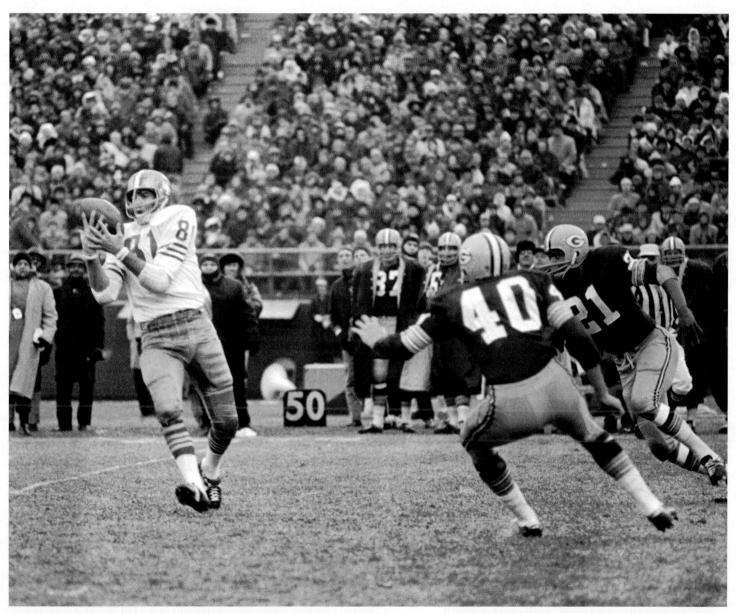

Dave Parks, seen here making a catch against the Green Bay Packers in 1966, hauled in 36 receptions as a rookie in 1964 before becoming the 49ers' premier pass-catcher in 1965 and '66. AP PHOTO

Josephine Morabito, Tony's widow, joined her 30 percent share of the franchise with a 25 percent share held by Jane Morabito, the widow of Victor. The two women remained in control of the team, but they promoted Lou Spadia to chief executive officer and, later, team president to handle the day-to-day operations.

"I don't say a woman couldn't run the team, but let's just say I don't want to be the one who did it," Josephine Morabito later told the *San Francisco Chronicle*. "I just do a little cooking."

On the field, there was not much cooking for the injury-plagued 49ers, who finished the 1964 season with a 4–10 record. But, at least, there was some promise. The club got strong performances from Parks, the top draft pick, and from linebacker Dave Wilcox, the team's third-round draft pick and a future Hall of Famer.

Parks, who joined a receiving corps that included Bernie Casey and Monty Stickles, did not wait long to show his big-play ability.

He averaged a team-best 19.5 average per catch in his debut season and scored a team-high eight touchdowns.

Parks was even better in his second NFL season. In 1965, he exploded with a team and league high 80 catches, 1,344 yards, and 12 touchdowns. A first-team All-Pro that year, Parks was selected for the Pro Bowl in each of his first three seasons.

Another San Francisco quarterback controversy began to simmer after Brodie threw four interceptions and was roundly booed at Kezar Stadium during a 27–22 loss to the Minnesota Vikings in late October 1964. Rookie George Mira replaced him in the game and heard boos, too, after he struggled to move the offense.

Fullback Ken Willard, the 49ers' first-round draft pick out of North Carolina, was a much-needed addition in 1965. The previous season, Dave Kopay had been the leading rusher with just 271 yards. Willard would go on to lead the 49ers in rushing for each of his first seven seasons (1965–1971). He broke into the NFL with 778 yards rushing as a rookie, fourth-most in the league that year.

Bosley was named to his first of three consecutive Pro Bowls after making the transition to center. A year later, guard Howard Mudd would begin his own streak of three straight Pro Bowl trips. With tackles Len Rohde and Walter Rock and guard John Thomas, the 49ers would boast one of the better offensive lines in the game over a period of years.

San Francisco opened the 1965 season with a 52–24 victory over the Chicago Bears at Kezar Stadium. Brodie threw for 259 yards and four touchdowns, and defensive tackle Charlie Krueger scored his first (and only) career touchdown on a 6-yard fumble return.

However, the Bears got revenge late in the season when rookie Gale Sayers scored six times in Chicago's decisive 61–20 win at Soldier Field. After putting the first points on the board with an 80-yard touchdown reception in the first quarter, Sayers scored four rushing touchdowns—on just nine carries totaling 113 yards—and added an 85-yard punt return for a touchdown.

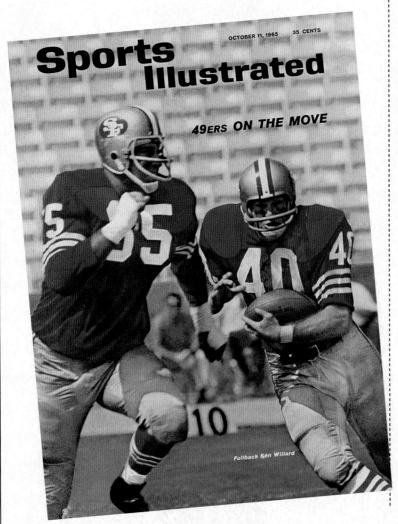

With rookie Ken Willard giving them a potent running game to complement the top-ranked passing, the 49ers seemed poised for big things in 1965, but a 3–5 start to the season set them on the wrong path.

BRIDGING ERAS

During a time in which most of the 49ers' stars played on the offensive side of the ball, defensive tackle Charlie Krueger stood in stark contrast to the franchise's identity.

Krueger played college football at Texas A&M under legendary coach and taskmaster Paul "Bear" Bryant. Krueger exuded toughness from his gnarled features to a trademark two-barred facemask. He even hunted mountain lions in the offseason.

Dallas Cowboys coach Tom Landry once said, "No one is able to gain running at Charlie Krueger."

Krueger was named to the Pro Bowl after the 1960 and 1964 seasons. He won the Len Eshmont Award in 1964. For years, he stood as the embodiment of how a football player should look and act.

"How can I describe Charlie? Very, very, very intense," longtime teammate Len Rohde said. "Back then, he was in love with [football], or in love with some part of it. Whatever Charlie did, he did with 110-percent intensity."

Krueger, was a run-stuffing, relentless force in the middle of the 49ers defense from 1959 through the 1973 season. But Krueger paid the price for playing the game for so long.

Beginning in 1963, Krueger regularly played through pain. Ultimately, the 49ers were found liable for fraudulent concealment for failing to inform him of the risks of playing through injuries. A reported settlement of $1 million was reached in 1992.

A court determined: "He was regularly anesthetized between and during games, and endured repeated, questionable steroid treatments administered by the team physician."

CHARLIE KRUEGER

49ers

DEFENSIVE TACKLE N.F.C.

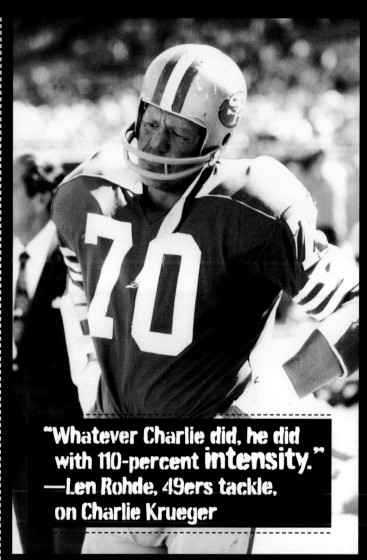

"Whatever Charlie did, he did with 110-percent **intensity.**"
—Len Rohde, 49ers tackle, on Charlie Krueger

Charlie Krueger on the sideline, October 1973. MICHAEL ZAGARIS/GETTY IMAGES

Krueger experienced a lot of ups and down with the 49ers during and after his tenure. Tom Dahms, a tackle in 1957, is the only other person in 49ers history to wear the No. 70. The season after Krueger retired, the 49ers, in turn, retired Krueger's No. 70.

BRODIE BECOMES
A POPULAR MAN

John Brodie led the NFL in pass attempts, completions, percentage, yardage, and touchdown passes in 1965, earning him a Pro Bowl selection. In the offseason, he asked the 49ers for a raise to $80,000. Team executive Lou Spadia made a counter-offer of $55,000 with some incentive bonuses.

Unable to come to a quick contract resolution with San Francisco, Brodie found himself in the middle of a tug o' war between the NFL and the AFL, a league that focused on raiding the senior league of some of its top quarterbacks. AFL Commissioner Al Davis, the former San Diego assistant and future Raiders owner, assigned Houston Oilers General Manager Don Klosterman to court Brodie.

Brodie flew to Houston in May to meet with Klosterman and Oilers owner Bud Adams for negotiations. Adams wrote on a cocktail napkin that the AFL would pay Brodie $250,000 annually for three seasons.

The news blindsided Spadia, who, according to Michael MacCambridge's book *America's Game*, was steadfast in his determination to keep Brodie a member of the 49ers. "I just want my quarterback," Spadia repeated.

The 49ers stalled because negotiations to merge the NFL and AFL were heating up. A short time later, the merger became official, and all the quarterbacks who were

Although he became the team's big-money quarterback in 1966, John Brodie was soon looking over his shoulder to fend off young backups George Mira and Steve Spurrier. He's seen here calling a play during San Francisco's 41–14 victory over the Detroit Lions on Thanksgiving Day, 1966. DIAMOND IMAGES/GETTY IMAGES

ready to jump from the NFL to the AFL were expected to return to their original teams.

When he learned of the arrangement, Brodie commented, "Somebody owes me $750,000."

Brodie returned to San Francisco and signed a contract for a reported $921,000 over 12 years. He arrived in training camp at Saint Mary's College a couple weeks late and was greeted warmly by his teammates.

On Brodie's first day of camp, center Bruce Bosley snapped him a pineapple—Brodie had fled to Hawaii during the controversy—with a note attached that read, "One million dollars, less $3,000." That was the figure his teammates decided to "fine" him for reporting to camp late. The players wanted to have a party at Brodie's expense, and Brodie was willing to accommodate.

There was not a whole lot else to celebrate over the next two seasons. The 49ers were a .500 team in 1966 and '67.

After compiling a disappointing 6–6–2 record in 1966, Christiansen promised changes. The club traded receiver Bernie Casey—who had ranked first or second on the team in receiving in each of the previous five seasons—guard Jim Wilson, and tackle Jim Norton to the Atlanta Falcons for their first-round draft pick. The 49ers used that pick to select Heisman Trophy–winning quarterback Steve Spurrier of Florida in March 1967.

The 49ers put together a strong draft class behind Spurrier with the additions of offensive lineman Cas Banaszek from Northwestern and linebacker Frank Nunley from Michigan.

In the days leading up to the 1967 regular-season opener, the 49ers acquired four-time All-Pro flanker Sonny Randle from the St. Louis Cardinals for a future

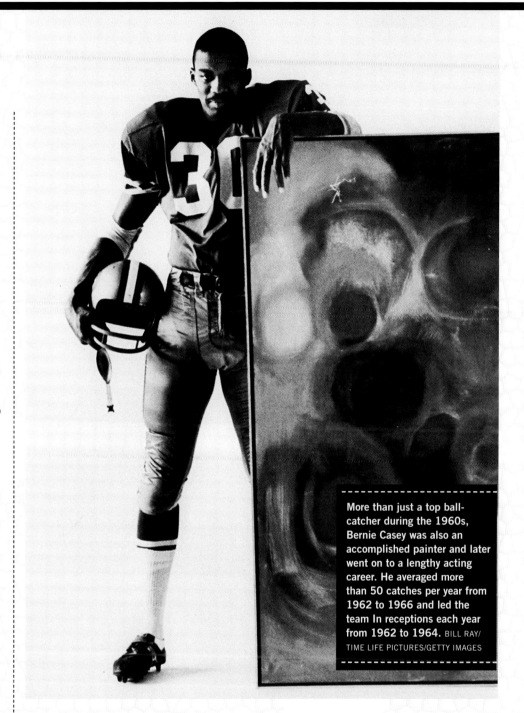

More than just a top ball-catcher during the 1960s, Bernie Casey was also an accomplished painter and later went on to a lengthy acting career. He averaged more than 50 catches per year from 1962 to 1966 and led the team In receptions each year from 1962 to 1964. BILL RAY/ TIME LIFE PICTURES/GETTY IMAGES

draft pick. In his most productive season with the 49ers, Randle caught 33 passes for 502 yards and four touchdowns in 1967.

Brodie struggled with 11 touchdown passes and 22 interceptions that season while both Mira and Spurrier saw limited action behind him.

The 49ers opened the season strong, notching five victories in their first six games, including a 27–24 win over the Rams to hand Los Angeles its only loss of the regular season.

But injuries took a toll on the team, and San Francisco failed to score in double-digits in four of the next five weeks. In all, the 49ers dropped six consecutive games and finished with a 7–7 record. It was time for another coaching change.

MR. DO-IT-ALL

In the early 1970s, Lou Spadia made his first trip to his ancestral home in Northern Italy. While there, he met cousins who knew of him only through the photographs in football programs that his mother shipped to them. As Spadia told *Sports Illustrated*, the programs confused his relatives in Piedmont.

One day, a family member told him, "Looie, we can see you are in excellent health, but you are also a man of more than 50 years. Now I see from these books your mother sends that the men in the pictures are all very young, very big and very strong. We are all worried about you. Looie, don't you think you should give up this game?"

Spadia did not play for the 49ers during more than three decades with the organization. But that's about the only thing Spadia *did not* do for the San Francisco 49ers.

Spadia rose through the ranks from office boy to the highest-ranking 49ers executive. And he continued to make a huge impact in the Bay Area after leaving the 49ers. Spadia spearheaded the Bay Area Sports Hall of Fame program that helped raise over $2 million for more than 400 youth sports programs.

A native San Franciscan, Spadia was a member of the Mission High School Class of 1938. He went on to serve in the U.S. Navy. Spadia was stationed at Treasure Island in the San Francisco Bay under executive John R. Blackinger, who was a Santa Clara buddy of 49ers founder Tony Morabito. Blackinger would serve as the first general manager in team history.

Spadia first interviewed with Morabito in December of 1945. He was hired to begin work for the 49ers in May 1946 with the title assistant general manager. Spadia told the *San Francisco Chronicle*, "That's the fancy title they gave me. We just had four people in the front office and I was the go-fer."

Spadia wrote biographical sketches on the players for the team programs. He also worked in the ticket department and business office before a promotion to general manager in 1952. The convivial Spadia fostered good relationships with the local newspapermen and routinely acted as peacemaker when the hot-tempered Morabito clashed with local reporters and columnists.

Lou Spadia, 1970. AP PHOTO/NFL PHOTOS

He was responsible as anyone for reaching out to the community and personalizing the team. Spadia coined the enduring term "Forty-Niners Faithful," to describe the unique bond the fan base had with the organization.

After the deaths of owners Tony Morabito (1957) and Vic Morabito (1964), Spadia was promoted to chief executive officer. He reported to the Morabito widows, who remained in ownership of the organization. In 1967, he was named team president.

Spadia remained with the 49ers organization until 1977, when the Morabito widows sold the franchise. Spadia's five-percent ownership stake in the team was included in the sale to Edward DeBartolo Sr. Spadia died on February 17, 2013. He was 92 years old.

NOLAN TIGHTENS UP
DEFENSE

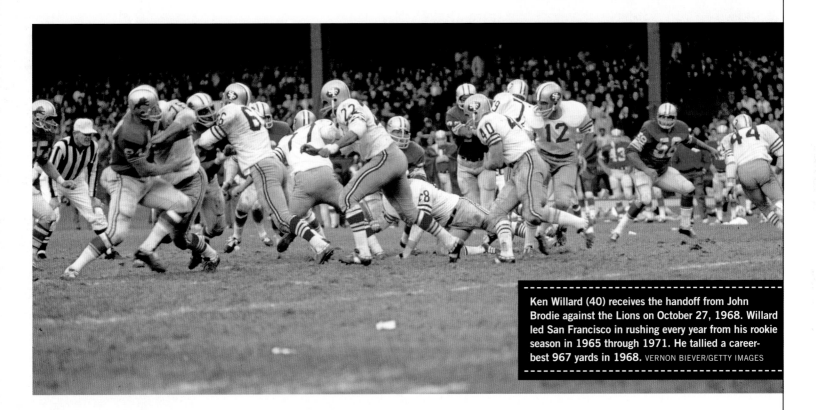

Ken Willard (40) receives the handoff from John Brodie against the Lions on October 27, 1968. Willard led San Francisco in rushing every year from his rookie season in 1965 through 1971. He tallied a career-best 967 yards in 1968. VERNON BIEVER/GETTY IMAGES

Jack Christiansen was fired after the 1967 season, and the 49ers hired defensive-minded Dick Nolan, who was a top assistant under Dallas Cowboys coach Tom Landry. Nolan became the franchise's sixth head coach.

Nolan helped tighten up the 49ers' defense en route to a 7–6–1 record in 1968. And instead of the constant shuffle at the quarterback position, Nolan settled on Brodie as his main guy. Brodie attempted all but 13 of the 49ers' passes during the course of the season and threw for 3,020 yards and 22 touchdowns.

But some of the other problems of the past persisted. Parks, who became disgruntled in a contract dispute, played out his option—like R. C. Owens did five years earlier. Parks signed with the New Orleans Saints in 1968. Many years later, Parks admitted that he should have remained with the 49ers as Brodie's top target.

"It was a bad move," Parks said. "I had a great offensive line [with San Francisco] and a great quarterback. As a receiver, you're nothing without a quarterback who has time to throw the ball."

In six more professional seasons, Parks never came close to compiling the kind of numbers he accumulated in his four seasons with San Francisco.

"He was a fabulous receiver, maybe the best I ever played with," Willard said of Parks. "If things had gone differently, he might be in the Hall of Fame."

ALL·PRO
DAVE WILCOX

A future Hall of Famer, Dave Wilcox appeared in six consecutive Pro Bowls from 1968 to 1973, plus another in 1966.

Instead, a newcomer to the team benefited from the good environment for a pass-catcher. Clifton McNeil became Brodie's top target. McNeil, acquired from the Cleveland Browns for a second round draft pick, led the 49ers with 71 catches for 994 yards and seven touchdowns in 1967.

Other changes were in the works, too. John David Crow, the 1957 Heisman Trophy winner at Texas A&M, retired at the end of the season. Crow shared most of the rushing duties with Willard in his first three seasons with the 49ers. He went along with Nolan's suggestion to transition to tight end in 1968. Crow caught 31 passes for 531 yards and five touchdowns. He had just 4 yards rushing on the season, and he finished 37 yards shy of 5,000 yards rushing for his career.

Prior to the final game, Nolan asked Crow if he wanted to play fullback in order to reach the 5,000-yard milestone. Crow declined the offer, saying, "I wanted to feel like I was helping the team, not that I was doing something for statistics."

In 1969, Brodie sustained a knee injury and the 49ers predictably slid to last place in the Western Conference's Coastal Division. The defense was decimated as well. Linebacker Matt Hazeltine retired. In addition, defensive ends Kevin Hardy and Stan Hindman and linebacker Ed Beard missed most of the season due to injuries.

The highlight of the season came in the final week when Brodie played hurt in a 14–13 victory over the Philadelphia Eagles. Mira, whom the 49ers finally traded prior to the season after he complained for years about his playing time, was the quarterback of the losing Eagles.

The 49ers finished Nolan's second season with a 4–8–2 record. Although it was difficult to believe at the time, the 49ers were on the verge of a three-year run as a championship contender.

Center Forrest Blue, the 49ers' top pick in 1968, would become a mainstay on the offensive line. Tight end Ted Kwalick and wide receiver Gene Washington, first-round draft picks in 1969, meshed quickly with Brodie.

And for the first time, the 49ers were building on defense, too. Cornerback Jimmy Johnson, who was a consistently solid player who flew under the NFL's radar for several seasons, flourished as one of the top cover men in the league. He recorded five interceptions in 1969 and was selected to the Pro Bowl for the first time in his Hall of Fame career.

Wilcox was reaching the prime of his Hall of Fame career. Linebacker Frank Nunley, a third-round pick in 1967, was a fixture in the starting lineup from 1969 to 1976. He proved to be a perfect complement to Wilcox. Nunley also had one of the all-time best nicknames: "Fudge Hammer." Teammate Stan Hindman gave Nunley the nickname because he looked like fudge and hit like a hammer.

Defensive lineman Tommy Hart was selected in the 10th round of the 1968 draft. And 1970 saw the additions of defensive end Cedrick Hardman and defensive back Bruce Taylor.

The 49ers finally had a lot of pieces on both sides of the ball to field a well-rounded team. Parks, the dynamic receiver who left the 49ers as Nolan arrived, felt like he missed out on something special.

"When Dick Nolan took over, he straightened out the defense," Parks said. "And that was our weakness."

Wide receiver Clifton McNeil pulls in one of his league-leading 71 catches in 1968. McNeil had his best season by far in 1968, with 994 receiving yards. VERNON BIEVER/GETTY IMAGES

SHUT DOWN CORNER

Jimmy Johnson in action, September 1972. CLIFTON BOUTELLE/GETTY IMAGES

I t's not easy to carve out your own athletic niche when one of the world's greatest athletes just happens to be your older brother.

But Jimmy Johnson, the 49ers' first-round selection in the 1961 draft at No. 6 overall, did pretty well for himself. Johnson's older brother, Rafer, won the gold medal in the 1960 Rome Olympics in the decathlon.

"I've got another brother who dropped out of sports because he got tired of having people tell him to follow in Rafer's footsteps," Johnson said. "They gave me the same jazz. I didn't like it, either. But instead of letting it bug me, I decided to accept it as a challenge to see if I could make it on my own in sports."

Johnson played 16 seasons for the 49ers, and 17 years after his playing career came to an end, he was inducted into the Pro Football Hall of Fame. Johnson was widely regarded as one of the National Football League's first true shutdown corners.

Johnson's career total of 47 interceptions was a 49ers record until Ronnie Lott came along. Of course, Johnson would go long stretches without seeing any action come his way as quarterbacks often decided to try their luck on the other side.

"I got four or five balls thrown my way, usually just to see if I had my head in the game," Johnson said.

Johnson was a two-way star at UCLA. He played cornerback as a rookie before shifting to receiver in his second season. Johnson was second on the 49ers behind Bernie Casey in receiving with 34 catches for 627 yards and four touchdowns.

"All young players want to get publicity and that usually comes on offense," Johnson said late in his career. "The first few years I

alternated on offense and different defensive positions. I couldn't get settled into one place.

"Finally, I had a conversation with Coach [Jack Christiansen] and told him I'd like to concentrate on one spot. I've been at left cornerback ever since."

Johnson was named first-team All-Pro four times in his career in consecutive seasons from 1969 through 1972. In 1971, he played eight games with a broken arm, demonstrating the durability and toughness that enabled him to play 212 games in his 49ers career.

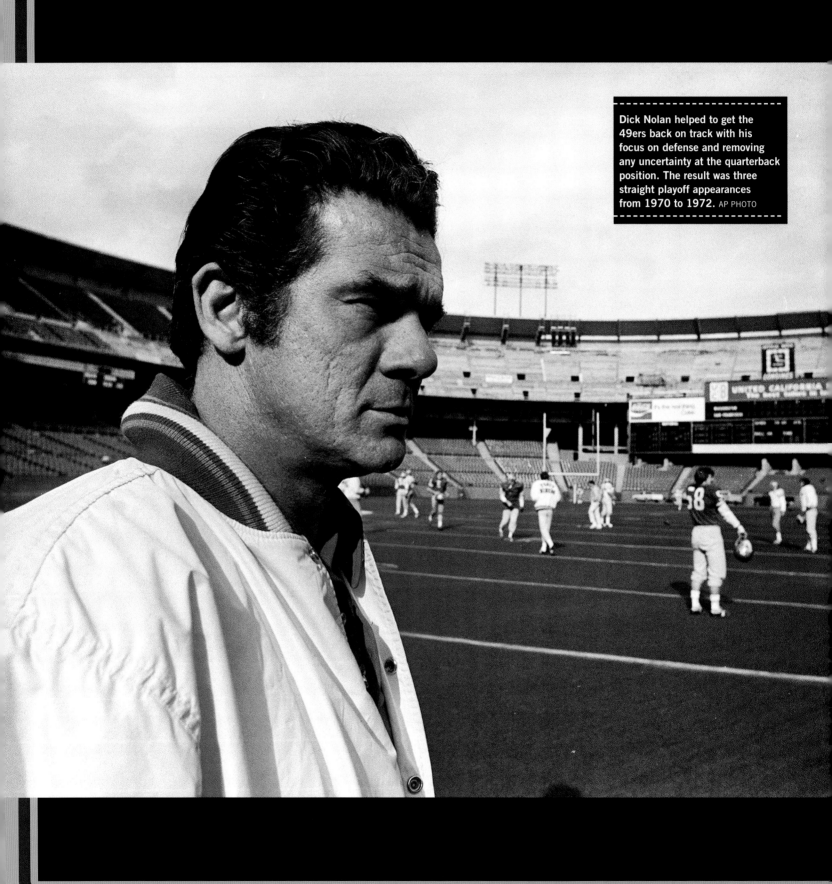

Dick Nolan helped to get the 49ers back on track with his focus on defense and removing any uncertainty at the quarterback position. The result was three straight playoff appearances from 1970 to 1972. AP PHOTO

chapter
4

DICK NOLAN AND DALLAS DÉJÀ VU

1970–1978

Since the franchise's inception in 1946, the San Francisco 49ers' identity had been closely tied to exciting, innovative offense and scoring points. Starting with the hiring of Dick Nolan in 1968, the 49ers began focusing on the other side of the ball as the team headed into a new decade.

Program covers from 1970s-era 49ers football

DIVISION CHAMPS

Dick Nolan had been a teammate of Tom Landry's on the New York Giants in the 1950s. Shortly after Landry became head coach of the Dallas Cowboys, he hired Nolan to be on his coaching staff. Nolan coached defensive backs and later ran the defense, along with Landry, and the two developed the Cowboys' famed "flex defense."

Nolan brought a no-nonsense approach to the 49ers. His goal was to shore up the defense and turn the 49ers into a well-rounded team.

"Dick Nolan was a very serious man," defensive lineman Charlie Krueger said, "and I never did see a harder working man than him."

Through Nolan's first two seasons in San Francisco, the results were mixed. The defense made only minor improvements from the previous regime. But Nolan's desired balance between offense and defense finally took shape early in the 1970 season.

The 49ers showed they still had the firepower on offense, as evidenced by a 34–31 victory over the Cleveland Browns in Week 2.

And the improved defense carried the day when the 49ers went to the Los Angeles Coliseum and defeated the Rams, 20–6, in front of 77,272 fans.

San Francisco had a strong defense with the help of two standouts at the top of their draft class. Defensive end Cedrick Hardman was an outstanding pass-rusher, and cornerback Bruce Taylor was chosen as the NFC Rookie of the Year.

Quarterback John Brodie threw for 2,941 yards with 24 touchdowns and 10 interceptions and was named the NFL Player of the Year. Half of his touchdown throws went to Gene Washington, who caught 53 passes for 1,100 yards and 12 touchdowns. Running back Ken Willard rushed for 789 yards and seven touchdowns.

The best unit on the team was an offensive line consisting of left tackle Len Rohde, left guard Randy Beisler, center Forrest Blue, right guard Woody Peoples, and right tackle Cas Banaszek. That group allowed just eight sacks of Brodie the entire season.

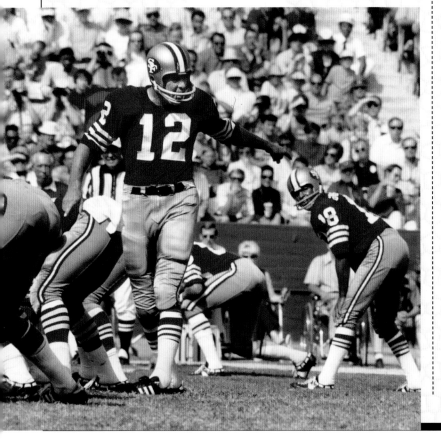

(Above) In just his second season in the NFL, Gene Washington led the league with 1,100 receiving yards and earned his second-straight All-Pro selection. **(Left)** Quarterback John Brodie was once again leading the offense in 1970, and he put forth one of the best seasons of his career to lead the 49ers to a division title. AP PHOTO/NFL PHOTOS

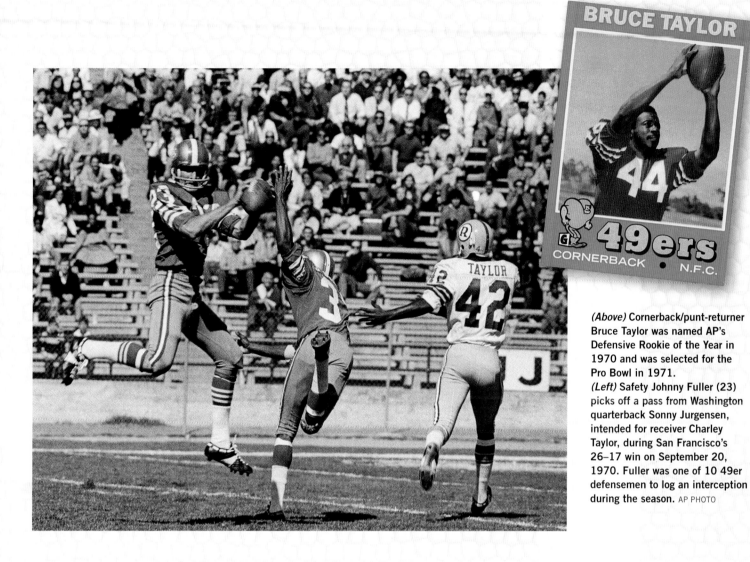

44
49ers
CORNERBACK • N.F.C.

(Above) Cornerback/punt-returner Bruce Taylor was named AP's Defensive Rookie of the Year in 1970 and was selected for the Pro Bowl in 1971.
(Left) Safety Johnny Fuller (23) picks off a pass from Washington quarterback Sonny Jurgensen, intended for receiver Charley Taylor, during San Francisco's 26–17 win on September 20, 1970. Fuller was one of 10 49er defensemen to log an interception during the season. AP PHOTO

The 49ers got off to a 7–1–1 start, but then dropped back-to-back games, including a 30–13 loss to the Rams at Kezar Stadium. Afterward, Nolan said, "Now we have to win the last three."

The 49ers put themselves in position to win their first division title in the 25-year history of the franchise with victories over Atlanta and New Orleans. But they still needed a victory in the final regular-season game against the playoff-bound Oakland Raiders across the Bay.

The 49ers franchise had become known as much for its heartbreak and failure as for its production of Hall of Fame talent on offense. It was easy to reflect back on 1957 when the 49ers found themselves in a playoff against the Detroit Lions for the right to advance to the NFL Championship Game. This game against Oakland was, in essence, a one-game playoff to advance to the postseason.

And when the 49ers led the Raiders, 24–7, at halftime, those who were around for the second-half meltdown against the Lions needed no reminder that it had been an identical 17-point edge the 49ers enjoyed that day in 1957 before blowing the game.

But it certainly was not on the minds of the players—at least, most of the players.

"In 1957, I was ten years old," tight end Ted Kwalick said afterward.

One player who did remember was quarterback John Brodie, who was Y. A. Tittle's backup as a rookie that season.

Thirteen years later, the veteran Brodie threw three touchdown passes in front of the crowd of 55,000 at the Oakland Coliseum. The flawless San Francisco offensive line kept the fearsome Raiders pass rush from laying a finger on him.

After the 49ers defeated the Raiders 38–7 to clinch the Western Division, linebacker Frank Nunley and others carried Nolan off the field on their shoulders.

In the victorious locker room, Brodie shook hands with Hugh McElhenny, who was working as an analyst on the 49ers' radio broadcasts.

"You and I know how much this means," Brodie told McElhenny.

BRAVING THE COLD

The victory over the Raiders meant the 49ers had earned the right to advance to the postseason for the first time in franchise history. The reward for the boys from California was a trip to Minnesota, where temperatures of 10 degrees with a wind-chill factor of minus 5 awaited at Metropolitan Stadium.

A year earlier, punter Bruce Gossett had been a member of the Los Angeles Rams. Coach George Allen had decided to take the Rams to Minnesota early in the week to get prepared for the frigid conditions.

"You know where the Vikings were working out while we were in the snow?" Gossett asked. "In a field house, that's where."

Nolan decided to spend as little time in Minnesota as possible, as the 49ers left Friday afternoon for the Sunday game. Said Brodie, "I'd rather freeze for three hours than four days."

But the weather did have an impact on the 49ers. Running back Ken Willard fumbled in the first quarter. Minnesota's Paul Krause picked up the loose ball and returned it 22 yards for a touchdown to give the Vikings a 7–0 lead.

The 49ers came back when Brodie hit receiver Dick Witcher on a 24-yard touchdown pass. Gossett added a 40-yard field goal to give the 49ers a lead that they would hold for the balance of the game.

With less than two minutes to play, the 49ers had a chance to put the game away with the ball on the Minnesota 1-yard line.

"In the huddle, I asked the players, 'What's up? Where could we hit?'" Brodie explained to reporters afterward. "Woody Peoples said, 'I got him,' and that meant he could handle his man. So I called the play, he got his man, and we had the touchdown."

Brodie followed his right guard, who had the block on Vikings defensive lineman Gary Larsen, for a 1-yard touchdown run to put the 49ers up 17–7 with 1:20 remaining in the game. The Vikings scored a touchdown in the closing seconds, and the victorious 49ers returned home. More than 6,000 fans were waiting at San Francisco International Airport to greet them.

Willard, who made amends with 85 yards rushing, was the most relieved man on the team after being responsible for giving the Vikings their first touchdown.

"No excuse," he said. "My fingers were a little cold, but I just got hit. But I knew we'd come back. I sure hoped we'd come back. If we didn't come back, I would've died a horrible death."

The 49ers, comprised of a mix of veteran leaders and rising stars, lived to play another week.

"I heard all these guys whooping it up for victory. And I looked over at Charlie Krueger and John Brodie sitting there and I was just happy for them," cornerback Jimmy Johnson said. "All the years they've toiled, all the criticism they've taken, and now they put it all together and are winners. It was a great, great thrill."

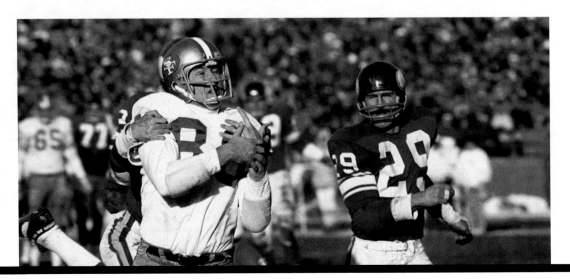

Wide receiver Dick Witcher is unable to hold onto this pass in the bitter cold at Minnesota's Metropolitan Stadium during the 1970 playoff game against the Vikings. Witcher did team up with John Brodie on a 24-yard touchdown pass in the first quarter.
AP PHOTO

NOLAN VS. LANDRY, I

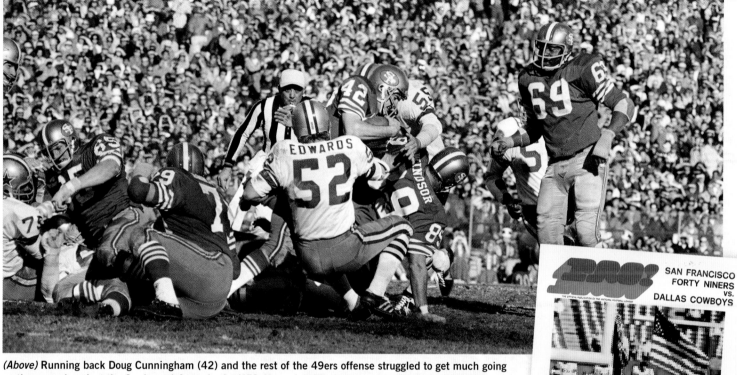

(Above) Running back Doug Cunningham (42) and the rest of the 49ers offense struggled to get much going on the ground against the Cowboys defense in the NFC Championship Game on January 3, 1971. The Niners managed only 61 yards rushing, compared to the Cowboys' 229 yards, in the 17–10 loss. AP PHOTO

(Right) Program cover from 1970 NFC Championship Game between the 49ers and the Cowboys

SAN FRANCISCO FORTY NINERS VS. DALLAS COWBOYS

NFC CHAMPIONSHIP GAME
Kezar Stadium, San Francisco, California • January 3, 1971 • Official Program 75¢

The thrill did not last long, however, as the 49ers had to get right back to work to prepare for a team Nolan knew very well. San Francisco was established as a 3½-point favorite over the Dallas Cowboys, a team that picked up a 5–0 (that's right, 5–0) victory over the Detroit Lions in the other NFC divisional playoff game.

In 1969, Nolan's 49ers went up against Landry's Cowboys in a Thanksgiving Day matchup that ended in a 24–24 tie. This time there would be a winner, even if it took all day. And the winner would represent the NFC in Super Bowl V at the Orange Bowl in Miami.

"Tom taught me everything I know," Nolan said in the days leading up to the game. "I enjoy playing against them. You're going to see two very similar defenses on the field."

A capacity crowd of 59,364 patrons who paid $12 per ticket packed Kezar Stadium for the final NFL game that would be played in the 49ers' first home.

Brodie threw for 262 yards, while Cowboys quarterback Craig Morton managed just 101 yards passing. But Brodie threw two critical interceptions, which led directly to Dallas's only touchdowns of the game.

The 49ers scored on Brodie's 26-yard pass to Witcher to draw close. But their

final attempt came up well short when Bob Windsor caught a 29-yard pass to the Dallas 40-yard line as time expired.

In the locker room filled with disappointed 49ers, there was no sense that this was just a one-time shot for the franchise.

"The farther you go, the farther you want to go," Nolan said. "We met a good team and we're a good team, and we'll be back."

Willard echoed the message from his coach: "We came a long way. We'll be back."

MOVING TO THE "STICK"

Candlestick Park under construction for conversion to a multipurpose facility to house both baseball and football, May 1971. AP PHOTO/ROBERT H. HOUSTON

Candlestick Park was built for baseball. It was the home of the San Francisco Giants after the club spent its first two seasons at Seals Stadium.

Then Vice President Richard Nixon toured Candlestick in 1959 and declared, "This will be one of the most beautiful baseball parks of all time."

In 1971, the 49ers moved out of Kezar Stadium, located in the southeastern corner of Golden Gate Park. They would share their new home with the Giants in the Hunters Point/Bay Point area on Candlestick Point.

In the 49ers' first season in the concrete edifice, the capacity was 45,000. With the upper-deck enclosure, the stadium was expanded. When the 49ers faced the Dallas Cowboys in the 1972 playoffs, 59,746 fans packed Candlestick.

The elements were every bit the story of Candlestick Park as at Kezar. The winds were brutal and, in the early years, the AstroTurf was atrocious.

In the first playoff game at Candlestick Park, the 49ers and Washington players slipped around the wet field in a sloppy game.

"The wind was going over sideways, coming over our bench to theirs," quarterback John Brodie said following the 49ers' 24–20 victory. "It was swirling, slippery, and raining, too. It was the worst conditions I've ever played under. They couldn't run and trying to throw the ball was like trying to throw a greased pig. It was hard to stand up, let alone try to throw the ball, catch it or run with it."

Running back Ken Willard, who led the 49ers in rushing for seven consecutive seasons, endured less-than-ideal field conditions at Kezar, which was used by local high schools and colleges, too.

"Kezar was the best field in the league until the last two games," Willard said. "Then it got to be one of the worst. I think the ground crew could so something at Candlestick. I'm sure it would be a lot better if they'd cover the field with a tarp. At least we'd start with a dry field. At the start of the year, I liked AstroTurf. On a dry field any kind of shoe works. On a wet one, no shoe works."

Willard played for the 49ers from 1965 to 1973. His career ended when he returned to Candlestick in 1974 with the St. Louis Cardinals and sustained torn knee cartilage.

Later, when the brittle and faded AstroTurf was replaced, there were more problems. Because the field was actually below sea level and on landfill, there were complications getting the turf in playing shape. Late in the season, the grounds crew often had to spend timeouts on the field tamping huge chunks of turf back into the ground.

If nothing else, Candlestick Park was resilient. The stadium survived the Loma Prieta earthquake of 1989, forcing the 49ers to move just one game to Stanford Stadium as experts checked the structural integrity of the stadium.

With naming-rights sponsors, the stadium took on a couple different names—3Com and Monster—yet everyone in San Francisco referred to it simply as "The Stick."

Owner Eddie DeBartolo gave it a less-flattering tag. DeBartolo called Candlestick a "pigsty" as he sought to build a new stadium to house his football team. Yet, the 49ers remained in what was universally regarded as the worst structure in the National Football League for another three decades.

This view from 1985 shows the Giants' baseball diamond evident within the football configuration. MIKE POWELL/ALLSPORT/GETTY IMAGES

MOVING ON

Even with Brodie producing one of his best seasons in 1970, there were questions about the future. The day after the season concluded, Glenn Dickey of the *San Francisco Chronicle* reported that the 49ers were interested in making a trade with the Boston Patriots for the draft rights to Heisman Trophy–winning quarterback Jim Plunkett of Stanford. The trade did not happen, and Plunkett was the top overall draft pick of the Patriots.

Brodie remained at quarterback, never allowing highly touted backup Steve Spurrier an opportunity to get on the field in 1971. But one big change did occur. The 49ers moved into windy Candlestick Park, which had been home to the San Francisco Giants since the 1960 Major League Baseball season.

Once again, the 49ers' season came down to the final game. San Francisco needed a victory over the Lions to win a second-straight Western Division title. The 49ers defeated Detroit, 31–27, coincidentally the same score they lost to the Lions in the 1957 playoff. Brodie had a 10-yard touchdown run in the fourth quarter to supply the winning points and send the 9–5 49ers into the playoffs against Washington at Candlestick Park.

Billy Kilmer, who spent his first four NFL seasons as a running option at quarterback behind Brodie, led Washington into the playoffs in his first season with the club. Kilmer threw a touchdown pass in the first quarter, and Washington held a 10–3 lead at halftime.

In the third quarter, Brodie hit Gene Washington on a 78-yard touchdown pass to tie the game. Brodie's 2-yard toss to Bob Windsor gave the 49ers their first lead, at 17–10.

The 49ers were able to put the game away when Washington's George Burman sailed his snap past punter Mike Bragg and 49ers' defensive tackle Bob Hoskins recovered the loose ball in the end zone for his first career touchdown.

Linebacker Frank Nunley led the team with 11 tackles and blocked a field goal, and Hardman sacked Kilmer in the final seconds near midfield to secure the victory.

Meanwhile, Dallas defeated the Minnesota Vikings to set up another Nolan vs. Landry showdown for the right to go to Super Bowl VI. Landry prepared his team for a great battle against the 49ers, who were no longer strangers to postseason play.

Gene Washington goes up in the air against the Rams in November 1971 to pull in one of his 46 catches during the season. JAMES FLORES/GETTY IMAGES

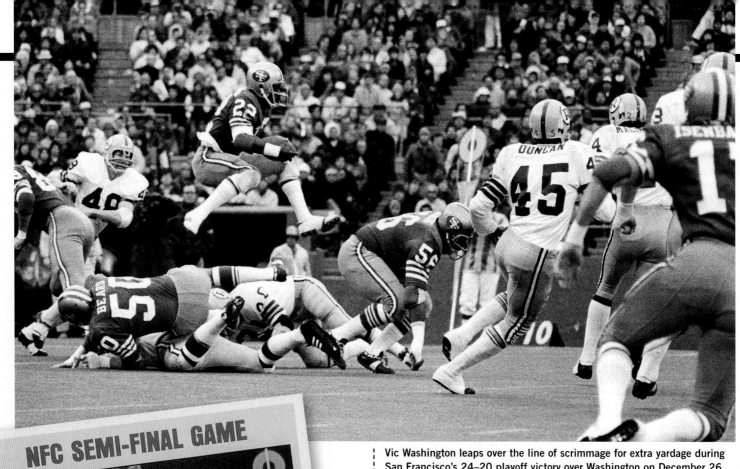

Vic Washington leaps over the line of scrimmage for extra yardage during San Francisco's 24–20 playoff victory over Washington on December 26, 1971. The rookie running back gained 811 yards rushing during the year and had 16 carries in the playoff win. AP PHOTO

NFC SEMI-FINAL GAME

49ers 24
REDSKINS 20

PRO ACTION

VIC WASHINGTON

"I expect it will be a tougher game than last year," Landry said. "San Francisco is a better club than it was last season. . . . Their defensive end play is better since Cedrick Hardman has another year. And Nolan has a lot more going for him because Kwalick at tight end has joined Gene Washington in having a good year. And Vic Washington gives them something at running back that hasn't been there before."

Hardman had a huge season with 18 sacks in 14 regular-season games. But that was before the NFL recognized sacks as an official statistic, so Hardman's outstanding season has been largely overlooked in the annals of 49ers history.

Sure enough, the 49ers had a lot more balance on offense. Willard led the team in rushing with 855 yards. Rookie Vic Washington gave San Francisco a rare one-two punch, chipping in 811 yards. Kwalick gave Brodie a reliable target, as he caught a team-high 52 passes for 664 yards and five touchdowns. Gene Washington was still a big-play option with a team-leading 884 receiving yards.

However, as strong and balanced as the 49ers proved to be in the regular season, they could not get anything going against Landry's stout "Doomsday Defense," featuring defensive tackle Bob Lilly, linebacker Chuck Howley, and defensive backs Herb Adderley, Mel Renfro, Cliff Harris, and Cornell Green.

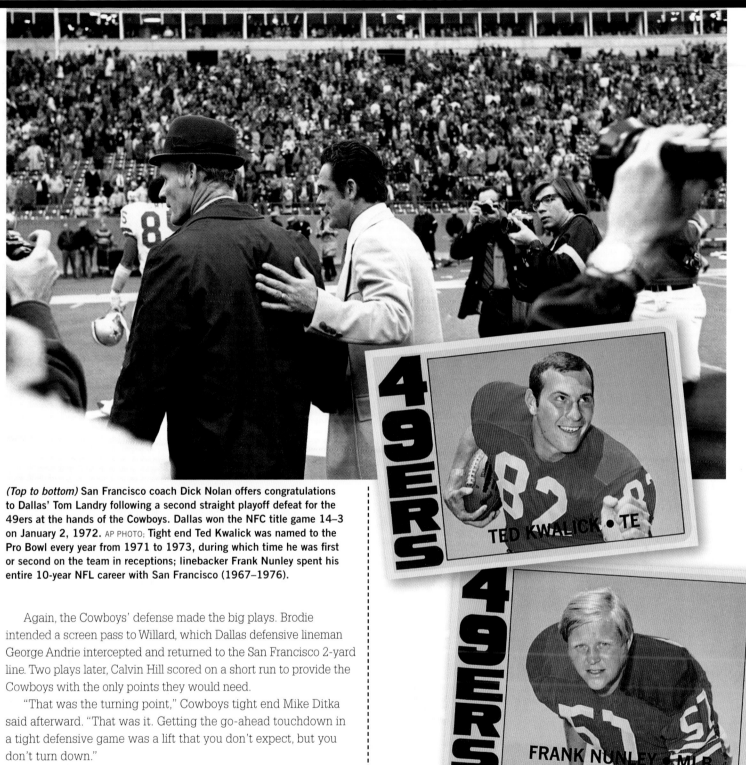

(Top to bottom) San Francisco coach Dick Nolan offers congratulations to Dallas' Tom Landry following a second straight playoff defeat for the 49ers at the hands of the Cowboys. Dallas won the NFC title game 14–3 on January 2, 1972. AP PHOTO; Tight end Ted Kwalick was named to the Pro Bowl every year from 1971 to 1973, during which time he was first or second on the team in receptions; linebacker Frank Nunley spent his entire 10-year NFL career with San Francisco (1967–1976).

Again, the Cowboys' defense made the big plays. Brodie intended a screen pass to Willard, which Dallas defensive lineman George Andrie intercepted and returned to the San Francisco 2-yard line. Two plays later, Calvin Hill scored on a short run to provide the Cowboys with the only points they would need.

"That was the turning point," Cowboys tight end Mike Ditka said afterward. "That was it. Getting the go-ahead touchdown in a tight defensive game was a lift that you don't expect, but you don't turn down."

The 49ers' turnovers played a huge role in spoiling an outstanding defensive effort led by Hardman, who had a hand in five sacks.

"If someone were to get five sacks in the NFC Championship Game today, they'd take his shoes and helmet and send them straight to Canton," Hardman said in 2005. "But we lost that game, so it wasn't a big deal."

Said Nolan, "Our defense was great, and so was theirs."

SPURRIER RESCUES SEASON, THEN PLAYOFF HEARTBREAK

The 49ers had invested their 1967 first-round pick in Heisman-winning quarterback Steve Spurrier. He remained inactive for most of his first five seasons with the organization. But in 1972, his services were needed.

In the previous two seasons, the 49ers had no reason to get Spurrier into the action. Brodie was healthy and playing well.

But five weeks into t he 1972 campaign, Brodie sustained a severely sprained ankle during a 23–17 loss to the New York Giants on October 15. The loss dropped the 49ers to 2–3, and their season appeared to be spiraling downward, with Brodie out for eight weeks.

However, Spurrier, who had completed just four of eight pass attempts over the previous two years, was ready to take advantage of his big opportunity. With Spurrier as the starter, the 49ers went 5–2–1 to get back into the hunt in the weak NFC Western Division.

Although Brodie was healthy for the regular-season finale, Spurrier remained as the starter. But when the 49ers needed a spark against the Minnesota Vikings, Nolan summoned Brodie off the sideline. The veteran threw two fourth-quarter touchdown passes to lead the 49ers to a 20–17 victory at Candlestick Park.

A week later, the 49ers opened the playoffs against the Cowboys at Candlestick. And Nolan—like Landry— had a decision to make at the quarterback position. The Cowboys had their own quarterback controversy, and Landry elected to start Craig Morton over Roger Staubach. Nolan decided to go with Brodie.

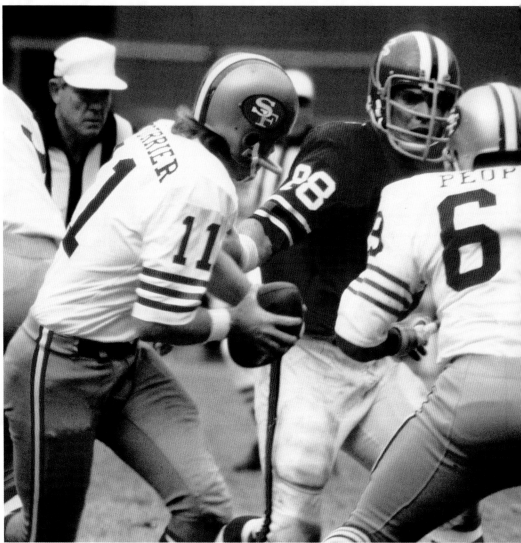

In just his second start of the 1972 season, quarterback Steve Spurrier (11) led the 49ers to a resounding 49–14 defeat of the Falcons in Atlanta on October 29, 1972. Spurrier attempted only 18 passes in the game, but he connected for three touchdowns. BOB VERLIN/GETTY IMAGES

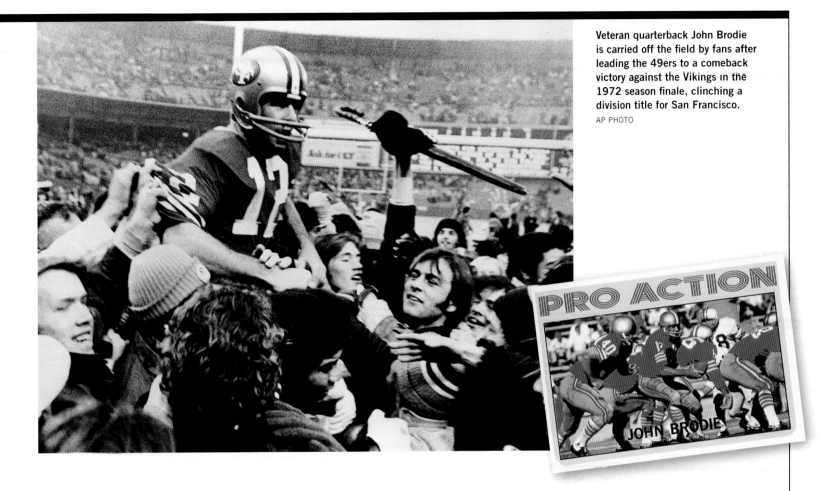

"I'm going with sixteen years of experience," Nolan said.

Said Spurrier, "I'm still going to have my ankles and knee taped Saturday. I'll be ready."

The 49ers' backup quarterback did not get into the game. But the Cowboys' No. 2 quarterback did, and he proved to be a catalyst in a game that was every bit as wild as another memorable game that day.

Earlier in the day, the Oakland Raiders' season came to an end when Pittsburgh Steelers quarterback Terry Bradshaw's late pass ricocheted into the hands of running back Franco Harris, who scored the winning touchdown in the final seconds. The play is forever known as "The Immaculate Reception."

At Candlestick Park, the Bay Area team was in control against the Cowboys and could only lose if something out of the ordinary were to occur. Vic Washington muffed the opening kickoff, picked it up off the turf, and returned it 97 yards for a touchdown to give the 49ers a 7–0 lead just 17 seconds into the game.

Everything was going right for the 49ers, who entered the fourth quarter with a commanding 28–13 advantage.

Staubach, who had replaced Morton late in the third quarter, led the Cowboys to a touchdown on his 20-yard pass to Billy Parks with just 90 seconds remaining in the game. Then, Dallas kicker Toni Fritsch's onside kick was recovered by teammate Mel Renfro.

Staubach ran 21 yards down the middle to the 49ers' 29-yard line. With 0:56 remaining, Staubach hit Parks for 19 yards. And on the next play, with Nunley coming on a blitz, Staubach found Ron Sellers matched in single coverage against 49ers rookie safety Windlan Hall for a 10-yard touchdown.

And just like that, the Cowboys had an improbable 30–28 victory over the doleful 49ers.

"I just can't believe it," Brodie said afterward. "I can't sit back and analyze a game like that when I can't quite believe it myself. We had it. We had it won."

There was plenty of blame to go around. The 49ers got conservative on offense once they had the lead, often running the ball on third downs and content to punt and play defense. Their breakdowns on every imaginable level were difficult to fathom.

"I've never had anything like this happen to me before," Nolan said.

Kicker Bruce Gossett missed two field goals, including a 32-yard chip shot early in the fourth quarter. And there was Preston Riley, who could not handle the onside kick and would never play again for the 49ers. Trying to recover an onside kick on the AstroTurf at Candlestick Park was no easy task.

"It was twisting and turning," Riley said. "What the dickens. I just missed it. What more can I say?"

"He was distraught," Banaszek recalled in Dennis Georgatos's book *Stadium Stories: San Francisco 49ers*. "I roomed with him one year, and he was a very fragile guy. He just didn't handle it well, kind of went off the deep end. But it wasn't his fault. So they got one onside kick. Why didn't we stop them? They went in like we weren't even out there playing."

The Cowboys had beaten the 49ers before, and they expected to beat them again. Even when it seemed a near-certainty the 49ers would be moving into the NFC Championship Game for a third consecutive season, the Cowboys did not stop battling.

"Before the game, I told our players to go all-out for sixty minutes," Landry said. "With two minutes left, it looked kind of bad, but there was always hope."

After three trips to the playoffs and three losses to the Dallas Cowboys, the 49ers' window slammed shut just as quickly as it opened.

Fullback Larry Schreiber (35) leaps into the end zone for one of his three one-yard touchdown plunges in the game against the Cowboys. Schreiber provided 18 of the 49ers' 28 points in the loss. JAMES FLORES/GETTY IMAGES

"We should've won the first one," Willard said. "We were probably the better ball club than Dallas. By the next one in January 1972, they were the better ball club. We peaked in 1970, and for some reason we started going downhill even though we were in the playoffs for two more years."

Willard said part of the problem was that San Francisco lost one of the best offensive coaches when coordinator Ed Hughes left to become head coach of the Houston Oilers. Hughes took offensive line coach Ernie Zwahlen with him. Zwahlen was instrumental in devising the blocking scheme that kept Brodie so well-protected in 1970. Zwahlen tightened the splits of the offensive linemen and had them cross ankles to take away any gaps from tackle to tackle for pass-rushers to penetrate.

Charlie Krueger and Cedrick Hardman converge on Dallas quarterback Roger Staubach for one of San Francisco's 5 sacks. Hardman had a hand in 3.5 of them. JAMES FLORES/GETTY IMAGES

THE ORIGINAL INTIMIDATOR

Dave Wilcox might have been understated off the field. But as the top outside linebacker of his era, Wilcox's play spoke loudly during an 11-year career that consisted of seven Pro Bowls and seven All-Pro seasons.

Quarterback John Brodie said Wilcox was able to completely eliminate the tight end from opposing offenses. Safety Mel Phillips figured Wilcox preserved his career because nobody ever made it past Wilcox to block him. And the great Dick Butkus asked, simply, "Who was better?"

"In the NFL, there are usually around five or six players during a season that nobody wants to mess with," said middle linebacker Frank Nunley, who lined up alongside Wilcox for seven seasons. "Deacon Jones was one; Dick Butkus was another; and Dave Wilcox was another guy that nobody ever wanted to get mad."

Fittingly, Wilcox earned the nickname "The Intimidator" due to his unique blend of size, speed, strength, and aggression. One of his trademarks was a tackling style in which he hit high and brought ball carriers to an immediate halt.

"Dave had a necktie tackle that squeezed helmets," said Mike Giddings, who coached 49ers linebackers and presented Wilcox at his Pro Football Hall of Fame induction in 2000.

"He could just naturally tackle. If the back was slippery or fast, he could just reach out and grab him with one hand and throw him down. He studied the game and was as well-prepared as any player I've ever seen."

Giddings would rate the performance of each player following the season. The typical score for a linebacker was 750. Wilcox's score in 1973 was 1,306 after he recorded 104 solo tackles, four forced fumbles, and 13 tackles for losses.

Perhaps because of his personality off the field, Wilcox nearly slipped through the cracks of the Hall of Fame. He was passed over on the regular ballot for years, so Wilcox's fate was in the hands of the senior committee. He found out on his 28th wedding anniversary that he would be enshrined in Canton.

"The Hall of Fame is real special, but as a player I just did what I did," Wilcox said. "I played in Pro Bowls and all of that stuff, and I did it as best I could. As for the recognition part, I grew up in an atmosphere where I didn't have to tell people

I was a good player. If I played well, enough people will know, 'Hey, Dave's a good player.'"

Said Nunley, "I was astonished it took so long for him to get into the Hall of Fame. Dave as an outside linebacker was definitely in the same class as Jimmy Johnson as a defensive back."

There was a huge 49ers flavor when Wilcox finally was inducted. He was part of the 2000 Hall of Fame class that also included quarterback Joe Montana and defensive back Ronnie Lott.

Dave Wilcox, 1974. AP PHOTO/NFL PHOTOS

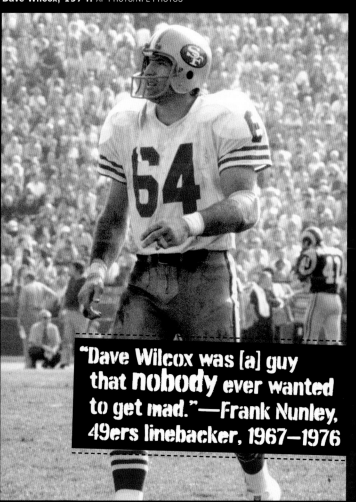

> "Dave Wilcox was [a] guy that **nobody** ever wanted to get mad."—Frank Nunley, 49ers linebacker, 1967–1976

BOTTOMING OUT

Just as quickly as the 49ers had risen to become Super Bowl contenders, the club went into a free fall over the next six seasons.

John Brodie runs onto the Candlestick Park field for the last time before the 49ers–Steelers game on December 15, 1973—John Brodie Day.
MICHAEL ZAGARIS/GETTY IMAGES

Coming off the hangover of their crushing playoff defeat, the 49ers opened the 1973 season on the road against the Miami Dolphins, the unbeaten Super Bowl champions of the previous year.

Brodie, who announced 1973 would be his final NFL season, got off to a hot start as he completed 11 of 14 passes. The 49ers took a 10–6 lead, but Brodie and company wilted in the 100-degree temperature of South Florida. Spurrier entered the game and completed just 6 of 18 passes, and the Dolphins came back for a 21–13 victory.

John Brodie Day at Candlestick Park on December 15 provided no special memories, either. At 38, and having played 17 NFL seasons—all for the 49ers—Brodie managed to complete just 6 of 12 pass attempts for 79 yards in the 49ers' 37–14 loss to the Pittsburgh Steelers.

There could not have been a worse conclusion to Brodie's tumultuous career with the 49ers.

"He's the most complicated man I've ever known," receiver Gene Washington once said of Brodie. "He's a very private person. He's very proud. No braggart, just proud. I like to think of myself as a competitive person, but I can do some things just for fun. John's got to win at everything. He's a good winner, but not a good loser."

The 49ers finished out of the playoff hunt with a 5–9 record.

Making matters worse, Spurrier showed no signs that he was capable of becoming the next great 49ers quarterback. In the finale against Pittsburgh, he completed 1 of 9 passes for 3 yards and one interception. After two more dismal seasons in San Francisco, Spurrier was traded to the Tampa Bay Buccaneers.

The 1973 season also brought an end to the careers of Willard and Krueger, whose careers were no doubt cut short by the unforgiving artificial turf at Candlestick Park.

Eight rookies made the 49ers in 1974, a sure sign that it was a rebuilding season. First-round draft pick Wilbur Jackson led the 49ers in rushing for 705 yards. In the second round, San Francisco added Delvin Williams, an electric runner from Kansas. Second-round pick Keith Fahnhorst became a fixture on the offensive line for more than a decade.

But the 49ers needed reinforcements at quarterback, and this was not a good year for that position. The Dallas Cowboys selected

the first quarterback of the draft when they chose Danny White with the first pick of the third round.

The 49ers waited until the 13th round after 14 other quarterbacks had already gone off the board to address their dire need. That's when they selected Tom Owen of Wichita State.

Joe Reed was Spurrier's top competitor for the starting job during training camp. And Spurrier was in the lead entering the final game of the exhibition season, but his bid to open the season as the starter came to an end when the Rams' 275-pound defensive lineman Larry Brooks slammed him into the hard Candlestick artificial

surface and landed on him with all his weight. Spurrier sustained a shoulder separation. He played in just two games and attempted just three passes all year.

Owen was the 49ers' leading passer in 1974, as he threw for 1,327 yards with 10 touchdowns and 15 interceptions. Dennis Morrison, a 14th-round selection in 1973, Reed, and Norm Snead also took snaps at quarterback for San Francisco, which lost seven games in a row but still managed a respectable 6–8 record.

The 1975 season was even worse. The 49ers still had no answer at quarterback. And for the first time since entering the NFL, the team did not send multiple players

to the Pro Bowl. Defensive end Cedrick Hardman was the only San Francisco player selected to the annual all-star game. He also became the first two-time winner of the Len Eshmont Award.

With the memories of their three-year run as division champions fading fast, Dick Nolan's eight-year stint as head coach came to an end. Under Nolan, the 49ers achieved its greatest success with three playoff appearances and back-to-back trips to the NFC Championship Game.

However, each season ended unfulfilled with losses to the Dallas Cowboys. After three consecutive losing seasons, the 49ers and Nolan parted ways.

ONE-TWO RUSHING ATTACK

John Brodie was gone, and the next great 49ers quarterback was several years from arriving. So for several seasons, the 49ers relied on a running game led by 1974 draft picks Wilbur Jackson and Delvin Williams.

Over the next four seasons, Jackson and Williams provided the lone highlights for an organization that had always built its identity around the quarterback position.

Jackson, a first-round draft pick from Alabama, led the 49ers as a rookie with 705 yards. In 1975, it was Williams, a second-round selection from Kansas, who led the way with 631 yards with a 5.4 average.

Williams had 1,203 yards rushing with seven touchdowns in 1976, with Jackson contributing 792 yards. And in 1977,

Williams had 931 yards and seven touchdowns, while Jackson added 780 yards and seven touchdowns.

Jackson and Williams were on display for a national TV audience on November 29, 1976, when Jackson gained 156 yards and Williams had 153 yards on *Monday Night Football* in a 20–16 victory over the Minnesota Vikings.

Earlier that season, Williams had a 49ers-record 194 yards rushing in an overtime loss to the St. Louis Cardinals. The record would last 22 years until Garrison Hearst topped the mark.

"I didn't realize I was doing what I was doing because I wanted to win that game so badly. Given all the 49ers' success through the years, it's amazing it [the record] lasted that long."

Williams' 1,203 yards rushing in that 14-game season broke Joe "The Jet" Perry's team record that lasted 22 years. Wendell Tyler broke Williams's record in 1984 in a 16-game season.

Williams was traded to the Miami Dolphins after the 1977 season for receiver Freddie Solomon and safety Vern Robinson. Williams went on to become the first NFL player to rush for more than 1,000 with two different teams.

Jackson missed the entire 1978 season with an injury, returned in 1979 behind O. J. Simpson and Paul Hofer, and finished his career with Washington.

MONTE CLARK, ONE AND DONE

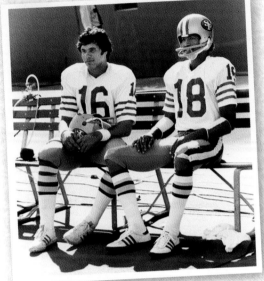

Quarterback Jim Plunkett and receiver Gene Washington look on from the bench during San Francisco's 33–3 victory over the New Orleans Saints in October 1976. The duo connected on a 55-yard touchdown pass in the game, which came in the midst of a five-game winning streak for the 49ers. MICHAEL ZAGARIS/GETTY IMAGES

Monte Clark was a fourth-round draft pick of the 49ers in 1959. He played on the offensive and defensive lines for three seasons before the club dealt him to the Dallas Cowboys. Dick Nolan was the Cowboys defensive backs coach in 1962.

After his retirement, Clark entered the coaching ranks on Don Shula's staff as the Miami Dolphins' offensive-line coach. Clark built one of the best lines in football history, a unit that included Hall of Famers Larry Little and Jim Langer.

Clark became the NFL's youngest head coach at the time on January 13, 1976, when the 49ers announced him as Nolan's successor.

Equipped with the power to make personnel decisions, Clark OK'd a move that had been rumored five years earlier: he brought Jim Plunkett back to the Bay Area. The 49ers acquired Plunkett from the Patriots for a steep price. They traded Owen, as well as two first-round draft picks in 1976 (one acquired from Houston in a previous trade), and first- and second-round picks in 1977.

Plunkett was a local hero. He won the Heisman Trophy while leading Stanford to an upset over Ohio State in the 1971 Rose Bowl. The NFL Rookie of the Year in 1971, Plunkett fell on hard times with the Patriots as he took a beating behind one of the league's worst offensive lines.

While Plunkett completed barely over 50 percent of his passes and tossed 22 touchdowns with 30 interceptions in his two seasons with San Francisco, at least there was no quarterback controversy. Plunkett was surprisingly durable with the 49ers even as he battled through rib injuries.

The 49ers were built around their defense in 1976. The front four of Hardman, Tommy Hart, Cleveland Elam, and Jimmy Webb formed "The Gold Rush," and the unit combined to record 61 sacks in 14 games.

"We were 'The Gold Rush,'" Hardman said. "Now, you have schemes and zone blitzes, where defensive linemen are dropping into pass coverage. You couldn't have gotten us to do that. We didn't know how to go south. We only went north."

The 49ers got off to a 6–1 start, and optimism was high. But kicker Steve Mike-Mayer missed an extra point and two field goals, including a 23-yard attempt late in regulation, and the 49ers lost an excruciating overtime game against the St. Louis Cardinals to begin a four-game losing streak. The 49ers finished second in the NFC Western Division with an 8–6 record.

The 49ers appeared to be going in the right direction under Clark.

"He was a good coach," Delvin Williams said. "I learned more about football in that year with Monte Clark. He was well-prepared and you knew all the nuances of what you had to do. I matured as a player. As a rookie, I was just happy to make the team."

But the 49ers were undergoing many changes.

Defensive tackle Cleveland Elam was part of San Francisco's formidable "Gold Rush" defensive frontline in the late 1970s. Elam was First-Team All-Pro in 1977.

THE JOE THOMAS DISASTER

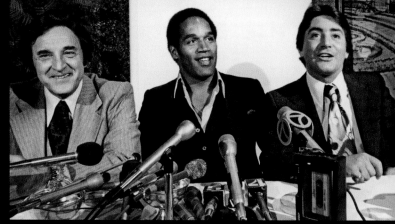

General manager Joe Thomas (left) at the press conference announcing the acquisition of O. J. Simpson (center). To Simpson's left is team owner Edward J. DeBartolo Jr. MICHAEL ZAGARIS/GETTY IMAGES

Joe Thomas made a large impact on the 49ers in his two seasons as general manager. No person in the history of the 49ers did more to set back the franchise than the controversial figure.

Thomas made poor personnel decisions, including an ill-advised trade for washed-up running back O. J. Simpson. And he almost single-handedly erased all of the goodwill that former team president Lou Spadia developed with the 49ers' ardent fan base.

Thomas's appointment as general manager was announced on the same day that Eddie DeBartolo took over as owner. Head coach Monte Clark wanted no part in remaining with the organization if it meant Thomas had control over the roster.

"I'm going to build a football team that is a winner," Thomas promised on his first day in charge. "I don't want to talk about the past. I want to look forward, positively, to a Super Bowl."

Thomas meant what he said. He no longer welcomed former 49ers players around the 1977 team. And he ordered that all publications and team archives from the first 30 years of franchise history be discarded as trash into a dumpster behind the team's Redwood City offices.

The irascible Thomas came to the 49ers with a reputation as a good judge of football talent but severely lacking in interpersonal skills. He was the director of player personnel for the Minnesota Vikings and Miami Dolphins. He remained with the Dolphins through their unbeaten 1971 season before moving on to become general manager of the Baltimore Colts.

Thomas cut quarterback Jim Plunkett, and other popular players were released or traded, including Gene Washington, Delvin Williams, Bruce Taylor, Skip Vanderbundt, Tommy Hart, and Woody Peoples.

Perhaps Thomas's most damaging move was the blockbuster trade that brought Simpson, a native San Franciscan, to the 49ers. The 49ers sent the Buffalo Bills a first-round draft pick in 1978, second-round picks in 1978 and 1979, a third-round pick in 1978, and a fourth-round pick in 1979.

Simpson gained 7,699 yards rushing over a five-year span for the Bills. But he had worn down for the Bills in 1977, gaining 557 yards in an injury-plagued season. In two seasons with the 49ers, he rushed for 1,053 yards and four touchdowns for the 49ers.

As Thomas became more and more unpopular, a grassroots movement began to encourage DeBartolo to fire him. The group, called "Doubting Thomas," grew to 4,000 members.

At one late-season game, a fan at Candlestick produced a sign, "Xmas wishes for 49ers Faithful: 1. A new owner; 2. A new general manager; 3. Another Monte Clark."

On January 8, 1979, DeBartolo took care of one of the presents on the wish list when he fired Thomas.

"I get embarrassed when things aren't working properly," DeBartolo said in announcing the move. "No one incident had a bearing on my decision. The philosophy of the organization the last two years was not what I had hoped for or set out to achieve.

"Nobody felt at ease and comfortable within the organization. I didn't even feel comfortable. You can't make an organization work that way."

DeBartolo said he had to bring back a sense of family to the 49ers that had disappeared with Thomas in charge of the organization. The 49ers had to do more to embrace the fan base, as well as the past players.

"It was either that or jump off the Golden Gate Bridge because I had a really, really tough year or so," DeBartolo said. "The fans wanted no part of me. I had everything from full beers thrown at me to people spitting on me. It was very difficult."

The turnaround for DeBartolo and the 49ers began with the end of Joe Thomas.

A TIME OF CHANGE

J osephine Morabito, the widow of 49ers founder Tony Morabito, and Jane Morabito, the widow of Vic, were the principle owners of the franchise. The two women owners remained in the background while chief executive officer Lou Spadia had been in charge of day-to-day operations since Vic's death in 1964.

With times changing in professional sports, the sisters-in-law looked to get out of the football business.

"We felt that, to be an owner of a professional football team, you had to be very wealthy," said team attorney Al Ruffo in *San Francisco 49ers: The First Fifty Years.* "We anticipated that salaries would take off. I felt that pay-TV had to come in before teams would make much money. The owners were very apprehensive."

Raiders owner Al Davis recommended Ohio mall developer Edward J. DeBartolo Sr. as the best candidate to buy the 49ers from the Morabito widows. The purchase was made for $17 million, and Davis received $100,000 for his role in the transaction. DeBartolo Sr. turned the team over to his 30-year-old son, Eddie.

At the press conference to announce the new ownership, Joe Thomas was present. Thomas was hired to run the 49ers' personnel department after stints with the Minnesota Vikings, Miami Dolphins, and Baltimore Colts. The moves were not exactly met with approval from the local media, especially when DeBartolo Jr. declared that he planned to run the 49ers like a business.

"Does everybody here realize this is a business, not a play toy?" DeBartolo said at the press conference. "With an investment of $17 million and more, we are not here to placate personalities."

Clark was out as coach.

"When I first heard about the deal, I heard Joe Thomas would be the general manager and that he'd have authority on all trades and personnel decisions—the same things that were clearly in my contract," Clark recalled to Glenn Dickey. "Those were the things I'd fought for. It was a matter of principle and a matter of integrity. The DeBartolos offered to extend my contract, to give me more money, but I felt that if I agreed to what I really didn't believe in, I'd have a 'Sold' sign on my forehead."

Over the next two seasons, the 49ers turned into NFL laughingstocks.

Under Ken Meyer, the 49ers fell to 5–9 in 1977. Pete McCulley was hired as coach in 1978, but he lasted just nine games (1–8 record) before Fred O'Connor finished the season, going 1–5.

The 49ers made headlines in 1978 with a blockbuster trade for aging running back O. J. Simpson, a native San Franciscan. However, the 49ers acquired a 31-year-old player with bad knees who was well past his prime.

"I don't know how it could've been worse than what we were with Pete McCulley and O'Connor," lineman Keith Fahnhorst said. "The whole approach to the game was, I hate to say unprofessional, but it was such a joke.

"When Fred O'Connor took over at midseason we were beating the hell out of each other in one-on-one drills. I remember that last game at Detroit, afterward he was

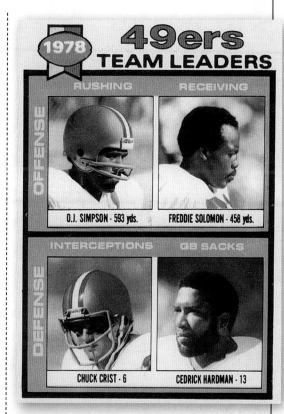

Future Hall of Famer O. J. Simpson came to San Francisco in a much-maligned trade before the 1978 season. Although Simpson was the team's rushing leader in 1978 with 161 carries and 593 yards, he was a part of two 2–14 campaigns.

saying that we were going to turn it around next year. He said we were going to go through the toughest training camp ever next year. I remember thinking, 'No, that's not the answer.'"

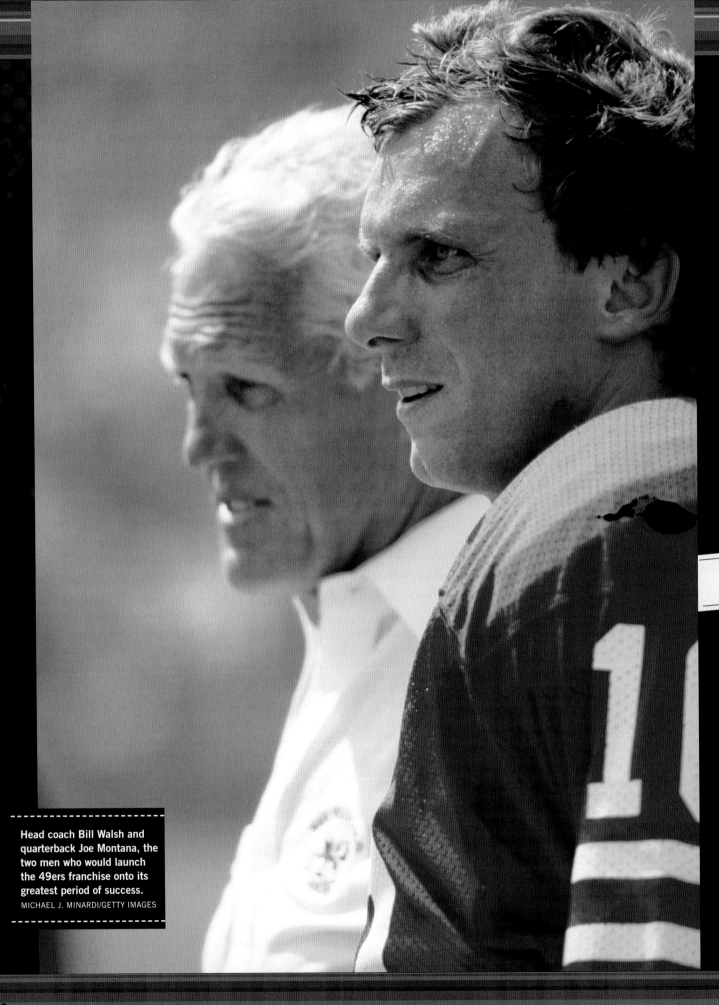

Head coach Bill Walsh and quarterback Joe Montana, the two men who would launch the 49ers franchise onto its greatest period of success.
MICHAEL J. MINARDI/GETTY IMAGES

JOE MONTANA AND THE FIRST SUPER BOWLS

1979–1984

On the day Bill Walsh was introduced as head coach of the San Francisco 49ers, he had a previous commitment to honor. Just hours before owner Eddie DeBartolo officially hired Walsh to be his new head coach, Walsh spoke to a gathering of the American Football Coaches Association, where he was giving a lecture entitled, "Controlling the Ball with the Passing Game." Throughout Walsh's tenure with the 49ers, his message went viral, spreading throughout the NFL and to every level of football. But in order for Walsh to have success with his offensive philosophy, he had to find the right pieces to his puzzle.

Program covers from 1980s-era 49ers football

DRAFTING THE SEEDS
OF A DYNASTY

The first draft pick of Bill Walsh's 49ers career was not particularly awe-inspiring. The team did not have a first-round selection in 1979 because of Joe Thomas' ill-fated trade for O. J. Simpson. San Francisco would have had the No. 1 overall pick. Instead, the Buffalo Bills received the 49ers' selection and chose linebacker Tom Cousineau (who would later play for the 49ers in 1986 and '87).

With the first pick in the second round, the 49ers chose speedster James Owens of UCLA. While Owens accounted for only 33 yards rushing and 254 yards receiving in two seasons, the 49ers' pre-draft interest in him indirectly led to the greatest draft pick in team history.

A young Joe Montana sports a moustache during training camp in August 1979. "Joe Cool" would earn his nickname more for his on-field composure than for his stylish facial hair. AP PHOTO

Just 10 days prior to the draft, passing-game coordinator Sam Wyche went to UCLA for a private workout with Owens. According to Gary Myers' book, *The Catch*, the scouting department learned that Notre Dame's Joe Montana was also in Southern California. They needed someone to throw passes to Owens, so the 49ers arranged for Montana to take part in the workout, too.

The 49ers were believed to be high on quarterback Steve Dils, who played for Walsh at Stanford. Dils was projected as a third- or fourth-round draft pick. Top scout Tony Razzano provided a strong recommendation on Montana, and Wyche came back to Walsh with a positive report, too.

"I told him Steve Dils was a very good player and I liked him, but there was something special about this kid from Notre Dame," Wyche told Myers. "He threw a very catchable ball. It arrived soft. He was very accurate; he had very quick feet and had natural instincts."

A few days later, Walsh came along to watch another workout involving Owens and Montana so he could see Montana for himself.

Another fortunate set of circumstances led to the 49ers' 1979 selection of a player on future championship teams who would forever be linked to Montana.

Clemson quarterback Steve Fuller attracted the attention of the quarterback-needy 49ers. Walsh called Fuller's room to arrange a workout. His roommate, a seldom-used receiver named Dwight Clark, answered the phone. Clark was ready to head out to play a round of golf when he had a change of plans.

Walsh asked if Clark would run routes for Fuller. Clark dropped his golf bag. His plan to play golf was the only thing he dropped that day.

"Fortunately, it was one of those lucky days," Clark said. "I caught everything. I ended up watching tape with Coach Walsh. And in the tenth round, they drafted me. I was in the right place at the right time."

A DIFFERENT LOOK

Neither Montana nor Clark made much of an impact as rookies. The 49ers had finished 2–14 in 1978 under the coaching duo of Pete McCulley and Fred O'Connor. In Walsh's first season, San Francisco had the exact same record.

But things sure looked different.

The offense was vastly improved under Walsh's direction. Quarterback Steve DeBerg, a second-year player from San Jose State, showed tremendous improvement. He raised his completion percentage from 45.4 in 1978 to 60 percent under Walsh's ball-control passing game. After averaging 13.7 points a game the previous season, the 49ers' production increased to 19.3 in 1979. San Francisco, owners of the 25th-ranked passing attack in 1978, rose to No. 3 in the NFL in Walsh's first season.

Running back Paul Hofer and wide receiver Freddie Solomon were the mainstays. Hofer accounted for nearly 1,300 yards from scrimmage with his gritty running style and reliable hands out of the backfield. Solomon was DeBerg's favorite target with 57 catches for 807 yards and seven touchdowns.

DeBerg more than doubled his output of the previous season, passing for 3,652 yards and 17 touchdowns.

Bill Walsh's NFL coaching career began with seven consecutive losses. The 49ers' first victory—20–15 over the Atlanta Falcons on October 21—came in front of a sparse crowd of 33,952 at Candlestick Park. Another six-game losing streak followed before the 49ers collected a 23–7 win over the Tampa Bay Buccaneers.

Five of the 49ers' losses were by six points or fewer, which provided hope that the franchise was at least heading in the right direction. After all, their quarterback of the future was still being groomed. Montana attempted only 23 passes as a rookie.

Off the field, Walsh assembled a strong supporting cast, including director of player personnel John McVay. Receivers coach Dennis Green was the first person Walsh hired to his staff, which included Wyche, offensive line coach Bobb McKittrick, administrative assistant/offensive line Mike White, defensive coordinator Chuck Studley, and linebackers coach Bill McPherson.

Walsh continued to mold the roster, as the club parted ways with Cedrick Hardman and fullback Wilbur Jackson prior to the 1980 season. The 49ers owned the No. 2 overall pick in the draft, which they traded to the New York Jets for two first-round selections. San Francisco added fullback Earl Cooper and defensive lineman Jim Stuckey with those picks. Linebacker Keena Turner was selected in the second round.

By the end of Walsh's second season, only 16 players acquired by Joe Thomas were still on the team.

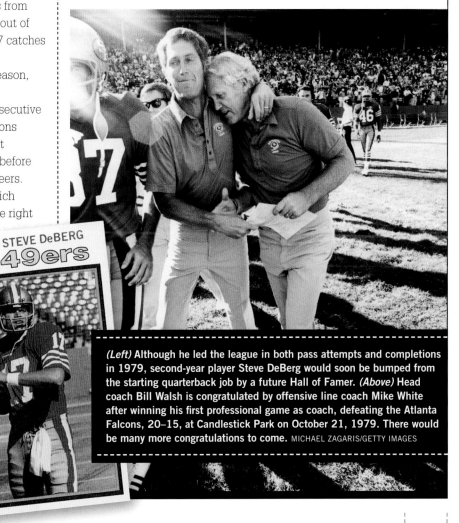

(Left) Although he led the league in both pass attempts and completions in 1979, second-year player Steve DeBerg would soon be bumped from the starting quarterback job by a future Hall of Famer. *(Above)* Head coach Bill Walsh is congratulated by offensive line coach Mike White after winning his first professional game as coach, defeating the Atlanta Falcons, 20–15, at Candlestick Park on October 21, 1979. There would be many more congratulations to come. MICHAEL ZAGARIS/GETTY IMAGES

THE QB OF THE FUTURE

Walsh continued to mold and develop Montana, finding advantageous situations to get him into games while DeBerg remained the primary starter.

The 49ers opened 1980 with a three-game win streak to immediately ensure the franchise's best record since the five-win team of 1977. But an eight-game losing streak ensued.

The team's best defensive lineman, Dwaine Board, was injured in the third game. And Hofer, who got off to a blazing start, sustained a season-ending knee injury. Hofer caught 41 passes in the 49ers' first six games and was on pace for a record-setting season.

The 49ers lost five games by a touchdown or less, but they also got blasted in a 48–26 loss to the Los Angeles Rams and a 59–14 thumping at the Dallas Cowboys.

Late in the season, Montana and Clark began to provide glimpses of what was to come.

Montana set a club record with a 64.5 completion percentage. Clark, who had built a strong bond with Montana, stepped up as the team's top wide receiver. As a rookie in 1979, he caught just 18 passes for 232 yards and no touchdowns. Clark's 82 receptions in 1980 were the most for a wide receiver in franchise history. Cooper led the NFC with 83 catches, the most up to that point from any rookie in NFL history.

Although the 49ers experienced an eight-game losing streak, there were some highlights, too. The 49ers' last win of the season was memorable. Trailing 35–7

(Above) In his second season as head coach, Bill Walsh continued to impart important lessons to his team. Here he addresses the players during halftime of a game against the St. Louis Cardinals at Candlestick Park on September 14, 1980. The 49ers went on to win 24–21 in overtime. MICHAEL ZAGARIS/GETTY IMAGES; *(Right)* In what would become a familiar pose for 49ers fans, Dwight Clark reaches up to make a grab in a game against the Atlanta Falcons on September 28, 1980. MICHAEL ZAGARIS/GETTY IMAGES

at halftime, the 49ers rallied for a 38–35 overtime victory against the New Orleans Saints. The 28-point comeback was the biggest in NFL history.

Montana was firmly entrenched as the 49ers' starter for training camp in 1981 as DeBerg moved on to become a backup for the Denver Broncos.

A SIGN OF THINGS TO COME

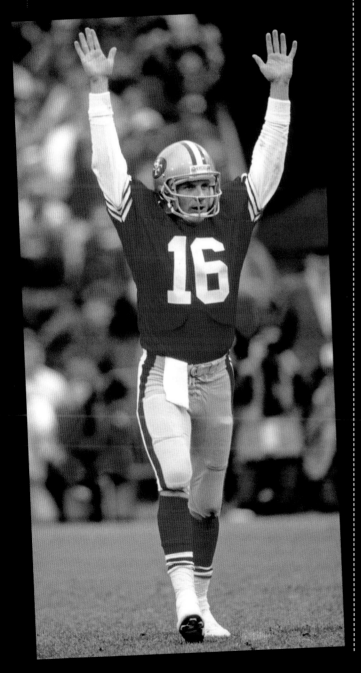

Joe Montana demonstrated that he was capable of amazing comebacks in his final season at Notre Dame. His starring role in the "Chicken Soup Game" ranks as an all-timer.

Montana had the flu. And in the worst ice storm Dallas experienced in 30 years, Montana's body temperature had fallen to 96 degrees. When Notre Dame came back on the field for the second half, trailing Houston 20–12 in the 1979 Cotton Bowl, Montana remained in the locker room, eating hot chicken bouillon in hopes of staving off hypothermia.

Notre Dame trailed 34–12 with 7½ minutes remaining in the game. Montana engineered a frenetic comeback, winning the game 35–34 with a touchdown pass on the final play of the game.

In his second NFL season, Montana first demonstrated his uncanny ability to rally a team from certain defeat while with the 49ers.

The 49ers' march to their first Super Bowl the following season might have started in 1980 when Montana led the team back from a 28-point halftime deficit against the New Orleans Saints.

On December 7, the 49ers trailed Saints 35–7 at halftime in front of 37,949 mostly disinterested fans at Candlestick Park. But the stadium came alive in the second half.

Montana ran for a touchdown and threw for 285 yards and two touchdowns to force overtime. Kicker Ray Wersching booted a 36-yard field goal to complete the historic 38–35 comeback victory.

The 49ers finished 6–10 that season. But coach Bill Walsh made a point to his team in the locker room after the win.

"After the game Bill said to us, 'For the next decade, remember this game because this will let us know we can overcome anything. So remember this day,'" Dwight Clark said.

The next year, the 49ers won their first Super Bowl. The lesson from that game against the Saints was something Walsh would reinforce to his team for years.

"Coming from behind like this could last the 49ers many years from the standpoint those veteran players will recall they came from that far behind and I think give them a certain amount poise and confidence in future years when we are behind and must come back and win," Walsh said.

From his earliest days as quarterback, Joe Montana had an uncanny ability to lead his teams to dramatic victories. FOCUS ON SPORT/GETTY IMAGES

GEARING UP ON DEFENSE

The San Francisco offense appeared to be in good hands, but the defense was still nowhere near what the 49ers needed to challenge the Los Angeles Rams, who won the NFC West in seven of the past eight seasons, or the 1980 champion Atlanta Falcons.

With Joe Montana running the offense and the acquisition of All-Pro Fred Dean bolstering the defense, the 49ers were the team to watch—and watch out for—in 1981.

Six of the 49ers' first seven draft picks in 1981 were on the defensive side of the ball, including defensive backs Ronnie Lott, Eric Wright, and Carlton Williamson in the first three rounds.

The season began in unspectacular fashion. The 49ers opened 1981 with a disappointing 24–17 loss to the Detroit Lions at the Pontiac Silverdome, the site of Super Bowl XVI more than four months later. There was absolutely no reason to believe the 49ers would be returning for the Super Bowl without purchasing tickets.

After all, the 49ers featured an unproven quarterback, a makeshift offensive line, a less-than imposing running game, a defense that lacked a threatening pass-rusher, and a defensive backfield that started three rookies.

"Obviously, we had some very young players, and Joe was coming into his own, but there was also a foundation of veterans like [linebacker] Jack Reynolds," said George Seifert, who was hired as defensive backs coach in 1980. "In our practices every day we practiced against each other. And Bill didn't script practices. It was our defense against our offense. It was very competitive because we were facing one of the best offenses, and the offense was facing one the best defenses.

"There was a lot of ferocity in those practices that you just couldn't do any more. There was a lot of hitting, and we were winning a lot of games. That's just the way we practiced. There were a lot of young players, and they didn't know any better."

The 49ers won two of their first four games of the season before heading to Washington for an October 4 game at RFK Stadium. And that's when a lot of the questions about San Francisco's secondary began to get answered.

The 49ers' secondary, came to be known as "Dwight Hicks and the Hot Licks," started to take shape. Hicks scored two touchdowns against Washington, returning a fumble 80 yards in the first quarter and adding a 32-yard interception return in the third; he also had another interception in the game. The 49ers built a 30–3 lead by the third quarter and cruised to a 30–17 victory.

Ronnie Lott celebrates one of the two interceptions he nabbed against the Cowboys during San Francisco's decisive 45–14 upset win on October 11, 1981. FOCUS ON SPORT/GETTY IMAGES

CLASSY ROOKIE SECONDARY

The 49ers had most of their pieces in place on the offensive side of the ball. But the defensive backfield was still in shambles after the 1980 season.

The 49ers had a revolving door in their defensive backfield, as the organization had a difficult time piecing together a competent unit of players. The one keeper the 49ers had in their midst was found on the scrapheap.

The 49ers signed safety Dwight Hicks in October 1979. Hicks was managing a health foods store in a Detroit suburb when the 49ers called.

Hicks was a sixth-round pick of the Detroit Lions in 1978, but did not survive final cuts. He played for the Toronto Argonauts of the Canadian Football League that year and was released at the conclusion of the season. Hicks was among the final cuts of the Philadelphia Eagles in 1979.

He played in half the 49ers' games in 1979, but started every game in 1980 and recorded four interceptions. The 49ers felt good about Hicks, but they set out to replace everyone else in the secondary.

In the 1981 draft, the 49ers placed a lot of emphasis on upgrading the team's most glaring weakness.

The 49ers got fortunate when the Seattle Seahawks selected safety Kenny Easley with the No. 4 overall pick. Easley was a good player, but he was not as versatile as Ronnie Lott.

"We scouted the all-star game in Hawaii, and both Easley and Ronnie Lott were there," said George Seifert, then the 49ers' defensive backs coach. "The thing that jumped out was that Ronnie could also play corner."

When the 49ers' turn came to select at No. 8 overall, Lott was their man. There was one problem solved.

In the second round, with the No. 40 overall selection, the 49ers selected Eric Wright from Missouri. Wright played safety in college, but Seifert knew Wright could fill a need at cornerback after coaching him in the Senior Bowl.

Wright would become the model by which the 49ers would use in evaluating cornerbacks due to his size, cover skills, and tackling ability.

In the third round, with the 65th overall pick, the 49ers selected safety Carlton Williamson of Pitt. The 49ers added three players who turned out to be first-round producers. In their first season together, the quartet combined for 23 interceptions, led by Hicks with nine and Lott with seven.

"We had Dwight Hicks already at safety," Seifert said. "We drafted Ronnie and Eric to play cornerback. Carlton could not play corner, but he was a natural ball-buster of a safety. We had big corners who were athletic enough to cover."

Seifert, who came from Stanford, was blessed with an ideal situation. He had a young secondary that was eager to learn and get better. So they hung on Seifert's every word.

"I was a technique fanatic," Seifert said. "And the rookies we brought in were interested in technique and detail. They were all competitive guys—all of them. It was a perfect marriage."

The year before the 49ers signed a defensive back, Ray Rhodes, who was short on talent but studied technique and the finer aspects of the game. Rhodes served as Seifert's assistant defensive backs coach in 1981. Rhodes would go on to work on five Super Bowl–winning staffs with the 49ers, including in his role as defensive coordinator in 1994.

The 49ers defensive secondary, November 1981: (left to right): Eric Wright (21), Saladin Martin (obscured), Carlton Williamson (27), Dwight Hicks (22), and Ronnie Lott (42). AP PHOTO/AL GOLUB

A WELCOME ADDITION

The victory over Washington served notice of the potential of the 49ers. And when Walsh pulled off a midweek trade for pass-rusher supreme Fred Dean, it helped raise the 49ers' game to a completely different level.

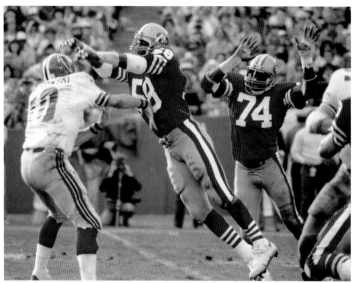

The acquisition of Fred Dean (74) helped bolster a fast-improving defensive core in San Francisco. Linebacker Keena Turner (58) was a mainstay on the defense throughout the decade. ARTHUR ANDERSON/GETTY IMAGES

Dean was not expecting to play more than a handful of snaps in his 49ers debut against the Dallas Cowboys. Sure enough, he did not start. But Dean did not spend much time on the sideline, either.

"To me, that game was my Super Bowl," Dean said. "Coach Walsh said he was going to ease me into the game. As it turned out, I played almost the whole game and I had a very good day."

Walsh and defensive coordinator Chuck Studley quickly became enamored of their new toy, so Dean remained on the field to harass Cowboys quarterback Danny White. He recorded three sacks, forced two hurries, and batted down two passes at the line of scrimmage.

"We didn't know it at the time, but Fred Dean turned it around," Walsh said. "It all started in that first game. He did things that shocked everybody."

The 49ers, playing in front of a rare sold-out crowd at Candlestick Park, destroyed the Cowboys 45–14. Montana threw for 279 yards and two touchdowns, and Lott added a 41-yard interception return for a touchdown.

San Francisco had not sent a player to the Pro Bowl since defensive tackle Cleveland Elam in 1977. Now, the team was beginning to catch the attention of the nation. But Walsh used one final perceived slight as fuel for his team.

Before the proliferation of NFL highlight shows, one of the few ways to follow the league was at halftime of *Monday Night Football* broadcasts. Howard Cosell would narrate highlights from a handful of games around the league. The 49ers figured to attract the spotlight after their decisive upset victory over the Cowboys.

"On Monday nights, we'd grab dinner and go to John McVay's office as we were preparing our game plans for the next week," Seifert said. "We'd watch the highlights in his office. I just remember how disgruntled everyone got because we'd never be on, even when we had a big game."

There were plenty more big games to follow, including a trip to Three Rivers Stadium to face the Pittsburgh Steelers, a franchise in the midst of nine consecutive winning seasons with four Super Bowl titles during that period.

Walsh, a military history enthusiast, got his team mentally prepared for the game as he emphasized the importance of banding together in a hostile environment.

"It's forty-five [players] against fifty-thousand[fans]," Walsh told his team. He would often use an "us-against-the-world" theme before particularly difficult road games. This was the first big road test of Walsh's tenure as coach, and the 49ers played like a unit with an emotional edge.

Montana, who grew up in Western Pennsylvania, did not let sore ribs or the flak jacket he wore for protection slow him down. Montana hit veteran tight end Charle Young for a 5-yard touchdown, and kicker Ray Wersching was perfect from 45 yards out to give the Niners a 10–0 lead.

The Steelers came back to take the lead in the third quarter. But Walt Easley—one of eight running backs the 49ers used throughout the season—scored on a 1-yard touchdown run in the fourth quarter for a 17–14 victory.

"To come into the locker room and see Bill Walsh jumping up and down like a kid—well, you know, it was something special," Clark said in *San Francisco 49ers: The First Fifty Years*.

FRED DEAN: THE CLOSER

FRED DEAN
SAN FRANCISCO 49ERS DE

Fred Dean was embroiled in a dispute with San Diego Chargers management 1981, and the 49ers were more than happy to step in and help with a solution.

Bill Walsh worked out a deal that would bring Dean to the 49ers in exchange for a second-round draft pick two years later, as well as the option to exchange first-round picks.

"I knew the day Coach Walsh came in and said we got Fred Dean that we were going to have a special season," longtime 49ers defensive coach Bill McPherson said. "This guy was something special. He really put us on the map."

Dean brought an uncanny blend of strength and quickness to the 49ers' defense. His presence also was a godsend to the 49ers' secondary, which was playing three rookies in 1981.

Dean honed his pass-rush skills, unbeknownst to him at the time, by chasing wild rabbits in the woods near his home in Ruston, Louisiana. That activity improved his quickness. He also worked hoisting 24-foot sections of pulp wood onto trucks, hauling hay, and rolling 500-pound barrels of tar for roofing projects.

"That was my means of working out without even being aware of it," Dean said. "You'd never think that it was actually building you up for life."

Dean built the 49ers up for a Super Bowl the moment he set foot on the field with the 49ers. He showed up just three days before a much-anticipated game against the Dallas Cowboys, and he terrorized quarterback Danny White that day.

He went on to register 12 sacks in 11 games with the 49ers and was named UPI NFC Defensive Player of the Year. He finished his first season with the 49ers in grand fashion with a sack of Cincinnati quarterback Ken Anderson in Super Bowl XVI.

Linebacker Keena Turner compared Dean, often used as a situational pass-rusher, as a baseball closer—a pitcher whose job it was to protect a late lead.

"If we were trying to protect a lead or we were close behind, Deano in the fourth quarter was a machine," Turner said.

Said McPherson, "Coach Walsh told me, 'We have to keep Fred fresh in the second half and in the fourth quarter particularly.' He was a big factor in a bunch of games. I've never seen opposing linemen turn away from the huddle like they did with Fred just to see when he was coming onto the field. He could dominate a game."

Dean's finest individual season with the 49ers came in 1983. He recorded a career-best 17.5 sacks, including six sacks in a 27–0 victory over the New Orleans Saints. In 2008, the game-altering Dean was elected into the Pro Football Hall of Fame.

"This guy was something special. He really put us on the map."
—Bill McPherson, 49ers defensive line coach, on Fred Dean

POSTSEASON RUN

After starting the 1981 season 1–2, the 49ers won 12 of their final 13 games to enter the playoffs with the best record in football at 13–3.

Their first playoff game since the heart-breaking 1972 loss to the Dallas Cowboys was on January 3, 1982, against the New York Giants at Candlestick Park.

Two future Hall of Famers set the tone for San Francisco. Montana threw for 304 yards, including an 8-yard touchdown throw to Young and a 58-yarder to Freddie Solomon. Lott intercepted two passes, including one he returned 20 yards for a fourth-quarter touchdown to give the 49ers a 21-point lead.

With Dallas's 38–0 victory over the Tampa Bay Buccaneers, the 49ers' old nemesis from a decade earlier would be coming to Candlestick Park for the NFC Championship Game.

When the clubs met earlier in the season, the 49ers were just beginning to capture the imagination of the home fans. Just two weeks earlier, there had been more than 13,000 empty seats for the game against the New Orleans Saints. That was the last game that was blacked out locally in the history of Candlestick Park.

When the 49ers faced the Cowboys in the conference championship game, attendance was 60,525, and there were just

Freddie Solomon caught 6 passes for 107 yards, including this 58-yard touchdown, in the 49ers' 38–24 win over the Giants in the divisional round of the 1981 playoffs. The victory set up another postseason meeting with the Dallas Cowboys. AP PHOTO/AL GOLUB

536 unused tickets. Those who failed to show up for the game missed an all-time classic.

It was not perfect, though. Montana had some problems throughout the game. The 49ers committed six turnovers. Montana threw three interceptions and also lost a fumble. And Lott was called for two pass-interference penalties that totaled 63 yards.

Another heart-breaking playoff loss to the Cowboys appeared inevitable when the 49ers took over at their own 11-yard line, trailing 27–21, with 4:54 remaining.

"I remember thinking, 'We had eighty-nine yards to go against America's Team; how can we possibly do it?'" wide receiver Dwight Clark said.

Walsh, demonstrating his calm sideline demeanor, saw that Dallas went with its nickel defense, fully expecting the 49ers to throw the ball. Instead, Walsh decided to exploit the weakness in Dallas's defense with the running game.

Running back Lenvil Elliott, whom Walsh claimed off waivers from the Cincinnati Bengals in 1979, had runs of 6, 11, 7, and 7 yards. On another play Elliott handed to Solomon on a reverse that picked up 14 yards.

The 49ers eventually had a third-and-3 situation from the Dallas 6-yard line. Walsh called timeout to set up a play designed

The San Francisco crowd was pumped up for the 1981 NFC Championship Game, held at Candlestick Park on January 10, 1982. AP PHOTO/AL GOLUB

to get Solomon the ball in the right front corner of the end zone. Walsh gave Montana some final instructions before sending him back onto the field.

"We're going to call a sprint option," Walsh said to Montana, as captured by NFL Films. The play had resulted in a Solomon touchdown reception of 8 yards in the first quarter. But Walsh advised Montana, if the first option was covered, Dwight Clark might be open at the back of the end zone.

"He's going to break up and into the corner," Walsh said. "You got it? Dwight will clear. As soon as you see the angle he's breaking, then just drop the ball in there. If you don't get what you want, simply throw the ball away. You know what I mean? Hold it, hold it, hold it, [if it's] not there, away it goes. Be ready to go to Dwight."

Walsh described "sprint right option" as a pick play drawn up by legendary coach Paul Brown in the 1950s. Although Walsh had Montana practice the throw to Clark in the back of the end zone during training camp, Montana had never thrown to Clark on that play in a game.

Montana had no other choice but to look for his second option when Solomon slipped as he made his cut parallel to the goal line.

Cowboys defenders Ed "Too Tall" Jones, D. D. Lewis, and Larry Bethea were bearing down on Montana, who rolled to his right. When Montana let the ball go while back-pedaling 7 yards behind the line of scrimmage and near the right sideline, it appeared to be hopelessly overthrown.

"I had to buy time, trying to wait for him [Clark] to realize that we didn't throw the ball [to Solomon]," Montana said, "and to get him to come back sliding across the back of the end zone."

Clark stretched his 6-foot-4-inch frame high into the air, over cornerback Everson Walls, who had two interceptions in the game. Clark got his fingertips on the pass and did not let go.

"I still remember [equipment manager] Chico Norton coming to me and saying, 'Your buddy saved your [butt] that time. He jumped out of the stadium,'" Montana said. "I said, 'Get out of here. He can't jump that high.' I thought Chico was just playing around. It wasn't until I went back and saw the replay. I didn't realize the ball was that high."

Wersching's extra point gave the 49ers a 28–27 lead with 51 seconds remaining. But the drama was not over quite yet.

On the Cowboys' first offensive play after the ensuing kickoff from their own 25-yard line, White found receiver Drew Pearson on a deep crossing route. Carlton Williamson and Lott took each other out of the play, and Eric Wright made a horse-collar tackle of Pearson to stop him at the 49ers' 44 with 38 seconds remaining.

The Cowboys needed only about 15 yards more for a shot at a winning field goal, but on the next play, defensive lineman Lawrence Pillers sacked White, forcing a fumble. Jim Stuckey recovered for the 49ers to clinch the victory and send the franchise to its first Super Bowl.

There was no more pivotal game in 49ers' franchise history. The team would go on to be a yearly Super Bowl contender for most of the next two decades. But Dallas coach Tom Landry did not envision that at the time.

"The Forty-Niners aren't a better team than us," Landry said, "but the game ended at the right time for them. Montana has to be the key. There's nothing else there except him."

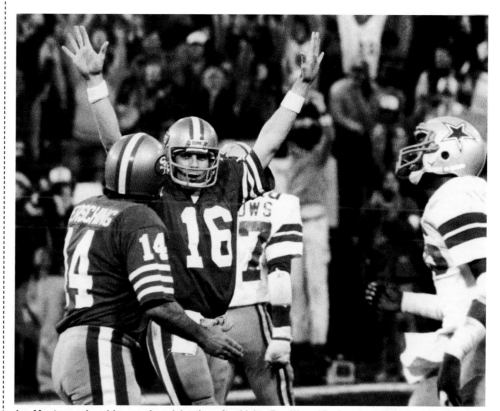

Joe Montana raises his arms in celebration after kicker Ray Wersching's extra point gives the 49ers a 28–27 advantage in the closing minutes of the NFC title game. BRUCE BENNETT STUDIOS/GETTY IMAGES

THE CATCH

by dwight clark

As we methodically marched down the field on "The Drive" during the final minutes of the NFC Championship Game against the Dallas Cowboys on January 10, 1982, I became completely exhausted. I had had the flu in the week leading up to the game.

I went down on a knee to catch my breath during a timeout late in the 13-play drive, and the trainer, Dr. James Klint, came out to check on me. I said I was all right, but Coach Bill Walsh pulled me out of the game so I could rest. I was standing next to Bill on the sideline, and I could hear him say into his headset, "Think about 'sprint right option.'" I knew the play was coming, so I got right back in the game.

Freddie Solomon was the primary option on the play. But if Freddie wasn't open and Joe Montana couldn't run the ball, my job was to slide across the back of the end zone. When Bill worked with us in training camp, he said he would never call that play on fourth down. He told Joe, "Throw it high enough that it goes out of bounds or Dwight can jump up and catch it. But don't throw an interception. Give us another play."

When it mattered most, Joe put the ball in the exact spot where only I could get it. Cowboys cornerback Everson Walls was right beside me. If the pass had been any lower, Everson could have made a play on it. Everson subsequently told me that he thought the pass was going out of bounds.

The best feeling in my entire career, in any sport, from when I was 10 years old until the time I retired, was spiking the ball after making the catch. My teammates mobbed me in the end zone. I remember running across the field back to my teammates on the sideline. Everyone was so excited—except for Bill, who was calmly standing there. After all the practices and hard work we put in together, it was a great feeling to know you helped get that group to the Super Bowl.

I can't say how many times I've been told by people what they were doing when I caught that pass. "I was with my dad, who was a huge 49ers fan." Or, "I was with my kids." Or "I jumped off the sofa and broke my ankle." "I jumped up and my hands went into the ceiling fan." John Brodie was at a restaurant in the city and became overcome with emotion, because we finally beat the Cowboys. I've heard story after

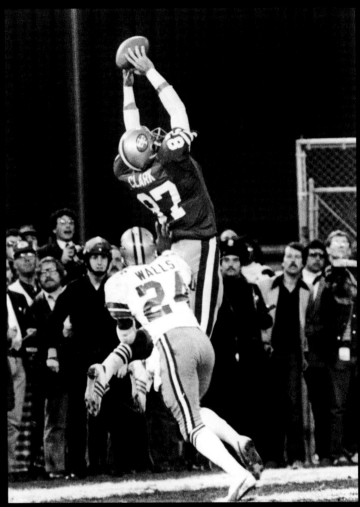

"The Catch," January 10, 1982. BRUCE BENNETT/GETTY IMAGES

story, even from Cowboys fans who were devastated by the loss.

But this was also like the United States hockey team defeating the Soviet Union in the 1980 Olympics. We still had to win the gold—the Super Bowl—to make it a great story. If we lost the Super Bowl, nobody would be talking that much about "The Catch." We had to come home with the ring to make it a great story. Thankfully, that's exactly what we did.

SURPRISE SUPER BOWL

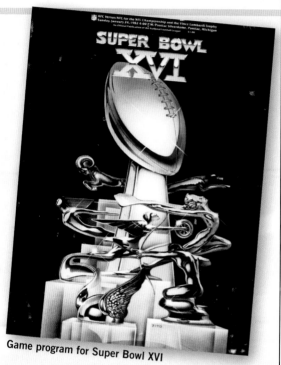

Game program for Super Bowl XVI

After going 15–47 over the previous four seasons, even the owner of the 49ers was shocked at how quickly things had turned around for the franchise.

"We had Joe Montana. We had Dwight Clark. We had my dearest friend Freddie Solomon. We had Hacksaw Reynolds. We had Archie Reese. All these guys were really great football players," DeBartolo said. "But it was a total, absolute, surprise. It happened so fast."

Montana, Lott, and Dean were among the 49ers' six Pro Bowl players. All three would become Hall of Famers. Dwight Clark was emerging as a star, and the lone veteran in the secondary, Dwight Hicks, earned his first of four consecutive trips to the Pro Bowl.

Pro Bowl guard Randy Cross was the team's best offensive lineman for most of the next decade. Cross and tackle Keith Fahnhorst were the anchors on the right side of the offensive line, joining center Fred Quillan and left guard John Ayers. Left tackle was a problem, and Walsh finally went with undersized Dan Audick.

The 49ers had a collection of unheralded players who were counted on for big contributions, including running backs Ricky Patton, Bill Ring, Walt Easley, Johnny Davis, and Paul Hofer; return man Amos Lawrence; tight ends Earl Cooper, Charle Young, and Eason Ramson; and receiver Mike Wilson.

"What that collective group did for the performance of Joe Montana was tantamount to what Tenzing Norgay did for Sir Edmund Hillary," Audick said. "We came together as a very special team."

And the 49ers conquered their Mount Everest with a fitting team effort on defense, too. Nothing epitomized that more than the key sequence in Super Bowl XVI.

As exhilarating as the 49ers' victory over the Cowboys in the NFC Championship Game was for the players, coaches, front office, and the fans, it would have become a mere footnote to history if the 49ers did not follow through with a victory over the Cincinnati Bengals in Super Bowl XVI.

Coincidentally, Walsh's team was matched against the organization that had passed him over for the head-coaching job in 1976 after Paul Brown stepped down. Brown's hand-picked successor was Bill "Tiger" Johnson, the former 49ers center, who had been on the Bengals' staff along with Walsh.

This game meant a great deal to Walsh, but he tried his best to remain loose leading up to the game. Walsh arrived ahead of the team at the 49ers hotel after accepting an NFL Coach of the Year Award in Washington. He dressed as a hotel worker and greeted the team in darkness a week before the game. At one point, he got into a tug of war with Montana, who refused to let the aggressive bellman take his carry-on bag.

On game day, there were more hijinks. The 49ers' second bus from the hotel to the Silverdome was stuck in a snarling traffic jam created by vice president George H. W. Bush's motorcade. Walsh, Montana, and half the team were stopped on an off-ramp, a half-mile from the dome. The conditions outside were frigid.

"After sitting there for twenty minutes, I was starting to get a little uneasy," Walsh said. "Everyone was cracking jokes, but I was looking at the angle we'd have to take to walk to the stadium, a cross-country trip, each person holding onto the next one's shirt so we wouldn't get blown over."

But Walsh did not let the team see his uneasiness with the situation.

"All of a sudden they stopped traffic and we were just sitting there," Montana said. "Bill stood up on the bus and said, 'Don't worry. I got the game on the radio. Chico just scored and Bronco kicked the extra point. We're up 7–0.'"

Chico Norton and Bronco Hinek were the 49ers' equipment managers. The bus finally made it to the Silverdome 90 minutes before kickoff and 20 minutes before the team was scheduled to be on the field for warmups.

A TEAM EFFORT

The game could not have started worse for the 49ers. Return man Amos Lawrence fumbled the opening kickoff and the Bengals recovered at the San Francisco 26-yard line. But on a third-and-goal from the 11, Dwight Hicks intercepted a Ken Anderson pass to thwart Cincinnati's scoring chance.

The 49ers took advantage of that opportunity to take a 7–0 lead on Montana's 1-yard quarterback sneak in the first quarter. They extended the lead to 14–0 on his 11-yard scoring pass to Earl Cooper, who punctuated the touchdown with a left-handed spike that would adorn the cover of the upcoming issue of *Sports Illustrated*.

One of the heroes of Super Bowl XVI was portly placekicker Ray Wersching. When the 49ers opened the regular season at the Silverdome against the Detroit Lions, Wersching had a muscle pull that prevented him from hitting the ball deep on kickoffs. Instead, he squibbed his kickoffs along the AstroTurf surface. The Lions had a difficult time fielding the bouncing balls.

When the 49ers returned to that venue for the Super Bowl, a healthy Wersching's squib kicks created all kind of problems for the Bengals. Cincinnati returnmen David Verser and Archie Griffin mishandled kickoffs, and Wersching added field goals of 22 and 26 yards.

The 49ers built a 20–0 lead at halftime. Their only offense in the second half consisted of two Wersching field goals, including

(Below) Joe Montana offers instructions to his offense in the huddle during Super Bowl XVI. Montana's leadership and play-making earned him Most Valuable Player honors in the game. GEORGE GOJKOVICH/GETTY IMAGES

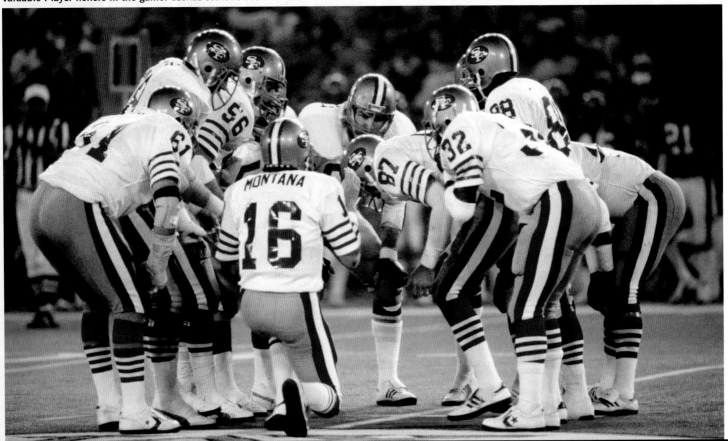

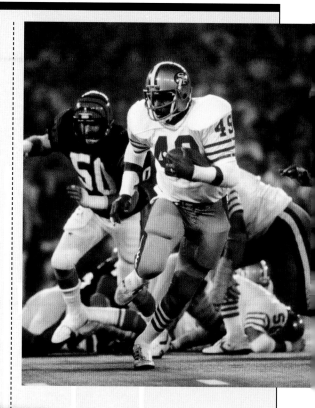

a 40-yarder that was set up by seven consecutive run plays to give San Francisco a 23–14 lead.

"Ray Wersching had nerves of steel in the clutch," Walsh recalled. "Ray's kicking was the difference in four games that year."

Montana was named as the Super Bowl MVP, but the pivotal sequence was a goal-line stand late in the third quarter with the 49ers leading 20–7. The Bengals had a first-and-goal situation at the 3-yard line.

Fullback Pete Johnson, a 250-pounder who scored 12 rushing touchdowns in the regular season, powered ahead for 2 yards on first down. He was stopped for no gain from the 1-yard line on second down. Linebacker Dan Bunz made a remarkable tackle of Charles Alexander at the goal line on third down. And, again, the 49ers swarmed Johnson on fourth down.

Cincinnati scored a late touchdown, and all that remained for the 49ers to win the Super Bowl was the recovery of an onside kick.

"All I could think about was that unfortunate onside kick against Dallas [in January 1973] when they fumbled it," said Dwight Clark, a member of the "hands team" entrusted to handle onside kicks. "Running across the field, that's all I could think about. It just bounced along the ground twice and came right to me. I caught it, and Ronnie Lott was my protector. Nobody was going to get to me. Ronnie started screaming, 'We're Super Bowl champs!'"

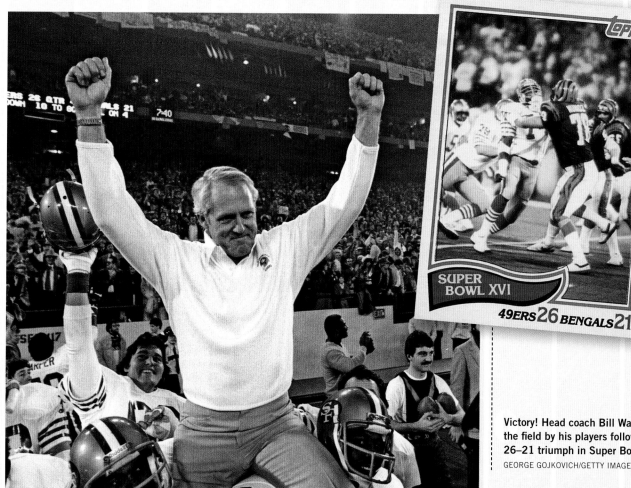

SUPER BOWL XVI

49ERS 26 BENGALS 21

Victory! Head coach Bill Walsh is carried off the field by his players following the 49ers' 26–21 triumph in Super Bowl XVI.

GEORGE GOJKOVICH/GETTY IMAGES

SUPER BOWL XVI: TAKING A STAND

The 49ers defense made a stand early, but their stinginess late in the third quarter will forever be remembered as the pivotal juncture in a 26–21 victory over the Cincinnati Bengals in Super Bowl XVI at the Silverdome in Pontiac, Michigan.

San Francisco's Amos Lawrence fumbled the opening kickoff at the 26-yard line. Moments later, the Bengals had a first-and-goal situation. On third down, Dwight Hicks intercepted Cincinnati quarterback Ken Anderson to prevent the 49ers from falling behind.

But the big sequence took part after the Bengals had started to cut into the 49ers' 20–0 lead in the second half. Cincinnati trailed 20–7 late in the third quarter and had a first-and-goal at the 3-yard line.

Powerful Pete Johnson got the call on first down. The Bengals double-teamed defensive tackle Archie Reese and ran right at him. John Choma, a backup 49ers offensive lineman who had a role exclusively for goal-line situations on defense, was left unblocked, which temporarily left him off-balance. He wrapped up Johnson, and linebacker Dan Bunz finished him off for a 2-yard gain to the 1-yard line.

On second down, Johnson again got the call, as the Bengals tried to run between left guard and Hall of Fame left tackle Anthony Munoz. Center Blair Bush tried to jump in the air over Reese, and missed his block on Jack "Hacksaw" Reynolds.

Reynolds slid to the hole and met Johnson head-on. Bunz stuffed lead-blocker Charles Alexander in the hole, and linebacker Craig Puki was left unblocked and got a hit on Johnson to help stop him for no gain.

The signature play of the sequence came on third down. Anderson faked a handoff to Johnson and rolled right. He threw slightly behind Alexander in the right flat. Alexander did not run his route into the end zone, which gave Bunz a chance to make the stop.

Bunz, whose role in the game was specifically for goal-line situations and special teams, read the play perfectly and flattened Alexander as he caught the pass approximately 12 inches shy of the goal line.

"He was a tremendous competitor," 49ers defensive coordinator Chuck Studley said in *The Ultimate Super Bowl Book*. "You never had to worry about Danny Bunz being ready to play football. [But] you put him in man-to-man coverage and you were scared to death. I would say Bunz would make that play one out of 100."

The play of Bunz's career set up a fourth-and-goal from the 1. And, again, Johnson, who scored 12 regular-season touchdowns, got the call with one minute remaining in the third quarter.

Bunz took on Alexander's lead block and did not budge. Lawrence Pillers and Choma were stout at the point of attack. Bunz, Reynolds, and Ronnie Lott converged on Johnson to stuff him at the line of scrimmage.

Reese had his back on the pile of players, bracing to make sure Johnson was stopped cold short of the goal line. He began pumping both arms in celebration of the 49ers' memorable goal-line stand.

Ronnie Lott (42) leaps in the air after the 49ers stopped the Bengals on a pivotal goal-line stand in the third quarter of Super Bowl XVI. VERNON BIEVER/GETTY IMAGES

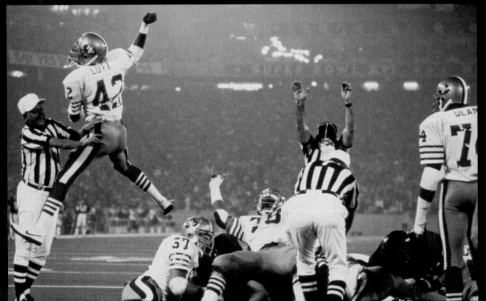

HOPE RESTORED

The City of San Francisco was going through a devastating, tragic period of time. The 49ers' dynasty of the 1980s came at exactly the right time to help pull the city out of a dark era.

In 1978, San Francisco Mayor George Moscone and Supervisor Harvey Milk were assassinated. Also, there was a mass murder-suicide in Guyana that claimed the lives of more than 913 people from the San Francisco–based People's Temple.

By the end of 1981, nine people had died of a mysterious disease later known as AIDS.

Dianne Feinstein, who became mayor after the killings at City Hall, said the emergence of the 49ers as a Super Bowl champion helped bring together the city.

"The days were dark, the winds were strong, and the fog was deep," Feinstein said.

Then, along came Walsh's 49ers to help change the climate with a Super Bowl title. The decade of the 1980s began with the 49ers considered laughingstocks in the NFL. In Walsh's 10 seasons as coach and architect of the franchise, the 49ers won three Super Bowl titles.

"We will always remember the hope you restored to this great city," said Feinstein, speaking at Walsh's 2007 memorial service.

Dwight Hicks, the only veteran starter in the 49ers' defensive backfield in 1981, witnessed how the winning of a Super Bowl helped bring the city together during a period of great strife.

"Bill Walsh, along with the greatest owner ever, Eddie DeBartolo, brought magic back to the city of San Francisco in a turbulent time," Hicks said.

The emergence of the 49ers as champions coincided with a continuing national trend that saw football overtake baseball in popularity. A CBS–New York Times poll showed that 48 percent of sports fans preferred football to 31 percent for baseball.

The CBS broadcast of the 49ers' victory in Super Bowl XVI over the Cincinnati Bengals produced the highest rating of any televised sports event with 49.1 percent of households watching for a 73-percent share.

The 49ers' Super Bowl triumph brought much-needed jubilation to the Bay Area in the early 1980s. BRUCE BENNETT STUDIOS/GETTY IMAGES

The 49ers returned home to a victory parade that drew a crowd estimated at more than 500,000 people to the city's biggest public rally since the end of World War II. Five 49ers players selected to the Pro Bowl attended the parade instead of going to Hawaii as requested. The league fined each player $300, a bill that DeBartolo paid for them.

ONE STEP BACKWARD, THEN BACK IN CONTENTION

The 1982 season was a disaster for the 49ers. The team lost its first two games before a 57-day players' strike. The 49ers did not win a home game the entire season.

Montana passed for more than 300 yards in five consecutive games to set an NFL record, and Clark had 60 receptions for 913 yards in just nine games. But the 49ers finished with a 3–6 record.

San Francisco's scheduled *Monday Night Football* game against the Tampa Bay Buccaneers never actually took place, as it was cancelled due to the players' strike.

"I was more embarrassed going 3–6 that season than going 2–14 in 1978 and 1979," Randy Cross said. "We had too much ability for that."

The players weren't the only ones embarrassed by the failure of the 1982 season. On the sideline, Walsh was cool and calculating, but inside he experienced a tumult of emotions and did not know how to cope with failure.

He seriously contemplated quitting and even considered three college coaches who might replace him: Illinois' Mike White, a member of his first 49ers coaching staff; John Robinson of USC; and Terry Donahue of UCLA.

Walsh decided to remain as coach, but he had another decision to make. Defensive coordinator Chuck Studley left to become head coach of the Houston Oilers, and defensive backs coach George Seifert was promoted to replace him.

The 49ers did not stay down long. Fred Dean was the game's dominant pass-rusher, as he recorded 17.5 sacks in 1983. Walsh also made a concerted effort to improve the run game with a pair of acquisitions. He acquired Wendell Tyler from the Los Angeles Rams for two draft picks, and the 49ers spent their first draft pick, a second-round selection, on versatile back Roger Craig out of Nebraska.

The 49ers won the NFC West title with a 10–6 record, but barely survived their first playoff game against the Detroit Lions at Candlestick Park. Montana hit Solomon for a 14-yard touchdown pass with two minutes remaining for a 24–23 lead. Then, Lions kicker Eddie Murray missed a 43-yard field-goal attempt as time expired. The 49ers advanced to the NFC Championship Game against Washington.

With a second trip to the Super Bowl on the line, the 49ers experienced one of the more bitter losses in franchise history.

Washington led 21–0 after three quarters, but Montana rallied San Francisco to tie the game. A couple of controversial calls assisted Washington's march down the field to recapture the lead.

From the 45-yard line, quarterback Joe Theismann threw deep to receiver Art Monk. The ball sailed way over Monk's head and out of bounds, but Eric Wright was called for pass interference. The penalty gave Washington the ball at the 49ers' 18-yard line.

"It was a ball a ten-foot-tall Boston Celtic couldn't catch, let alone a receiver," Walsh said after the game. "Their final drive was really a pair of penalties. Right now I'm a little bitter about the officials. It's just too bad that a championship game's decided by a call that close. I'd rather lose by the Redskins driving for a touchdown than on a call so close."

Three plays later, Theismann threw incomplete, but Lott was called for holding on the other side of the field. Kicker Mark Moseley, who missed four field goals in the game, converted from 25 yards to end the 49ers' season with a 24–21 defeat at RFK Stadium. It was a loss the 49ers would not soon forget. The loss provided fuel for the 49ers in 1984.

"Everybody was on such a mission because we knew the Redskins weren't better than us," Cross said in *San Francisco 49ers: The First Fifty Years.* "We were obsessed in training camp with the idea that we were going to the Super Bowl. And we really got on a roll after a while."

(Below) Newly acquired running back Wendell Tyler provided San Francisco with a dangerous ground game in the regular season, but it wasn't enough to overcome Washington in the 1983 NFC Championship Game. RONALD C. MODRA/ SPORTS IMAGERY/GETTY IMAGES *(Right)* Dwight Clark led the receiving core in 1983 with 70 catches for 840 yards and 8 TDs.

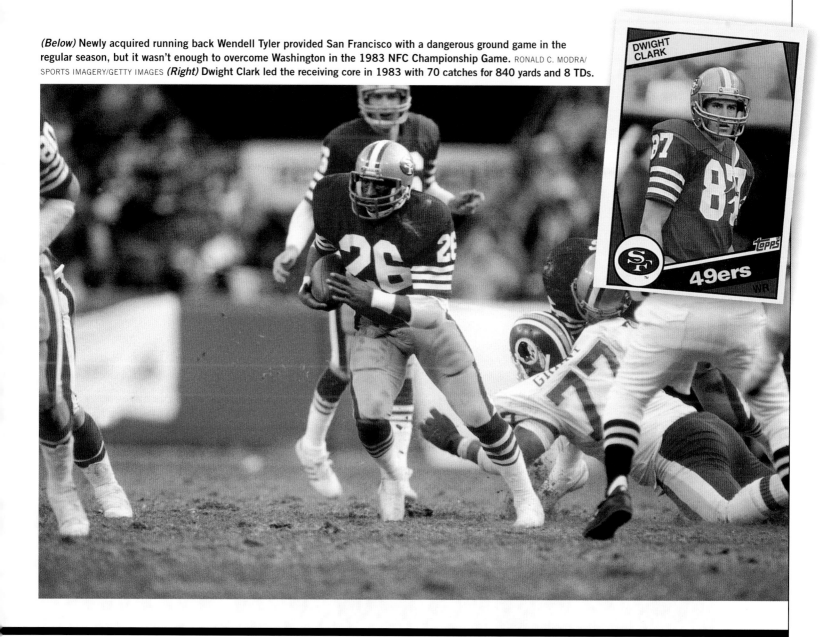

FOCUS ON A TITLE

The 49ers added another couple layers of reinforcements to an already-solid roster in 1984. Linebacker Todd Shell, nose tackle Michael Carter, safety Jeff Fuller, tight end John Frank, and guard Guy McIntyre were added in the draft. And the club bolstered its defensive line with trades for Louie Kelcher, Manu Tuiasosopo, and Gary "Big Hands" Johnson.

"We had backups on that team that could've won the Super Bowl," DeBartolo said. "We had All-Pro backups, especially on the defensive line."

The 49ers set 14 team records throughout the course of the season. The team opened with a 6–0 record. After a 20–17 home loss to the Pittsburgh Steelers, the 49ers closed with nine consecutive victories to finish the regular season with a 15–1 mark.

The defense led the charge in the postseason. Dean had two sacks and Montana threw three touchdown passes in a 21–10 victory over the New York Giants. The next week, Carter and Johnson had two sacks apiece in a 23–0 victory over the Chicago Bears in the NFC Championship Game.

That set up a home game, of sorts, for the 49ers. After all, Super Bowl XIX would be played at nearby Stanford Stadium against the Miami Dolphins, led by rookie sensation Dan Marino.

"We were up against one of the most dynamic offenses in football," Seifert said. "Our offense jumped all over them with Joe and Roger cutting them up pretty good. And we were able to get in our nickel defense. The thing we did a little different was we used a lot of defensive linemen. We just kept interchanging guys."

Marino was under siege from the outset. The 49ers sacked Marino four times and pressured him relentlessly with a constant shuttle of defensive linemen, including Dwaine Board, Dean, Johnson, Tuiasosopo, Kelcher, Carter, Lawrence Pillers, and Jeff Stover.

Offensively, the Niners carved up a defense that was under the direction of former 49ers defensive coordinator Chuck Studley. Roger Craig demonstrated his versatility as a runner and receiver with three touchdowns. He had 58 yards and one touchdown rushing, along with 77 yards and two more touchdowns receiving.

Wendell Tyler and Roger Craig were a dangerous backfield duo in 1984. Tyler collected 1,262 yards rushing while Craig had 1,324 yards from scrimmage, 649 running and 675 receiving. Here, Craig provides blocking for Tyler during a 14–5 win over the Falcons.

GEORGE GOJKOVICH/GETTY IMAGES

San Francisco's formidable offensive line in 1984 (kneeling, left to right): Randy Cross, Fred Quillan, Guy McIntyre, and John Ayers; (standing, left to right): Bubba Paris, Allan Kennedy, offensive line coach Bobb McKittrick, Billy Shields, and Keith Fahnhorst.
MICHAEL ZAGARIS/GETTY IMAGES

Montana, who had been mostly overlooked with the pregame buildup surrounding Marino, was on the top of his game. For the second time, Montana was named Super Bowl MVP. He had his way with the Dolphins' "Killer B's" defense, completing 24 of 35 passes for 331 yards and three touchdowns.

He was well on his way to establishing himself as one of the great quarterbacks in NFL history. He also had an offensive line that had remained virtually intact—other than left tackle—since the 1979 season.

Bubba Paris, the 49ers' second-round pick in 1983, joined the solid quartet of right tackle Keith Fahnhorst, right guard Randy Cross, center Fred Quillan, and left guard John Ayers. That group, under the leadership of tactician line coach Bobb McKittrick, gave Montana all the time he needed to work his magic.

"Joe Montana could put a game plan into work like few humans have ever been able to do—or ever will be able to do," said tight end Russ Francis, whom Walsh lured out of retirement in 1982.

"He was uncanny in what he was able to do. When you're watching film, you'd see him look at the first receiver. He may not have even been looking at the second and third options, but he's located them. Then, he could look at number four and go back to number one. Most quarterbacks look at number two and then just get rid of the ball."

NFC CHAMPIONS - SAN FRANCISCO 49ERS

SUPER BOWL XIX: DON'T FORGET ABOUT JOE

The Miami Dolphins had the quarterback who received most of the attention leading up to Super Bowl XIX at Stanford Stadium.

Most of the talk was about Dolphins wunderkind Dan Marino, his lightning-quick release, strong arm, and deadly accuracy.

The new NFL rules, which limited downfield contact against wide receivers, were believed to make a quarterback like Marino unstoppable. After all, he had explosive wide receivers Mark Duper and Mark Clayton as his top targets.

"All you heard about the whole week was Marino, Clayton, and Duper," 49ers halfback Wendell Tyler said. "Nobody was talking about Dwight Clark, Roger Craig, and Wendell Tyler."

Quarterback Joe Montana distributed the ball to Craig, Clark, Russ Francis, and Tyler, each of whom had at least 60 yards receiving. Montana's first touchdown pass was a 33-yarder to running back Carl Monroe for his only catch of the game.

And the 49ers' underrated defense left Marino bruised and bloodied as the pass rush constantly harassed him throughout the game.

"We did something everybody said could not be done," linebacker Keena Turner said afterward. "We put pressure on Marino. We sacked him, and we blitzed less than usual."

The 49ers played mostly a nickel defense, and the Dolphins still could not run the ball successfully. The Dolphins had just 25 yards rushing in the game.

The 49ers defense was all over Miami quarterback Dan Marino throughout Super Bowl XIX. Here nose tackle Manu Tuiasosopo secures one of the four sacks of Marino in the game. ROB BROWN/GETTY IMAGES

"I think some underestimated our defense," Walsh told Ira Miller of the *San Francisco Chronicle*. "How many touchdowns were scored against us in all the playoffs?"

The answer: one.

The 49ers' 38–16 victory over Miami capped a postseason in which the 49ers outscored the opposition

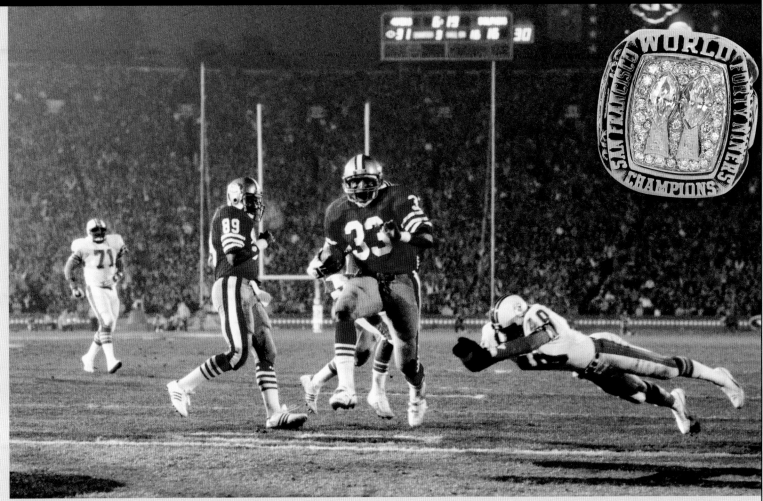

Running back Roger Craig struts into the end zone with the third of his three touchdown runs in Super Bowl XIX at Stanford Stadium on January 20, 1985.

GEORGE GOJKOVICH/GETTY IMAGES

83–26. One score against the 49ers came on an interception return.

"Our offense has been slowed this year, but it hasn't been stopped," Miami coach Don Shula said after the game. "Today, it was stopped."

On the other side of the ball, Montana and the offense were clicking. During a 22-minute stretch from early in the second quarter until midway through the third, the 49ers scored four touchdowns on five possessions to turn a 10–7 deficit into the 22-point winning margin.

Montana, the game's MVP, threw for a then Super Bowl–record 331 yards with three touchdowns and no interceptions. He also rushed for 59 yards. And Roger Craig became the first player in Super Bowl history to score three touchdowns.

Chuck Studley, the Dolphins' defensive coordinator, did not like this view. He was the 49ers' defensive coordinator for the 49ers' first Super Bowl three years earlier.

"You know what makes Montana so tough?" Studley asked. "You can stick a guy in there in practice, but nobody simulates Montana. The way he knows where he is, where his receivers are, that complete vision he has—it's unbelievable."

> "All you heard about the whole week was **Marino, Clayton, and Duper.** Nobody was talking about Dwight Clark, Roger Craig, and Wendell Tyler."
> —Wendell Tyler, 49ers halfback, on the run-up to Super Bowl XIX

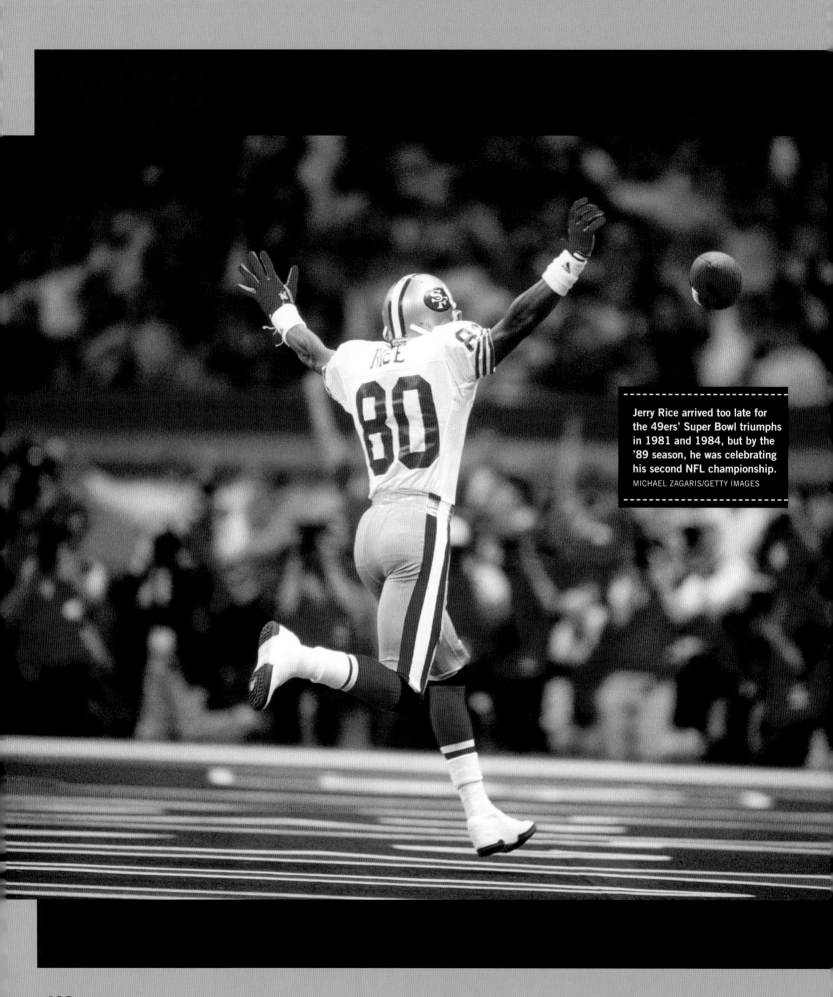

Jerry Rice arrived too late for the 49ers' Super Bowl triumphs in 1981 and 1984, but by the '89 season, he was celebrating his second NFL championship.

MICHAEL ZAGARIS/GETTY IMAGES

chapter
6

BACK-TO-BACK CHAMPIONSHIPS AND THWARTED THREE-PEAT

1985–1990

Coming off of their second Super Bowl championship in four years and a dominating 15–1 season in 1984, the San Francisco 49ers continued to build a dynasty, acquiring one of the greatest wide receivers ever to play the game in the 1985 draft. Fourteen consecutive double-digit-win seasons and three more Super Bowl triumphs were to follow.

Program covers from late 1980s-era 49ers football

RICE DREAMS

The 49ers were midway through their Super Bowl season of 1984 when Bill Walsh found himself unexpectedly looking ahead to the following year's draft.

He was unwinding with a glass of wine in his hotel room the night before the 49ers' game against the Houston Oilers. On his TV were highlights that made him take notice.

Mississippi Valley State was lighting up the scoreboard against Texas Southern, and Walsh paid particular attention to a record-setting wide receiver named Jerry Rice.

Within a couple of weeks, Michael Lombardi, who worked in the 49ers' personnel department, had three game films sent to him at Walsh's request. Lombardi had to ship the tapes back to Mississippi Valley State. Walsh told him he could find the 16mm game film on his desk.

"So I went up there and he had a little note attached to them, and in his left-handed handwriting he had, 'John Jefferson . . . with speed.' That's how he described Jerry Rice," Lombardi said.

Jefferson was a four-time Pro Bowl player who had three consecutive seasons for the San Diego Chargers from 1978 to 1980 in which he caught 1,000 yards in passes with at least 10 touchdowns.

Knowing the 49ers wouldn't be selecting until late in the first round, Walsh did not think there was much chance Rice would still be around.

Freddie Solomon was nearing the end of his career. Dwight Clark had only a couple more seasons as a top producer. And Renaldo

Nehemiah, an international star as a hurdler who played for the 49ers from 1982 to 1984, had run his course as an experiment.

Walsh engineered a trade with the New England Patriots to move up from No. 28 overall to the 16th spot in the draft to select Rice. Walsh considered wide receivers as "luxury picks" in the draft. And with a strong roster, Walsh was patient and waited to select a player at that position, which paid off.

Rice was the first pure wide receiver Walsh drafted within the first nine rounds of his first seven drafts. Walsh previously took two wide receivers—Clark (1979) and Dave Moritz (1984)—in the 10th round.

Rice struggled for much of his rookie season with dropped passes. But as he became more familiar with his surroundings and the 49ers' offense, Rice took off.

In a late-season game against the Los Angeles Rams on *Monday Night Football*, Rice caught 10 passes for 241 yards. He finished his rookie season with 49 catches for 927 yards—the only time he would be held to fewer than 1,000 yards in his first 12 seasons.

Meanwhile, Roger Craig, who blocked for Wendell Tyler as he gained 1,262 yards in 1984, became the featured back in Walsh's offense. Craig rushed for 1,050 yards and caught 92 passes for 1,016 yards to become the NFL's first player to achieve a 1,000–1,000 season.

But the Los Angeles Rams knocked San Francisco from the top spot in the NFC West in 1985. The 49ers were sent to New York to play the Giants in an NFC wild-card game. Joe Montana threw for 296 yards, but Lawrence Taylor and Co. kept the Niners out of the end zone. The 49ers' season came to an end with a 17–3 loss.

Walsh put together what is widely considered his best draft in 1986 to provide the team with some building blocks for the future. He made six draft-day trades with six different teams.

Among their selections were eight eventual starters: defensive end Larry Roberts, fullback Tom Rathman, cornerback Tim McKyer, wide receiver John Taylor, pass-rusher Charles Haley, tackle Steve Wallace, defensive lineman Kevin Fagan, and safety Don Griffin.

Although his role as the premier 49ers receiver was being eclipsed, Dwight Clark set a franchise career record for receptions in November 1985, breaking Billy Wilson's previous mark of 407. Clark also led the team with 10 touchdown catches that year. MICHAEL ZAGARIS/GETTY IMAGES

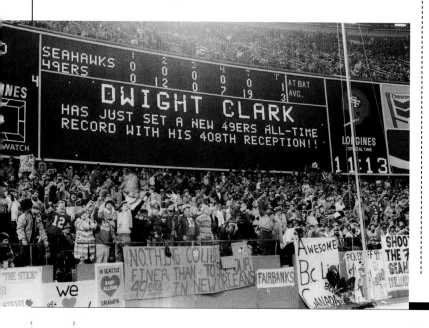

MR. THOUSAND THOUSAND

There was little evidence Roger Craig would become a pioneering pass-catcher out of the backfield when the 49ers selected him in the second round of the 1983 draft. After all, in four seasons as part of Nebraska's wishbone offense, Craig caught just 16 passes.

"Roger had outstanding speed and elusiveness and great hands as a receiver," Bill Walsh said. "When we had [pre-draft] workouts with him, he caught everything thrown his way, so we knew his receiving skills weren't going to be a problem."

Craig was the most versatile back of his generation. He began his career at fullback, where he blocked for 1,000-yard rusher Wendell Tyler in 1984. That season ended with Craig becoming the first player in Super Bowl history to score three touchdowns (two receiving, one rushing).

At the ring ceremony that offseason, Walsh pulled Craig aside and told him he expected 1,000 yards from him the following year. Craig said he was not sure whether Walsh meant 1,000 yards rushing or 1,000 yards receiving.

In 1985, Craig became the first player in NFL history to account for more than 1,000 yards as a rusher *and* as a receiver in the same season. Craig led the 49ers with 1,050 rushing yards. He added 1,016 receiving yards while leading the NFL with 92 receptions.

Craig accounted for more than 1,100 yards from scrimmage in each of his first seven seasons, including an NFL-best 2,036 yards in 1988. *Sports Illustrated* named Craig the NFL Player of the Year.

His career with the 49ers came to an end after averaging just 3.1 yards per carry in 1990 and then losing a fumble in the closing minutes of the 49ers' devastating loss to the New York Giants in the NFC Championship Game.

After playing his final three seasons with the Los Angeles Raiders and Minnesota Vikings, Craig capped his career on a high note in August of 1994. Craig signed a one-day contract to retire as a member of the organization he helped to three Super Bowls.

"Throughout my career I received a lot of awards," he said that day. "But all of that doesn't compare to coming back to retire as a 49er. It's definitely a dream come true for me."

In addition to his 1,000-yards rushing accomplishment, running back Roger Craig tallied more than 1,000 yards receiving in 1985.

1000 YARD CLUB
RUSHING & RECEIVING
1000
ROGER CRAIG
SAN FRANCISCO 49ERS • RB

GAMEDAY
49ers vs. Falcons

In the game against the Falcons on September 15, 1985, Craig ran for 107 yards and caught 6 passes for 77 yards. The 184 total yards from scrimmage was his second-highest total of the season.

THE DRAFT OF 1986

The 49ers franchise was reaching a crossroads with an aging nucleus of players still around from the franchise's first Super Bowl. Coach Bill Walsh hatched a plan to replenish the roster via the draft.

The stars aligned in 1986.

With Walsh pushing the buttons and General Manager John McVay manning the phone lines, the 49ers made six draft-day trades with six different teams. The 49ers traded down repeatedly to stockpile extra draft picks.

"A lot of teams are virtually unable to make a trade," McVay told *Sports Illustrated*. "They've invested so much time and money in the draft that they don't want to make a spur-of-the-moment decision. They need to justify all their efforts. If they trade, they might be wrong—and so they don't trade, even though it might be the right thing to do."

The 49ers traded out of the first round and still had not selected anyone through 38 picks in the draft. The phone rang in the 49ers' draft room. Eddie DeBartolo was on the other line.

"Hey," the owner said. "When are you going to pick somebody? Give me a name! My phone bills are going to be bigger than our signing bonuses!"

The 49ers were slated to have the 18th overall pick in the first round. They had one pick in each of the next three rounds and no picks in the fifth. But with their constant dealing, the 49ers turned those four picks into eight newly added players.

Finally, the 49ers made their first pick defensive end Larry Roberts at No. 39 overall. When Walsh was done, the 49ers made 14 selections in the 12-round draft.

Eight players from that impressive draft class were in the starting lineup in the 49ers' victory over the Cincinnati Bengals in Super Bowl XXIII. Coincidentally, that game served as the last time Walsh would ever be on an NFL sideline.

The third round provided the 49ers with a bounty on both sides of the ball. Fullback Tom Rathman was added with the first pick of the third round, followed by cornerback Tim McKyer just eight picks later. Later in the third round, the 49ers added wide receiver John Taylor, who would form a classic pass-catching combination with Jerry Rice over the next decade.

Pass-rusher supreme Charles Haley was selected in the fourth round, followed a short time later by offensive tackle Steve Wallace and defensive lineman Kevin Fagan. Cornerback Don Griffin, who started 107 games in his eight seasons with the 49ers, was a sixth-round selection.

UNORDINARY JOE

The 49ers' hopes for the 1986 season were dealt what appeared to be a fatal blow in the first game of the season. In the third quarter of a 31–7 victory over the Tampa Bay Buccaneers, Montana rolled to his left and threw a sideline pass across his body to Dwight Clark. Montana remained in the game and threw for 356 yards, but the next day he could barely move.

Montana had ruptured a disc low in his back. He underwent surgery eight days after the second game of the season. There was speculation it might be a career-ending injury. Surely, he would not play again in 1986.

Montana's surgery and subsequent reports on his progress were big news in the Bay Area. But the season carried on and the 49ers won more than they lost—just barely—without him.

Jeff Kemp took over for the next six games, a stretch in which the team remained in contention with a 3–2–1 record. When Kemp got injured, Mike Moroski stepped in and defeated the Green Bay Packers 31–17 in Milwaukee. But with a 23–10 loss to the New Orleans Saints, the 49ers' playoff hopes were looking bleak.

That's when Montana defied all odds. After just eight weeks on the sideline, Montana made his return at Candlestick Park against the St. Louis Cardinals. He completed 13 of 19 passes for 270 yards and three touchdowns in a 43–17 victory.

"We can't think we are going to march right into the playoffs now," tackle Keith Fahnhorst told *Sports Illustrated*. "Not having Joe wasn't the only reason we weren't producing. . . . He's a superstar. He honestly is. I remember John Ayers and I were watching Joe do this incredible stuff on film once, and John looked at me and said, 'You know, maybe he is all we have.'"

The 49ers finished the season with five victories in their final seven games after Montana's return to the lineup to regain possession of the NFC West with a 10–5–1 record.

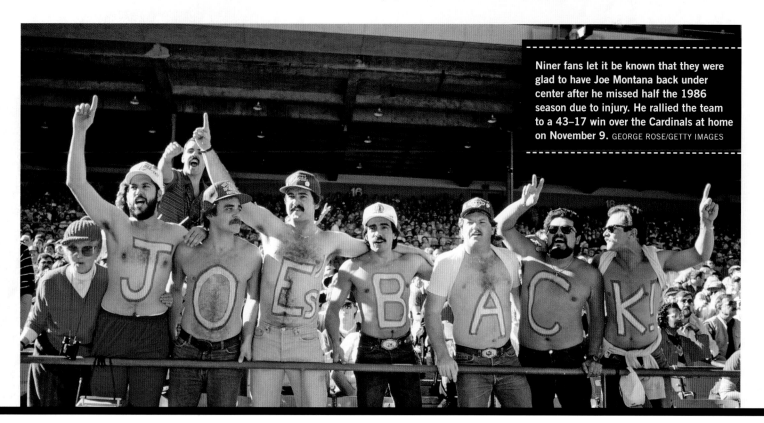

Niner fans let it be known that they were glad to have Joe Montana back under center after he missed half the 1986 season due to injury. He rallied the team to a 43–17 win over the Cardinals at home on November 9. GEORGE ROSE/GETTY IMAGES

EARLY EXITS

The 49ers once again opened the playoffs in the Meadowlands against the New York Giants. The game started poorly and only got worse.

Two-and-a-half minutes into the action, Rice got behind the Giants secondary. Montana put the ball on the money for what appeared to be a sure touchdown. Rice was running all by himself when he lost control of the football around the New York 25-yard line. The ball continued to roll toward the end zone, where the Giants recovered.

The rest of the game was all Giants. Montana was knocked out of the game with a nasty hit from defensive lineman Jim Burt. Montana was taken to a hospital, where he remained overnight with a severe concussion. Kemp entered and completed just of 7 of 22 pass attempts for 64 yards in the Giants' 49–3 victory.

With Montana showing signs of wearing down, it became imperative for Walsh to find a quarterback for the future to begin grooming immediately.

Four days before the 1987 draft, Walsh and Eddie DeBartolo negotiated a deal with Tampa Bay Buccaneers owner Hugh Culverhouse to acquire quarterback Steve Young for second- and fourth-round draft picks.

Young was best-known for signing a then-outrageous $40.1 million contract with the Los Angeles Express of the USFL in 1984. He exercised an option to leave the Express and move on to the Tampa Bay Buccaneers, which selected him in the first round of the 1984 supplemental draft.

After Young had two dismal seasons, Tampa Bay was looking to move on and make Vinny Testaverde their selection with the No. 1 overall pick. Young came to San Francisco with the expectation of taking over for Montana in the near future. After all, Young was led to believe that Montana would not physically be able to hold up for much longer.

It did not take Young long to realize Montana wasn't going anywhere any time soon. Young witnessed the Montana magic early in his first season. The 49ers were in danger of falling to 0–2 after an opening-week loss at Pittsburgh. They trailed the Cincinnati Bengals, 26–20, with six seconds to play. Faced with a fourth-and-long, Bengals coach Sam Wyche did not want

Kicker Ray Wersching provided the only points—a 26-yard field goal in the first quarter—for the normally high-scoring 49ers in the 49–3 playoff loss to the Giants on January 4, 1987. GEORGE GOJKOVICH/GETTY IMAGES

to risk a punt, so he called a wide sweep for running back James Brooks. Wyche expected the play to last long enough to run out the clock.

But 49ers defensive lineman Kevin Fagan shot through and tackled Brooks for a 6-yard loss, leaving two seconds on the clock. It left time for one Montana-to-Rice attempt. Shockingly, the Bengals had a rookie cornerback in single coverage against Rice, who leaped in the air to catch a pass known as "Hail Jerry" with no time remaining.

After Ray Wersching's game-winning extra point, Walsh literally skipped off the field after the impossible victory.

The biggest problems the 49ers faced in 1987 were off the field. After two games, the NFL players went on strike. After games were canceled in the first week, NFL teams fielded squads of replacement players. San Francisco's no-name players defeated the New York Giants on *Monday Night Football*.

A week later, Montana and 11 others, torn between their commitment to the union and their loyalty to owner Eddie DeBartolo, crossed the picket line.

When the full team returned to action, Montana and Jerry Rice were virtually unstoppable. Despite playing in just 12 games that season, Rice caught 22 touchdown passes and had 1,078 yards receiving. Montana completed two-thirds of his passing attempts and threw 31 touchdowns against 13 interceptions. An injury suffered in Week 13 against the Bears forced Montana to miss the final two regular-season games. Young led San Francisco to resounding wins over the Falcons (35–7) and Rams (48–0).

With Montana back in the lineup, the 49ers entered the playoffs as the No. 1 seed in the NFC and the clear favorites to win the Super Bowl.

But the 49ers did not even win a playoff game, as the Minnesota Vikings put on a 49ers-like offensive display with Anthony Carter playing the role of Jerry Rice. Carter caught 10 passes for 227 yards to lead the Vikings to a 36–24 victory over the shell-shocked 49ers.

The following day, 49ers cornerback Tim McKyer told Tom FitzGerald of the *San Francisco Chronicle:* "I just got through looking at the tape and I still don't believe some of the catches he made."

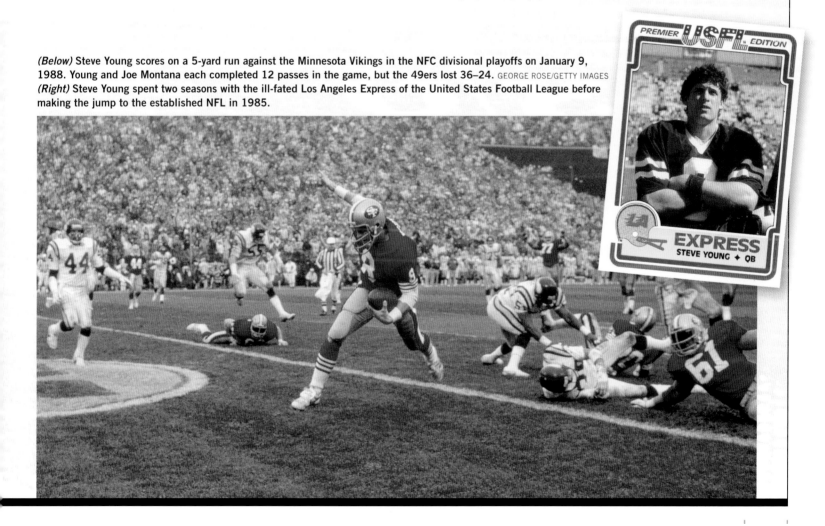

(Below) Steve Young scores on a 5-yard run against the Minnesota Vikings in the NFC divisional playoffs on January 9, 1988. Young and Joe Montana each completed 12 passes in the game, but the 49ers lost 36–24. GEORGE ROSE/GETTY IMAGES
(Right) Steve Young spent two seasons with the ill-fated Los Angeles Express of the United States Football League before making the jump to the established NFL in 1985.

QUARTERBACK OF THE DEFENSE

Joe Montana was the face of the 49ers' four Super Bowl titles in the 1980s. But defensive back Ronnie Lott was widely considered the heart, soul, and conscious of those championship teams.

Lott was a key component on the 49ers' first championship team as a rookie after he was selected with the No. 8 overall pick in 1981. Lott spent his first four NFL seasons at left cornerback, where he intercepted 17 passes. In 1985, he moved to safety, where he remained for the balance of his 14-year career.

He was a 10-time Pro Bowl performer and a six-time first-team All-Pro selection. Lott is best remembered for his hard-hitting style and his selfless determination to drive the 49ers toward championships.

"He's like a middle linebacker playing safety," Hall of Fame coach Tom Landry once said. "He's devastating. He may dominate the secondary better than anyone I've seen."

Nothing epitomizes Lott's dedication more than his voluntary amputation of the tip of his small finger.

In the final game of the 1985 regular season against the Dallas Cowboys, Lott came up to make a tackle on running back Timmy Newsome. The small finger on Lott's left hand was smashed between his shoulder pads and Newsome's helmet. The bone at the tip of the finger was crushed.

Lott played just six days later in excruciating pain and, admittedly, did not have a great game in the 49ers' 17–3 loss to the New York Giants in the playoffs.

When the finger did not heal properly through the first part of the offseason, Lott opted to have the tip amputated so that he would be ready for the start of the 1986 season.

Years later, just prior to his 2000 induction ceremony into the Pro Football Hall of Fame, Lott said, "It's kind of hard to get people to understand why you would do that. But at the end of the day, it's all worth it."

Fittingly, Lott and Montana went into the Hall of Fame together in 2000 as first-ballot enshrines.

Montana retired after the 1994 season, following two seasons with the Kansas City Chiefs. Lott, who also played for the Los Angeles Raiders and New York Jets toward the end of his career, signed with the Chiefs in April of 1995. He sustained a broken leg in the exhibition season, missed the entire season, and then retired.

"It makes it a little sweeter that Ronnie and I are coming in at the same time," Montana said of the Hall of Fame. "We both came into the league at the initial flip of the page for the 49ers."

During their speeches, Lott and Montana made special mention of each other.

Said Montana, "To Ronnie Lott, who's meant to me, not only on the football field but off the football field as well, what a true man is supposed to be. Ronnie spoke, and Ronnie delivered. I had a few injuries in my career, and Ronnie was always the first one to pick me up."

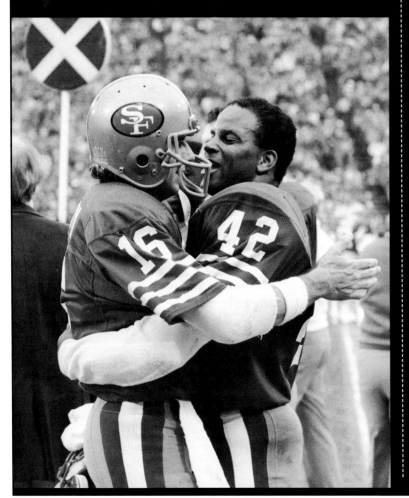

Ronnie Lott and Joe Montana were the heart and soul of the San Francisco defense and offense, respectively, during the dynasty of the 1980s and early '90s. AP PHOTO/ERIC RISBERG

QUARTERBACK
CONTROVERSY

The defense took a beating, but perhaps the biggest thing to come out of the loss to the Vikings in the 1987 playoffs was a 49ers quarterback controversy that would rage for years. Montana completed just 12 of 26 passes for 109 yards and an interception. In the middle of the third quarter, Walsh benched Montana in favor of Young.

"Joe wasn't the only one who was struggling out there," Randy Cross said. "We were all struggling."

Still, when the 1988 season began, San Francisco had a quarterback controversy on its hands. For the first time since Joe Montana took over for Steve DeBerg, there was somebody else on the roster making a serious bid for the job.

The locker room was still firmly behind Montana, as Walsh named him the starter. But the team's mettle was tested with a midseason skid in which the 49ers dropped three of four.

The only victory in that string was a dramatic 24–21 victory over Minnesota, in which Steve Young made a memorable 49-yard scramble through the defense and stumbled into the end zone for the winning points. Walsh called the play "an unbelievable athletic feat . . . a tremendous effort."

Young, playing in place of an injured Montana, had heard boos earlier in the game when several drives stalled.

After that victory, the 49ers lost back-to-back games. Young was at quarterback for a discouraging 24–23 loss at the Phoenix Cardinals. Then Montana returned but could not generate any offense in a 9–3 loss to the Los Angeles Raiders at Candlestick Park.

"We didn't look like we could even make the playoffs," DeBartolo said. "At the time we were 6–5. Bill was having a tough time because we had a better football team than that. And he gathered himself. And I think that was his best coaching job, without question, because he brought that team together."

Montana rallied the 49ers to four consecutive victories to win the NFC West title for the third consecutive season. And again they were matched against the Vikings in the playoffs.

At Candlestick on January 1, Minnesota receiver Anthony Carter was held to three catches for 45 yards. Jerry Rice caught three touchdown passes, and Roger Craig rushed for 135 yards and two touchdowns in the 49ers' 34–9 triumph.

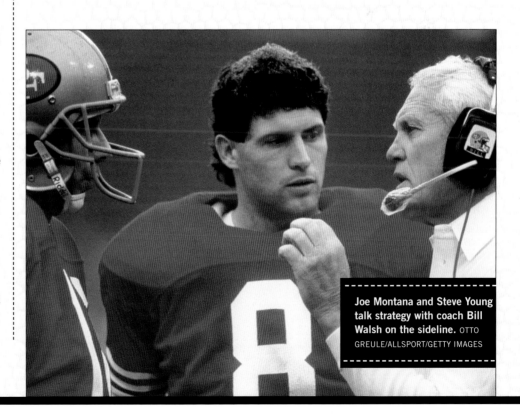

Joe Montana and Steve Young talk strategy with coach Bill Walsh on the sideline. OTTO GREULE/ALLSPORT/GETTY IMAGES

49ERS WEATHER

The victory over the Vikings in the divisional playoff game earned the 49ers a trip to Soldier Field the following week to face the Chicago Bears, who compiled an NFC-best 12–4 record during the regular season. The Bears still had many pieces in place from the dominant unit of 1985 that tore through the league en route to the Super Bowl title.

The 49ers team many outsiders considered "finesse" was believed to stand no chance against the tough and physical Bears, especially in the frigid conditions that awaited the players. At kickoff, the temperature was in the teens with a wind-chill factor of minus-26 degrees for the NFC Championship Game.

But the 49ers proved to be the tougher and simply better team—in any conditions. Craig, who rushed for 68 yards, said the field was so hard that he did not wear cleats because there was no traction.

"Every time I got tackled it was like falling on a sidewalk with sharp edges of concrete sticking up," Craig said in his book *Roger Craig's Tales from the San Francisco 49ers Sideline*. "At the end of the game, my arms were all cut up from the ice and frozen grass."

Even with the wind howling off Lake Michigan, the air attack of Montana and Rice could not be slowed down. Rice got behind the Bears' secondary and Montana, never known for his arm strength, powered his pass through the conditions to deliver a throw that Rice turned into a 61-yard scoring pass in the first quarter.

"The wind was really taking the ball all day long," Rice said afterward. "You had to watch the ball in. On that one, Joe told me the ball might not be right where I wanted it to be and I would have to make a play on it. And I did."

Rice caught a 27-yard touchdown pass in the second quarter. Montana threw a 5-yard touchdown strike to tight end John Frank in the third quarter, and Tom Rathman scored on a 4-yard run in the fourth quarter. The San Francisco defense held Chicago to just 267 yards of total offense in a 28–3 victory.

Montana was at his best, completing 17 of 27 passes for 288 yards with three touchdowns and no interceptions. Afterward, Walsh told Ira Miller of the *San Francisco Chronicle*, "It's one of the greatest games Joe Montana has played, considering the situation, climate, and everything that goes with it. . . . This is as great a game as we've had in many, many years."

The 49ers' defense proved to be more tough and rugged than the Bears' all-star cast. Defense had been the focus of the 1988 draft

San Francisco 49ers players try to stay warm by the heater on the sideline during the 1988 NFC Championship Game against Chicago at Soldier Field on January 8, 1989. It turned out to be the Bears who never got warm in the 49ers' 28–3 win. MICHAEL ZAGARIS/GETTY IMAGES

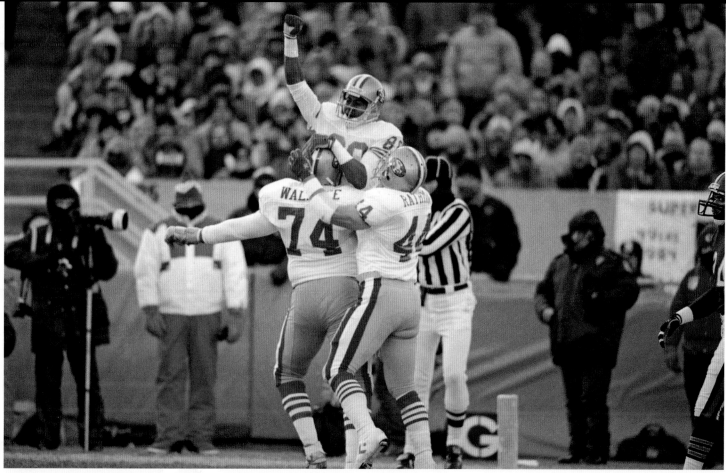

Jerry Rice celebrates with tackle Steve Wallace (74) and fullback Tom Rathman (44) after his 61-yard touchdown reception in the first quarter of the NFC Championship Game in Chicago. AP PHOTO/JOHN SWART

class, as San Francisco added defensive linemen Daniel Stubbs and Pierce Holt in the second round, and linebacker Bill Romanowski in the third round.

Nose tackle Michael Carter earned a trip to the Pro Bowl, and the 49ers were solid up the middle with linebackers Jim Fahnhorst and Michael Walter. Lott was still at the top of his game, and Jeff Fuller was in his second season as a starter at strong safety.

So much for "Bears weather."

"All they talked about all week was how we were going to freeze," Walter said. "They were the ones who looked cold."

The 49ers practiced in comfortable conditions in the Bay Area in the week leading up to the game. Walsh prepared the players mentally for the challenge, and the team delivered a masterpiece performance. Focus never wavered. The team did not commit a single penalty, becoming the first club in 117 postseason games to go without being flagged since the Pittsburgh Steelers did it in the Super Bowl following the 1975 season.

The 49ers continued a trend of playing their best football on the road. In 10 seasons from 1981 to 1990, the organization compiled a .809 win percentage on the road and .671 at home. Beginning in late November 1988, the 49ers went on a streak of 19 consecutive road victories.

Bay Area columnist Lowell Cohn playfully suggested the team should board an airplane and fly in a holding pattern for a while and land back at San Francisco International Airport before home games.

Walsh, a master at getting his players prepared for challenges, thrived at building a mindset among the team before entering enemy territory.

"We spoke of it, addressed it, we discussed it week after week after week, even before the season started," Walsh said. "I used axioms and experiences I read about in warfare, where troops were backed up and they had nowhere to go. We went in with a vengeance and all we had was each other."

With that memorable road conquest against Chicago, a season that began with a quarterback controversy and featured a midseason collapse, and a march through "Bears weather," would conclude with the team's third trip to the Super Bowl in the decade.

WALSH'S FINAL GAME

The journey of 1988—and the previous several seasons—took its toll on Walsh, who felt the stress from attempting to live up to owner Eddie DeBartolo's expectations. Walsh was stripped of his title as team president after the crushing playoff loss to Minnesota that concluded the 1987 season.

He was under constant pressure—internal and external—to deliver Super Bowl titles on a yearly basis. Walsh created an atmosphere in which anything short of a title was considered an abject failure.

In the days leading up to Super Bowl XXIII in Miami, DeBartolo predicted Walsh would step down after the game. It was another emotional week for Walsh, who was facing the Cincinnati Bengals in the Super Bowl . . . again.

And, this time, his former 49ers lead assistant, Sam Wyche, was on the Bengals sideline as head coach.

Through three quarters, 49ers kicker Mike Cofer and the Bengals' Jim Breech traded field goals, making it 6–6 before Cincinnati's Stanford Jennings provided the first touchdown of the game with a 93-yard kickoff return in the third quarter.

The 49ers came back to tie it at 13–13 on Montana's 14-yard scoring pass to Rice. When the Bengals' 11-play drive resulted in Breech's third field goal of the game, the 49ers were down 16–13 late in the fourth quarter.

Defensive coordinator George Seifert recalled the phenomenal effort of linebacker Riki Ellison, who had a wristband and was in charge of relaying the defensive calls to his teammates in the huddle.

"It got to the point that Riki was having such a great time calling the defenses that he'd turn his back to the sideline and start calling the plays himself," Seifert said. "He called a helluva game."

The defense kept San Francisco in the game. But it was up to the offense to come through in the clutch. After a penalty on the kickoff, the 49ers took over at their own 8-yard line with 3:20 remaining. The 49ers had been in this spot before.

Dwight Clark, who retired following an injury-plagued 1987 season, was on the sideline as an administrative assistant. He could not help but think back to the beginning—when the 49ers had to travel the length of the field to launch this new era of the franchise in the 1981 NFC Championship Game against the Dallas Cowboys.

"This reminded me of that drive, not much time, coming from behind," Clark said. "The situation, he [Joe] has done that so many times. It was a nerve-wracking drive, but I knew Joe was going to get it done."

Walsh dialed up the sequence of plays and Montana threw only one incompletion on the ensuing drive. The drive actually covered 102 yards, as the 49ers were penalized once for an ineligible man downfield.

The 49ers moved the ball to the 10-yard line and then called their second timeout with 39 seconds remaining. Walsh planned to go for the end zone twice. If they failed, Cofer would be sent in for the tying field goal to force overtime.

Most of the Bengals' focus was on Rice. But Montana looked for John Taylor, who was held without a catch up to that point. Taylor ran a post pattern and Montana

Head coach Bill Walsh and owner Eddie DeBartolo pose together during the week leading up to the 49ers' meeting with the Bengals in Super Bowl XXIII. MICHAEL ZAGARIS/ GETTY IMAGES

(Above) Safety Jeff Fuller (49) and defensive end Pierce Holt converge on Bengals running back Ickey Woods during Super Bowl XXIII on January 22, 1989. The 49ers defense held Woods to 79 yards (he had averaged 114 yards in the two previous postseason games) in the 20–16 victory for San Francisco. SYLVIA ALLEN/GETTY IMAGES *(Below)* The City of San Francisco came out in full force for the victory parade following Super Bowl XXIII to honor the "team of the eighties." DAVID MADISON/GETTY IMAGES

put the ball on his hands for the game-winning touchdown.

Rice, who caught 11 passes for 215 yards and a touchdown, was the game's most valuable player in the 20–16 victory. As the 49ers were presented with the Lombardi Trophy, NFL Commissioner Pete Rozelle declared, "The Forty-Niners truly are the team of the eighties."

In the victors' locker room, another scene unfolded as Brent Musburger, on national TV asked, "Is this the last game for the great coach Walsh?" Walsh broke down in tears.

"It was one of the great games I've been involved in," Walsh said later. "This was a lifetime experience, believe me."

SUPER BOWL XXIII: THE DRIVE

Joe Montana, known throughout his career as "Joe Cool" because of his unwavering hand under pressure, tried to calm nerves in the huddle before "The Drive."

He pointed toward a familiar face in the stands and asked notorious worrier Harris Barton, "Isn't that John Candy?"

But Montana might not have been as calm as his play on the game-winning drive against the Cincinnati Bengals in Super Bowl XXIII would suggest.

"Everybody talks about how poised Joe was during the drive," 49ers tight end John Frank said. "But I'm not so sure he was as poised as he was made out to be. He was hyperventilating. But it was pretty amazing how it just clicked."

Montana completed short passes to Roger Craig, tight end John Frank, and Rice. On a third-and-2 play after the two-minute warning, Craig gained 4 yards off tackle.

Coach Bill Walsh was forced to take a timeout on the final drive to allow Montana time to catch his breath.

"I had to call it because Joe was about to faint," said Walsh in Bob McGinn's *The Ultimate Super Bowl Book*. "He was so excited, and his adrenaline was pumping so hard, he was hyperventilating."

But Montana's performance under pressure remained steady, as he orchestrated the final drive to perfection. Montana and Jerry Rice combined for 51 passing yards on the final drive, and everything went according to plan until the final play of the drive.

Rice caught a 17-yard pass, and Craig picked up 13 yards on a throw from Montana. After a penalty for ineligible man down field, Rice caught a 27-yard pass to the Bengals' 18-yard line. Craig gained 8 yards on a short pass from Montana to set up a second-down play from the Cincinnati 10 with 39 seconds remaining.

Craig and Tom Rathman, both of whom played at Nebraska, were virtually interchangeable as halfback and fullback. Often, they would line up in each other's positions and fulfill the other man's responsibility without even a nonverbal acknowledgment.

And when they broke the huddle to execute "20-Halfback Curl X-up," they lined up in the spots designated for each other. The play was designed to dump the ball off to Craig, the halfback. But because Craig was now in the fullback position, his assignment was to remain in the backfield to block.

However, both Craig and Rathman left the backfield to run curl routes. The Bengals blitzed, which provided a window for the quick-thinking Montana to deliver a perfect pass to John Taylor, his secondary receiver, for the game-winning 10-yard touchdown pass with 34 seconds remaining.

Craig said the 49ers practiced those two-minute scenarios so often that the final drive was able to fall into place with relative ease, even with some unintended happenings along the way.

Said Walsh, "The last drive was a culmination of many years of establishing not only our system of football but a style that emphasized precision and skill to reduce the risk factor."

John Taylor hauls in the game-winning touchdown in Super Bowl XXIII. LEON HALIP/GETTY IMAGES

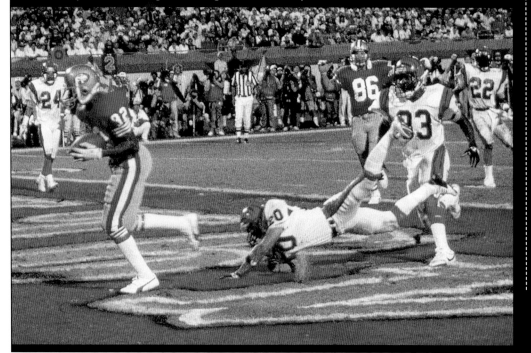

SEIFERT STEPS IN

A couple of days after the 49ers' third Super Bowl title, it became official.

Bill Walsh stepped down as San Francisco's head coach after 10 remarkable seasons. The news came just in time to prevent Seifert from interviewing with the Cleveland Browns for their head-coaching vacancy.

Seifert had a layover at Dallas-Fort Worth International Airport when he called his wife, Linda. She told him to take the next plane home because he was going to be the next coach of the San Francisco 49ers.

At his introductory press conference, Seifert spoke of his goal of not standing in the way of the franchise achieving continued greatness.

"A standard has been set," Seifert said. "When Bill became the coach of the Forty-Niners, it was a club that needed direction. I'm fortunate that I have now inherited a football team with some very fine, outstanding players. As my wife told me before we headed off to play some of these final playoff games, 'Don't screw it up, George.'"

Seifert promoted quarterbacks coach Mike Holmgren to offensive coordinator, and linebackers coach Bill McPherson to defensive coordinator. In the front office, team attorney Carmen Policy took a more active role as executive vice president in charge of front office and league affairs.

The roster remained mostly intact. The most notable roster change was tight end John Frank's surprising decision to retire at age 27 after just five NFL seasons. Frank went back to school and became one of the nation's leading hair transplant surgeons.

Initially, Frank worried he was leaving the 49ers in a bad situation. But his former position was in good hands. Brent Jones stepped seamlessly into the role as the starting tight end. He quickly emerged as one of the top tight ends in the NFL, earning four trips to the Pro Bowl over the next nine years.

"They had a hard time the next year without me," Frank joked.

The 1989 club ultimately was every bit as dominating as the team that had cut a swath through the NFL in 1984 and secured a 22-point victory over the Miami Dolphins in Super Bowl XIX.

The 49ers opened with narrow road victories over Indianapolis and Tampa Bay before a memorable showdown at Philadelphia. The 49ers trailed 21–10 in the fourth quarter, and Montana had been

New head coach George Seifert confers with his quarterback at summer training camp in Rocklin, California, July 1989. Seifert inherited a Super Bowl champion club, and expectations were high for a return to glory.
AP PHOTO/WALT ZEBOSKI

sacked eight times by an Eagles pass rush that featured Reggie White, Jerome Brown, and Clyde Simmons.

Montana was simply amazing in the fourth quarter, tossing four touchdown passes. He finished with 428 yards passing and five touchdowns to rally the 49ers to a 38–28 victory at Veterans Stadium.

Montana kept Steve Young on the sideline, out of sight and mostly out of mind, with the best season of his Hall of Fame career. Montana completed 70 percent of his passes while compiling 3,521 yards, 26 touchdowns, and just eight interceptions. His passer rating was a career-best 112.4. Montana was a consensus selection as the NFL Player of the Year.

The 49ers' offensive thrived under Holmgren's direction. Rice, John Taylor, Roger Craig, and guard Guy McIntyre all joined Montana on the NFC Pro Bowl team. San Francisco went 14–2 on the year and finished with a five-game win streak heading into the postseason.

The close-knit 49ers team, many of whom commuted to work on a daily basis, were confronted with a scary moment in midseason when 27-year-old defensive back Jeff Fuller suffered a frightening injury during the October 22 win over the New England Patriots. He tore several vertebrae in his spine while making a tackle and had to be quickly taken to the hospital, where he underwent numerous surgeries.

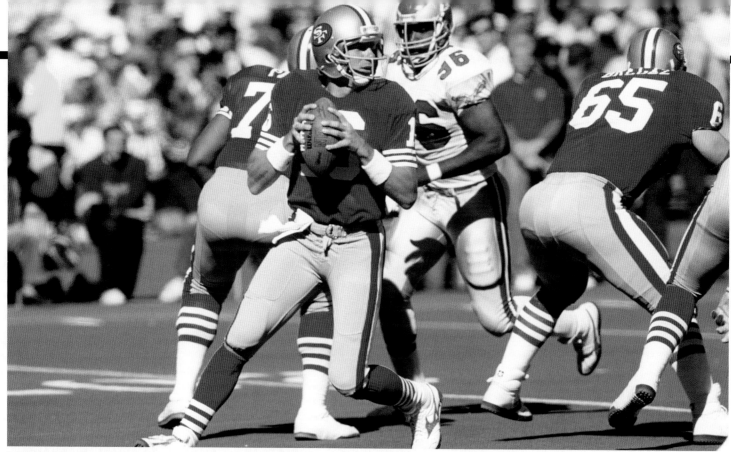

In perhaps the finest performance of his All-Pro season in 1989, Joe Montana led the 49ers to a 38–28 victory over the Eagles by completing 25 passes for 428 yards and 5 touchdowns. FOCUS ON SPORT/GETTY IMAGES **(Below)** Ronnie Lott celebrates his 58-yard interception return for a touchdown against the Vikings in the playoffs on January 6, 1990, at Candlestick Park. MICKEY PFLEGER/SPORTS ILLUSTRATED/GETTY IMAGES

The devastating event seemed to draw the team tighter together and brought even more focus to the playing field. That sharpened focus was apparent in the playoffs.

The 49ers blew past the Minnesota Vikings in the divisional round. Montana threw four touchdown passes in the first half, Craig rushed for 118 yards, and Ronnie Lott returned an interception 58 yards for a touchdown in a 41–13 victory at Candlestick Park.

In the NFC Championship Game, San Francisco scored 30 consecutive points after spotting the Los Angeles Rams a 3–0 lead after one quarter. Tight end Brent Jones caught a 20-yard touchdown pass from Montana, and cornerback Tim McKyer intercepted Rams quarterback Jim Everett deep in Los Angeles territory to set up Craig's 1-yard touchdown run. Taylor added an 18-yard touchdown reception from Montana, and the 49ers moved on to Super Bowl XXIV with a 30–3 victory over their Southern California rival.

NO CONTEST

Against the Broncos' defense in Super Bowl XXIV, the 49ers offensive line—including Guy McIntyre (62), Bruce Collie (69), and Harris Barton (79)—provided good pass protection for Joe Montana and opened plenty of holes for running back Roger Craig (33) and fullback Tom Rathman (44). GIN ELLIS/GETTY IMAGES

Two weeks after dismantling the Rams in the NFC title game, the 49ers picked up where they left off as they headed to New Orleans.

Seifert's first Super Bowl came in his first season. And the 49ers left little room for doubt by setting Super Bowl records for points scored and margin of victory against the overmatched Denver Broncos.

With John Elway at quarterback, the Broncos had the best record in the AFC (11–5). They advanced to their third Super Bowl in four years with a decisive 37–21 victory over the Cleveland Browns in the AFC Championship Game.

But the 49ers thoroughly outclassed the Broncos, just as they had against Minnesota and Los Angeles to march through the NFC playoffs.

Leading 7–3 in the first quarter, San Francisco scored five unanswered touchdowns over the next two quarters. Montana completed 22 of 29 passes for 297 yards and five touchdowns to earn his third Super Bowl MVP trophy.

He did it with the help of an offensive line—left tackle Bubba Paris, left guard Guy

SUPERBOWL MVP's
JERRY RICE • JOE MONTANA

McIntyre, center Jesse Sapolu, right guard Bruce Collie, and right tackle Harris Barton—playing at a level the Broncos' front seven could not match.

"I think I might have gotten touched once," said Montana, who was 33 years old. "I could play 'til I'm forty if the line plays like that."

Rice caught seven passes for 148 yards and three touchdowns. Fullback Tom Rathman scored on two short touchdown runs, and Jones, Taylor, and Craig each added scores of their own in a 55–10 romp.

When asked if he expected his first Super Bowl victory to come so easily, Seifert answered, "I can't say I did. And, yet, when you look at the players we have and our ownership and the coaching staff, and what we've developed here over the years, it doesn't surprise me, either."

While receiving mate Jerry Rice lit it up with three touchdowns in the 55–10 win over Denver, John Taylor pulled in a 35-yard TD catch of his own in the third quarter of Super Bowl XXIV.
GEORGE ROSE/GETTY IMAGES

A RUN AT HISTORY

After two consecutive Super Bowl titles, the 49ers kept their veteran roster mostly intact in a bid for an unprecedented third championship in a row.

Running back Dexter Carter, a first-round draft pick, overtook Roger Craig as the team's leading rusher. Carter gained a career-best 460 yards as a rookie, as Craig's yard-per-attempt dropped to 3.1 yards.

The defensive line got more help with the selection of defensive end Dennis Brown in the second round. He made an immediate contribution with six sacks as a rookie. Cornerback Eric Davis, also a second-round selection, added depth in the secondary.

Everything was in place for the team to achieve history.

Again, the 49ers won the NFC West with a 14–2 record and secured home-field advantage throughout the playoffs with an NFL-best regular season. Some of the older players began showing signs of age, but sixth-year player Jerry Rice was able to camouflage some of the team's blemishes. Rice caught 100 passes for 1,502 yards and 13 touchdowns in the regular season.

The Niners opened the playoffs against Washington. Montana threw two touchdown passes and nose tackle Michael Carter intercepted a pass, which was tipped at the line of scrimmage by Charles Haley, and returned it 61 yards for a touchdown in the fourth quarter to put the finishing touches on a 28–10 victory.

That set up a rematch against the New York Giants in the NFC Championship Game. The teams met seven weeks earlier in a hard-fought game on *Monday Night Football*. The 49ers won the first meeting, 7–3. This time, the teams played a similar, taut defensive struggle for the right to go to the Super Bowl.

John Taylor scored the only touchdown of the game when he hauled in a Montana pass 61 yards for a third-quarter touchdown to give the 49ers a 13–6 lead. The 49ers could not get much else going against the punishing Giants defense.

Montana was knocked from the game on a brutal backside hit from defensive lineman Leonard Marshall, a play on which Montana sustained a broken right hand and bruised sternum. Montana did not return, and he would not have been able to play a week later if the 49ers had advanced to Super Bowl XXV.

With Steve Young in at quarterback and with less than three minutes to play, Roger Craig picked up the 49ers' first rushing first down of the game as the offense wanted to milk the clock.

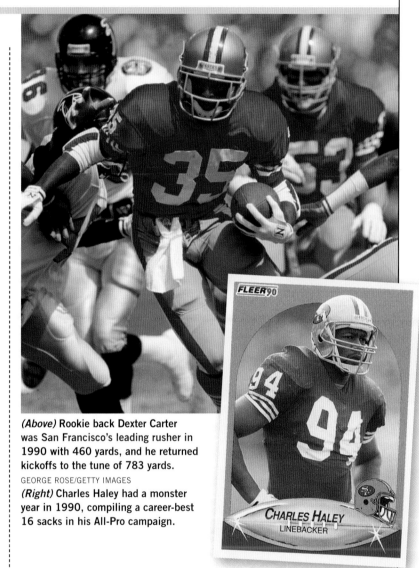

(Above) Rookie back Dexter Carter was San Francisco's leading rusher in 1990 with 460 yards, and he returned kickoffs to the tune of 783 yards.
GEORGE ROSE/GETTY IMAGES

(Right) Charles Haley had a monster year in 1990, compiling a career-best 16 sacks in his All-Pro campaign.

On the next play, Giants defensive lineman Erik Howard put his helmet on the ball, jarring it out of Craig's grasp. Lawrence Taylor caught the ball before it hit the ground. The game's only turnover gave the Giants hope with the ball on their 43-yard line.

Giants quarterback Jeff Hostetler completed a 19-yard pass to tight end Mark Bavaro and a 13-yarder to Stephen Baker to position kicker Matt Bahr for a 42-yard field goal with four seconds remaining. Moments after the kick sailed inside the left upright, CBS play-by-play announcer Pat Summerall uttered the crushing words to 49ers fans: "There will be no three-peat."

SUPER BOWL XXIV: NEVER A DOUBT

Bill Walsh had an unfamiliar vantage point from which to watch Super Bowl XXIV in New Orleans.

Walsh, the three-time Super Bowl–winning coach, was still a member of the 49ers in his short-lived role as vice president for football operations. He was no longer on the sideline running the show.

Instead, Walsh was in the owner's suite at the Louisiana Superdome doing all he could to soothe the nerves of owner Eddie DeBartolo.

The 49ers opened the game in familiar fashion with Jerry Rice scoring on a 20-yard touchdown pass from Joe Montana. But the Denver Broncos answered with a field goal to make the score 7–3 in the first quarter.

DeBartolo anticipated another tightly fought Super Bowl, such as the one the 49ers endured the previous year in Walsh's final game against the Cincinnati Bengals.

"I was a little nervous," DeBartolo said. "I think we were drinking a beer, and obviously, we're playing John Elway and

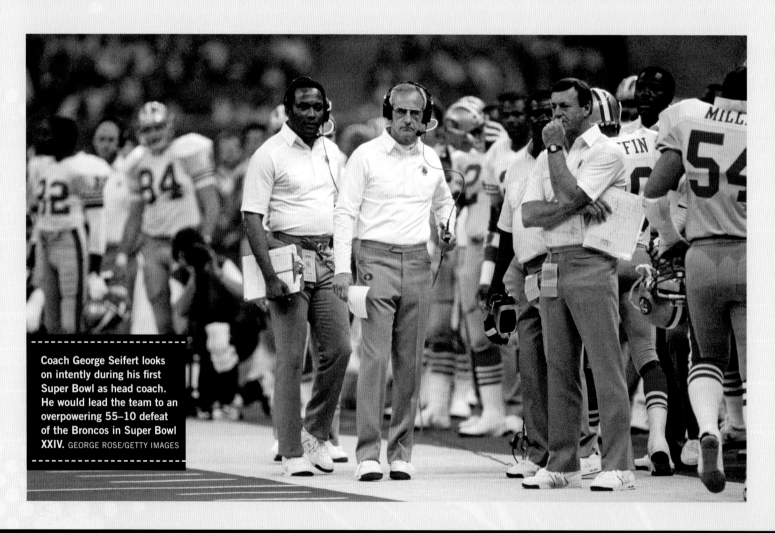

Coach George Seifert looks on intently during his first Super Bowl as head coach. He would lead the team to an overpowering 55–10 defeat of the Broncos in Super Bowl XXIV. GEORGE ROSE/GETTY IMAGES

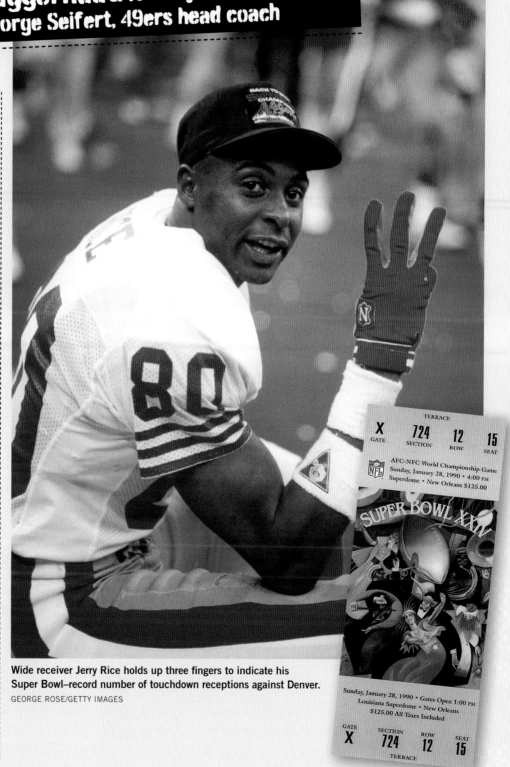

everything. We're about three minutes into the game and I said, 'Oh, boy, we're going to sit through this? This is going to be a real tough one.'"

But Walsh saw something much different as he studied the 49ers' pass protection and receivers releasing into the Denver secondary.

"Eddie, I'm telling you right now, they can't cover anybody," Walsh told DeBartolo. "Everybody is open. This game is going to be a blowout."

Years later when told what Walsh said to DeBartolo, Seifert responded, "That's easy for Bill to say."

The 49ers certainly made it look easy on that day, January 28, 1990. Montana threw for 297 yards and four touchdowns. Rice caught scoring passes of 20, 38, and 28 yards. Brent Jones and John Taylor also added touchdown receptions, and Tom Rathman scored on a couple short runs.

Meanwhile, Elway was under constant harassment. The 49ers' rotation of pass-rushers accounted for six sacks. Daniel Stubbs led the way with two sacks. Safety Chet Brooks and linebacker Mike Walter intercepted passes.

Another outstanding 49ers defensive showing contributed mightily to Elway's miserable game. The former Stanford star completed just 10 of 26 attempts for 108 yards.

"I'm amazed at how focused that team was," Seifert said. "All the coaches and players busted their butts. Some say the 1984 or the 1994 teams were our best, but that team in 1989 was a juggernaut. It was just, 'Stand back, here we come.'"

Wide receiver Jerry Rice holds up three fingers to indicate his Super Bowl–record number of touchdown receptions against Denver.
GEORGE ROSE/GETTY IMAGES

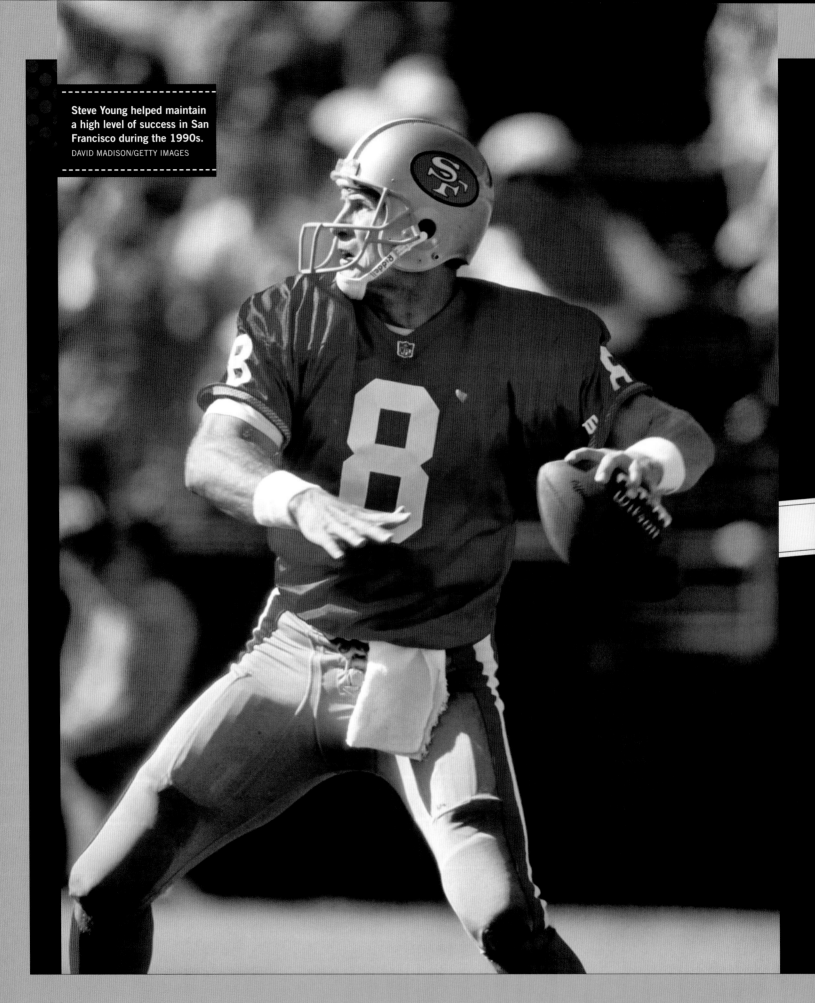

chapter
7

STEVE YOUNG & A FINAL FLING

1991–1999

As many of the key pieces from San Francisco's four-time Super Bowl champions began to enter their twilight years, a new star quarterback was waiting in the wings, ready to take over for the legendary Joe Montana and lead the 49ers to one more run at glory.

Program covers from 1990s-era
49ers football

AGE, INJURIES, AND TENSION TAKE THEIR TOLL

The San Francisco 49ers' failed three-peat attempt was the catalyst for many offseason changes.

Safety Ronnie Lott and running back Roger Craig played their final games with the organization. Both were exposed as Plan B free agents and signed with the Los Angeles Raiders a week apart in the spring of 1991.

The crushing loss to the New York Giants took a physical toll, too.

Quarterback Joe Montana sustained a broken right hand late in the game. The months of inactivity weakened his throwing arm, and he partially tore a tendon in his elbow after returning in training camp.

After seven weeks of rest, Montana tested his arm in an early October practice. The tendon tore completely, and he underwent season-ending surgery four days later to reattach the common flexor tendon to the bone.

Without Montana and Lott, the offensive and defensive leaders in each of the 49ers' four Super Bowl seasons, the team showed signs of falling apart. The nadir of the season occurred September 29 when the 49ers lost 12–6 to the Los Angeles Raiders.

Charles Haley went on a rampage in the losing locker room. Things got so bad that Lott, dressed only in a towel, was brought from the Raiders side into the 49ers locker room to get Haley to calm down.

Haley's behavior grew worse. He clashed with Tim Harris, a veteran the 49ers acquired who played the same position. George Seifert engineered a trade in the offseason to ship Haley to the Dallas Cowboys for two draft picks.

"I don't think Charles ever forgave me for Ronnie getting away," Seifert said.

Trading Haley to the Cowboys was a move both Seifert and owner Eddie DeBartolo would long regret. Haley went on to win three Super Bowls in five seasons in Dallas.

Haley battled with Seifert. In one of his most notorious incidents, Haley urinated on Harris' BMW. He demonstrated lewd locker room acts in front of teammates, staff, and reporters.

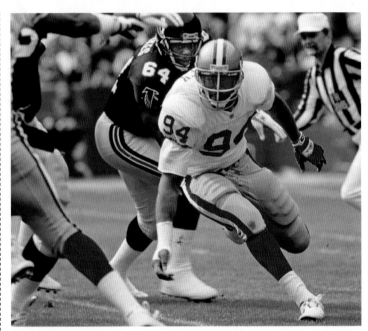

Charles Haley had another big year for San Francisco in 1991—collecting a team-high seven sacks and making his third Pro Bowl in four years—but his erratic off-field behavior led to his departure following the season.
GIN ELLIS/GETTY IMAGES

"As I look back at it now, in hindsight, I was a young head coach," Seifert said. "I reacted. There were some tough things going on with Charles. But if I'd been a head coach with more experience, I could've figured it out and found a way to get it done."

Haley, who had been a key component of two 49ers Super Bowl teams, revealed in 2010 that he struggled for years with bipolar disorder.

DeBartolo considered the trade of Haley one of his biggest mistakes as owner.

"If we don't trade Charles Haley, we win another Super Bowl," DeBartolo said. "There's no question in my mind. It was a mistake and I should've stepped in. I know he had some problems with some people, but we could've solved that."

HOME FOR THE PLAYOFFS

Steve Young opened the 1991 season as the 49ers' starter, and the team struggled. Steve Bono, the No. 3 quarterback, took over when Young sustained a knee injury in a 17–14 loss to the Atlanta Falcons.

With Bono in the starting lineup the next week, San Francisco lost at New Orleans to fall to 4–6 and tumble out of contention for a playoff spot. But the 49ers got hot to finish the season. Bono won four starts in succession to remain as the starter even after Young was cleared to return to action.

But when Bono sustained a knee injury of his own on December 14, Young became the starter again. Said Young, "Things wouldn't be normal if they weren't bizarre."

The 49ers finished the season as the hottest team in the league, posting six consecutive victories. Chicago Bears coach Mike Ditka accused the 49ers of running up the score in the season finale. Reserve quarterback Bill Musgrave tossed a touchdown pass late in the game when the Niners were already leading by a score of 45–14. (At least Ditka kept his gum in his mouth. In 1987, he fired a wad of gum into the stands at Candlestick Park and struck a fan at halftime of a game that the Bears lost 41–0.)

The loss to the 49ers to conclude the 1991 regular season prevented Chicago from winning the NFC Central. But the Bears were still going to the playoffs. The 49ers were not.

"It's no fun to lose like that any time," said Chicago quarterback Jim Harbaugh, whose team lost to the Cowboys the following week in an NFC wild-card playoff game.

Said Young, "I can't imagine we're not going to the playoffs with the way we're playing."

Aside from the nine-game, strike-shortened 1982 season, it was the only time from 1981 through 1998 the 49ers did not earn a trip to the playoffs.

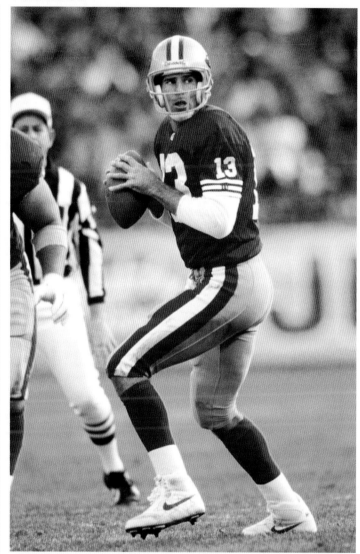

Filling in for an injured Steve Young, Steve Bono led the team to four straight wins down the stretch of the 1991 season. Against New Orleans, on December 1, he completed 27 passes for 347 yards and 3 touchdowns in the 38–24 victory. MICHAEL ZAGARIS/GETTY IMAGES

MONTANA INSPIRES
YOUNG

After sitting behind Montana for most of his first four seasons with the 49ers, Young opened 1992 as the starter for the second year in a row. Montana still was not fully recovered from the elbow injury that required surgery in 1991.

Young had played well, when healthy, in 1991 and posted a league-best passer rating of 101.8. In 1992, he was even better. Young led the 49ers to a 14–2 record in the regular season with a body of work that earned him recognition as the consensus NFL Player of the Year.

Perhaps more important, Young earned the respect of his teammates, being selected as the Len Eshmont Award winner. The team's most prestigious award goes annually to the team's most inspirational and courageous player. The players vote on the honor.

Although the years of Young and Montana together on the roster threatened the harmony in the locker room and led to a long period of uneasiness, Young was always quick to give credit to Montana.

At his induction into the Pro Football Hall of Fame in 2005, Young shared his motivation for his determination to remain with the 49ers when he could have demanded to go anywhere else and be a starter.

"Joe Montana was the greatest quarterback I've ever seen," Young said. "I was in awe. I was tempted many times to play for other teams. But I was drawn by the inevitable challenge to live up to the challenge that I was witnessing.

"I knew if I was ever going to find out how good I could get, I needed to stay in San Francisco and learn, even if it was brutally hard to do."

Young was on the back-to-back Super Bowl–winning teams of 1988 and 1989. His role was to remain ready in case there was a need to replace Montana. Young's services were rarely required.

"I remember watching Joe from the sideline and thinking, 'How do you do that?' I don't even know how to start thinking about doing

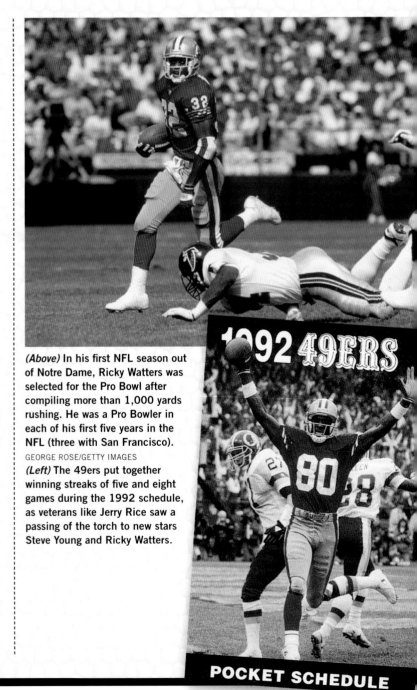

(Above) In his first NFL season out of Notre Dame, Ricky Watters was selected for the Pro Bowl after compiling more than 1,000 yards rushing. He was a Pro Bowler in each of his first five years in the NFL (three with San Francisco).
GEORGE ROSE/GETTY IMAGES
(Left) The 49ers put together winning streaks of five and eight games during the 1992 schedule, as veterans like Jerry Rice saw a passing of the torch to new stars Steve Young and Ricky Watters.

that," Young said at a 2012 charity event organized by Harris Barton that brought Young and Montana together on stage. "And by watching it, you start doing it."

Young was doing it as well as anyone in the NFL. In 1992, he completed 66.7 percent of his passes while throwing 25 touchdowns and seven interceptions. After an adjustment period together, Jerry Rice and Young began to develop chemistry similar to what Rice enjoyed with Montana. Rice caught 84 passes for 1,201 yards and 10 touchdowns.

Running back Ricky Watters, a 1991 draft pick, showed Roger Craig–like versatility with his running and receiving skills out of the backfield. He gained 1,013 yards rushing and added 43 receptions for 405 yards. Guard Guy McIntyre and tackle Steve Wallace did the work up front to earn Pro Bowl recognition.

On the other side of the ball, Harris led the team with 17 sacks, just one-half sack shy of Fred Dean's club record. Defensive lineman Pierce Holt was the only 49ers' defensive player chosen to the Pro Bowl.

One of the only two regular-season losses that season came in Week 2 when the two-time Super Bowl runner-up Buffalo Bills came to Candlestick Park for a memorable showdown.

Neither team punted. Both teams turned the ball over three times. Both quarterbacks, Young and Jim Kelly, threw for more than 400 yards and three touchdowns.

San Francisco wide receiver Mike Sherrard had six catches for 159 yards, and John Taylor added 112 yards receiving and two touchdowns. But Buffalo wide receiver Andre Reed caught 10 passes for 144 yards, and tight end Pete Metzelaars added 113 yards and two touchdowns as the Bills outlasted the 49ers 34–31.

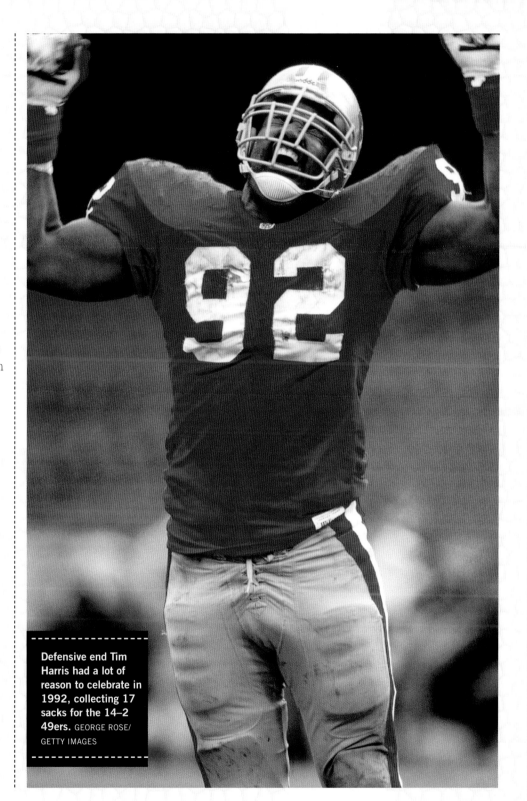

Defensive end Tim Harris had a lot of reason to celebrate in 1992, collecting 17 sacks for the 14–2 49ers. GEORGE ROSE/ GETTY IMAGES

MONTANA'S FINALE

The 1992 regular-season finale saw the conclusion to Joe Montana's career with the 49ers.

On Monday, December 28, 1992, against the Detroit Lions, Montana entered for the second half of play. It was his first action since his injury against the New York Giants on January 20, 1991. The crowd at Candlestick Park gave him a rousing ovation as he jogged onto the field.

"And all is right with the world once again," said Dan Dierdorf, an analyst on *Monday Night Football* as Montana took his familiar position.

Montana did not disappoint. He completed 15 of 21 passes for 126 yards and threw fourth-quarter touchdown passes to Brent Jones and Amp Lee.

"That game was almost my audition tape for my next job, and I had to prove I could still play," Montana said. "I went out with the attitude that I did not care what the score was, I was playing like it was a Super Bowl. I was happy and sad at the same time."

The 49ers won 13 of their final 14 games of the season to enter the playoffs as the No. 1 seed in the NFC. Montana remained on the sideline in the postseason as the 49ers opened at home against Washington.

Young threw for 227 yards and two touchdowns and added 73 yards rushing in a tough 20–13 victory over Washington. The defense won the game for the 49ers, as defensive tackle Pierce Holt recorded three sacks. The 49ers sacked Washington quarterback Mark Rypien four times on the final drive to preserve the victory.

Eight days later, the 49ers were established as four-point favorites at

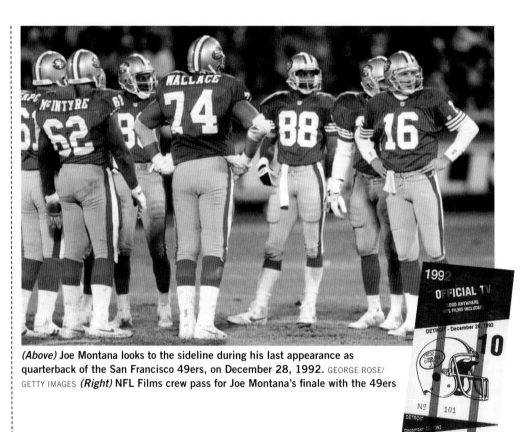

(Above) Joe Montana looks to the sideline during his last appearance as quarterback of the San Francisco 49ers, on December 28, 1992. GEORGE ROSE/ GETTY IMAGES *(Right)* NFL Films crew pass for Joe Montana's finale with the 49ers

Candlestick Park against Dallas in the NFC Championship Game.

Haley was in his first season with the Cowboys, a team that featured burgeoning offensive stars running back Emmitt Smith, quarterback Troy Aikman, and wide receiver Michael Irvin.

Young was intercepted twice in the game. He threw for 313 yards and a

touchdown to Jerry Rice in the fourth quarter that cut the Cowboys lead to 24–20. But the Cowboys responded with a 70-yard catch by Alvin Harper that led to another Dallas touchdown and the final margin of 30–20.

In 1993, the 49ers dealt Joe Montana to the Kansas City Chiefs, where he played the final two seasons of his career.

COWBOYS IN CHARGE

The 49ers took a step back in 1993, and there was little doubt that the reigning Super Bowl–champion Cowboys were the best team in all of football. The 49ers were just as clearly a distant second.

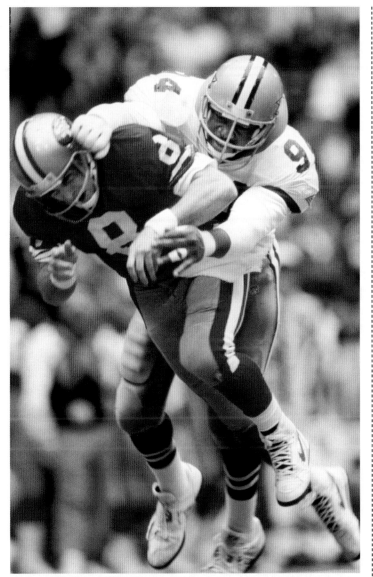

Former teammate Charles Haley was just one of many Cowboys players to harass the 49ers during the 1993 NFC Championship Game, won by Dallas 38–21 on January 23, 1994. JAMES SMITH/GETTY IMAGES

San Francisco won the NFC West with a 10–6 record, and Young became the first player in NFL history to lead the league in passing for three consecutive seasons. Rice was NFL Offensive Player of the Year after recording 98 catches, 1,503 receiving yards, and 15 touchdowns.

There was little standing in the path of another 49ers–Cowboys matchup for NFC supremacy.

The 49ers blitzed the New York Giants, 44–3, in a divisional playoff game at Candlestick Park. Ricky Watters established a single-game NFL playoff record with five rushing touchdowns. He scored from 1, 1, 2, 6, and 2 yards while picking up a total of 118 yards on 24 carries.

That victory set up another date with the Cowboys in the NFC Championship Game, this time at Texas Stadium. Dallas was very good. And they knew it.

Brash head coach Jimmy Johnson, perhaps emboldened by a cocktail or two, called a Dallas radio station on the Thursday before the game and declared, "We will win the ballgame. And you can put it in three-inch headlines: 'We will win the ballgame!'"

The following day, Seifert responded: "Well, the man's got balls. I don't know if they're brass or papier-mâché. We'll find out here pretty soon."

The Cowboys' team speed proved too much for the 49ers to handle. Dallas scored 21 unanswered points in the second quarter and rolled to a 38–21 victory. The Cowboys capped the season with their second consecutive Super Bowl title over the Buffalo Bills.

The loss was particularly difficult for DeBartolo and team president Carmen Policy because there was no denying that Seifert did not have the talent necessary to compete with the squad that Cowboys owner Jerry Jones put together.

SUPER GOAL

After starting the season 1–2, the 49ers won 12 of their final 13 games to enter the 1994 playoffs with the best record in football at 13–3.

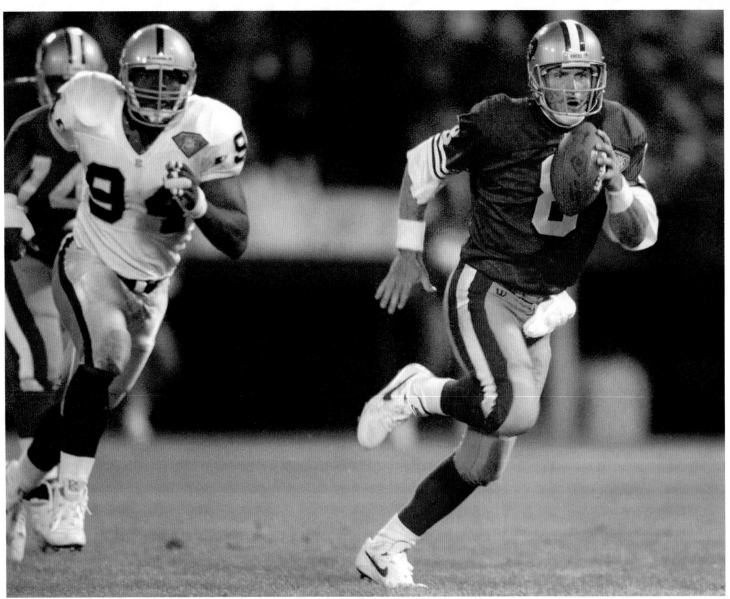

Steve Young had another phenomenal year in 1994. In addition to his league-leading and career-high 112 passer rating and 70.3 completion percentage, he also led the 49ers with seven rushing touchdowns on the season. RONALD C. MODRA/SPORTS IMAGERY/GETTY IMAGES

The previous season, the 49ers signed safety Tim McDonald from the Cardinals. In the offseason before the 1994 campaign, San Francisco beefed up its defense with the additions of linebackers Ken Norton Jr., a member of the Cowboys' Super Bowl teams, and Gary Plummer. They added pass rushers Rickey Jackson, Richard Dent, and Charles Mann, and cornerback Toi Cook.

The draft produced results for the 49ers, too. The club traded up to select defensive tackle Bryant Young of Notre Dame. In the second round, they grabbed fullback William "Bar None" Floyd. The 49ers found a surprise in the sixth round, as linebacker Lee Woodall of West Chester earned his way into the starting lineup as a rookie.

It was Super Bowl or bust for the 49ers.

The pressure was driven up a few notches with an emotional Week 2 game at the Kansas City Chiefs, where Joe Montana awaited to play his former team. Montana passed for just 203 yards, but he threw two touchdowns. Young had 288 yards passing but threw two interceptions and was sacked four times, including once for a safety, in a 24–17 loss to the Chiefs.

Four days later, the 49ers signed free-agent cornerback Deion Sanders to a one-year contract and moved right cornerback Merton Hanks to free safety. Hanks benefited as much as anyone from Sanders's arrival, as his game went prime time. Hanks picked off seven passes in 1994. He had 26 interceptions over a five-year span and his "pigeon dance," patterned after Bert from *Sesame Street*, became his signature celebratory expression.

With Sanders locked in for one season, he seemingly handled half the field. The other half of the secondary was in the good hands of Eric Davis, who emerged as a top-flight cornerback. In November, the 49ers added pass-rusher Tim Harris for his second tour of duty with the club.

Ironically, the turning point of the 49ers' season came at the team's lowest point. In Week 5, the Philadelphia Eagles thumped the 49ers, 40–8, at Candlestick Park. The most memorable moment of the game occurred on the sideline.

Seifert took Young out of the game in the third quarter after he threw two interceptions and had taken several hard sacks. On the sideline, the usually mild-mannered Young flew into a rage at his head coach.

"As a player you want to go the distance," Young said afterward. "There's never a time when you say, 'Well, this game is over.' I would much rather beat myself to a pulp trying to get back into the game than have to wait until next week."

The outburst seemed to galvanize the 49ers at a point of adversity. Nobody was under more pressure than Seifert, who had not delivered a Super Bowl title since his first season as head coach.

Moving over to the safety position allowed Merton Hanks to put forth his first of four straight Pro Bowl seasons in 1994. He collected a career-best seven interceptions that year—plus one more in the playoffs against Chicago, seen here. PETER BROUILLET/GETTY IMAGES

The 49ers' flagship radio station, KGO, conducted a listener poll, asking if Seifert should be fired. The numbers were overwhelming against Seifert. When he learned of the results, Seifert responded, "I'd like to thank the fifteen percent who voted for me."

The 49ers rallied for a 27–21 triumph over the Detroit Lions the following week to begin a streak of 10 consecutive victories before the reserves lost a meaningless regular-season finale to the Minnesota Vikings.

The 49ers averaged 31.6 points a game in 1994. Young compiled an extraordinary passer rating of 112.8. Wide receiver Jerry Rice etched his name in the record book in Week 1 when he eclipsed Jim Brown's NFL record with his 127th career touchdown. Sanders was named NFL Defensive Player of the Year after recording six interceptions and turning them into 303 return yards, including three touchdowns.

NEON DEION

The 49ers had a certain way of doing things, and coach George Seifert was not sure if he liked the idea of Deion Sanders testing the limits.

Even with all the star power owner Eddie DeBartolo accumulated throughout the 1980s and 1990s, the 49ers typically maintained a businesslike work approach. Nobody had ever accused Sanders of being just another blue-collar worker.

"When Deion first came to us, I was not a fan of his game-day antics," Seifert admitted. "I was concerned about that, but I knew we had a strong locker room. Eddie busted his butt to get him to come in and be a part of the team.

"The enjoyable thing was watching him practice and how he handled himself in meetings. Now, game days he did a couple things contrary to an old guy like myself. But his practices and preparation were everything you'd want as a coach. Deion was not a screw-around kind of guy."

Sanders, who signed a one-year contract with the 49ers in Week 3, had six interceptions for a team-record 303 yards in interception return yards. He returned three interceptions for touchdowns and was named NFL Defensive Player of the Year.

"All he wanted to know was who he was going to cover man-to-man," longtime defensive assistant coach Bill McPherson said. "George would get so mad because Deion wouldn't go to the huddle. George would come into the meetings and say, 'Get him in the damn huddle!'

"We'd have to say, 'Don't worry about him.' Deion would say, 'Which cat do I got?' We could roll our defense away from him because he was unbelievable. He'd bait receivers. He'd play off of the receiver, and then he had the speed and acceleration to make a break on the ball."

In the 49ers' 49–26 victory over the San Diego Chargers in the Super Bowl, Sanders had one interception and two passes broken up.

The 49ers typically kept Sanders on an island at right cornerback, and the 49ers shifted Merton Hanks to free safety. Eric Davis locked down left cornerback. Hard-hitting Tim McDonald, who earned three straight Pro Bowl trips, rounded out a defensive backfield that Sanders called the "best secondary to me" during his Pro Football Hall of Fame induction speech in 2011.

DALLAS GOES DOWN

The 49ers quickly dismantled the Chicago Bears, 44–15, in the divisional round of the 1994 playoffs at Candlestick Park. Floyd scored three rushing touchdowns, and Young threw an 8-yard touchdown pass to Brent Jones and ran for another touchdown to set up another meeting against the Cowboys in the NFC Championship Game.

Among the 49ers' defensive backs, Sanders got most of the attention. But Eric Davis came up with the biggest plays as the 49ers finally got over the hump to defeat Dallas for a trip to the Super Bowl.

Davis intercepted Troy Aikman in the first quarter and returned it 44 yards for a touchdown. He also forced a fumble that the 49ers cashed in for another touchdown. San Francisco had five takeaways in all and took a 21–0 lead. The Cowboys came back, but Young hit Rice with a 28-yard pass at the end of the first half to secure a commanding 31–14 advantage.

Although Young did not have a great game, completing just 13 of 29 attempts for 155 yards, he tossed two touchdowns and no interceptions. Afterward, he took a victory lap around Candlestick Park to share the moment with the fans.

"It's one of the most emotional sidelines I've been involved in since I've been coaching," Seifert said afterward. "It's one of the most exciting experiences certainly in my life. It's just great to be part of this. To see Steve Young's emotions is something I won't forget. I've been here for four Super Bowl rings, I've got four rings, but none compares to the emotion of this."

The 49ers had already made it past the Cowboys, so Super Bowl XXIX against the San Diego Chargers seemed to be a mere formality. San Francisco was a 19-point favorite and cruised to a 49–26 victory in a game that wasn't even that close.

Young, the man who sat and learned from Montana for the first four seasons of his Niners career, saved his best performance for last. Young completed 24 of 36 passes for 325 yards and a Super Bowl record six touchdowns. Young was named the game's MVP. Jerry Rice had 10 catches for 149 yards and three touchdowns. Ricky Watters added three touchdowns in the romp.

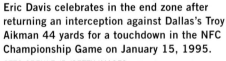

Eric Davis celebrates in the end zone after returning an interception against Dallas's Troy Aikman 44 yards for a touchdown in the NFC Championship Game on January 15, 1995.
OTTO GREULE JR./GETTY IMAGES

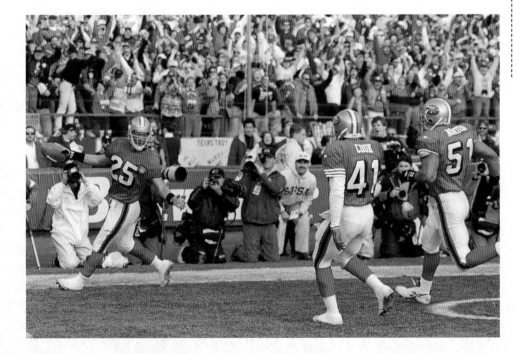

SUPER BOWL XXIX: ON A MISSION

Owners Eddie DeBartolo and 49ers President Carmen Policy were on the elevator at Texas Stadium in January 1994. The Dallas Cowboys had once again defeated the 49ers in the NFC Championship Game.

DeBartolo looked at Policy. He said, "We cannot let this happen again."

And, thus, the 49ers enacted a plan to beef up the roster to compete against Jerry Jones' team, which would go on to win its second consecutive Super Bowl title. The 49ers went on a free-agent spending spree, adding a number of veteran players nearing the ends of their careers.

Hard-nosed linebacker Gary Plummer was the first piece added to the defense. A month later, the 49ers signed linebacker Ken Norton Jr. away from the Cowboys. The 49ers later acquired defensive linemen Ricky Jackson, Charles Mann, and Richard Dent. Cornerback Toi Cook was added for depth. On offense, the 49ers signed center Bart Oates and wide receiver Ed McCaffrey.

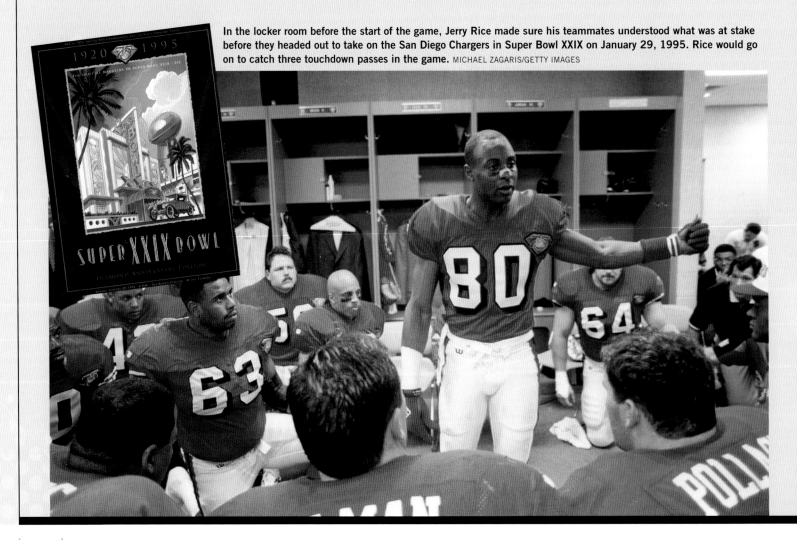

In the locker room before the start of the game, Jerry Rice made sure his teammates understood what was at stake before they headed out to take on the San Diego Chargers in Super Bowl XXIX on January 29, 1995. Rice would go on to catch three touchdown passes in the game. MICHAEL ZAGARIS/GETTY IMAGES

Quarterback Steve Young earned MVP honors in Super Bowl XXIX for his record-setting six touchdown passes in the game. GEORGE ROSE/GETTY IMAGES *(Right)* The 49ers brought home the fifth Super Bowl ring in franchise history with the 49–26 win over the Chargers in Super Bowl XXIX.

In Week 3, they brought in Deion Sanders to a minimal contract that included a $750,000 bonus if the 49ers won the Super Bowl.

Dent recorded two sacks in two games before sustaining a season-ending injury. And Mann was just a minor contributor. In November, the 49ers signed Tim Harris, adding another quality pass-rusher. Harris recorded two sacks in the final five regular-season games. He had 4.5 sacks in the playoffs, including two against Dallas in the NFC Championship Game.

With the 49ers' 38–28 victory over the Cowboys, the 49ers had the formality of defeating the San Diego Chargers ahead of them to win Super Bowl XXIX and fulfill the mission statement from the elevator ride the year before.

Quarterback Steve Young threw six touchdown passes and the 49ers cruised to a 49–26 victory at Joe Robbie Stadium. Policy was named NFL Executive of the Year.

"That season belonged to everybody in the organization," 49ers coach George Seifert said. "It was the whole deal. We had Carmen signing guys with the new salary cap. All of the scouts did their jobs. We had young players mixing with the older players. It was awesome. You talk about teams, that was Eddie's greatest organization."

CHAMPIONS RECONFIGURE

The 49ers' Super Bowl victory was followed by a lot of offseason changes. Offensive coordinator Mike Shanahan and defensive coordinator Ray Rhodes were hired as head coaches of the Denver Broncos and Philadelphia Eagles, respectively. Rhodes went on to become NFL Coach of the Year in his first season. Shanahan won two Super Bowls with Denver.

The team that had added important players via free agency in 1994 lost a number of key pieces after the season, including Sanders and Watters. The 49ers signed free-agent cornerback Marquez Pope to step in for Sanders, and Derek Loville was given a shot to replace Watters.

The 49ers lost two games in three weeks when second-year kicker Doug Brien missed last-second field goals. He missed a 40-yard attempt at Detroit on *Monday Night Football* that would have forced overtime. Two games later, he missed from 46 yards to enable the Indianapolis Colts to hold on for an 18–17 victory.

Only years later did Seifert find humor in the visual of Colts quarterback Jim Harbaugh reveling in the 49ers' demise as he ran past the 49ers' sideline in celebration.

"He was very flamboyant in the way he reacted," Seifert said of Harbaugh. "It was unique. He did the airplane. He ran by our bench after they secured the win, looking at us, smiling in a mocking way. At the time it wasn't too amusing. But, now, looking back on it, it was one of the funny things that happened."

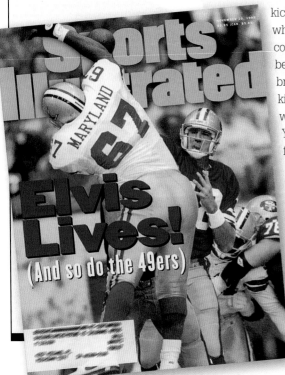

The 49ers signed kicker Tony Zendejas, who lasted just a couple of games, before the team brought in first-year kicker Jeff Wilkins, who played at Youngstown State, to finish the season.

The 49ers lost four of six games, including an 11–7 loss to the New Orleans Saints in which fullback William Floyd was lost for the season with a knee injury. That was followed by a 13–7 defeat at the hands of the Carolina Panthers.

Next on the schedule was a date at Texas Stadium against the heavily favored Cowboys. The 49ers had to play with Steve Young on the sideline with an injured shoulder and Deion Sanders in a Dallas uniform.

Backup Elvis Grbac found Jerry Rice for an 81-yard touchdown on the second play of the game. Thirteen seconds later, Merton Hanks picked up a Michael Irvin fumble and raced 38 yards for a touchdown.

The 49ers upset the Cowboys, 38–20, and kept the momentum going with Grbac at quarterback in a 44–20 victory over the Miami Dolphins a week later.

San Francisco won the NFC West with an 11–5 record but failed to secure home-field advantage throughout the playoffs due to a final-game loss to the wild-card-clinching Atlanta Falcons.

The 49ers entered the postseason with a home game against the upstart Green Bay Packers and their young quarterback, Brett Favre. Things did not start well. Fullback Adam Walker, who was playing with a broken thumb, had taken over for Floyd.

On the first play of the game, Young threw a swing pass to Walker, who caught the ball but fumbled upon being hit by Green Bay linebacker Wayne Simmons. Cornerback Craig Newsome picked up the ball and returned it 31 yards for a tone-setting touchdown.

The 49ers were playing catch-up all game. With no semblance of a running game, Young attempted an NFL postseason record 65 passes. He completed 32 of them for 328 yards with no touchdowns and two interceptions.

The 49ers' bid for a repeat came to an end with a 27–17 loss to Green Bay, a team that would become the organization's new NFC nemesis.

Despite a midseason injury to Steve Young, backup quarterback Elvis Grbac helped instill new life into the 49ers in 1995.

LIVING THE DREAM

A s a youngster who attended school across the street from the home of the San Francisco 49ers, George Seifert had only one team near to his heart.

And throughout his coaching career he somehow maintained the same boyish enthusiasm for his hometown team.

"I've earned a paycheck from somebody else at one time, but the 49ers have always been my team and that hasn't changed," said Seifert, who earned five Super Bowl rings with the 49ers—two as head coach and three as an assistant under Bill Walsh.

As a kid, Seifert worked 49ers games as an usher at Kezar Stadium. He agonized along with the paying customers when the 49ers squandered a big lead and lost to the Detroit Lions in a 1957 playoff to deny the organization a trip to the NFL Championship Game.

"I was ushering as a way to get into the games free," Seifert said. "It was a great time and a great era."

Later, Seifert's coaching path would take him to Stanford with Bill Walsh. He joined Walsh's staff with the 49ers as defensive backs coach in 1980.

And when the 49ers finally advanced to Super Bowl XVI with the momentous victory over the Dallas Cowboys, nobody had to tell Seifert the historical significance of the moment. The 49ers had recorded playoff losses to the Cowboys three consecutive seasons in the early 1970s.

In the moments after Dwight Clark caught the go-ahead touchdown, Seifert's coaching life quite possibly hung in the balance. Everybody remembers "The Catch." What Seifert reflects on was possibly the most important play of his coaching career.

With the 49ers protecting a 28–27 lead, Dallas quarterback Danny White found Drew Pearson down the middle of the field. Defensive backs Carlton Williamson and Ronnie Lott collided.

Rookie cornerback Eric Wright managed to pull down Pearson with a then-legal horse-collar tackle at the 49ers' 44-yard line with 38 seconds remaining to prevent a touchdown.

If the 49ers had given up the winning points on such a play, Seifert realizes he probably would have paid the price for the inexcusable blunder.

"That tackle was lifesaving for a young coach," Seifert said. "Eric Wright has long been a family hero. If he'd missed that tackle, the only question is: What high school would I be coaching at the next year?"

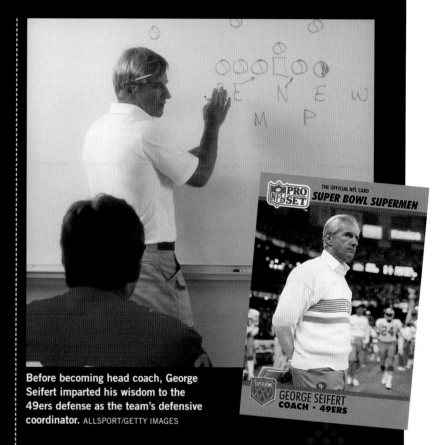

Before becoming head coach, George Seifert imparted his wisdom to the 49ers defense as the team's defensive coordinator. ALLSPORT/GETTY IMAGES

THE OFFICIAL NFL CARD
SUPER BOWL SUPERMEN
GEORGE SEIFERT
COACH · 49ERS

Seifert not only continued coaching on the 49ers' staff, but he continued to rise in the organization. Among the highlights for Seifert was the mere chance to work in the same building as two of his football heroes. R. C. Owens and Billy Wilson, who Seifert admired as players, were longtime 49ers employees after their playing days concluded.

Seifert was known as a cutting-edge defensive coach on Walsh's staffs. And after the 49ers won the Super Bowl following the 1988 season, Seifert was a hot commodity. He boarded a plane to interview with the Cleveland Browns for their head-coaching job. Unbeknownst to him, Walsh had decided to retire as coach.

Seifert was promoted to head coach and remained in that office for eight seasons with a record of 98–30–1 (.766). Seifert kept the 49ers near the top of the football world for the entirety of his reign at the helm.

NEW RIVALS EMERGE

San Francisco found another worthy foe within the NFC West in 1996. The Carolina Panthers, in that franchise's second season, unseated the 49ers for the top spot in the division. Cornerback Eric Davis, a second-round draft pick for the 49ers in 1990, was never offered a contract despite being selected to his first Pro Bowl following the 1995 season. The Panthers signed Davis as a free agent to shore up their secondary.

The 49ers, however, received contributions from a free-agent class that included guard Ray Brown and defensive linemen Chris Doleman and Roy Baker. The Niners finished with a 12–4 record. Two of their losses came against the Panthers, who finished with the same record but won the division based on head-to-head record.

Young missed four games due to injuries, and Elvis Grbac stepped in and generally played well. The exception came on November 10 when the Cowboys defeated the 49ers, 20–17, in overtime at Candlestick Park. Mayor Willie Brown, who was in Paris on business, spoke to the Bay Area via radio and referred to Grbac as a "disgrace to humankind." Grbac had gotten little sleep the week before, as he spent his nights in a San Francisco hospital after his infant son was recovering from spina-bifida surgery.

The 49ers were in a three-year stretch in which the defense was every bit as strong statistically as the offense. Defensive linemen Bryant Young, Doleman, and Barker each recorded 11 sacks or more.

And play-making safety Merton Hanks earned his third consecutive trip to the Pro Bowl.

Again, Seifert was on the hot seat as head coach. A sense of desperation grew inside the organization. Former coach Bill Walsh was brought back to work with second-year offensive coordinator Marc Trestman.

So the playoffs were of the utmost importance for a franchise that only considered a season successful if it ended with a Lombardi Trophy.

The 49ers advanced past the Philadelphia Eagles, 14–0, in the wild-card round of the playoffs. But the victory came with a price. While rushing for a 9-yard touchdown in the second quarter, quarterback Steve Young sustained broken and displaced ribs.

With rain in the forecast for the Bay Area, the 49ers traveled to Arizona the following week for work at the Cardinals' practice facility before flying to Green Bay to face the Packers at Lambeau Field.

Young had several pain-killing injections in his ribcage prior to kickoff. Young started and completed two of five pass attempts before it was determined he could not continue. Grbac was intercepted three times in a game played in 34-degree conditions with a driving rain.

Desmond Howard returned a punt 71 yards for a first-quarter touchdown, and Green Bay led 21–0 early in the second quarter. The Packers went on to a 35–14 victory, ending the 49ers' season for the second year in a row.

Tight end Brent Jones was a four-time Pro Bowl player during his 11-year career with the 49ers beginning in 1987. He took over as the starter in 1989 and played through the 1997 season, amassing 417 receptions for 5,195 yards and 33 touchdowns as one of Steve Young's favorite targets.
AL BELLO/ALLSPORT/GETTY IMAGES

SEIFERT OUT; MARIUCCI IN

About a week after the 1996 season concluded, team president Carmen Policy met with Steve Mariucci, a charismatic former Packers assistant who had just completed his first season as coach at Cal. Mariucci was offered a position as 49ers offensive coordinator with assurances he would become the head coach within two seasons. Mariucci declined the 49ers' proposal.

But things quickly changed. Seifert figured his time with the 49ers was coming to an end, and rather than accept lame-duck status, he stepped down. The 49ers offered Mariucci the head-coaching job. And DeBartolo paid Cal three times the $100,000 buyout figure that was in his contract.

The following day, Seifert took part in a press conference to announce his resignation and Mariucci's appointment as the team's next head coach. Seifert and Walsh joined Mariucci for a photo.

"I even asked Carmen, 'Why isn't George the coach? He's terrific. He's great,'" Mariucci said. "And what Carmen told me was that there's a shelf life for every coach."

Policy explained, "Bill gave us ten great years, George had eight years. You won't be here forever, either. We want your best for as long as you're here. There will be a time when we need a fresh voice and a new message. That's our way of doing things."

Seifert, whose teams won two Super Bowls and had a win percentage of .766 in eight seasons, seemed to understand the 49ers' way of business.

"It happened to Bill Walsh. It happened to Joe Montana. It happened to Ronnie Lott," Seifert told Dennis Georgatos of the Associated Press. "Basically, it was my turn to move on. That's just part of the process, shedding off old skin for the new skin. It's like a snake. You get a new skin and keep on going so you can survive."

The 49ers geared up in 1997 for another championship run in Mariucci's first season. The 49ers added a handful of veteran free agents to immediately step in as starters. Running back Garrison Hearst and Kevin Gogan were brought aboard to help a struggling run attack. Hearst was the team's first 1,000-yard rusher since 2002. Pass-rusher Kevin Greene and cornerback Rod Woodson were added to a defense that would be ranked No. 1 in the NFL.

San Francisco's new head coach, Steve Mariucci, confers with its franchise player, Steve Young, early in the 1997 season. OTTO GREULE JR./ ALLSPORT/GETTY IMAGES

A ROUGH START GIVES WAY
TO ANOTHER DIVISION CROWN

Mariucci's coaching debut could not have gone much worse. Jerry Rice's season seemingly came to an end when Tampa Bay Buccaneers defensive tackle Warren Sapp brought Rice down by the facemask on an end around. Rice sustained a torn anterior-cruciate ligament in his left knee.

Sapp also delivered a knee to Young's head that sent the quarterback out of the game with a concussion. Backup quarterback Jeff Brohm was also injured, as were Brent Jones and Kevin Greene. The 49ers opened the Mariucci era with a 13–6 loss to the Buccaneers.

"I started thinking that maybe I should go back to Cal and sell tie-dye T-shirts on Telegraph Avenue," Mariucci said.

Young, who sustained two concussions the previous season, and Brohm were unavailable to play the following week in St. Louis. The 49ers had no choice but to turn to first-round draft pick Jim Druckenmiller for the only start of his short career.

Druckenmiller had reported to camp late because the 49ers did not have enough salary-cap room to sign their first-round draft pick. Woefully unprepared, Druckenmiller completed just 10 of 28 passes for 102 yards, but one of his completions was a 25-yard strike to J. J. Stokes for the only touchdown in a 15–12 victory over the Rams.

Rice was not placed on season-ending injured reserve, as the 49ers held out hope he could return for the playoffs. His absence allowed Stokes and Terrell Owens the opportunity to show what they

With Jerry Rice down for the season, primary receiving duties fell to Terrell Owens (81), tight end Brent Jones (84), and J. J. Stokes (obscured behind Jones) in 1997. The trio caught 147 passes, and fullback William Floyd chipped in 37 more. OTTO GREULE JR./ALLSPORT/GETTY IMAGES

In his fifth season, Dana Stubblefield stepped it up a notch in 1997, tallying 15 sacks and earning All-Pro and Defensive MVP honors.

could do. Owens, a second-year player, caught a team-high 60 passes for 936 yards and eight touchdowns. Stokes added 58 receptions for 733 yards and four scores.

The 49ers' No. 12 league-wide ranking was its lowest-ranked offense since the franchise's first Super Bowl season. But the team's top-ranked defense made up for it. Defensive tackle Dana Stubblefield, who recorded four sacks in a Monday night victory over the Philadelphia Eagles, was named NFL Defensive Player of the Year. Stubblefield was second in the league with 15 sacks. Doleman had 12 sacks, while Greene added 10.5.

J. J. Stokes leaps to make one of his nine catches in the NFC divisional playoff game against the Vikings on January 3, 1998. Stokes tallied 101 receiving yards in the 38–22 49ers win. OTTO GREULE JR./GETTY IMAGES

Five of the seven 49ers named to the NFC Pro Bowl team were on the defensive side: Stubblefield, Doleman, Hanks, and linebackers Lee Woodall and Ken Norton Jr. Guard Kevin Gogan joined Young on offense.

After the season-opening loss, San Francisco rattled off 11 consecutive wins and finished the regular season with a 13–3 record and home-field advantage in the playoffs.

But the organization changed forever in early December when DeBartolo stepped down from any involvement with the team after he became the focus of a federal investigation into gambling fraud in Louisiana. DeBartolo ultimately pleaded guilty to the felony charge of failing to report an extortion attempt by former Louisiana Governor Edwin Edwards. DeBartolo would never regain control of the team. His sister, Denise DeBartolo York, and her husband, John York, took over as the co-chairs of the 49ers.

The team's popular owner was out, and the 49ers would have to move into the playoffs without Jerry Rice, too.

Rice had targeted the 49ers' Monday night game on December 15 as his return date. He returned to action and even caught a touchdown pass in the 49ers' 34–17 victory over the Broncos. But Rice sustained a fractured kneecap when he landed in the end zone.

The bone had been weakened by the September surgery to repair his ACL.

Running back Terry Kirby gained 120 yards and two touchdowns, and Ken Norton returned an interception 23 yards for a touchdown in the 49ers' 38–22 victory over the Minnesota Vikings in the divisional round of the playoffs.

That set the stage for an NFC Championship Game showdown against the Packers on a rainy day at Candlestick Park. Owens and Stokes did not appear ready for the magnitude of the game. Both dropped passes, and the 49ers' run game could not get going, either.

Still, the defense had a chance for a game-changing play. On the opening play of the second half, with the 49ers trailing 13–3, Packers fullback William Henderson caught a pass in the right flat and was immediately hit by linebacker Lee Woodall. Linebacker Gary Plummer scooped up the ball and ran it into the end zone for an apparent touchdown. However, the pass was ruled incomplete, nullifying the score.

The 49ers were never able to gain any momentum. They trailed 23–3 before Chuck Levy returned a kickoff 95 yards for a fourth-quarter touchdown. The Packers were 23–10 winners and went on to lose to Mike Shanahan's Denver Broncos in Super Bowl XXXII.

ANOTHER RUN

The following season, Stubblefield signed a lucrative free-agent contract with Washington. Greene and Woodson were gone after one season. The 49ers tried unsuccessfully to fill some areas of need through free agency. Plummer, one of the team's consummate pros, announced his retirement. San Francisco signed Winfred Tubbs to replace him. The 49ers also swung and missed mightily with a pair of free-agent acquisitions: cornerback Antonio Langham and defensive lineman Gabe Wilkins.

But there was still plenty of talent remaining. Garrison Hearst rushed for 1,570 yards in 1998, while Young threw for 4,170 yards and 36 touchdowns. After failing to play in a complete game the previous season due to two separate knee injuries, Rice was back in pre-injury form, securing a team-leading 82 catches for 1,157 yards and nine touchdowns. Owens truly emerged as a playmaker with 1,097 yards and 14 touchdowns.

The season opened in dramatic fashion with a 36–30 overtime win against the New York Jets at Candlestick Park. On the first play of overtime, Hearst took a handoff and got a great block by pulling left guard Ray Brown. Hearst broke a couple of tackles and then had a devastating stiff arm. In the meantime lineman Dave Fiore was running with Hearst for the first 70 yards. Owens caught up to Hearst and ran interference for the final yards of Hearst's 96-yard game-winning touchdown run.

Things really appeared to be coming together on November 30 when the 49ers played host to the New York Giants on *Monday Night Football*. But the 49ers' impressive 31–7 victory

Garrison Hearst rattled off seven 100-yard rushing games in 1998 (including the playoffs), and he got off to an impressive start in the season opener against the Jets. A 96-yard touchdown run contributed to a 187-yard day.
OTTO GREULE JR./ALLSPORT/GETTY IMAGES

The first playoff game provided an abundance of drama, as the 49ers were facing the Green Bay Packers in an NFC wild-card matchup.

Owens had a difficult game with several dropped passes. But in a time of desperation, Young looked for Owens once again. With eight seconds remaining and the 49ers trailing 27–23, Young stumbled while backing out from center. He regained his balance and threw a perfect pass for Owens between four Green Bay defenders. The 25-yard score was Young's third touchdown pass of the game.

While some chose to call Owens' grab "The Catch II," longtime 49ers offensive line coach Bobb McKittrick had a different idea. He believed Young's perfect throw was what made the play happen. The following day, McKittrick wrote "4,400" on a grease board.

Explained McKittrick, "I put that up on the board and I said this is how many passes he [Young] has thrown here and I've seen every one of them. And there's none that was as great a pass as that."

The following week, though, the 49ers' season came to an end. Hearst sustained a fracture to his lower left leg on the first play of their divisional-round game against the Atlanta Falcons while making a cut in the hole. He would miss the next two seasons when the bone did not properly heal due to lack of blood flow.

The 49ers also lost their top remaining defensive lineman for nearly half the game. Mariucci vividly recalls that former 49ers public-relations director Rodney Knox came to him on the sideline to inform him that Doleman's mother was receiving treatment inside the 49ers locker room after suffering a heart attack.

Mariucci summoned Doleman, who rarely came off the field, to the sideline and advised him to get into the locker room. Doleman rode in the ambulance with his mother to the hospital. After she stabilized, Doleman returned to the Georgia Dome and finished the game.

Without Hearst, San Francisco managed just 46 rushing yards. Meanwhile, Jamal Anderson powered the "Dirty Birds" with 113 yards and two touchdowns on the ground for a 20–18 victory at the Georgia Dome.

was overshadowed by a grisly injury to one of the team's most-respected stars.

Defensive tackle Bryant Young sustained breaks to his tibia and fibula when teammate Ken Norton inadvertently drove into Young's right lower leg as it was planted. Young was immediately taken to Stanford Hospital, where surgery was performed to place a titanium rod in his leg.

"The guy has an 'S' on his chest," Mariucci said. "If somebody can recover from something like this, like a Jerry Rice can recover from his surgeries, B.Y. is in that category. So we have to remain optimistic for next season."

Optimism still remained high for the playoffs, and the 49ers' solid defensive line, led by Doleman, Junior Bryant, and Roy Barker, picked up the slack. San Francisco made the playoffs as a wild card with a 12–4 record behind the NFC West champion Atlanta Falcons.

FIVE McRINGS

Seen here in 2011, former team executive John McVay admires the fruit of his many years of labor with the San Francisco 49ers organization—five Super Bowl trophies. AP PHOTO/PAUL SAKUMA

The 49ers won five Super Bowls over a span of 14 seasons, and only a few members of the team's coaching staff and front-office leadership had hands-on roles in each of the titles.

The five-ring club includes three men who made incredible impacts in the front office, offense, and defense: John McVay, Bobb McKittrick, and Bill McPherson.

McVay is considered one of the unsung heroes of the 49ers' organization after coming to the franchise as director of football operations upon the 1979 hiring of Bill Walsh as head coach.

McVay, who served as New York Giants head coach from 1976 to 1978, was known for his unflappable and steady manner. He was the front-office person most likely to remain calm in the face of a crisis. And that occurred often with quick-tempered owner Eddie DeBartolo and Bill Walsh.

"I don't know how many times we'd lose a game when Eddie and Carmen [Policy] were back in Youngstown, and Eddie would get mad and fire Bill," McPherson said. "All the coaches would know about it, and we'd wonder if Bill had been fired or if Bill would quit. We'd have a Monday morning meeting, and John McVay would walk him and said, 'OK, men, don't worry about what went on yesterday. We'll take care of it.'

"I can't say enough about how he kept the thing afloat when things were hot."

McVay even returned to the 49ers to help guide the organization in October 1998 when top executives Carmen Policy and Dwight Clark left to join the expansion Cleveland Browns.

"John McVay is as good as it gets," Steve Mariucci said. "I love him. He's Mr. Steady. He doesn't get nearly enough credit for helping start the dynasty way back with Bill."

In fact, it wasn't until after Walsh retired as head coach in 1988 that McVay received any formal recognition. In 1989,

McVay was honored as NFL Executive of the Year as the 49ers won back-to-back Super Bowl titles.

From 1982 through 1999, the 49ers ranked outside the top 10 in total offense just once. The 49ers chose an offensive lineman in the first round only once during that time (Harris Barton in 1987). The one constant was McKittrick.

He remained as line coach from the 1979 season until his death from bile duct cancer on March 15, 2000. He always managed to mold his undersized, athletic groups into one of the top units in the NFL.

"I don't play golf, don't ski, don't hunt, don't fish, don't play tennis," McKittrick once said. "I coach football and I love it."

McPherson was also hired on Walsh's first 49ers staff in 1979. During his 20 seasons as an assistant, McPherson coached the defensive line and linebackers.

He was defensive coordinator when the 49ers won the Super Bowl following the 1989 season. He was George Seifert's assistant head coach for the Super Bowl season of 1994.

Defensive coach Ray Rhodes and administrator Neal Dahlen are among the few others who achieved five Super Bowl rings with the 49ers.

"I'm very proud of that," said McPherson, who returned to the 49ers after he retired as a coach to serve as director of pro personnel from 2000 to 2005.

TIME OF CHANGE

Off the field, the 49ers were in shambles. Carmen Policy left in July 1999 to become president and CEO of the expansion Cleveland Browns. Before the end of the season, General Manager Dwight Clark followed Policy to Cleveland and interim team president Larry Thrailkill resigned.

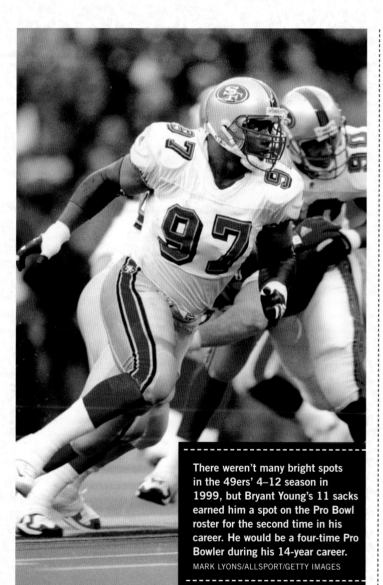

There weren't many bright spots in the 49ers' 4–12 season in 1999, but Bryant Young's 11 sacks earned him a spot on the Pro Bowl roster for the second time in his career. He would be a four-time Pro Bowler during his 14-year career.

MARK LYONS/ALLSPORT/GETTY IMAGES

"We had no front office," Mariucci said. "Some of that was nice because I didn't have to answer a lot of questions. But I'd yell down the hallway, 'Anybody home?' And nobody would answer. Nobody was there."

John McVay and Bill Walsh both came out of retirement to help navigate the team through the difficult period. Salary-cap issues forced the club to part ways with several veterans, including Barker, Gogan, and tight end Irv Smith.

On the field, things were just as bad.

In Week 3, Steve Young was knocked unconscious when running back Lawrence Phillips failed to pick up blitzing Arizona Cardinals defensive back Aeneas Williams. Young never played another NFL game.

Behind Young, the 49ers were woefully unprepared at the quarterback position. After all, in training camp that year, Young took 61 percent of the snaps. Jim Druckenmiller was next with 17 percent. Five days before the season opener, the 49ers traded Druckenmiller to the Miami Dolphins.

Jeff Garcia opened the season as the backup in his first year with San Francisco after taking just nine percent of the practice snaps in training camp.

With Garcia and Steve Stenstrom at quarterback, the 49ers lost eight consecutive games and finished with a 4–12 record. After giving thought to playing for former offensive coordinator Mike Shanahan in Denver the following year, Young decided to retire.

"People thought I was trapped by my concussions," Young said. "It wasn't close to that. Emotionally, I was so tied into the Forty-Niners, I felt like I couldn't go anywhere else. Bill [Walsh] and others told me, 'Steve, the run's over.'"

Team management, including Walsh, decided it was time to dismantle the team and rebuild from "salary cap hell." Young announced his retirement June 12, 2000, at a podium set up inside the team's locker room at the practice facility in Santa Clara.

EDDIE AND BILL

It was a gorgeous sun-splashed August day at Candlestick Park. A crowd of more than 8,000 fans, many of whom wore 49ers jerseys and held signs, showed up for a sad occasion. But it turned into a celebration.

Eddie DeBartolo took the microphone to speak about Bill Walsh at a public memorial service in 2007. Walsh died from leukemia at the age of 75.

In December 1997, DeBartolo was forced to cede control of the 49ers after pleading guilty to the felony offense of failing to report an extortion attempt. DeBartolo's departure coincided with the team's downturn.

At the time of Walsh's death, the 49ers were in the midst of eight consecutive seasons without a winning record. DeBartolo

represented a better time. He was showered with affection as he began to address the crowd. Chants of "Ed-die! Ed-die!" echoed through the stadium. DeBartolo appeared embarrassed to hear the crowd reaction.

"Let's yell, 'Bill!'" DeBartolo encouraged the audience. On cue, a new chant began.

Quoting a line from the musical *Camelot*, DeBartolo said, "Don't let it be forgot that once there was a spot, for one brief, shining moment that was known as Camelot."

DeBartolo added, "Bill Walsh was our King Arthur, and this stadium was our castle."

Eddie DeBartolo was too young to be an NFL owner.

Bill Walsh was too old to be a first-time head coach.

The two men did not always get along, though they shared the same vision for the San Francisco 49ers. Their relationship was often combustible. The results were spectacular.

Under DeBartolo's ownership, the 49ers won five Super Bowl championships. Three of the titles came under Walsh's direction as head coach. The other two came with a nucleus of players that Walsh acquired.

There were many times the Walsh–DeBartolo union could have split before their 10-year run together was completed.

"I think I was ordered by Eddie to fire Bill Walsh approximately seven, maybe eight times," former 49ers executive Carmen Policy said in the 2012 NFL Network documentary *Eddie DeBartolo: A Football Life*. "And there were times when Bill deserved it."

DeBartolo, who took control of the 49ers when he was 30 years old, deserved credit for making the call two years later to hire Walsh when others were trying to discourage him, Policy said. Walsh was 48 years old, and many wondered if he was too old for the demands of the position.

"The single most important ingredient was Bill Walsh," Policy said. "And the single most important decision was Eddie DeBartolo's singular decision to have Bill Walsh as our head coach."

Owner Eddie DeBartolo and coach Bill Walsh had many happy moments in the 49ers locker room over the course of their many years together. Here they celebrate following a dramatic win over the Bengals in 1987.
MICHAEL ZAGARIS/GETTY IMAGES

DeBartolo supplied Walsh with all the resources to win championships. In return, DeBartolo expected—no, demanded—excellence from the team.

"I don't think, without Eddie, Bill could've done it," Dwight Clark said.

Said Randy Cross, "Bill, he was a giant in the NFL. But it was Eddie behind the scenes that made a lot of those things even possible."

Walsh's shrewd personnel and coaching decisions, coupled with his professorial appearance, earned him the nickname "The Genius."

Walsh's influence will forever be felt in the NFL, through his many coaching protégés and his timeless offensive system, predicated on a ball-control passing game. Walsh was inducted into the Pro Football Hall of Fame in 1993 after compiling a 102–63–1 career record, including 10 victories in 14 playoff games.

"His legacy is not the three Super Bowls, it's not the architect of the West Coast offense or the architect of modern-day football," DeBartolo said. "His legacy is that he did what he wanted to do with his life and his profession, which he did without trying. It just came natural."

Walsh inherited a team in 1979 that was in complete shambles. The 49ers had five coaches the previous four seasons when DeBartolo hired Walsh, who was head coach at Stanford, following a 15-minute interview. The 49ers went 2–14 in Walsh's first season, followed by a 6–10 campaign.

Everything clicked for the team in 1981. Walsh's offensive innovations and his eye for talent in the draft led the 49ers to their first Super Bowl.

The 49ers won Super Bowl XVI over the Cincinnati Bengals, 26–21, at the Silverdome in Pontiac, Michigan, on January 24, 1982. Walsh became the first

It was all about the Super Bowl trophies for both Walsh and DeBartolo, and their star quarterback Joe Montana. AP PHOTO

head coach of a winning Super Bowl team to wear a headset during the game.

Walsh was an intense coach who demanded a lot from his players—especially his superstars. He regularly butted heads with Joe Montana, Ronnie Lott, and Jerry Rice, among others. All the players eventually saw that Walsh was able to make them much better.

Walsh's last public appearance was November 19, 2006, when he took part in a halftime ceremony in front of 68,367 fans at Candlestick Park to celebrate Rice's retirement. Rice told the crowd that he loved Walsh "with all my heart" because of the way he stuck with him through difficult times early in his career.

As great as Walsh was in dissecting X's and O's, he was equally adept at getting his players in the right mindset. Walsh was a master motivator.

"He always had a connection with his players," Rice said. "He knew exactly how to use everybody, like John Taylor and Joe Montana and Ronnie Lott. I remember

one time, I had over 200 yards and three touchdowns, and he called me into his office. I thought he was going to give me a pat on the back. But he told me, 'I need more out of you.' I found out he called Lott and Montana and those guys into his office and told them the same things. He was an excellent motivator."

Roger Craig also spoke of Walsh's skills as a motivator. After the 1984 season, Walsh approached Craig and said, the team "needs 1,000 yards out of you next season." Craig said he didn't know if Walsh meant rushing or receiving, so he did both. In 1985, Craig became the first player in league history to gain 1,000 yards rushing and receiving in the same season.

"When we were down, he would find a way to bring us up," Craig said. "And when we were too high on the hog, he knew how to bring us down. He was a mastermind at dealing with people."

Walsh had a specific set of responsibilities for every player and every staff member.

"I've never been around anybody like him," said Bill McPherson, a longtime defensive assistant. "He knew exactly what he wanted from everybody."

Walsh logged more than 100 bouts as an amateur boxer. His affinity for the sport was apparent in many of his meetings, during which he used examples from boxing to get his points across to the team.

"He would tell us that sometimes the opponent will land a punch here and there and it might make us a little wobbly, but any true champion will keep fighting," Craig said.

Said Walsh, "The whole idea of our team was to beat the other team to the punch, even by one inch or two inches. Be there before he's ready. Where does that come from? From boxing."

Although his teams were often thought to play "finesse football," they were also incredibly tough-minded. In one of the 49ers' more memorable playoff games, they blasted the Chicago Bears 28–3 in brutal 26-below-zero conditions in the 1988 NFC Championship Game.

DeBartolo was also known as a fighter.

"He's a tough, Youngstown, Ohio, guy, and he'll brawl in a second," Clark said. "But that's what we loved about him, and he wanted to win as much as we did."

He did not accept losing.

Said DeBartolo, "Show me a good loser, and I'll show you a loser."

DeBartolo built a winning culture around the 49ers. He also built a family atmosphere. Under DeBartolo, the team paid the highest salaries and celebrated holidays and Super Bowls with extravagant parties.

The 49ers traveled in luxury and every player had his own hotel room. During a three-year span, the 49ers won an NFL record 18 consecutive road games.

"All of it was due to him," Lott said. "The way we traveled was the way we played."

Added Jerry Rice, "It was always first class, and it was because of him."

During his 1993 Pro Football Hall of Fame induction speech, Walsh said, "Each man was an extension of the other. It was a chain reaction."

Walsh ended his 10-year run as head coach after the 49ers won the Super Bowl in January 1989. He stepped down and defensive coordinator George Seifert took over and won two more Super Bowls.

Walsh would often say he resigned too soon.

"I should have continued to coach," Walsh told Mike Silver in a March 2007 *Sports Illustrated* article. "If I could've taken

DeBartolo was on hand in Canton, Ohio, for Walsh's induction into the Pro Football Hall of Fame on July 31, 1993. BRUCE DIERDORFF/GETTY IMAGES

a month off, or something, to get away . . . but I had all the other jobs. I couldn't leave. The draft was coming, and I was the general manager. So I didn't see any place to go. I should've turned it over to other guys and taken off. It would've been all right. Of course, it would have. But I didn't do it."

A decade later, DeBartolo was out of football, too. NFL Commissioner Paul Tagliabue suspended him in 1999 after he pleaded guilty to the felony offense of failure to report an extortion attempt involving former Louisiana Governor Edwin Edwards.

In a messy family squabble, DeBartolo and his sister, Denise York, separated their assets. York took control of the 49ers. DeBartolo was out of the NFL after 23 eventful years in charge of the 49ers.

"I think it's hurt more than anything that's happened in his life, other than losing his parents," Montana said. "That was his pride and joy. So I'm sure it hurt deeply."

Was Bill Walsh a Hall of Fame coach because of Eddie DeBartolo? Or was Eddie DeBartolo a winning owner because of Bill Walsh? The two men were so intertwined that it's an impossible question to answer.

Said Rice, "Those guys working together as a team, I think that's why we won."

TURMOIL UPSTAIRS

December 1997: Eddie DeBartolo steps down as controlling owner of the 49ers after becoming the focus of a federal investigation into gambling fraud in Louisiana. Control of the team is turned over to his sister, Denise DeBartolo York, and her husband, John York.

July 1998: Team president Carmen Policy leaves the 49ers to become president and CEO of the expansion Cleveland Browns.

October 1998: DeBartolo pleads guilty in a Louisiana court to a felony charge of failing to report that Edwards allegedly extorted $400,000 from him to win a casino license.

Former 49ers executive John McVay comes out of retirement to work as a special assistant to interim club president Larry Thrailkill.

November 1998: The 49ers give general manager Dwight Clark permission to leave the organization to join Policy with the Cleveland Browns. McVay steps in as interim general manager.

January 1999: Thrailkill steps down as interim club president. McVay takes over on an interim basis.

Bill Walsh comes out of retirement to return to the 49ers as general manager.

Two days after taking over, Walsh hires Terry Donahue as director of player personnel and fires Vinnie Cerruto, who previously held that position.

March 1999: NFL Commissioner Paul Tagliabue suspends DeBartolo for the 1999 season and fines him $1 million for conduct detrimental to the NFL.

April 1999: Denise DeBartolo York filed a $94 million lawsuit against her brother to force him to repay money he borrowed from the DeBartolo Corporation. Less than a week later, DeBartolo filed a countersuit against his sister, claiming she reneged on a deal to turn the team over to him for $350 million in corporate assets.

March 2000: Eddie DeBartolo and his sister finalize a settlement under which DeBartolo gives up ownership stake in the 49ers in exchange for real estate and stock holdings.

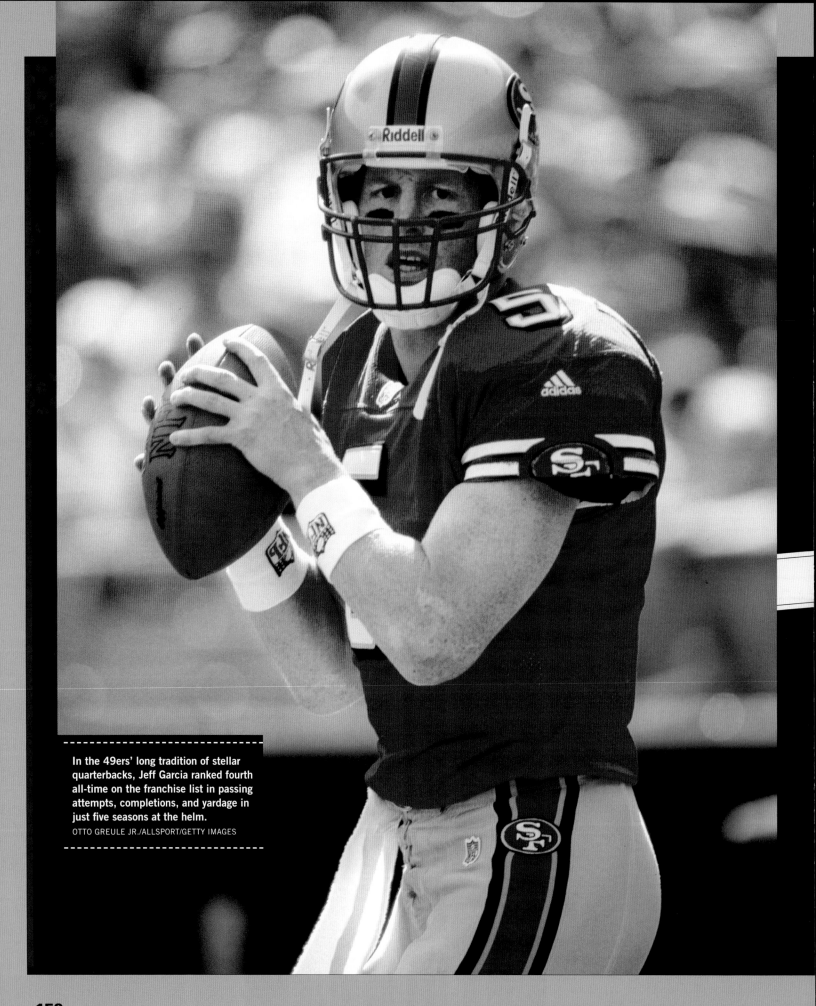

In the 49ers' long tradition of stellar quarterbacks, Jeff Garcia ranked fourth all-time on the franchise list in passing attempts, completions, and yardage in just five seasons at the helm.

OTTO GREULE JR./ALLSPORT/GETTY IMAGES

JEFF GARCIA AND AN ERA OF TRANSITION

2000–2010

When the 49ers went looking for a quarterback to pick up the impressive line that was most recently held by two future Hall of Famers, they ended up with a guy who had to play in Canada before any NFL team would consider him.

Program covers from 2000s-era 49ers football

GARCIA FILLS SOME BIG SHOES

Bill Walsh had an impossible time getting any team in the National Football League to take his recommendation. In 1993, Walsh returned to coach at Stanford. His team nearly lost to San Jose State, whose quarterback threw for 380 yards and three touchdowns.

"He almost beat us by himself," Walsh said.

The following spring when that quarterback, Jeff Garcia, went undrafted, Walsh faxed letters to half the teams in the league to suggest Garcia was a player worthy of signing as a free agent.

Garcia did not land in any NFL training camp. But Walsh kept pushing and Garcia finally found a spot as a backup to Doug Flutie with the Calgary Stampeders of the Canadian Football League.

"The only point I made to him was, if I was to ever come back as the general manager of the Forty-Niners, we would sign him immediately," Walsh said.

Garcia took over for Flutie and had three outstanding seasons in the CFL. In 1998, he led the Stampeders to the Grey Cup.

And when Walsh was back in charge of the 49ers in 1999, he kept his promise. The local boy from nearby Gilroy signed a contract with San Francisco and won the job as Steve Young's backup.

Garcia produced some up-and-down play in his first season with the club after taking over for Young, whose season ended early due to a concussion. Garcia earned the job with a 437-yard passing performance at Cincinnati late in 1999 and was the clear-cut starter entering his second NFL season.

The 49ers were coming off a 4–12 finish in 1999, a season that featured four consecutive games when the team failed to score more than seven points. But offense was certainly not the problem in 2000 with Garcia at the controls.

Garcia threw for 4,278 yards—more than Joe Montana or Steve Young ever had in a single season—to go along with 31 touchdowns.

"He was more impressive in games than in practice," coach Steve Mariucci said. "In practice, his leadership and work ethic would show. But if I'm recruiting for Cal, I don't know if I'd been interested. He's not very big and he didn't exactly have a cannon for an arm. But when this guy starts playing, improvising and running around when things break down, he was a star."

In addition to passing for more than 4,200 yards, Jeff Garcia used his athleticism to gain more than 400 yards on the ground, making him the team's second-leading rusher in 2000. TOM HAUCK/GETTY IMAGES

MODEL OF TOUGHNESS

Bobb McKittrick did not make a whole lot of friends outside of the organization during his 21 years as 49ers offensive line coach. But he died in March 2000 without an enemy.

McKittrick was known for molding undersized and overlooked linemen into the foundation of some of the great offenses in the NFL. But he also found himself at the center of controversy because of the blocking techniques he taught.

Former Raiders defensive lineman Howie Long was outspoken against McKittrick's use of cut-blocking—a legal method of attacking a defensive player at the legs to try to get him on the ground. Long went after McKittrick in the tunnel after a 1985 game at the Los Angeles Coliseum.

Long said he never held a personal grudge against McKittrick, whose blocking techniques infuriated the Hall of Famer. But Long still was the last person with whom McKittrick felt he had to make amends. When McKittrick knew he was in the last weeks of his life, he asked Joe Montana to help put him in touch with Long.

"I had no problem with Bobb McKittrick personally," Long said in 2000. "Our battles were on the football field. I can turn that switch off when I walk off the field. I expressed my respects for him as a person and as a coach. I wanted him to know that I had no animosity. I was touched that he wanted to speak with me."

McKittrick maintained his indefatigable spirit and work ethic even as his failing health forced him to work half days and skip road trips during his last season with the team. McKittrick continued to work up to his death on March 15, 2000.

"This most recent year was his most impressive year," then-coach Steve Mariucci said at McKittrick's memorial service, "because what he did goes far beyond commitment, loyalty, and dedication; far beyond courageousness and toughness; far beyond optimism and persistence. In so many ways, he took coaching to a whole new level."

McKittrick was an ex-Marine who wore the same threadbare T-shirt and coaching shorts every day even in the most inclement conditions. In 1988, McKittrick wore a short-sleeve shirt but no jacket in a game at Chicago's Soldier Field that was played in freezing rain. McKittrick was in charge of calling the run plays, and Walsh could barely hear him through his chattering teeth.

Walsh ordered that all coaches must cover their arms during harsh weather. When the 49ers returned to Soldier Field the following January for the NFC Championship Game for a game in wind-chill conditions of minus-26 degrees, McKittrick wore a *windbreaker*.

"I've never known anybody in my number of years in the league who worked as hard as that guy and was such a technician," Bill McPherson said. "He was just a grinder. He'd be grinding film when you got there in the morning and when you left at night, he was still in there grinding film."

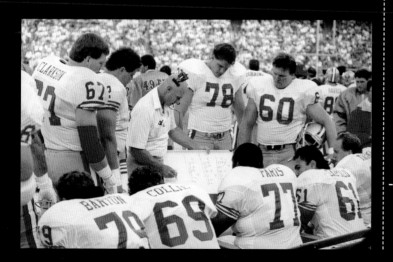

> "I've never known anybody in my number of years in the league who worked as hard as that guy and was such a **technician**."
> —Bill McPherson, 49ers defensive line coach, on Bobb McKittrick

Offensive line coach Bobb McKittrick works strategy with his players during a preseason game at Candlestick Park in 1989. AP PHOTO/AL GOLUB

BECOMING T.O.

For the first time since Jerry Rice entered the league, there was a better wide receiver on the 49ers. Receiver Terrell Owens became the top dog in 2000.

Owens caught 97 passes for 1,451 yards and 13 touchdowns, while Rice was second on the team with 75 receptions for 805 yards and seven scores in his final season in San Francisco.

But Owens was beginning to exhibit some behavior problems for Mariucci and Walsh.

In Week 4, after Owens caught a touchdown pass from Garcia against Dallas at Texas Stadium, he ran to the Cowboys' star logo at midfield and extended his arms while looking skyward through the hole in the roof. A short time later, Dallas running back Emmitt Smith scored a touchdown, ran to the middle of the field, and slammed the ball down while staring at the 49ers' bench.

When Owens scored his second touchdown of the game, he nearly ran over Garcia, who was attempting to stop him from returning to the middle of the field. Owens made it to midfield, where Dallas safety George Teague hit him. A melee ensued. The 49ers won the game 41–24, but they lost their best receiver for one game as the club imposed a one-game suspension on Owens.

"This decision is based on how we intend to conduct ourselves," Mariucci said. "It disturbs me when the integrity of the game is compromised in any way, shape or form."

Owens seemed to become addicted to all the attention he received. Sometimes he did not even have to go out of his way to seek the spotlight.

Owens managed to steal the show in Rice's farewell performance at Candlestick Park as a member of the 49ers. Owens caught a then-NFL record 20 passes for 283 yards in a 17–0 victory over the Chicago Bears. The 49ers awarded Jerry Rice a game ball in the locker room. Later, at the team's practice facility, Rice gave the ball to Owens.

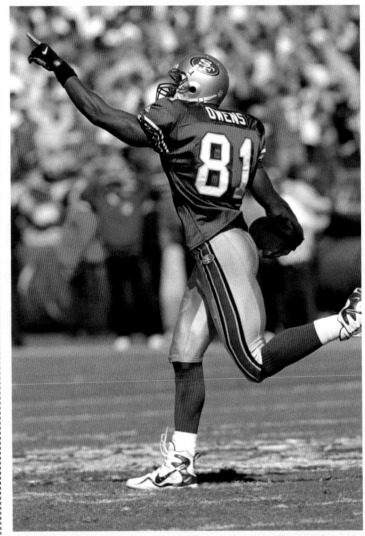

Never known for his modesty, Terrell Owens signals to the crowd as he makes his way toward the end zone against the Oakland Raiders at 3Com Park in October 2000. Owens caught 12 passes for 176 yards and two touchdowns in the game, but San Francisco lost 34–28.
TOM HAUCK/ALLSPORT/GETTY IMAGES

DIFFICULT TO CONTAIN

When he arrived on the scene as a rookie, Terrell Owens was described by 49ers great R. C. Owens (no relation) as a "Southern gentleman." Terrell Owens typically addressed media members as "sir."

But somewhere along the line, Terrell became "T. O." And the wide receiver became as well known for his mercurial personality as his prodigious talent.

"I wish every coach in pros and college could have the experience of coaching in a situation like that," former 49ers coach Steve Mariucci said without a trace of sarcasm.

"To grow as a coach you have to get tested. You have to learn about different types of personalities in your locker room. You learn what you did right and what you could've done differently."

Mariucci said he had a great relationship with Owens when he first got to the 49ers. Owens played on Mariucci's bocce ball team at his annual charity event. He would pull pranks on Mariucci's children at training camp.

"He was fun, friendly, and engaging," Mariucci said. "And then the contract thing threw it all out of whack."

Owens caught the game-winning touchdown against the Green Bay Packers in the playoffs and cried in Mariucci's arms. That offseason, the 49ers tagged Owens as their franchise player.

"I learned how disappointed a player can get when you place that tag on him," Mariucci said. "I had no idea that it could be so disappointing to a player."

The 49ers and Owens agreed somewhere in the middle on a seven-year, $34.2 million contract extension in July 1999. Owens signed the contract and angrily pushed the paperwork toward team executives John McVay and John York and stomped out of the room.

On the field, though, Owens was outstanding. His combinations of size and speed made him virtually impossible to cover. And once he had the ball in his hands, he was a load for any defensive back to tackle.

Owens put his unique signatures on many of his touchdowns. He twice ran to midfield at Texas Stadium after scores, nearly causing a riot in the process. The 49ers suspended him for a

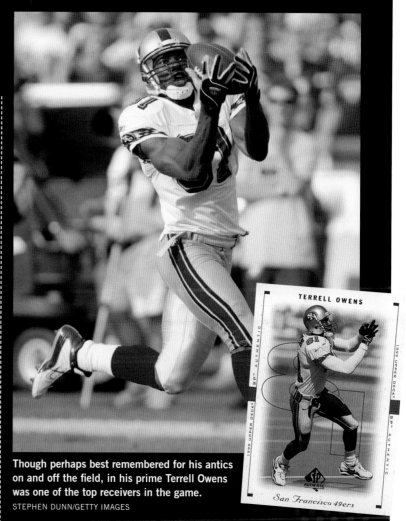

Though perhaps best remembered for his antics on and off the field, in his prime Terrell Owens was one of the top receivers in the game.
STEPHEN DUNN/GETTY IMAGES

game. He grabbed a cheerleader's pom-poms, a box of popcorn, and he pulled a Sharpie out of his sock to autograph a football for his financial advisor.

Owens had one final surprise for Mariucci in him.

The day after Mariucci got fired, he was cleaning out his office. Owens unexpectedly stopped by to say goodbye.

"He came in, and I said, 'What's up, man?'" Mariucci said. "He said, 'I just wanted to tell you I appreciate everything' and he gave me a hug.

"He drove me nuts, but I remember and appreciate that. He didn't have to come in there at all, but he did. It was really good."

PRACTICE MAKES PERFECT

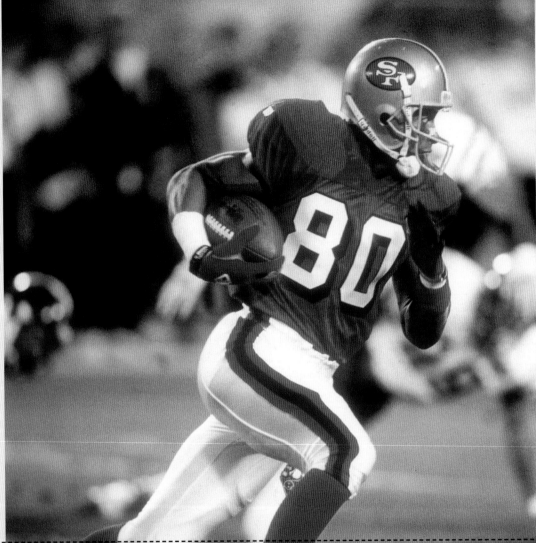

Jerry Rice could do it all—unquestionably one of the greatest ever at the position—and he was often at his best when the most was at stake, such as his 10-catch, three-touchdown performance in **Super Bowl XXIX.** FOCUS ON SPORT/ GETTY IMAGES

"He was a star. He rose to every occasion. The bigger the moment, the better he played." —Steve Young, on Jerry Rice

The numbers say Jerry Rice was the greatest wide receiver in football history. It's easy to build a case for Rice as the hardest-working wideout of all-time, too.

Rice already held every significant NFL receiving record in the late 1990s when Bill Walsh, as a team executive, advised him to stop working so hard. Walsh thought Rice might run himself into the ground.

"Bill wanted me to cut back a little bit," Rice recalled. "He's said, 'Well, Jerry, maybe you should take the day off,'" I couldn't do that. I felt like I had to be hands-on on the football field to get a feel for what my opponent was trying to do to me. I wouldn't back off and Bill and I went back and forth on this."

Rice was named to the Pro Bowl 13 times in his career. And for as many highlights as he provided in packed stadiums, those who witnessed his nonpareil work ethic remember just as vividly what he did when few people were watching him on the practice fields.

"When I stepped out there on the field, I wanted to be the best-conditioned athlete and I wanted to be able to go four quarters and wear my opponent down," Rice said. "So I had to sacrifice a lot and that's why I trained so hard in the offseason. That also gave me longevity to play for a long time."

Rice, it seemed, was always working to prove himself after being hidden away during most of his college career at tiny Mississippi Valley State. Prior to the draft, some reports circulated that Rice lacked speed.

"I heard some people say I ran a 4.7," Rice said. "I ran the 40 once and I was around 4.5. But when you got somebody chasing you, I think I was running maybe around a 4.2."

Rice had all the physical tools to be a great player, but his work ethic separated him from the field.

Cornerback Eric Davis remembers covering Rice during training camp on a play in which Rice was supposed to run a clearing route. On three consecutive plays, offensive coordinator Mike Shanahan demanded do-overs because of penalties on offensive linemen. Even though the ball had no chance of coming to Rice on the play, he ran every play all-out.

"To him, every snap mattered even when everybody knew the ball wasn't going to come his way," Davis said. "And I had to run with him every one of those plays. That was competition at the highest level."

Said Rice, "Practice for me was like a game situation. I wanted to make every catch and finish every play. Then, it becomes instilled in you and you don't have to think about it in a game when it's happening."

Even when it was the offense's turn to rest, Rice could usually be found running patterns or catching passes from an equipment manager. He did not believe in down time.

"There are a lot of hard workers who just peter out," said quarterback Steve Young, who teamed with Rice on 85 touchdown passes. "Jerry was a hard worker from the beginning to the end. He outworked everyone. He outworked free agents. Even the guys who all they had was work ethic, he outworked them."

"He was the best to ever play the position," said Hall of Fame quarterback Joe Montana, who tossed Rice his first touchdown reception in 1985 and 54 more. "His numbers will probably never be reached. I watch the league all the time and there's no one who compares to his consistency."

It is no coincidence that Rice provided some of his biggest performances in the games that mattered the most. In his three Super Bowls with the 49ers, Rice caught 28 passes for 512 yards and seven touchdowns.

"He was a star," Young said. "He rose to every occasion. The bigger the moment, the better he played."

REBUILDING THE D

The 49ers finished with a 6–10 record in 2000, but it was not because of the team's offense. In addition to its dynamic passing game, San Francisco also got major contributions from running back Charlie Garner, who collected 1,142 yards and seven touchdowns rushing.

The organization was in the process of rebuilding the defense through the draft. Such mainstays as Bryant Young, Junior Bryant, and Ken Norton remained, but a new crop of defensive players, including safeties Lance Schulters and Zack Bronson, moved into the lineup. Moreover, the 49ers invested four draft picks within the first two rounds on defensive players. And each was expected to start immediately.

Outside linebacker Julian Peterson and cornerback Ahmed Plummer were chosen in the first round. The 49ers selected defensive end John Engelberger and cornerback Jason Webster in the second round. Inside linebacker Jeff Ulbrich was a solid pickup as a third-round selection. He started 75 games over his 10-year career with the 49ers.

Even as the 49ers were going through a rough beginning with eight losses in their first 10 games, Mariucci kept the energy positive. The young players might not have known any better.

"I had some special guys, Julian Peterson and all young guys were quality people and workers," Mariucci said. "They weren't Hall of Famers, or a bunch of Pro Bowlers, really, but they were team players. They were just an unusual bunch. One of my jobs I had to do was to make sure these young guys didn't start doubting themselves or feeling like they weren't good enough. Heck, there'd be times when I'd be happy if they lined up right in the huddle."

The 49ers closed the season with four wins in their final six games to build some momentum going into 2001. But there were still plenty of doubters as the next season was set to kick off.

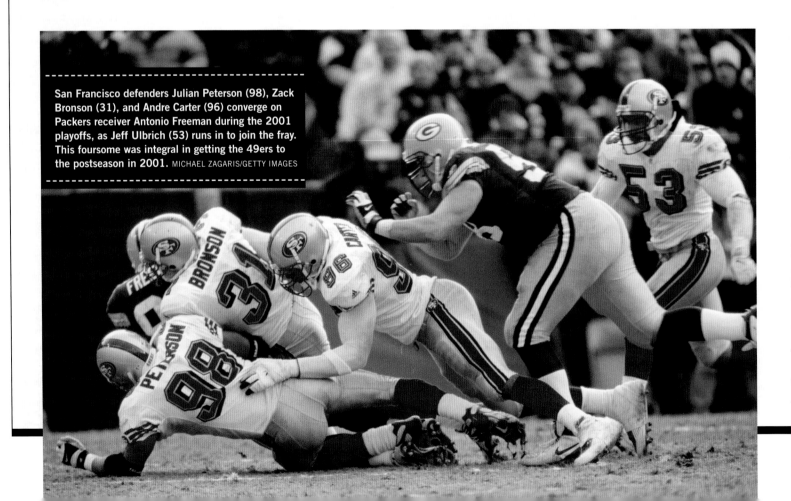

San Francisco defenders Julian Peterson (98), Zack Bronson (31), and Andre Carter (96) converge on Packers receiver Antonio Freeman during the 2001 playoffs, as Jeff Ulbrich (53) runs in to join the fray. This foursome was integral in getting the 49ers to the postseason in 2001. MICHAEL ZAGARIS/GETTY IMAGES

GARCIA SHINES

On the eve of training camp before the 2001 season, the 49ers rewarded Garcia with a six-year, $36 million contract extension after his record-setting season, which ended with his first of three consecutive trips to the Pro Bowl.

"To me, the expectations aren't any different," Garcia said. "Whether it's an old contract or a new contract, I want to be the best quarterback I can be."

The terrorist attacks of September 11, 2001, forced postponement of the NFL's Week 2 games. The 49ers took part in the first home weekend of games for the New York teams when they played the New York Jets on *Monday Night Football* on October 1.

Garrison Hearst, who made a remarkable return after a two-year absence from his broken fibula, rushed for 95 yards, and rookie Kevan Barlow added 83. Kicker Jose Cortez kicked four field goals in a 19–17 victory. Afterward, Mariucci presented game balls to New York City Mayor Rudy Giuliani and Governor George Pataki and to the New York fire and police departments.

Two weeks later, Owens was the show-stopper once again. He caught a 52-yard touchdown pass on a slant-and-go against the Atlanta Falcons in overtime for a 37–31 victory at the Georgia Dome. He finished with nine catches for 183 yards, despite being held without a reception for the first half.

But in the 49ers' next game, Owens made more headlines for the wrong reasons. San Francisco squandered a 28–9 lead in the third quarter against the Chicago Bears, who sent the game into overtime at Soldier Field.

On the first play of overtime, Owens could not handle Garcia's pass on a quick slant. The ball deflected off his hands and straight to Bears safety Mike Brown, who

returned it 33 yards for a touchdown. Owens accused Mariucci of lacking killer instinct, saying his coach took it easy on his old friend, Dick Jauron, the Bears head coach.

The 49ers won their next five games but lost for the second time to the NFC West champion St. Louis Rams. With a 12–4 record, the 49ers advanced into the playoffs as a wild-card team, where they traveled to face the Green Bay Packers.

It turned out to be a quick exit from the playoffs. Garcia hit Tai Streets on a touchdown pass and a two-point conversion to tie the game at 15–15 in the fourth quarter. With the 49ers trailing 18–15

and five minutes remaining, Garcia tried to hit Owens deep down the right sideline. But the ball was tipped and intercepted at the Packers' 7-yard line. Green Bay put together the game-clinching drive for a 25–15 victory.

That season, Garcia made history again, becoming the first player in the franchise's quarterback-rich history to throw for 30 or more touchdowns in back-to-back seasons. The young defense, including the addition of defensive end Andre Carter, was getting better and playing with more confidence. Bronson and Plummer led the defense with seven interceptions apiece.

(Right) Ticket stub to the 49ers–Jets game on October 1, 2001, the first home football game in New York following the attacks of September 11. *(Below)* In the 2001 season finale, Jeff Garcia led the 49ers to a 38–0 romp of the Saints, throwing four touchdown passes. RONALD MARTINEZ/GETTY IMAGES

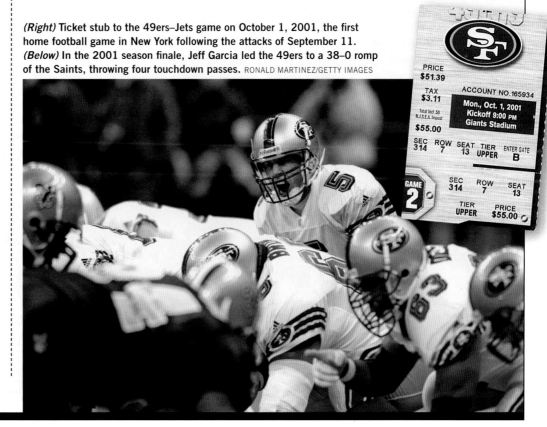

MARIUCCI'S END

In 2002, the 49ers returned to the top of the NFC West for the first time since 1997. Hearst and Barlow became more of a two-headed monster at running back. Hearst gained 972 yards and eight touchdowns with a 4.7 average, while Barlow rushed for 675 yards and four touchdowns with a 4.5 average. Center Jeremy Newberry and guards Ron Stone and Ray Brown paved the way in the run game. Owens had another big season, gathering in 100 receptions for 1,300 yards and 13 touchdowns.

On defense, safety Tony Parrish signed with San Francisco and put together a strong first season with the club, notching seven interceptions. Andre Carter continued to show signs of developing into one of the game's elite pass rushers with 12.5 sacks.

Again, leave it to Terrell Owens to create a commotion. On the same night that the San Francisco Giants won the National League pennant, Owens caught his "signature touchdown."

Owens had a scoring pass against the Seattle Seahawks and removed a Sharpie from his sock. He autographed the ball and handed it to his financial adviser, who was sitting in the field box owned by Seahawks cornerback Shawn Springs. Owens, coincidentally, had beaten Springs for the touchdown.

Despite losing two of their last three games, the 49ers clinched the division and headed to the playoffs with a home game against the New York Giants on wild-card weekend.

It initially appeared as if it would be another short stay in the playoffs for the 49ers. The Giants led 38–14 with four minutes remaining in the third quarter. But Garcia led the 49ers on a 25-point rally to pull off the greatest comeback in NFC playoff history.

The 49ers' season ended a week later, as the eventual Super Bowl–champion Tampa Bay Buccaneers thumped the 49ers 31–6 at Raymond James Stadium. Garcia completed just 22 of 41 pass attempts and threw three interceptions, and Owens was held to just four catches for 35 yards.

Mariucci had led the 49ers back from a 4–12 record in 1999 to back-to-back playoff appearances, including a playoff victory. But his time as San Francisco's coach came to an end.

Team owner John York interrupted a Mariucci family viewing of the reality TV show "Joe Millionaire" with a phone call. General manager Terry Donahue had become the most powerful person on the football side of the organization. Donahue and Mariucci did not get along, and York believed that Mariucci had tried to use Notre Dame as leverage in hopes of securing a long-term contract one year previously. Mariucci said he did not pursue an opening at Notre Dame, and he spurned the university's offer of a 10-year contract to remain with the 49ers.

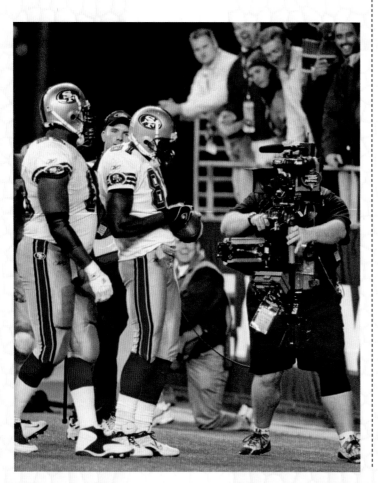

Terrell Owens takes a moment to autograph the football after scoring a touchdown against the Seattle Seahawks on October 14, 2002, at Seahawks Stadium in Seattle. TAMI TOMSIC/NFL/GETTY IMAGES

Two days after the playoff loss, Mariucci entered York's office. The media were alerted through a series of phone calls that Mariucci had been fired as head coach. One assistant coach whose office was down the hall from York's saw the report on TV just moments after the door closed behind York and Mariucci. York publicly cited "philosophical differences" as the reason for firing Mariucci.

"I've been in this business long enough to know that it's the owner's prerogative who he wants to be his head coach, the general manager, and the face of the organization," Mariucci said. "Bill Walsh and John McVay were bowing out. Terry Donahue was in as the new guy. I could see the writing on the wall. I was an Eddie DeBartolo guy. And most of the Eddie DeBartolo people were gone. I understand why John and Denise did it. But I think they listened to Terry more than they should have. Terry felt they could do better.

"They let me go after the second round of the playoffs. That doesn't happen very often. But I get it. Did I want to stay? Absolutely. I wanted to be in that building and see it through. We won twenty-three games the previous two seasons and we were starting to get out of the salary-cap crunch."

Steve Mariucci heads off the field following what would prove to be the final game of his head coaching career in San Francisco. Just days after the 31–6 loss to the Buccaneers in the divisional playoff on January 12, 2002, Mariucci was fired, with his 57–39 record in six seasons with the Niners.
CRAIG JONES/GETTY IMAGES

CONTROVERSIAL COMEBACK WIN

On January 5, 2003, the 49ers were well on their way to the franchise's largest home playoff defeat when things turned around and history of a different kind was made.

Bay Area product Amani Toomer was having the kind of game that Minnesota's Anthony Carter produced against the 49ers in the playoffs after the 1987 season. Toomer caught three touchdown passes from quarterback Kerry Collins, as the Giants held a commanding 38–14 lead in the third quarter.

"We were down by twenty-four points and we got lucky that Jeremy Shockey dropped a pass in the end zone," 49ers coach Steve Mariucci said. "I'm looking up at the scoreboard and I started thinking, 'Are they going to put a seventy-burger on us?' Those are the thoughts that start creeping into your mind."

Shockey's drop in the end zone meant the Giants settled for a short field goal instead of taking a four-touchdown lead.

"We needed to make some changes, so we went to the no-huddle early in the third quarter," Mariucci said. "We started getting some breaks and things snowballed."

Terrell Owens caught a 26-yard touchdown pass from Jeff Garcia, and the two hooked up again for the two-point conversion with 2:03 left in the third quarter. Garcia had a 14-yard touchdown run, and he found Owens again on the two-point conversion just five seconds into the fourth quarter.

Kicker Jeff Chandler made a short field goal to pull the 49ers to within five points in the middle of the fourth quarter. The 49ers took over after a missed field goal and drove for the go-ahead points on Garcia's 13-yard touchdown pass to Tai Streets with one minute remaining.

Chandler's ensuing kickoff was short, and the Giants returned it close to midfield. The Giants had one final chance to pull out the victory. The game ended on a controversial play.

Veteran long-snapper Trey Junkin, who came out of retirement for the playoffs, botched his snap on the potential game-winning 41-yard field goal attempt on the final play. Holder Matt Allen gathered in the ball and heaved it deep toward guard Rich Seubert, who had reported as an eligible receiver. But as the pass was arriving, 49ers defensive end Chike Okeafor tackled Seubert. The only announced penalty was for ineligible man downfield. The game was over. The 49ers won 39–38.

The next day, the league's director of officiating, Mike Pereira, admitted the officials incorrectly called the final play. There should have been offsetting penalties, including one on Okeafor for pass interference. The Giants should have gotten one more shot at the game-winning field goal.

When told of the officiating error, Mariucci responded, "Bummer."

Giants receiver Amani Toomer (81) argues with the officials while 49ers players celebrate following the hectic final moments of the 2002 NFC Wild Card Game at 3Com Park.
DONALD MIRALLE/GETTY IMAGES

ERICKSON'S PROBLEM

Terry Donahue had taken over as 49ers general manager in 2001, and he engineered Bill Walsh's exit from the franchise. Donahue conducted a meandering coaching search mostly from his beach house on Balboa Island. He maintained his residence in Southern California and was in the 49ers' offices on a part-time basis year-round.

Donahue offered Washington coach Rick Neuheisel an annual salary of $3 million to become the next head coach of the 49ers. Neuheisel rejected the offer. The team then narrowed its search to three NFL defensive coordinators: Jim Mora (49ers), Greg Blache (Chicago Bears), and Ted Cottrell (New York Jets).

The coach search, which Garcia at one point called "embarrassing" because it apparently lacked direction, concluded with the hiring of Oregon State coach Dennis Erickson.

Mora and Greg Knapp, the offensive coordinator, were retained on Erickson's first staff with the 49ers. And the 2003 season opened in impressive fashion with a 49–7 victory over the Chicago Bears.

But a three-game losing streak followed, culminating in a 35–7 loss to the Minnesota Vikings. This game was special for Terrell Owens because Randy Moss, the league's other elite receiver, was on the other sideline. Moss had eight catches for 172 yards and three touchdowns. Owens had five receptions for 55 yards. His frustration with the team was mounting, and his rapport with Garcia was going downhill fast.

"I'm so frustrated. I'm out there beating guys. I mean, what else can I do? I'm out there playing one hundred percent," Owens said. "Coach keeps saying, 'We're all in this together,' but at some point we've got to find a way to win. That was the quote last week: 'We've got to find a way to win.' Now what?"

That was not the only discourse in the 49ers' locker room. Veteran fullback Fred Beasley and running back Kevan Barlow physically clashed on more than one occasion. Barlow insisted his locker be moved to the opposite wall of the locker room.

The 49ers picked up a 24–17 victory over Steve Mariucci's Detroit Lions on October 5 at Candlestick Park. But there were few other highlights for the club. The 49ers staggered to a 7–9 record and a third-place finish in the NFC West.

Under Donahue, the 49ers set into place a slash-and-burn approach to their salary-cap problems the following offseason. The team balked at paying Garcia his scheduled salary of $9.9 million, so he was released. San Francisco also released offensive linemen Derrick Deese and Ron Stone and running back Garrison Hearst.

Erickson said he had no idea the 49ers would tear the team apart after just one season.

The 49ers had no intention of retaining Owens, who was scheduled to become a free agent. Owens' agent missed a February deadline to void the final year of his contract. The 49ers traded Owens to the Baltimore Ravens. Owens refused to show up for his physical and insisted he wanted to play for the Philadelphia Eagles. The union filed a grievance, and a settlement was reached in which the 49ers sent Owens to the Eagles in exchange for defensive tackle Brandon Whiting, who would play one injury-plagued season with the club.

In September, York awarded Donahue with a four-year contract extension through the 2009 season. Four months later, he would be out of a job, along with Erickson.

Kevan Barlow poses with a 49ers cheerleader on the cover of a 2003 game program.

ROLLIN' WITH NOLAN

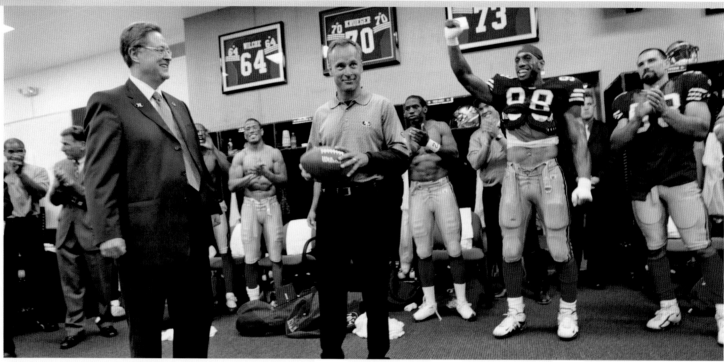

Head coach Mike Nolan receives the game ball from owner John York following the 49ers' season-opening victory over the St. Louis Rams on September 11, 2005, in San Francisco. MICHAEL ZAGARIS/GETTY IMAGES

Things were so bad in late 2004 that Erickson interviewed for a head-coaching job at Ole Miss on a Tuesday night while his assistant coaches were putting together the final touches on a 49ers game plan for that week.

Tim Rattay and seventh-round draft pick Ken Dorsey shared time at quarterback in 2004. Barlow was the team's top rusher with 822 yards and seven touchdowns but just a 3.4-yard average. Tight end Eric Johnson replaced Owens as the top receiver. He caught 82 passes for 825 yards and two touchdowns.

John York, son Jed York, and 49ers executives Paraag Marathe and Terry Tumey took over the task of finding the next coach after Erickson was fired.

"By going for a head coach first, that gives the Forty-Niners the best opportunity to get a look at the best candidates and the most candidates," John York said.

The 49ers hired a legacy to serve as the team's next head coach. Mike Nolan, son of former 49ers coach Dick Nolan, was chosen to take over a team that finished 2004 with a 2–14 record.

San Francisco owned the No. 1 overall pick in the upcoming draft. The team publicly announced four candidates for the top pick: quarterbacks Alex Smith and Aaron Rodgers, wide receiver Braylon Edwards, and cornerback Antrel Rolle.

Despite large support for Rodgers, a native of Northern California who played at Cal, it was unanimous within the organization that Smith was the man.

Nolan and new general manager Scot McCloughan had a roster to overhaul. In one of the first moves, the 49ers signed free-agent offensive tackle Jonas Jennings to a seven-year, $36 million contract. The oft-injured Jennings did not contribute much on the field, but during the press conference to announce his signing he coined a phrase that was fitting with the optimism of the new regime. "I'm rollin' with Nolan," Jennings said.

But, mostly, the 49ers continued to roll in the losses.

TRAGIC LOSSES

Tragedy struck the 49ers on August 20, 2005, when 23-year-old offensive lineman Thomas Herrion collapsed in the locker room at Denver's Invesco Field shortly after an exhibition game against the Broncos.

Herrion had suffered a heart attack. Dr. John York led resuscitation efforts in the locker room. Players and coaches knelt for the Lord's Prayer. Paramedics used a defibrillator and continued chest compressions as Herrion was placed in an ambulance and sped to a local hospital.

Herrion was pronounced dead approximately an hour after the game. Nolan gathered the team in a hangar at the airport to deliver the tragic news.

"It's a day of mourning for the Forty-Niner family," Nolan said. "We lost a teammate and a very good friend as well."

Herrion's dream was to make it in the NFL and buy a house for his mother, Janice, in Texas. The 49ers ended up overseeing the construction of a house for Janice Herrion to see his dream come to fruition. The club also established the Thomas Herrion Award, which goes annually to the first-year player who has taken advantage of every opportunity to turn his dream into a reality.

In the season opener, undrafted rookie Otis Amey, who performed a song at Herrion's memorial service, provided the big play. On his first touch in the NFL, Amey returned a punt 75 yards for a touchdown in the 49ers' 28–25 victory over the St. Louis Rams.

There weren't many highlights that season for the offensively inept 49ers. They lost 12 of their next 13 games.

After a Week 3 loss to the Dallas Cowboys, Nolan decided he did not want linebacker Jamie Winborn on the team. He eventually worked a trade with the Jacksonville Jaguars. In October at the trade deadline, the 49ers got rid of Tim Rattay, whom Alex Smith supplanted as the 49ers' starting quarterback.

Smith had a rough rookie season. He completed just 50.9 percent of his passes and threw 11 interceptions and only one touchdown. But the 49ers won their final two games to avoid earning the No. 1 overall pick in back-to-back years.

There were plenty of lowlights on the season. The 49ers scored two defensive touchdowns in the first quarter of the NFL's first

regular-season game played outside the United States on October 2, but the Arizona Cardinals scored 31 unanswered points for the victory in front of a league-record crowd of 103,467 at Mexico City's Azteca Stadium.

In mid-November, during a game that featured wind gusts of up to 47 mph, kicker Joe Nedney's 52-yard field goal attempt at the end of the first half reached the back of the end zone. That's where Bears defensive back Nathan Vasher was stationed. He caught the kick and returned it 108 yards for a touchdown. Quarterback Cody Pickett made his second start due to Alex Smith's knee injury. He completed just one of 13 pass attempts for 28 yards in the 49ers' 17–9 loss at Soldier Field.

A highlight was finding a running back, Frank Gore, in the third round of the draft, which made Kevan Barlow expendable. Despite 49 fewer attempts, Gore outgained Barlow 608 to 581.

Nedney, who made 26 of 28 field-goal attempts, and linebacker Derek Smith were co-recipients of the Bill Walsh Award, an honor established in 2004 for the team's most valuable player. Defensive lineman Bryant Young continued to show remarkable consistency; he recorded eight sacks and was named the Len Eshmont Award winner.

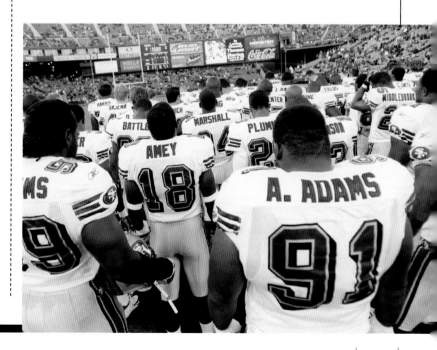

The 49ers observe a moment of silence in honor of Thomas Herrion during the preseason game against the Tennessee Titans on August 26, 2005.
MICHAEL ZAGARIS/GETTY IMAGES

A RESPECTED LEADER

Defensive tackle Bryant Young entered the NFL as a first-round draft pick in 1994, and stepped onto the most-loaded roster in the league.

When Young retired following the 2007 season, the 49ers had gone five consecutive years without making the playoffs. Through it all, Young distinguished himself as one of the most-respected players in franchise history.

Young showed no signs of slowing down during his 14-year career. In his final season, he led the 49ers with 6.5 sacks while starting all 16 games. His teammates voted him the winner of the Len Eshmont Award for a record eighth time.

General Manager Bill Walsh made the no-brainer decision in 2001 to sign Young to a six-year, $37.7 million contract extension in 2001 at a time when the 49ers needed the kind of stabilizing locker room presence that only Young could have provided.

"In one sense, this costs us any number of players we could've had," Walsh said. "But a team without Bryant Young wouldn't be fair."

Young earned trips to the Pro Bowl four times in his career. And he played his entire career with the 49ers.

"I know what can happen in this game," Young said. "You see guys like Ronnie Lott and Jerry [Rice] and Joe Montana, those were some of the greatest guys to play their positions, if not the best. It can happen to anybody and I knew I wasn't immune to it. I could've been in that situation as well. That was a way of keeping me humble."

Even late in his career, Young did not want any special favors that came along with his veteran status. When coach Mike Nolan excused Young from afternoon practices during double-days in training camp, Young asked to be included in all workouts.

"I felt like I didn't want to cheat my teammates," Young said. "Being out there and not being able to practice, it was tough watching."

Said Nolan, "As the players go, Bryant is one of the guys they all look to. If I said, 'Everybody go on that field,'" Nolan said, motioning to the right, "and Bryant started to head to the left, I'd have some defectors. What I love about it is Bryant is on-board.

"So if I say, 'Go over there,' they're all going, and Bryant's going to lead the way."

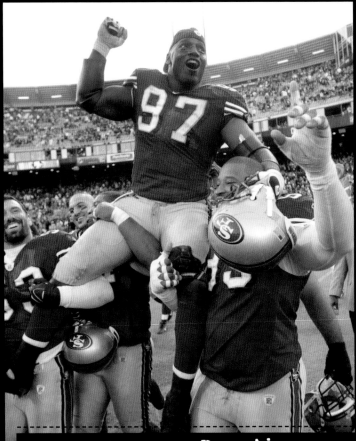

"As the players go, Bryant is one of the guys they **all look to.**"
—Mike Nolan, 49ers head coach

Bryant Young is carried off the field by teammates following the final home game of his career on December 23, 2007. MICHAEL ZAGARIS/GETTY IMAGES

ONE STEP FORWARD, TWO BACK

The 49ers showed a lot of progress in 2006. Alex Smith became the first quarterback in club history to take every snap in the course of a season. He made significant improvement under first-year offensive coordinator Norv Turner.

The team traded Barlow in the preseason, leaving no doubt that Gore was San Francisco's featured back. Gore responded by setting a franchise-record 1,695 yards rushing on 312 attempts. Gore also led the 49ers with 61 receptions. He was named the winner of the Bill Walsh Award.

Tight end Vernon Davis and outside linebacker Manny Lawson, both first-round draft picks, were starters. Lawson joined a veteran defense that included linemen Bryant Young and Marques Douglas, as well as cornerback Walt Harris, a free-agent pickup who led the team with eight interceptions.

The 49ers surpassed all expectations for the season and finished with a 7–9 record. They capped it off with a 26–23 overtime win against the host Denver Broncos to keep them out of the playoffs.

Expectations were high heading into the 2007 season. The 49ers were suddenly a trendy preseason pick to win the division. Things got off to a good start with victories over the Arizona Cardinals and at the St. Louis Rams to open the season. After a Week 3 loss to the Pittsburgh Steelers, Alex Smith's right shoulder—and the 49ers' season—fell apart under the weight of Seattle Seahawks defensive tackle Rocky Bernard.

Smith absorbed a punishing hit from Bernard and sustained a separated throwing shoulder on the first series of the game. Veteran backup quarterback Trent Dilfer replaced Smith over the next three games.

Smith returned to action four weeks later but was clearly not 100 percent, and the losing continued as the team fell to the New Orleans Saints, Atlanta Falcons, and Seattle, extending the losing streak to seven games. Nolan repeatedly said that Smith's injury was not an issue, though Smith was often seen clutching his shoulder in pain after passes.

Finally, after a 12-of-28 performance on *Monday Night Football* against the Seahawks, Smith admitted what everyone could see.

"Without a doubt, I'm not throwing the same way I was the first three weeks, and last year," Smith said. "Trying to play through this is hard. I chose to go out there and play, thought I could, thought it would get better as the weeks go on, and it hasn't."

Said Nolan, "I would never force a player to go if he says things aren't right. The communication lines aren't as good as I thought."

Alex Smith stepped up to become the team's clear No. 1 starter in 2006.

Smith opted for season-ending surgery. In fact, Smith would also miss the entire 2008 season with a broken bone in his right shoulder.

San Francisco lost the following Sunday at home to the Rams, falling to 2–8. Dilfer struggled, throwing seven touchdowns and 12 interceptions in seven games, before he sustained a concussion against the Minnesota Vikings and left the 49ers' lineup permanently. Shaun Hill took over at quarterback and immediately dazzled despite a broken index finger on his throwing hand. Hill completed 54 of 79 passes for 501 yards with five touchdowns and

Frank Gore left many Seahawk defenders in the dust on November 19, 2006, when he compiled a franchise-record 212 yards rushing in the 49ers' 20–14 win. Gore had nine games with at least 100 yards rushing while also setting a new franchise single-season mark with 1,695 yards.
JED JACOBSOHN/GETTY IMAGES

one interception in his first two games.

When Hill was unable to play in the season finale, newly signed Chris Weinke got the call in a 20–7 loss to the Cleveland Browns.

Mostly due to his handling of the Smith injury, Nolan was on the hot seat.

John York deliberated for several days before deciding to keep Nolan as coach but with less personnel power. McCloughan was promoted to general manager, holding "the trigger" on personnel moves.

The 2007 season was a disaster for the 49ers. They made a huge splash in free agency with the signing of cornerback Nate Clements to a deal widely reported as eight years, $80 million. In reality, Clements played four seasons and made $35.6 million.

While the 49ers did not get much value from free agency, the draft was a different story.

The franchise selected five eventual starters and three future Pro Bowl performers in the 2007 draft. Patrick Willis, chosen with the No. 11 overall pick, made an immediate impact as one of the game's top inside linebackers. The 49ers also got huge contributions down the road from left tackle Joe Staley, defensive lineman Ray McDonald, safety Dashon Goldson, and cornerback Tarell Brown.

The team got no such help from a 2008 draft class that included first-round pick Kentwan Balmer, a defensive tackle who never contributed, and underachieving guard Chilo Rachal.

But San Francisco made one of its all-time best free-agent signings in the 2008 offseason when it acquired defensive lineman Justin Smith, who spent his first seven pro seasons with the Cincinnati Bengals. Smith went on a helicopter ride around the Bay Area with Nolan before agreeing to a six-year, $45 million contract to relocate to California.

Nolan hired his fourth offensive coordinator in four seasons. After Mike McCarthy (Green Bay Packers) and Norv Turner (San Diego Chargers) moved on for head-coaching jobs, Nolan promoted Jim Hostler in 2007. Nolan fired Hostler after one season and

replaced him with flamboyant Mike Martz, former ringleader of "The Greatest Show on Turf" while offensive coordinator and head coach of the St. Louis Rams.

J. T. O'Sullivan won the competition in training camp to open the season as the starting quarterback. The 49ers began the season with a 2–1 record before a fourth consecutive loss forced the 49ers to make a change.

Vice President Jed York, son of John and Denise, fired Nolan after reports started to circulate that Nolan would be fired during the bye week. That prompted the 49ers to move up their decision by one week.

Nolan later said he did not disagree with the decision to fire him given his 18–37 record in three and a half seasons as head coach.

"It's been a difficult experience," Nolan said. "Even from the beginning there have been a lot of trials and things—from a player dying in the locker room to a lot of unexpected things happening on this job."

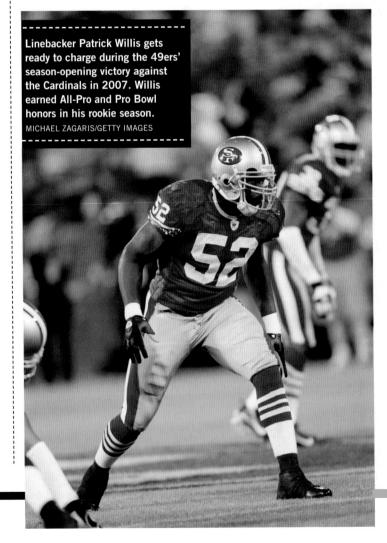

Linebacker Patrick Willis gets ready to charge during the 49ers' season-opening victory against the Cardinals in 2007. Willis earned All-Pro and Pro Bowl honors in his rookie season.
MICHAEL ZAGARIS/GETTY IMAGES

OVERCOMING THE ODDS

There was no denying Frank Gore's talent. But the star-crossed running back slid down draft boards in 2005 because of a troubling history of knee injuries.

He sustained a tear to the ACL in his right knee in the spring of 2002. A year later, he tore his left ACL. He left college for the NFL in 2005 and was mostly viewed as damaged goods.

But San Francisco's personnel chief Scot McCloughan had closely followed Gore since his freshman year of college. When the 49ers' medical staff gave Gore a passing physical grade, McCloughan made the call to select him with the first pick of the third round.

"He's going to do everything in his power to make himself a great player," McCloughan said early in Gore's career with the 49ers. "If you take football away from him, you take his life away. He's overcome a lot. He's God-given as a runner. He has balance and vision. He's a very unique back."

Gore was the best player on some bad 49ers teams. He experienced some bumps along the way—including a fractured hip in 2010 that ended his season at 853 rushing yards in 11 games—but Gore remained remarkably durable after coming into the NFL.

Eventually, Gore became the 49ers' all-time leader in rushing attempts, yards, and touchdowns.

There were also questions about how Gore would be able to adapt to complex NFL offenses. He struggled with a learning disability in high school, but football came easily to him.

"He's one of the most gifted, knowledgeable, and intelligent football players that I've been around, really at any position," 49ers offensive coordinator Greg Roman said. "He just has a feel and an understanding for the game. It's funny, when you install something or put something new in, he can just see it. It's pretty impressive."

Gore had to overcome a lot to achieve his status as one of the NFL's most consistent running backs of his era. His most painful time came in September 2007 when his mother, Liz, died from kidney disease. She was 46.

A couple days later, Gore was sitting in front of his locker as the 49ers prepared to face the St. Louis Rams.

"She used to call me at a certain time before every game," Gore said. "When that time came and I didn't get the call, I just busted out and cried and cried and cried."

Gore scored two touchdowns that game, including a 43-yard run late in the third quarter, as the 49ers came away with a 17–16 victory.

"I had a pretty good game that day," Gore said. "I think she came on the field with me. I had a crazy run. I don't know how I broke all the tackles and scored the winning touchdown."

After just his first eight seasons in the league, Frank Gore had rewritten the 49ers rushing record books. LEON HALIP/GETTY IMAGES

SINGLETARY IN CHARGE

Mike Singletary, Nolan's assistant head coach, was promoted to the top spot on an interim basis. Singletary, a Hall of Fame linebacker with the Chicago Bears, distinguished himself on Nolan's staff more for his oratory skills than his tactics.

Said linebacker Takeo Spikes, "He's a great speaker. If you put him in front of a guy who wouldn't want to play football, within five minutes he'll have a helmet and be ready to play."

Singletary boldly made his first game a memorable experience despite a 34–13 loss to the Seattle Seahawks.

He benched O'Sullivan, Martz's selection at quarterback, in favor of Shaun Hill. He dropped his pants in the locker room at halftime to provide a visual aide to show his players that the Seahawks were kicking their butts. He ordered tight end Vernon Davis off the field in the third quarter when Davis was called for a penalty and did not show remorse. And he apologized to the fans near where the 49ers' exited the field for the team's performance in the blowout loss.

In a classic postgame tirade, Singletary explained why he sent Davis to the locker room early: "I'm from the old school. I believe I'd rather play with ten people and get penalized all the way until we have to do something else, rather than play with eleven when I know that right now that person is not sold out to be a part of this team. It is more about them than it is about the team. Cannot play with them. Cannot win with them. Cannot coach with them. Can't do it. I want winners. I want people who want to win."

Singletary's unique motivational methods actually seemed to have an impact. The 49ers won five of their final seven games. Immediately following the 49ers' 27–24 season-ending victory over Washington, which gave San Francisco a 7–9 record, Singletary was announced as the team's permanent head coach.

"I told the team this is the last time our season ends in December," said newly crowned team president Jed York.

Singletary fired Martz shortly after the season but struggled to find anyone to take his place with his narrow vision of what he wanted the 49ers' offense to become. Ultimately, Jimmy Raye was hired as offensive coordinator.

Nothing epitomized Singletary's tenure with the 49ers more than a training camp drill he called the "nutcracker." In this drill, players lined up against each other, collided at the sound of a whistle and then struggled to drive each other backward until another whistle sounded to end the drill.

Patrick Willis, guard David Baas, cornerback Tarell Brown, running back Michael Robinson, and outside linebacker Parys Haralson were among the players who missed time in training camp due to injuries sustained during the nutcracker drill. Offensive linemen Eric Heitmann, a veteran leader on the team, sustained a stinger in training camp the following year. He eventually underwent career-ending neck surgery.

Head coach Mike Singletary had an intensity on the sidelines and in the locker room that was both inspirational and controversial.
MICHAEL ZAGARIS/GETTY IMAGES

Linebacker Jeff Ulbrich also saw his career come to an end early in the 2009 season after sustaining a severe concussion on special teams. Takeo Spikes had taken over for Ulbrich, an eight-year starter.

First-round draft pick Michael Crabtree sat out all of training camp in 2009 in a contract dispute. After the 49ers had already played four games, rapper MC Hammer helped broker a meeting between the team, Michael Crabtree, and his agent, Eugene Parker, at the Four Seasons in East Palo Alto.

Crabtree got the deal signed but sat out the next game. San Francisco lost to the Atlanta Falcons, 45–10, in a game best remembered for 49ers cornerback Dre' Bly intercepting a pass and showboating before Falcons receiver Roddy White stripped him from behind to get the ball back.

After the bye week, Alex Smith returned to regular season action for the first time since the 2007 season when he replaced Shaun Hill at the start of the third quarter with the 49ers trailing the Houston Texans 21–0. Smith threw for 206 yards and three touchdowns in the second half, but the 49ers lost 24–21.

Smith was the starter for the remainder of the season, and the 49ers won three of their final four games to finish with an 8–8 record.

Michael Crabtree leapt into the 49ers' offense as a rookie in 2009 following a contract dispute that carried over into the regular season.

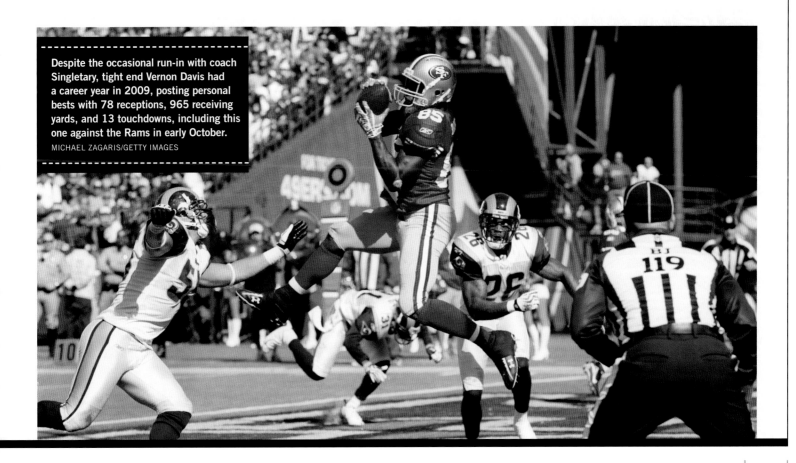

Despite the occasional run-in with coach Singletary, tight end Vernon Davis had a career year in 2009, posting personal bests with 78 receptions, 965 receiving yards, and 13 touchdowns, including this one against the Rams in early October.
MICHAEL ZAGARIS/GETTY IMAGES

OPTIMISM QUICKLY FADES

The 2010 season opened with high expectations, but training camp got off to a bizarre start. Running back Glen Coffee, a third-round draft pick the previous season, abruptly retired for religious reasons. Balmer, a top choice in 2008, left the team as he saw himself slipping further down the depth chart.

On October 31, 2010, the 49ers took on the Broncos at Wembley Stadium in London. The 49ers came away with the 24–16 victory, putting them at 2–6 to start the year. GETTY IMAGES

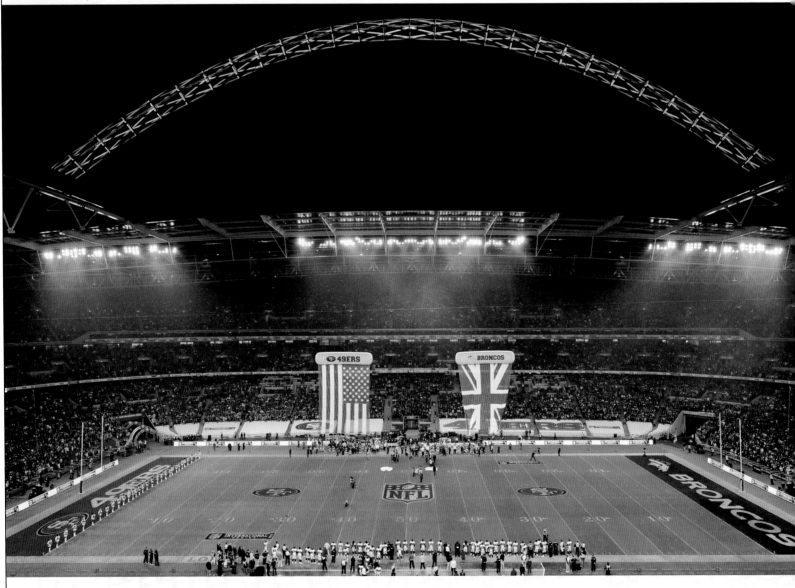

San Francisco's trio of quarterbacks exit the tunnel prior to the game against the Arizona Cardinals on November 29, 2010. Troy Smith (1) got the start in this game, a 27–6 win, while Alex Smith (11) started 10 games on the year. David Carr (5) made only a brief appearance during his one season as a 49er.

CHRISTIAN PETERSEN/GETTY IMAGES

The team's goal of a return to the playoffs imploded in the first five weeks of the season. Singletary fired Jimmy Raye as offensive coordinator after a Week 3 loss at Kansas City. The following week, veteran safety Michael Lewis left the team after receiving word that rookie safety Taylor Mays would begin taking some of his playing time.

The 49ers had a one-point lead against the Atlanta Falcons with less than two minutes remaining when cornerback Nate Clements intercepted a Matt Ryan pass. But Roddy White stripped Clements of the ball and the Falcons recovered. Atlanta kicked the game-winning field goal as time expired, and Singletary declined to shake hands with Falcons coach Mike Smith afterward.

The season-opening skid reached a low point on October 10 against the Philadelphia Eagles when Alex Smith committed three turnovers, including a lost fumble that was returned for a touchdown.

Smith was the target of venomous boos. The Candlestick crowd called for backup quarterback David Carr with chants of "We want Carr!" Singletary threatened to bench Smith, who remained in the game and led a couple of scoring drives. Still, the 49ers fell short 27–24, and dropped to 0–5 on the season.

Carr finally got his chance to play two weeks later when Smith sustained an injury to his non-throwing shoulder against the

Carolina Panthers. The 49ers left immediately after that game for a week in London, where they would face the Denver Broncos at Wembley Stadium.

Singletary made the surprising call to go with third-stringer Troy Smith as his starter. Initially, the move worked. Troy Smith had a strong arm and was not afraid to put the ball up for his receivers to make plays. Troy Smith had a good showing in a 24–16 triumph over the Broncos. But he soon faded.

Alex Smith returned to the lineup for a victory over the Seattle Seahawks and a loss to the San Diego Chargers.

Despite their 5–9 record, the 49ers were still in the playoff hunt in the weak NFC West Division with two games remaining. And with the team's season on the line, Singletary went with Troy Smith against the St. Louis Rams. It proved to be the wrong call. Troy Smith struggled, and the 49ers lost 25–17 to be eliminated from the playoff picture.

When the 49ers arrived back in the Bay Area, Jed York fired Mike Singletary and named popular defensive line coach Jim Tomsula as the interim head coach.

Tomsula went with Alex Smith as his starter in the final game of the season, and the team responded with a 38–7 win to earn Tomsula a victory and bring the 49ers' 6–10 season to an end.

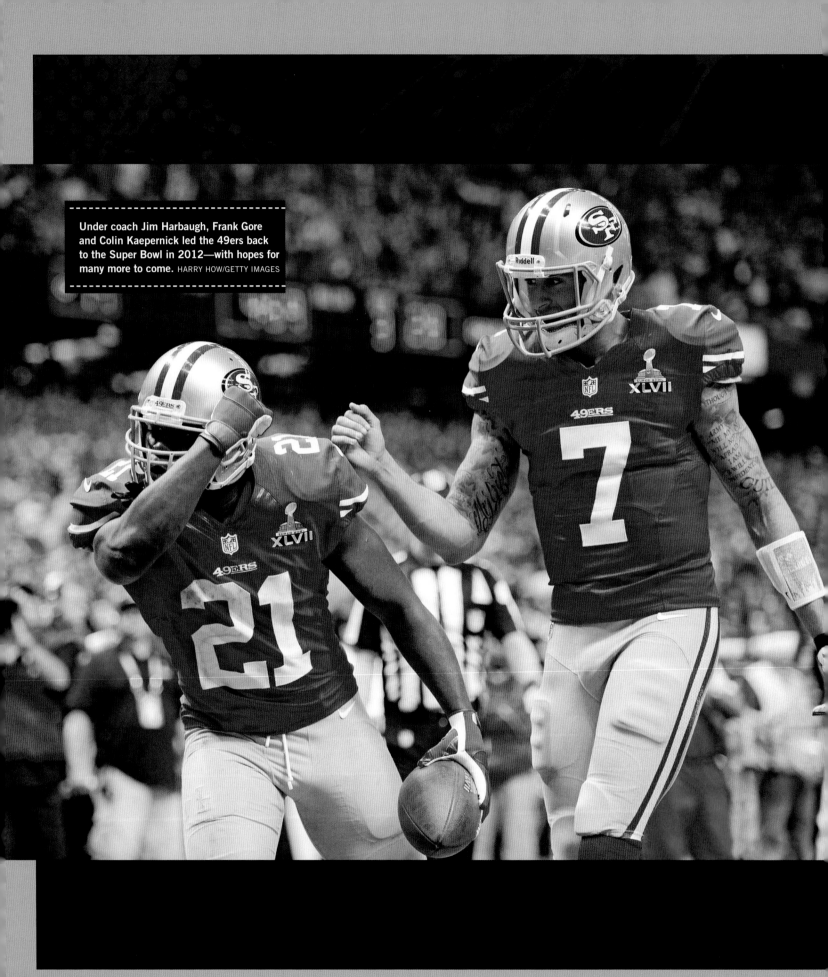

Under coach Jim Harbaugh, Frank Gore and Colin Kaepernick led the 49ers back to the Super Bowl in 2012—with hopes for many more to come. HARRY HOW/GETTY IMAGES

JIM HARBAUGH AND A RETURN TO THE WALSH ROOTS

2011 and Beyond

After a playoff drought that reached eight seasons, Jed York hired Trent Baalke as the general manager and brought Jim Harbaugh over from Stanford as head coach to turn things around. It didn't take long.

HARBAUGH FACES
CHALLENGES

With a five-year deal in place to make Jim Harbaugh the next head coach of the San Francisco 49ers, Jed York called his uncle to deliver the exciting news.

Just like Eddie DeBartolo in 1979, York hired a Stanford coach with a background in offense to turn around the organization.

"I don't think Jed hired Jim Harbaugh because I hired Bill Walsh," DeBartolo said. "I think Jed hired Jim Harbaugh because he was the very best coach available and he happened to be coaching at Stanford."

Coincidentally, Walsh had helped attract Harbaugh from the University of San Diego to Stanford in December 2006. The two men spent a great deal of time together in the final nine months of Walsh's life.

Jim Harbaugh speaks at a press conference where he was introduced as the new San Francisco 49ers head coach on January 7, 2011. MICHAEL ZAGARIS/SAN FRANCISCO 49ERS/GETTY IMAGES

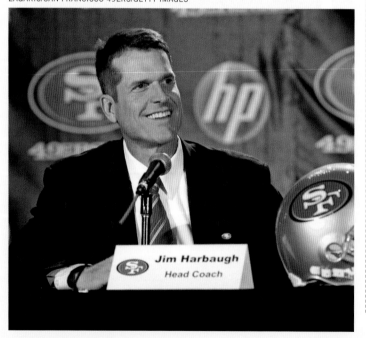

Unlike Walsh, who was an under-the-radar hire for the 49ers, Harbaugh was considered *the* top NFL coaching candidate in 2011. He guided a Stanford program that bottomed out under previous coach Walt Harris with a 1–11 record in 2006 to become a national power during his four-year tenure.

Harbaugh's challenge with the 49ers was every bit as daunting. San Francisco had a nucleus of good players, but the organization had not advanced to the playoffs since the 2002 season under Steve Mariucci.

"It really comes down to, this is the level I want to be on," Harbaugh said at his introductory press conference. "This is the shot and the organization that I wanted to do it with and it's the perfect competitive opportunity and I willingly accept it."

Harbaugh accepted the challenge of taking over a team with labor unrest and an expected lockout looming. He would not be able to get his players on the field until a new collective bargaining agreement was in place and training camp could get underway.

Before the lockout officially began, Harbaugh met with quarterback Alex Smith several times at the team's practice facility in Santa Clara. The two men even went onto the practice field and threw the ball around.

At the conclusion of the 2010 season, Smith gave virtually no thought to the possibility of returning to play for the 49ers. Smith had been a controversial No. 1 overall pick in the 2005. He struggled as a rookie and had his career derailed for two seasons with a shoulder injury.

While Smith was rounding back into shape, Aaron Rodgers, whom the 49ers brought in for a pre-draft visit in 2005, had taken over as the starter with the Green Bay Packers after sitting for three seasons behind Brett Favre. Rodgers immediately became one of the top quarterbacks in the league, while Smith showed only incremental progress every healthy season of his career.

A FRESH START

Alex Smith had six different offensive coordinators and defensive-minded head coaches Mike Nolan and Mike Singletary in his first six seasons. His surrounding cast was largely inadequate. In 2010, for the first time, the fans at Candlestick Park began to loudly express their impatience with Smith. It was enough to inspire him to look for a fresh start elsewhere.

But Harbaugh had an answer for that.

"Some people say Alex Smith needs a fresh start," Harbaugh said. "I say let that place be here."

Harbaugh made a convincing argument. Smith began to believe a change of scenery was not his best option.

After the lockout began, Harbaugh could not have any direct contact with Smith. Instead, Harbaugh took advantage of every opportunity to shower Smith with praise through media interviews. The NFL threatened to fine Harbaugh if he continued to talk about Smith, an unrestricted free agent, during the time in which teams were not allowed to communicate with players.

When a judge temporarily ordered the lockout over in April, it created a one-day window in which teams could talk to players. Smith, still unsigned, spent most of that day at the 49ers' practice facility to take part in a crash course taught by Harbaugh, offensive coordinator Greg Roman, and the other offensive coaches. Smith took home a box full of playbooks, film, and PowerPoint material so he could get a head start on learning the offense.

Two weeks later, with the lockout back in effect, Harbaugh got clearance from the NFL to deliver flowers to Smith's wife, Elizabeth, upon the arrival of the couple's first child, Hudson, on May 11, 2011.

"Everybody knew she was getting induced the day before, so I think he [Harbaugh] thought he was coming the day after," Smith said. "But he got there, literally, an hour after the birth."

This period of time also signaled a rebirth of Smith's career. He studied the material he received from the offensive coaching staff. He learned the 49ers' offense well enough that he could begin to coach it to his teammates. Smith took care of financial considerations with San Jose State University and organized a series of workouts and classroom sessions that became known as "Camp Alex."

"It was like the first coat of paint, the primer," Smith said about how those workouts shaped the 49ers' 2011 season.

When the lockout lifted with a new collective bargaining agreement, many of the 49ers' offensive players reported to training camp with an understanding of the terminology and basic concepts of the team's new West Coast system.

New head coach Jim Harbaugh didn't have much time to confer with his starting quarterback prior to his debut season in 2011, but the two quickly got on the same page, as the team jumped out to a 9–1 start. RICH SCHULTZ /GETTY IMAGES

FINE-TUNING THE ROSTER

Ted Ginn's 102-yard kickoff return against the Seahawks in the 2011 opener at Candlestick Park helped get the season off to an exciting start. EZRA SHAW/GETTY IMAGES

General Manager Trent Baalke, who first joined the 49ers in 2005 as the organization's West region scout, worked with Harbaugh to fill any gaps in personnel on an already-talented roster.

San Francisco needed to make an impact in the draft, and that's exactly what it did. With the No. 7 overall pick, the 49ers selected Aldon Smith from Missouri to provide the kind of outside pass rusher they had lacked for years.

Chris Culliver, a third-round selection, worked his way into the action as the team's No. 3 cornerback. Running back Kendall Hunter had a productive rookie season behind Frank Gore, and seventh-round pick Bruce Miller made a startling transition from defensive end at Central Florida to starting fullback as a rookie.

The 49ers cleaned up in free agency, too, with chief negotiator Paraag Marathe working overtime to hammer out contracts to get the players into camp quickly. Cornerback Carlos Rogers and

safety Donte Whitner, veteran free agents, solidified the defense. Rogers tied with Dashon Goldson for team-high honors with six interceptions, and both were named to the Pro Bowl team for the first time in their careers.

Center Jonathan Goodwin stepped in to replace David Baas, who left for a lucrative deal with the New York Giants. Goodwin joined a solid nucleus on the offensive line that included left tackle Joe Staley, a first-round draft pick in 2007, and 2010 first-round picks Anthony Davis and Mike Iupati.

The 49ers struggled throughout the season in the red zone, giving free-agent acquisition David Akers ample opportunity to set the NFL record with 44 made field goals on 52 attempts. Akers, for

one season, gave the 49ers an outstanding group of specialists in the kicking game.

Long-snapper Brian Jennings was a seventh-round pick in 2000 whose dependability meant there was one fewer problem the organization had to worry about. In 2004, Jennings had been the only 49ers player to earn a trip to the Pro Bowl. Punter Andy Lee was one of the top punters in the game. A multiple Pro Bowl selection, Lee posted an NFL-record 44.0 net-punting yards in 2011.

Special teams played a huge part in the season opener. Harbaugh's debut was looking shaky after the Seattle Seahawks scored a touchdown with less than four minutes to play to cut the 49ers' lead to 19–17.

But Ted Ginn, who had accepted a $1 million pay reduction earlier in the week to remain with the team, returned the ensuing kickoff 102 yards for a touchdown. Then, when San Francisco held Seattle to a three-and-out, Ginn put the capper on the 33–17 opening-day victory with a 55-yard punt return for a touchdown.

The team's most eye-opening victory came three weeks later. After a less-than-picturesque 13–8 win over the Cincinnati Bengals, the 49ers remained in Ohio to avoid the back-and-forth air travel before the following week's game at Philadelphia. They stayed at the Holiday Inn in Boardman near Youngstown, Ohio.

The Youngstown area was chosen because of the team's close ties to that community. The DeBartolo Corporation was headquartered nearby. The Yorks still lived there.

After a week of practice at Youngstown State University, the 49ers made the short flight to face the Eagles, a preseason Super Bowl favorite after landing free-agent cornerback Nnamdi Asomugha.

The 49ers trailed 23–3 in the third quarter before the defense stiffened and the offense took flight. Frank Gore, who had gotten off to a rough start through the first three games, tore the Eagles apart with 127 yards and a touchdown. Alex Smith completed 21 of 33 passes for 291 yards and delivered touchdown passes to Joshua Morgan and Vernon Davis to highlight the comeback.

But the key play belonged to defensive tackle Justin Smith, who ran down speedy wide receiver Jeremy Maclin and forced a fumble that Dashon Goldson recovered with two minutes remaining. The play preserved the 49ers' 24–23 victory. The play proved to be a catalyst for the season.

"That's a defensive equivalent of 'The Catch,'" 49ers defensive coordinator Vic Fangio said. "Now 'The Catch' happened in an NFC Championship Game, which added to the luster. This was the fourth regular-season game, but it was a tremendous effort."

Justin Smith's (94) forced fumble of Philadelphia receiver Jeremy Maclin in Week 4 provided another turning-point moment for the 49ers. The play helped preserve San Francisco's 24–23 win and put the team at 3–1 to start the season. DREW HALLOWELL/ PHILADELPHIA EAGLES/GETTY IMAGES

BLUE-COLLAR STARS

Opposing offenses have the daunting task of having to stop defensive lineman Justin Smith (94) and *then* deal with linebacker Patrick Willis (52).
MICHAEL ZAGARIS/GETTY IMAGES

Linebacker Patrick Willis and defensive lineman Justin Smith provide the 49ers with plenty of star power. But the two All-Pro defenders also maintain blue-collar approaches that resonate within the organization.

"Everybody should have a Justin Smith on their team," coach Jim Harbaugh said. "He is a great talent, great character, great leader. Along with Patrick Willis, he is the core and fabric of our leadership on defense."

Smith is a selfless athlete who thrives at helping those around him. He does not mind doing the grunt work of tying up extra blockers to enable outside linebacker Aldon Smith to avoid double-teams en route to rushing the passer.

And Smith is also adept at preventing blockers from reaching the second level to contend with Willis and fellow All-Pro inside linebacker NaVorro Bowman. For Smith, it's all about doing whatever it takes to win football games.

The 49ers' 2011 season was launched when Smith came through with a big play to strip Philadelphia Eagles wide receiver Jeremy Maclin of the football to preserve a comeback win on the road.

"I think that win just kind of cemented this group, like 'OK, we've got something here, let's keep rolling,'" Smith said. "That winning attitude starts coming out."

That victory was a building block for victories the following season, Smith said, as the 49ers came back from a big deficit to defeat the Atlanta Falcons in the NFC Championship Game.

"Even in Atlanta, we are down 17–0, the sideline never wavered," Smith said. "It's just a testament to the guys and the confidence and ability of this team to come back, score, stop them, and get it fixed."

Willis, who the 49ers selected with the No. 11 overall pick in 2007, has a similar no-nonsense approach. That's why fans rarely see Willis draw attention to himself after making an outstanding play.

> "Everybody should have a Justin Smith on their team. . . . Along with Patrick Willis, he is the **core** and **fabric** of our leadership on defense."
> —Jim Harbaugh, 49ers head coach

"I've always had high expectations for myself," he said. "Any time I'm able to make a play or do something that most [people] don't think I could do, for me, in my mind, I've already seen it or felt like I could do it. So I don't get overly excited about anything because in my mind I'm just doing my job."

Said Harbaugh, "There are two kinds of people: The people that get the job done, and the people that want to take credit for getting the job done. It's far less competitive in the second case. Patrick Willis is certainly a get-the-job-done type of guy. That just influences, and the rest of the team feeds off of that."

SHAKING THE LOSING TREND

The 49ers were winning games, and they were doing it with style. On October 16, Alex Smith hit tight end Delanie Walker with a 6-yard touchdown pass on fourth down to help drop the Detroit Lions from the ranks of the unbeaten. Detroit coach Jim Schwartz took offense to Harbaugh's overzealous postgame handshake following the 49ers' 25–19 win at Ford Field.

A skirmish ensued that involved the coaches, players, and staff members. It carried into the tunnel leading to both teams' locker rooms. Afterward, Harbaugh took responsibility for his actions but declined to apologize.

"I was just really revved up, and it's totally on me," Harbaugh said. "I shook his hand too hard. I mean, I really went in and it was a strong kind of a slap, grab handshake."

In a story that Baltimore Ravens coach John Harbaugh, Jim's older brother, relayed months earlier to the *Philadelphia Inquirer*, Schwartz had gotten under Jim's skin when he predicted during a dinner conversation at an NFL offseason get-together that any new coach would be set up to fail because of the lockout.

"[Schwartz] told him there's no way you're going to be able to accomplish what you need to accomplish in two weeks if this thing lasts a while," John Harbaugh said. "Jim just kind of bit his tongue, which is what you've got to do in this situation."

The challenges that Jim Harbaugh and his coaching staff faced provided an additional layer to the franchise's amazing turnaround in 2011. But the team's eight-game win streak predictably came to an end following a cross-country flight to play John Harbaugh's Ravens on Thanksgiving Night.

The Niners had a long touchdown pass wiped out on a controversial chop-block penalty called on Gore. The 49ers managed only 170 yards of total offense, and Alex Smith was sacked nine times in a 16–6 loss to the older Harbaugh's team.

The one constant throughout the season for San Francisco was a strong defense that took pride in stopping the run. Justin Smith, Ray McDonald, and Isaac Sopoaga formed a strong front three, and the 49ers had first-team All-Pro inside linebackers Patrick Willis and NaVorro Bowman.

Under Fangio's direction, the 49ers became the first team in NFL history to not allow a rushing touchdown in the first 14 games of a season. The club also went 36 games without allowing a 100-yard rusher. Both of those streaks ended on December 24, when Seahawks running back Marshawn Lynch rushed for 107 yards and a touchdown.

The 49ers survived a scare in the game against Seattle when linebacker Larry

Grant, playing in place of an injured Willis, forced a late fumble against scrambling quarterback Tarvaris Jackson. Donte Whitner's fumble recovery preserved the 19–17 road win.

A 34–27 triumph over the St. Louis Rams concluded the 13–3 regular season, with the 49ers atop the NFC West Division for the first time since 2002.

The 49ers defense stifled the opposition all year in 2011, and in the 26–0 shutout of the Rams on December 4, they held St. Louis's 1,000-yard rusher, Stephen Jackson (39), to just 19 yards on 10 carries. The Rams had a total of 31 rushing yards in the game. MICHAEL ZAGARIS/SAN FRANCISCO 49ERS/GETTY IMAGES

PLAYOFF UPS
AND DOWNS

Harbaugh was named NFL Coach of the Year in 2011 for engineering the 49ers' amazing turnaround. Baalke was honored as NFL Executive of the Year.

San Francisco earned the No. 2 seed in the NFC playoffs behind the 15–1 Green Bay Packers. The 49ers hosted the New Orleans Saints in the divisional round for San Francisco's first home playoff game since the near-miraculous come-from-behind victory over the New York Giants on January 5, 2003.

And this one proved to be every bit as memorable.

The lead changed hands four times in the final four minutes. The 49ers got the final word when, with nine seconds remaining, Alex Smith's beautifully thrown 14-yard pass was caught by tight end Vernon Davis, who held on as Saints safety Roman Harper collided with him at the goal line. The touchdown clinched a 36–32 victory.

That win set up a rematch against the New York Giants—who were 37–20 upset winners over the Green Bay Packers—in the NFC Championship Game at Candlestick Park.

The 49ers went right back to the Smith–Davis combination to get the team going. Davis, who caught seven passes for 180 yards and

two touchdowns the previous week against the Saints, opened with a 73-yard scoring play to get San Francisco off to a strong start.

Smith and Davis teamed up for a second touchdown in the third quarter to give the 49ers a 14–10 lead. But that proved to be the extent of the 49ers' offense. Smith completed just 12 of 26 passes for 196 yards. Michael Crabtree caught only one pass for 3 yards to account for the entirety of the team's production from the wide-receiver position, which had been decimated by injuries. Joshua Morgan had sustained a season-ending broken leg earlier in the season. The 49ers parted ways with Braylon Edwards, who had become disengaged after missing time with injuries. Ted Ginn, the team's top return man, was out with a knee injury he sustained a week earlier.

With Ginn out of action, Kyle Williams was entrusted to handle the punt-return duties. Williams' inexperience showed at two critical junctures in the game. He failed to get away from a bouncing punt, which nicked his leg in the middle of the fourth quarter. The Giants recovered and immediately cashed in with Eli Manning's 17-yard touchdown toss to Mario Manningham to put the Giants ahead, 17–14.

The 49ers settled for Akers' 25-yard field goal with 5:39 remaining to force overtime. After both teams went three-and-out on their first possessions of overtime, Williams fumbled on a punt return to set up Lawrence Tynes' 31-yard game-winning field goal for New York. The Giants went on to win Super Bowl XLVI with a 21–17 victory over the New England Patriots.

Williams handled the situation with grace and vowed to help the 49ers bounce back stronger than ever in 2012.

"It's one of those feelings that you don't ever want to feel on the football field," Williams said. "It's painful. We're very passionate about what we do and we're very passionate about getting to the Super Bowl. To be able to be that close and not to get to it is painful, but hopefully we're going to get through it as a team and we'll be back."

Kyle Williams's fumbled punt return against the Giants in the NFC title game on January 22, 2012, proved to be the blunder that brought the 49ers' season to a frustrating conclusion. DOUG PENSINGER/GETTY IMAGES

SMITH'S REDEMPTION

Alex Smith's first six seasons with the 49ers were rife with frustration. Any 49ers quarterback is held to ridiculously high standards because of the legacies left over from Hall of Famers Joe Montana and Steve Young.

For Smith, there might have been even more pressure due to his status as the No. 1 overall pick in the 2005 draft.

But Smith's reputation was forever changed with a game-for-the-ages performance and his late-game heroics against the New Orleans Saints in an NFC divisional playoff game following the 2011 season.

"Winning games as a quarterback this time of year speaks for itself," Smith said after rallying the 49ers twice in the closing minutes for a near-miraculous 36-32 victory over the Saints at Candlestick Park.

The game had plenty of build-up and drama. But even more intrigue surrounded the game because of the Saints' bounty scandal, which came to light weeks after the game.

It was later revealed New Orleans Saints defensive coordinator Gregg Williams encouraged his players to cause injury to several key 49ers players, including Smith, Frank

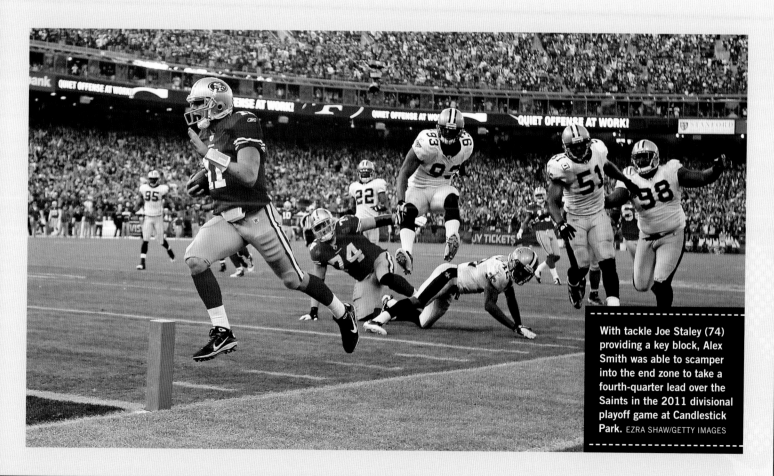

With tackle Joe Staley (74) providing a key block, Alex Smith was able to scamper into the end zone to take a fourth-quarter lead over the Saints in the 2011 divisional playoff game at Candlestick Park. EZRA SHAW/GETTY IMAGES

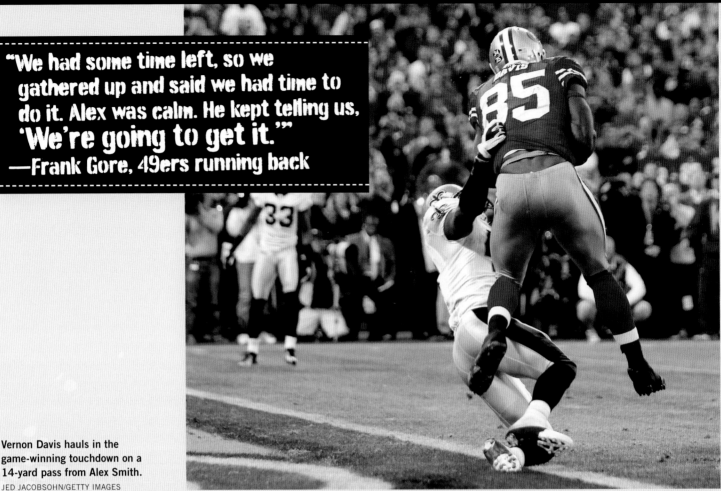

"We had some time left, so we gathered up and said we had time to do it. Alex was calm. He kept telling us, 'We're going to get it.'"
—Frank Gore, 49ers running back

Vernon Davis hauls in the game-winning touchdown on a 14-yard pass from Alex Smith.
JED JACOBSOHN/GETTY IMAGES

Gore, Michael Crabtree, Vernon Davis, and Kyle Williams. NFL Commissioner Roger Goodell later suspended Saints head coach Sean Payton, Gregg Williams, and several players as part of a widespread bounty system.

But it was 49ers safety Donte Whitner who delivered a knockout blow early in the game with a legal helmet-to-helmet hit on running back Pierre Thomas that forced him out of the game and provided the 49ers with a key first-quarter turnover.

The 49ers led 20–14 entering the fourth quarter when things got crazy. New Orleans took a 24–23 lead on Darren Sproles's 44-yard touchdown pass from Drew Brees with 4:02 remaining.

The 49ers covered 80 yards on six plays on their next possession. Alex Smith beat a Saints blitz off the right side with a quarterback sweep in the opposite direction. Slot receiver Kyle Williams made a block on defensive end Will Smith and left tackle Joe Staley got down field to level safety Isa Abdul-Quddus with a cut block to open the way for Smith to race 28 yards untouched into the end zone. The touchdown run enabled the 49ers to take a 29–24 lead with 2:11 remaining.

The Saints quickly reclaimed the lead on Brees' 66-yard touchdown pass to tight end Jimmy Graham with 1:37 remaining.

"We had some time left, so we gathered up and said we had time to do it," Frank Gore said. "Alex was calm. He kept telling us, 'We're going to get it.'"

Vernon Davis beat single coverage to shake free for a 47-yard pass from Smith. That set up a play from the 14-yard line that Geep Chryst, the 49ers quarterbacks coach, installed just days earlier because of his familiarity with how the Saints liked to play near the goal line.

"I knew it was coming," Davis said. "We rehearsed it all week."

Smith made a perfect pass before Davis cleared the Saints' inside linebacker. Smith put the pass onto Davis's body just as safety Roman Harper arrived at the goal line. The 14-yard touchdown pass with nine seconds remaining sent Candlestick Park into bedlam.

"You all know what 'The Catch' is?" Davis asked, referring to Montana's game-winning touchdown pass to Dwight Clark to win the 1981 NFC Championship Game. "I was born in '84. I made the play. Alex made the play."

DEFENSE INTACT

One of the major coups of the offseason was the 49ers' ability to keep their entire starting defense intact from 2011. Outside linebacker Ahmad Brooks and cornerback Carlos Rogers were retained with multiyear deals, and safety Dashon Goldson was designated as the team's franchise player.

Although the return of Alex Smith never appeared to be in doubt, the organization investigated the possibility of signing free agent Peyton Manning, whom the Indianapolis Colts released to make way for No. 1 overall pick Andrew Luck.

Harbaugh and Roman traveled to the Duke University campus in Durham, North Carolina, to watch Manning work out. On the day that Manning decided to sign with the Denver Broncos, he called Harbaugh to inform him of his decision.

"Alex Smith is our quarterback, was our quarterback," Harbaugh said. "[We] had every intention of always bringing him back. There would have been no circumstance that would have let Alex Smith go. Were we out there seeing and evaluating if we could have them both."

After making a free-agent trip to visit with the Miami Dolphins, Smith signed a three-year, $24 million contract with the 49ers. Smith would only be around for one of those seasons. After an impressive first half of 2012, there was no indication that he would become expendable. But an unforeseen turn of events led to his being traded to the Kansas City Chiefs at the first opportunity in March 2013.

There was no question when training camp opened that Smith was the team's top quarterback. Colin Kaepernick, a second-year player out of the University of Nevada and veteran Josh Johnson competed for the backup job. Kaepernick won the role, and second-year player Scott Tolzien nailed down the No. 3 spot.

San Francisco attempted to add more offensive firepower for Smith. The club signed free agents Randy Moss, who sat out the 2010 season due to family reasons, and Mario Manningham. The 49ers also used their top overall pick to select wide receiver A. J. Jenkins of Illinois.

Behind Frank Gore and backup Kendall Hunter, the 49ers brought in former Giants power back Brandon Jacobs, and they selected shifty runner LaMichael James from Oregon in the second round.

The offensive line was ready to make the leap toward becoming the best unit in all of football. One key offseason move was the decision to convert 6-foot-8 tackle Alex Boone to right guard. Boone brought stability to a position that had been a weakness in recent years. Staley became one of the top left tackles in the NFL. Mike Iupati and Anthony Davis developed into very strong components for the stacked offensive line.

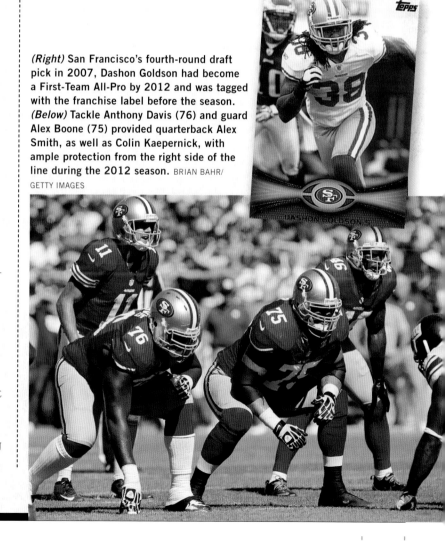

(Right) San Francisco's fourth-round draft pick in 2007, Dashon Goldson had become a First-Team All-Pro by 2012 and was tagged with the franchise label before the season. **(Below)** Tackle Anthony Davis (76) and guard Alex Boone (75) provided quarterback Alex Smith, as well as Colin Kaepernick, with ample protection from the right side of the line during the 2012 season. BRIAN BAHR/ GETTY IMAGES

SMITH'S HOT START

The 49ers opened the 2012 season in impressive form, defeating the Green Bay Packers 30–22 at Lambeau Field. The model of efficiency, Alex Smith completed 20 of 26 passes for 211 yards and two touchdowns. Gore gained 112 yards and a touchdown.

Kicker David Akers provided a highlight when his NFL-record-tying 63-yard field goal on the final play of the first half bounced off the crossbar and through the uprights. Akers' kick was set up by Kaepernick's 17-yard run, foreshadowing what the Packers would encounter when the clubs met again in the playoffs.

The 49ers' season followed along a unique pattern in which two victories in a row were followed by a loss or tie. After a 24–13 defeat at the Minnesota Vikings, the 49ers again worked out at Youngstown State as they prepared to face the New York Jets the following week. The 49ers destroyed Rex Ryan's Jets, 34–0, as Kaepernick saw his first significant role in a game plan.

Kaepernick scored the first touchdown of the game on a 7-yard run in the second quarter. He finished with 50 yards rushing and passed up a second touchdown when he elected to slide inside the 5-yard line so his team could run out the final seconds.

Even as Kaepernick was being integrated into the offense, Alex Smith was playing at a career-best level. He completed 18 of 24 passes for 303 yards and three touchdowns in a 45–3 win over the Buffalo Bills. The 49ers became the first team in NFL history to throw for more than 300 yards and eclipse 300 yards rushing in the same game. Gore rushed for 106 yards, while Michael Crabtree and Vernon Davis had 113 yards and 106 yards receiving, respectively.

Aside from a lackluster 26–3 loss to the New York Giants on October 14, things were going well for San Francisco. The pass defense had tightened up, and outside linebacker Aldon Smith established himself as one of the game's top pass-rushers. He became an every-down player in his second season, which was already the plan before Parys Haralson underwent season-ending surgery in August for a triceps tear. Cornerback Tarell Brown emerged as a front-line starter to help solidify the secondary.

Alex Smith was never more accurate than during a Monday night game against the Arizona Cardinals. He completed 18 of 19 pass attempts for 232 yards and three touchdowns in a 24–3 victory. For the first time in his career, he was recognized as NFC Offensive Player of the Week.

It was the last full game Smith would play in his 49ers career.

Alex Smith had one of the best games of his young career against the Buffalo Bills on October 7, 2012, when he threw for 303 yards and three touchdowns in a 45–3 triumph.
JASON O. WATSON/GETTY IMAGES

A BOLD DECISION

Little did they know it, but the 49ers were about to undergo a seismic shift at quarterback. The development began to take place on November 11 when Smith took a huge hit from St. Louis Rams linebacker Jo-Lonn Dunbar. Smith remained in the game but began to experience blurred vision after taking a hit from linebacker James Laurinaitis on a quarterback sneak. Smith stayed on the field long enough to lead San Francisco on a scoring drive, capped with a 14-yard touchdown pass to Crabtree.

Prior to the 49ers' next offensive possession, Smith informed the medical staff of his condition. He was diagnosed with a concussion, and Kaepernick entered the game. The 49ers settled for a 24–24 tie. It was San Francisco's first tie since 1986 against the Atlanta Falcons. Struggling kicker David Akers missed a 41-yard field-goal attempt in overtime that would have supplied the 49ers with a win.

All indications were that Alex Smith would be cleared in time for the next game, eight days later against the Chicago Bears. But when he experienced a setback the day before the Monday night game, Kaepernick was in line for his first NFL start.

Kaepernick was outstanding. He opened up the field with deep throws and pinpoint accuracy. He completed 16 of 23 passes for 243 yards and two touchdowns.

"It was A-plus, plus," Harbaugh said in evaluating Kaepernick's performance. "He did a great job. Decision-making, everything he did was in the high nineties, A-plus."

Smith was not medically cleared to return to action until the day prior to the following Sunday's game against the New Orleans Saints at the Superdome, site of Super Bowl XLVII more than two months later. Kaepernick again got the start, though Harbaugh did not officially make

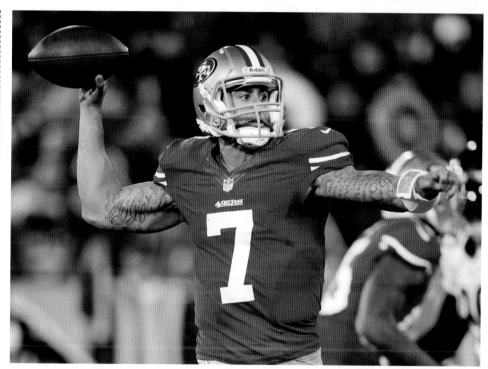

Filling in for the injured Alex Smith, Colin Kaepernick made the most of his opportunity in his first NFL start, leading the 49ers to a 32–7 win over the Bears on November 19, 2012.
THEARON W. HENDERSON/GETTY IMAGES

it clear that he had a new starter for the remainder of the season.

Kaepernick did not play as well as he did in his starting debut, but the 49ers defeated the surging Saints 31–21 with the help of Ahmad Brooks' 50-yard interception return for a touchdown off Drew Brees.

Harbaugh's announcement three days later—that Kaepernick was the team's starting quarterback—left Smith bitterly disappointed.

"I mean, it sucks," Smith said. "I don't know what else to say. . . . I feel like the only thing I did to lose my job was get a concussion."

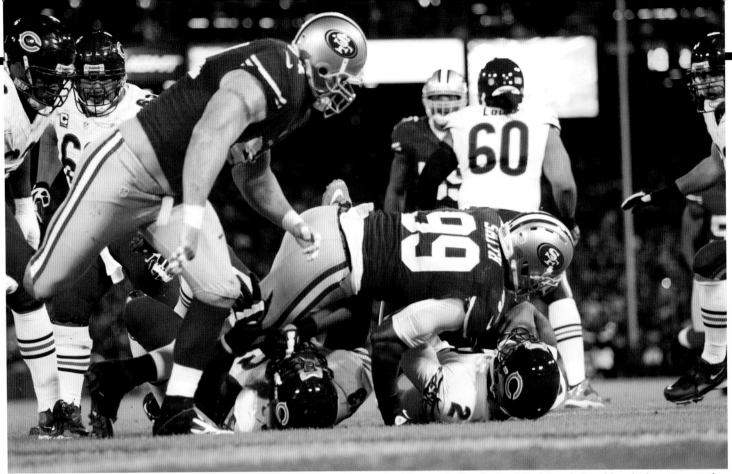

Aldon Smith (99) tallied 5.5 sacks in the victory against the Bears in November, finishing one-half sack shy of Fred Dean's franchise single-game record. Smith did secure the franchise season record with his 19.5 sacks on the year. MICHAEL ZAGARIS/SAN FRANCISCO 49ERS/GETTY IMAGES

Harbaugh's controversial decision never reached a raging debate point because Kaepernick played well enough to quiet the opposition. Although he made several rookie mistakes in a 16–13 overtime loss to the Rams, he rebounded strong with performances against the Miami Dolphins and the New England Patriots.

Kaepernick had four touchdowns passes against the Patriots on a cold and rainy night in Foxboro, Massachusetts, as the 49ers escaped with a 41–34 victory in front of a national-television audience on *Sunday Night Football.*

After San Francisco squandered a 28-point third-quarter lead, LaMichael James had a 62-yard kickoff return. Kaepernick then hit Crabtree for a 31-yard catch-and-run for what amounted to the winning points against the Patriots.

That victory proved costly for the 49ers, however, as defensive tackle Justin Smith sustained a partially torn triceps tendon early in the second half and would miss the remainder of the regular season. Without Justin Smith on the field, the defense was not nearly as effective.

Aldon Smith, who had already established a new franchise record with 19.5 sacks through the first 13 games, was held without a sack for the rest of the way. The 49ers surrendered 13.9 points per game before Justin Smith's injury. In the final two and a half regular-season games without him, that number rose to 34.4, including a 42–13 loss to the Seahawks on December 23.

Once again, San Francisco entered the NFC playoffs as the No. 2 seed. And again, the team was short-handed at some offensive skill positions due to injuries.

Manningham ranked second on the club with 42 receptions for 449 yards but played in only 12 games before sustaining a season-ending knee injury against Seattle. Kyle Williams had a good bounce-back season until a knee injury ended his year, too.

Moss, who earned a starter spot after those injuries, never became a big part of the 49ers' passing game. He finished with just 28 catches. Jenkins had one pass thrown his direction the entire season, and he dropped it.

Kendall Hunter averaged 5.2 yards as Gore's backup, but he sustained a torn Achilles that brought an end to his season after 11 games. Jacobs never did earn a role, and when he aired his complaints about the coaching staff on social media sites, the club suspended him for the final three games and released him at the start of the playoffs.

Gore kept churning away, though. He gained more than 1,000 yards rushing for the sixth time in the past seven seasons. With eight scores on the ground, Gore also became the franchise's all-time NFL leader with 51 rushing touchdowns.

KAEPERNICK TAKES OVER

In his second training camp with the 49ers, quarterback Colin Kaepernick was the target of some good-natured ribbing from his veteran teammates in the defensive backfield.

"He doesn't want to throw the ball," one player shouted from the sideline.

Indeed, Kaepernick seemed to be a lot more comfortable running the ball in training camp practices than using his powerful arm. Everyone knew that Kaepernick could be a threat with his legs. But what attracted Jim Harbaugh to the former Nevada quarterback was his arm.

Harbaugh was blown away when he worked him out prior to the 2011 draft. The 49ers traded up in the second round to select Kaepernick with the No. 36 overall pick.

"I fit coach Harbaugh's offense well, their style of play," Kaepernick said at the time. "Just watching a little bit of Stanford and knowing Andrew Luck a little bit, a lot of things they do follow my skill set. They like a mobile quarterback. They like a quarterback who can do a lot of different things."

Kaepernick was likely going to remain on the sideline, though, because Alex Smith was playing at an all-time best level. Smith led the NFL in completion percentage, and his 104.1 passer rating was among the league-leaders.

But when Smith sustained a concussion, Kaepernick was given the opportunity to show what he could do. And what he did was convince Harbaugh that a permanent switch should be made for the final seven regular-season games.

"I knew there was an opportunity there, no question," Smith said about Kaepernick. "You're letting the next guy step in and get an opportunity. I fully knew what Colin was potentially capable of. He came in and made the most of it. It's the nature of sports."

Kaepernick continued to show his dual-threat capabilities in leading the 49ers to the Super Bowl with two come-from-behind playoff victories. He rushed for 181 yards in a divisional-round victory over the Green Bay Packers—the most rushing yards for a quarterback in NFL history.

In the end, Harbaugh's controversial decision was justified. Kaepernick demonstrated star quality with his skills as an accurate pocket passer, as well as his prowess running the read option.

"[We had] two quarterbacks that were playing extremely well," Harbaugh said. "We did what we thought was best for the team. We did what we thought would give us the best chance to win games."

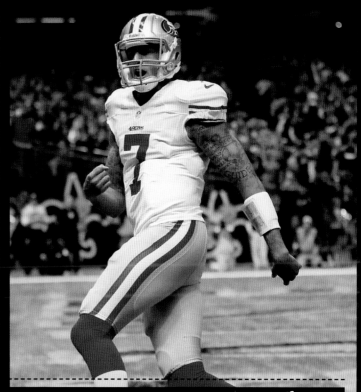

Colin Kaepernick took over the starting quarterback job when Alex Smith went down with an injury—and he never gave it back. CHRIS GRAYTHEN/GETTY IMAGES

"I fully knew what Colin was potentially capable of. He came in and made the most of it. It's the **nature of sports.**"
—Alex Smith, 49ers quarterback

KAEPERNICK:
A DUAL THREAT

After Kaepernick ascended into the starting lineup, Michael Crabtree's production took off. In another parallel to the 49ers' first title run of 1981, Crabtree led the team with 85 receptions for 1,105 yards. The 49ers' leading receiver in 1981 was Dwight Clark—with 85 catches for 1,105 yards.

Even with the addition of big-name receivers Mario Manningham and Randy Moss, Michael Crabtree was the 49ers' top receiver in 2012. His 85 catches on the year produced 1,105 yards and nine touchdowns.
JOE ROBBINS/GETTY IMAGES

Tight end Vernon Davis, however, experienced a significant dropoff as a pass-catcher. He had just 41 receptions for 548 yards and five touchdowns. In the final six games of the season, Davis caught a combined six passes for 61 yards.

After his initial reaction to losing the starting job, Alex Smith did not complain again about his demotion. He remained supportive of Kaepernick and even expressed his admiration with how the young quarterback carried himself.

"I think the thing I've been impressed with most is, not so much the play-making. I knew that and the guys around here knew that," Smith said. "I think it's the lack of young mistakes that's really jumped out at me. Most young guys who come in, yeah, they show flashes and they can play good at times. But they also seem to have those young moments as well, rookie moments, and bone-headed things. He hasn't done it. Period. He's played good ball. He's played patient and smart."

There was certainly pressure on Kaepernick to take the 49ers further than they had gone the previous season. And he had every reason to be rattled when his second pass attempt of the divisional-round game ended up in the hands of Green Bay defensive back Sam Shields for a 52-yard interception return.

But that was about the last mistake Kaepernick would make in his historic playoff debut. Offensive coordinator Greg Roman incorporated more of the pistol formation and the read-option game into the plan.

Kaepernick, who mastered the quarterback's responsibilities at Nevada under pistol inventor Chris Ault, put on a memorable display at Candlestick Park. Kaepernick rushed for 181 yards—the most for a quarterback in any NFL game in history—and two touchdowns. He also threw for 263 yards and two touchdowns in a 45–31 victory over the Packers.

"I mean, that was ridiculous," said Justin Smith, who returned to action with a brace on his left arm. "Almost two-hundred yards

rushing from a quarterback? You're not going to win. I don't care who you've got, you're not going to win."

The 49ers became the first team in league history to have two 100-yard rushers (Gore had 119 yards) and a 100-yard receiver (Crabtree had nine catches for 119 yards and two touchdowns) in a playoff game. San Francisco also set a club postseason record with 323 yards rushing.

The win earned the 49ers a return trip to the NFC Championship Game. They took on the top-seeded Atlanta Falcons at the Georgia Dome.

Kaepernick's ability to lead his team back from a deficit was tested again. This time, the 49ers fell behind 17–0 early in the second quarter. James had a 15-yard touchdown run and Vernon Davis caught a 4-yard scoring pass to pull the 49ers close in the second quarter. Atlanta tacked on another touchdown to lead 24–14

before the teams headed in for halftime.

The San Francisco defense, which has been torn to shreds by Falcons quarterback Matt Ryan and top targets Julio Jones, Roddy White, and Tony Gonzalez, toughened up in the second half. Touchdown runs of 5 and 9 yards by Gore gave the 49ers a 28–24 lead.

Linebackers NaVorro Bowman and Ahmad Brooks made key fourth-quarter plays to preserve the victory and send the 49ers to Super Bowl XLVII in New Orleans two weeks later.

Former owner Eddie DeBartolo was invited on stage, along with Jed York, John York, and Denise DeBartolo York, for the presentation of the NFC's George Halas Trophy.

"Having our whole family, my son being here, that's what the Forty-Niners are about," Jed York said. "Whether it's the DeBartolo family, the York family, the extended Forty-Niner family, that's what this team's about."

Colin Kaepernick completed 62.4 percent of his passes during the 2012 season, but it was his feet that did the damage against the Packers in the NFC divisional playoff game on January 12, 2013. He singlehandedly outrushed the entire Green Bay team, 181 to 104 yards. MICHAEL ZAGARIS/SAN FRANCISCO 49ERS/GETTY IMAGES

THE HARBOWL

The journey ended one victory short in the 49ers' quest for the franchise's sixth Lombardi Trophy.

Super Bowl XLVII matched brothers as opposing head coaches for the first time in NFL history. John Harbaugh's Baltimore Ravens took a seemingly comfortable 28–6 lead on Jacoby Jones' 108-yard kickoff return to open the third quarter.

After a 34-minute delay due to a partial power outage at the Superdome, the 49ers found a spark. They scored 17 points in a span of just 4 minutes and 10 seconds to close the gap to 28–23 with 18 minutes remaining in the game.

The Ravens added a field goal before Kaepernick's 15-yard touchdown run with 10 minutes to go pulled the 49ers within two points, 31–29. But Kaepernick and Randy Moss were not able to hook up on the two-point conversion.

The 49ers moved to the Ravens' 5-yard line late in the game, but their frenetic comeback attempt was thwarted. For the second year in a row, San Francisco's season ended with a painful loss just shy of the ultimate goal.

"Five yards short," said left tackle Joe Staley. "All the work we did in the offseason, the whole entire season, everything came down to five yards and we weren't able to get it done."

The 49ers had come back, but not all the way back. After winning in the franchise's first five trips to the Super

Dubbed the "Harbowl," Super Bowl XLVII pitted San Francisco's Jim Harbaugh against brother John Harbaugh, coach of the Ravens. The Harbaugh boys chatted amicably on the field prior to the start of the game. CHRISTIAN PETERSEN/GETTY IMAGES

Bowl, the 49ers' string of perfection ended with a heartbreaking 34–31 loss to the Baltimore Ravens.

As they had the previous offseason, the 49ers were looking for motivation from the loss. The franchise's quest for a sixth ring would continue in 2014 with perhaps the NFL's strongest roster.

While the defeat left a lot of 49ers' followers conflicted about the season,

Harbaugh maintained the same approach he took since getting his team on the practice field for the first time in the summer of 2011.

"Either team could've won it," Harbaugh said. "We're forging ahead with a new day, and we're attacking it with an enthusiasm unknown to mankind. And we'll see if we can't make today better than yesterday and tomorrow, and be better tomorrow than we were today. That's our attitude."

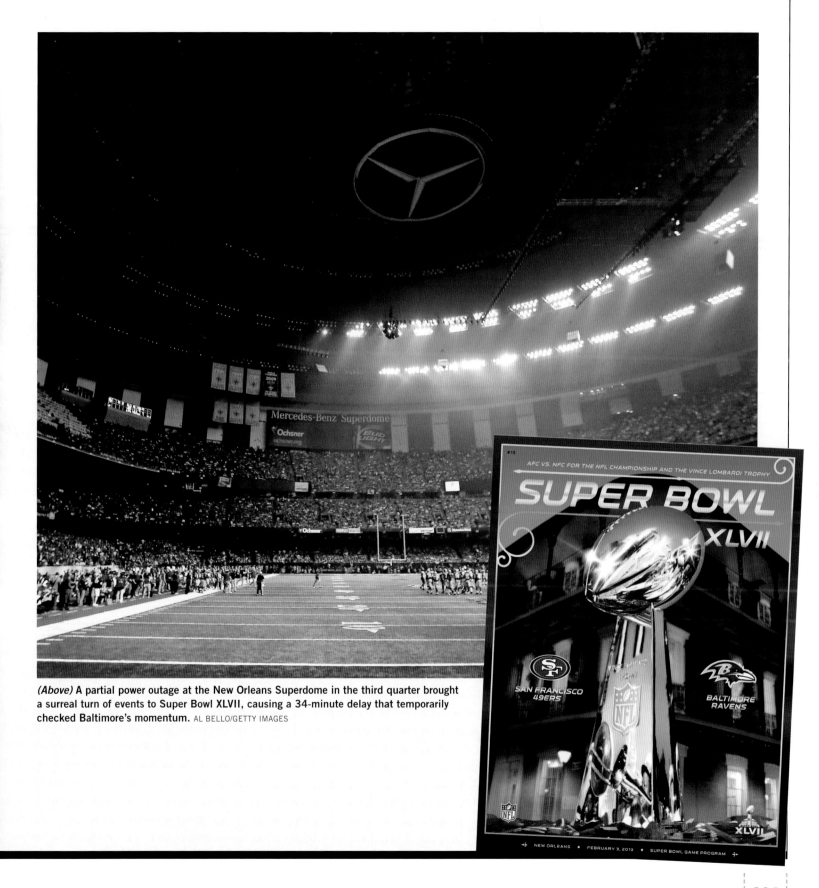

(Above) A partial power outage at the New Orleans Superdome in the third quarter brought a surreal turn of events to Super Bowl XLVII, causing a 34-minute delay that temporarily checked Baltimore's momentum. AL BELLO/GETTY IMAGES

SUPER BOWL XLVII: FIVE YARDS SHORT

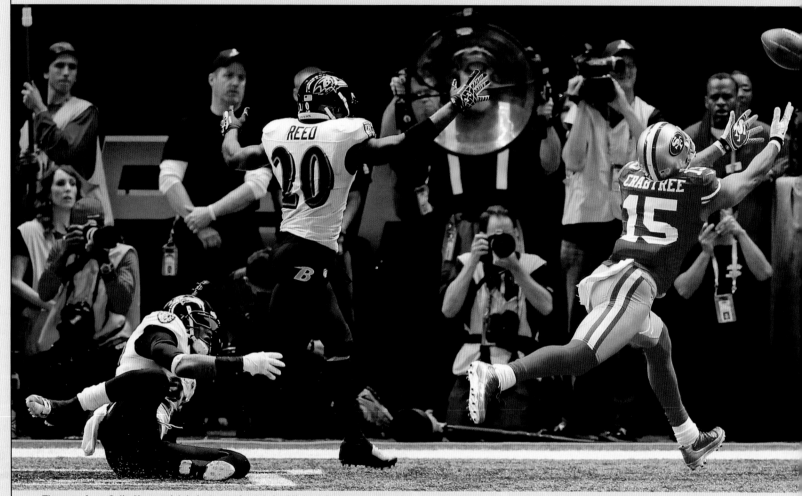

The pass from Colin Kaepernick is just out of reach for Michael Crabtree as the 49ers fail to score on the final drive of Super Bowl XLVII. JAMIE SQUIRE/GETTY IMAGES

The lights went out in Super Bowl XLVII in the third quarter at the Superdome in New Orleans on February 3, 2013. But, even before that, the 49ers appeared to be in the dark. Trailing 28–6 after Baltimore Ravens speedster Jacoby Jones had a 108-yard kickoff return for touchdown to open the second half, the 49ers needed a blast of energy. And, perhaps, they received it after a 34-minute stoppage due to a partial power failure.

The 49ers certainly came to life. The defense, which could not stop Baltimore quarterback Joe Flacco in the first half, made some stops. And the 49ers' offense became ultra-explosive at the flip of a switch.

The 49ers made Super Bowl history with an offensive show that included a 300-yard passer, two 100-yard receivers, and a 100-yard rusher. But, ultimately, the 49ers came up 5 yards short of a victory. The Ravens held on for a 34–31 victory.

"Our guys battled back to get back in," 49ers coach Jim Harbaugh said. "I thought we battled right to the brink of winning."

There was added intrigue as the game matched Harbaugh's 49ers against his older brother John's Ravens. Afterward, the men embraced briefly at midfield and expressed their pride in one another.

Jim Harbaugh said it certainly was not any easier losing the Super Bowl to his brother. And it was especially difficult after the 49ers rallied and had a chance to pull off the victory.

Running back Frank Gore, who gained 110 yards, tore off a 33-yard run to give the 49ers a first-and-goal situation at the Baltimore 7-yard line. The 49ers trailed 34–29 with 2 minutes, 39 seconds remaining. Gore was exhausted, so he came out of the game for one play.

Backup LaMichael James picked up 2 yards on first down. After quarterback Colin Kaepernick threw incomplete pass to Michael Crabtree on second down, the 49ers had a designed quarterback run as the call on third down. However, Harbaugh called a timeout just prior to the snap to avoid a delay penalty.

On third and fourth downs, Kaepernick threw incomplete to Crabtree against all-out blitzes. Kaepernick finished with 302 yards passing. Crabtree had 109 yards and one touchdown on

five receptions, while tight end Vernon Davis added six catches for 104 yards.

Harbaugh said "there was no question in my mind" that Ravens cornerback Jimmy Smith should have been penalized for his contact against Crabtree on the fourth-down play.

Said Crabtree, "It is what it is, man. It was the last play, and I'm not going to blame the refs. It is what it is. It came down to the last play and it didn't happen. [If] somebody grabs me, you always expect the call, but you can't whine to the referee."

There were many things the 49ers could have done after the achieving the first-and-goal situation. Gore did not touch the ball on the final set of downs, but he did not blame the play-calling.

"That's why we've got coaches," Gore said. "Every player wanted the ball at that time, but coach made the decision and we tried our best to make it happen."

The 49ers lost for the first time in six Super Bowl appearances, and this one could not be pinned on any one area or any one facet of the game. Offense, defense, and special teams each had critical errors in the 49ers' loss.

"Everybody had their hand on this game," 49ers All-Pro linebacker Patrick Willis said. "We point the fingers at nobody. We win together and we lose together, and today we lost it."

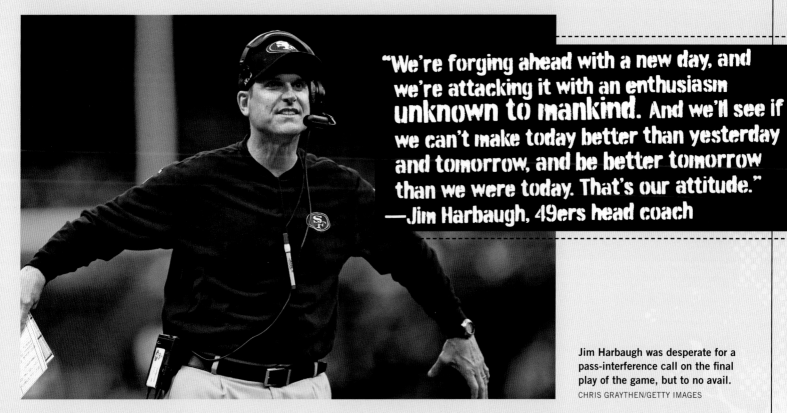

"We're forging ahead with a new day, and we're attacking it with an enthusiasm unknown to mankind. And we'll see if we can't make today better than yesterday and tomorrow, and be better tomorrow than we were today. That's our attitude."
—Jim Harbaugh, 49ers head coach

Jim Harbaugh was desperate for a pass-interference call on the final play of the game, but to no avail.
CHRIS GRAYTHEN/GETTY IMAGES

SAN FRANCISCO 49ERS ALL-TIME RECORD BOOK

THROUGH THE 2012 SEASON

YEAR-BY-YEAR RESULTS

Year	W-L-T	Postseason	Head Coach	Year	W-L-T	Postseason	Head Coach
1946	9–5		Buck Shaw	1980	6–10		Bill Walsh
1947	8–4–2		Buck Shaw	1981	13–3	Won Super Bowl XVI	Bill Walsh
1948	12–2		Buck Shaw	1982	3–6		Bill Walsh
1949	9–3	Lost AAFC championship	Buck Shaw	1983	10–6	Lost NFC championship	Bill Walsh
1950	3–9		Buck Shaw	1984	15–1	Won Super Bowl XIX	Bill Walsh
1951	7–4–1		Buck Shaw	1985	10–6	Lost wild card	Bill Walsh
1952	7–5		Buck Shaw	1986	10–5–1	Lost divisional round	Bill Walsh
1953	9–3		Buck Shaw	1987	13–2	Lost divisional round	Bill Walsh
1954	7–4–1		Buck Shaw	1988	10–6	Won Super Bowl XXIII	Bill Walsh
1955	4–8		Red Strader	1989	14–2	Won Super Bowl XXIV	George Seifert
1956	5–6–1		Frankie Albert	1990	14–2	Lost NFC championship	George Seifert
1957	8–4	Lost divisional playoff	Frankie Albert	1991	10–6		George Seifert
1958	6–6		Frankie Albert	1992	14–2	Lost NFC championship	George Seifert
1959	7–5		Red Hickey	1993	10–6	Lost NFC championship	George Seifert
1960	7–5		Red Hickey	1994	13–3	Won Super Bowl XXIX	George Seifert
1961	7–6–1		Red Hickey	1995	11–5	Lost divisional round	George Seifert
1962	6–8		Red Hickey	1996	12–4	Lost divisional round	George Seifert
1963	2–12		Red Hickey, Jack Christiansen	1997	13–3	Lost NFC championship	Steve Mariucci
1964	4–10		Jack Christiansen	1998	12–4	Lost divisional round	Steve Mariucci
1965	7–6–1		Jack Christiansen	1999	4–12		Steve Mariucci
1966	6–6–2		Jack Christiansen	2000	6–10		Steve Mariucci
1967	7–7		Jack Christiansen	2001	12–4	Lost wild card	Steve Mariucci
1968	7–6–1		Dick Nolan	2002	10–6	Lost divisional round	Steve Mariucci
1969	4–8–2		Dick Nolan	2003	7–9		Dennis Erickson
1970	10–3–1	Lost NFC championship	Dick Nolan	2004	2–14		Dennis Erickson
1971	9–5	Lost NFC championship	Dick Nolan	2005	4–12		Mike Nolan
1972	8–5–1	Lost divisional round	Dick Nolan	2006	7–9		Mike Nolan
1973	5–9		Dick Nolan	2007	5–11		Mike Nolan
1974	6–8		Dick Nolan	2008	7–9		Mike Nolan, Mike Singletary
1975	5–9		Dick Nolan	2009	8–8		Mike Singletary
1976	8–6		Monte Clark	2010	6–10		Mike Singletary, Jim Tomsula
1977	5–9		Ken Meyer	2011	13–3	Lost NFC championship	Jim Harbaugh
1978	2–14		Pete McCulley, Fred O'Connor	2012	11–4–1	Lost Super Bowl XLVI	Jim Harbaugh
1979	2–14		Bill Walsh				

INDIVIDUAL HONORS

SAN FRANCISCO 49ERS IN THE PRO FOOTBALL HALL OF FAME
(minimum two seasons with the 49ers)

Name	Position	Years with 49ers	Induction Year
Larry Allen	OG	2006–2007	2013
Fred Dean	DE	1981–1985	2008
Chris Doleman	DE	1996–1998	2012
Rickey Jackson	DE	1994–1995	2010
Jimmy Johnson	CB	1961–1976	1994
John Henry Johnson	FB	1954–1956	1987
Ronnie Lott	S/CB	1981–1990	2000
Hugh McElhenny	HB	1952–1960	1970
Joe Montana	QB	1979–1992	2000
Leo Nomellini	DT	1950–1963	1969
Joe Perry	FB	1948–1960, 1963	1969
Jerry Rice	WR	1985–2000	2010
O. J. Simpson	RB	1978–1979	1985
Bob St. Clair	OT	1953–1963	2008
Y. A. Tittle	QB	1951–1960	1971
Bill Walsh	coach/exec.	1979–1988, 1999–2004	1993
Dave Wilcox	LB	1964–1974	2000
Steve Young	QB	1987–1999	2005
Bob St. Clair	OT	1953–1963	2009
Y. A. Tittle	QB	1951–1960	2009
Bill Walsh	coach/exec.	1979–1988	2009
Dave Wilcox	LB	1964–1974	2009
Steve Young	QB	1987–1999	2009

MEMBERS OF THE EDWARD J. DEBARTOLO SR. 49ERS HALL OF FAME

Name	Position	Years with 49ers	Induction Year
John Brodie	QB	1957–1973	2009
Dwight Clark	WR	1979–1987	2009
Roger Craig	RB	1983–1990	2011
Fred Dean	DE	1981–1985	2009
Edward DeBartolo Jr.	owner	1977–2000	2009
Jimmy Johnson	CB	1961–1976	2009
John Henry Johnson	FB	1954–1956	2009
Charlie Krueger	DT	1959–1973	2009
Ronnie Lott	S/CB	1981–1990	2009
Hugh McElhenny	HB	1952–1960	2009
Joe Montana	QB	1979–1992	2009
Tony Morabito	founder	1946–1957	2010
Vic Morabito	co-owner	1950–1964	2010
Leo Nomellini	DT	1950–1963	2009
R. C. Owens	WR	1957–1961	2011
Joe Perry	FB	1948–1960, 1963	2009
Jerry Rice	WR	1985–2000	2010
Gordy Soltau	WR/K	1950–1958	2012

FIRST-TEAM ALL-PROS
(players with two or more All-Pro selections)

Name	Position	Years
Jerry Rice	WR	10 (1986–1990, 1992–1996)
Leo Nomellini	DT/T	6 (1951–1954, 1957, 1959)
Ronnie Lott	DB	5 (1981, 1986, 1987, 1989, 1990)
Patrick Willis	LB	5 (2007, 2009–2012)
Jimmy Johnson	DB/HB	4 (1969–1972)
Gene A. Washington	WR/SE	3 (1969, 1970, 1972)
Joe Montana	QB	3 (1987, 1989, 1990)
Steve Young	QB	3 (1992–1994)
Terrell Owens	WR	3 (2000–2002)
Andy Lee	P	3 (2007, 2011, 2012)
Bruno Banducci	G	2 (1947, 1954)
Hugh McElhenny	HB	2 (1952, 1953)
Joe Perry	FB	2 (1953, 1954)
Abe Woodson	DB/HB	2 (1959, 1960)
Forrest Blue	C	2 (1971, 1972)
Dave Wilcox	LB	2 (1971, 1972)
Harris Barton	T/G	2 (1992, 1993)
Navorro Bowman	LB	2 (2011, 2012)

PRO BOWLERS
(players with five or more Pro Bowl selections)

Name	Position	Years
Jerry Rice	WR	12 (1986–1996, 1998)
Leo Nomellini	DT/T	10 (1950–1953, 1956–1961)
Ronnie Lott	DB	9 (1981–1984, 1986–1990)
Steve Young	QB	7 (1992–1998)
Joe Montana	QB	7 (1981, 1983–1985, 1987, 1989, 1990)
Dave Wilcox	LB	7 (1966, 1968–1973)
Patrick Willis	LB	6 (2007–2012)
Billy Wilson	E/FL	6 (1954–1959)
Jimmy Johnson	DB/HB	5 (1969–1972, 1974)
Hugh McElhenny	HB	5 (1952, 1953, 1956–1958)
Abe Woodson	DB/HB	5 (1959–1963)
Bob St. Clair	T	5 (1956, 1958–1961)
Guy McIntyre	G	5 (1989–1993)

ACKNOWLEDGMENTS

Little did I know when I began covering the San Francisco 49ers full time in 1995 as a beat reporter for the *Oakland Tribune* that I had also started compiling information for a book chronicling the history of the fabled franchise.

Really, this book has been a work of nearly 20 years. Throughout my time covering the 49ers, I've come in contact with many of the organization's great players and notable personalities.

Hundreds—if not, thousands—of interviews through two decades with past and present players, past and present coaches and executives, provided the foundation for this work. Many of those key individuals in the history of the 49ers have since passed. This book stands as a tribute to those men, including Lou Spadia, Visco Grgich, Joe "The Jet" Perry, R. C. Owens, Bobb McKittrick, and Bill Walsh.

I had great fun during the research for this project, as I combed through archives of each of the Bay Area's daily newspapers to piece together the history of the 49ers. I have a great appreciation and respect for the individuals who reported on the organization through the years and whose work I truly enjoyed reading during the process.

Thanks to my bosses at Comcast SportsNet Bay Area, Ted Griggs and Jen Franklin, for supporting this project from the beginning.

I'm particularly appreciative of the time 49ers historian Donn Sinn devoted to assisting me. We communicated regularly, and I listened intently any time he had a suggestion. He provided invaluable help as a fact-checker and a sounding board throughout the process.

Thanks to Josh Leventhal at MVP Books for approaching me with what seemed like a daunting proposal. Then, he exhibited tremendous patience to work around my schedule during an interesting and demanding football season.

And, of course, the biggest thanks of all go my wife, Sarah, and our two children, Jane and Lucy, for putting up with my writing schedule on top of the many demands of covering a Super Bowl team.

INDEX